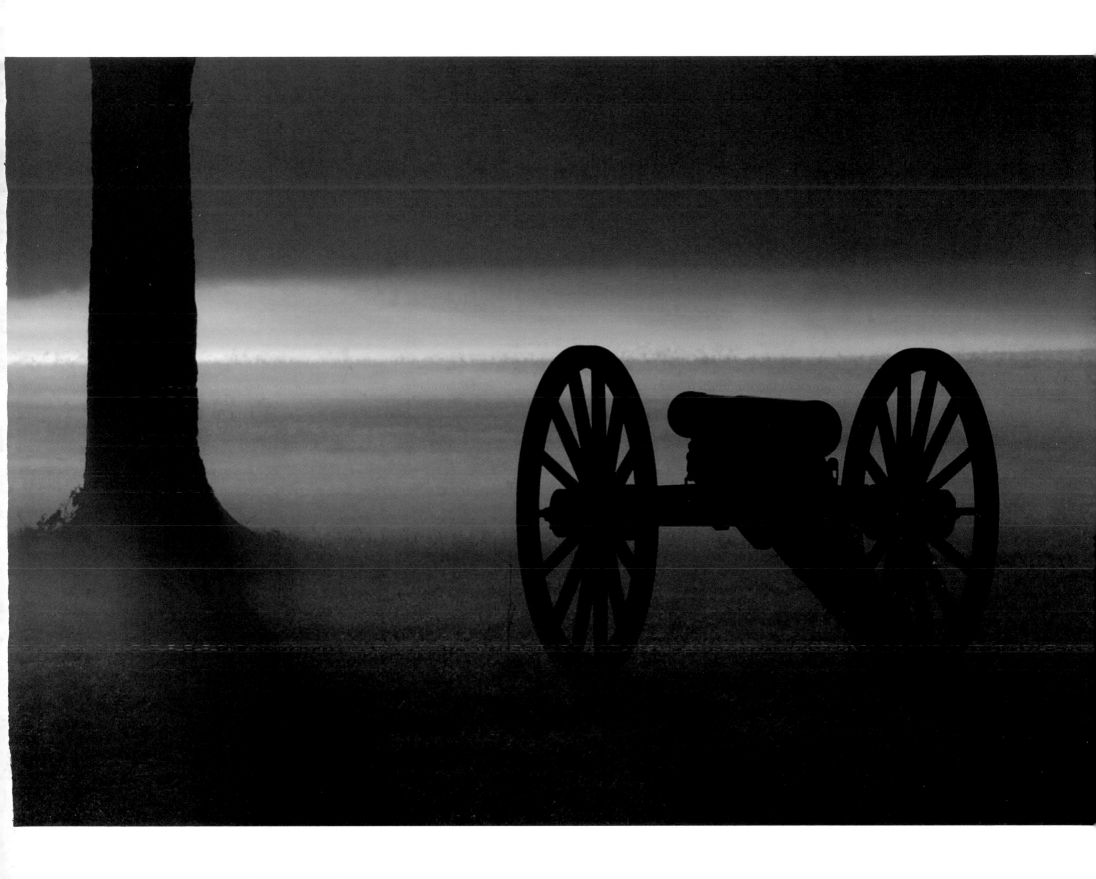

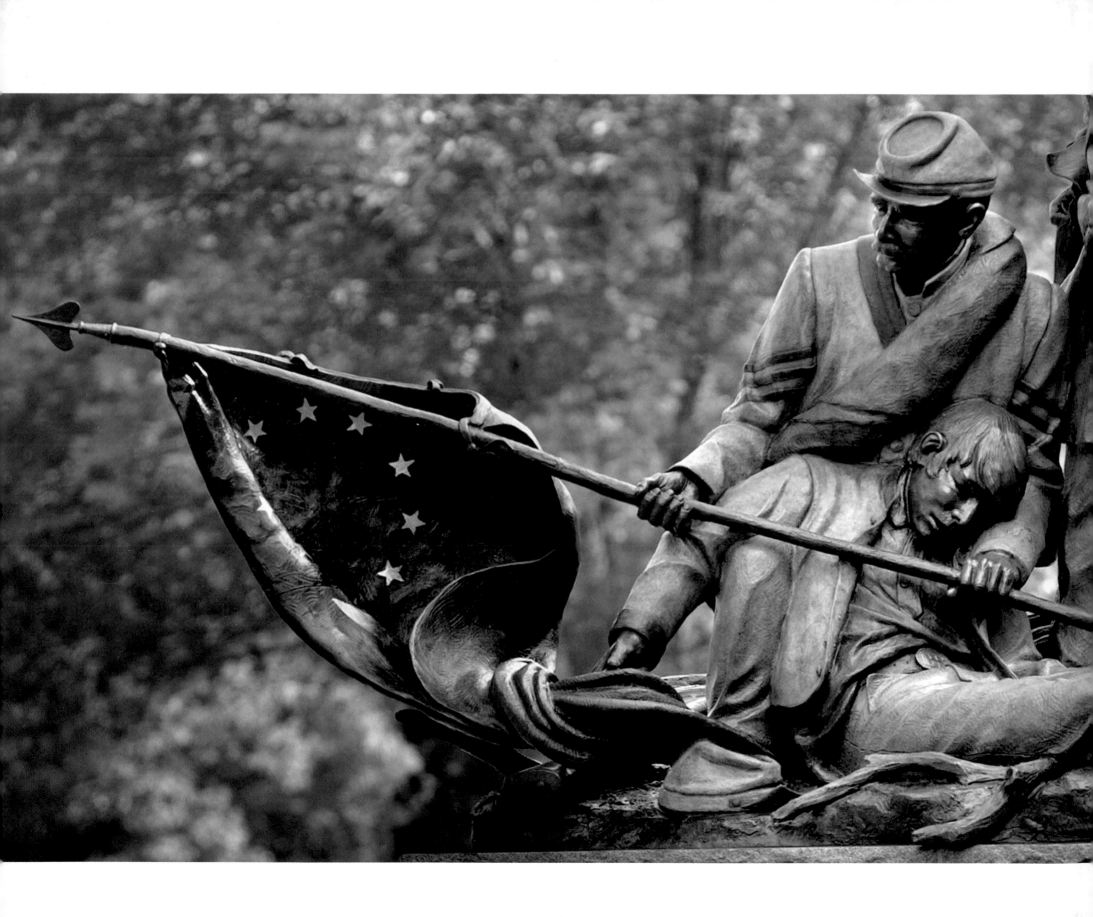

Shiloh and Corinth

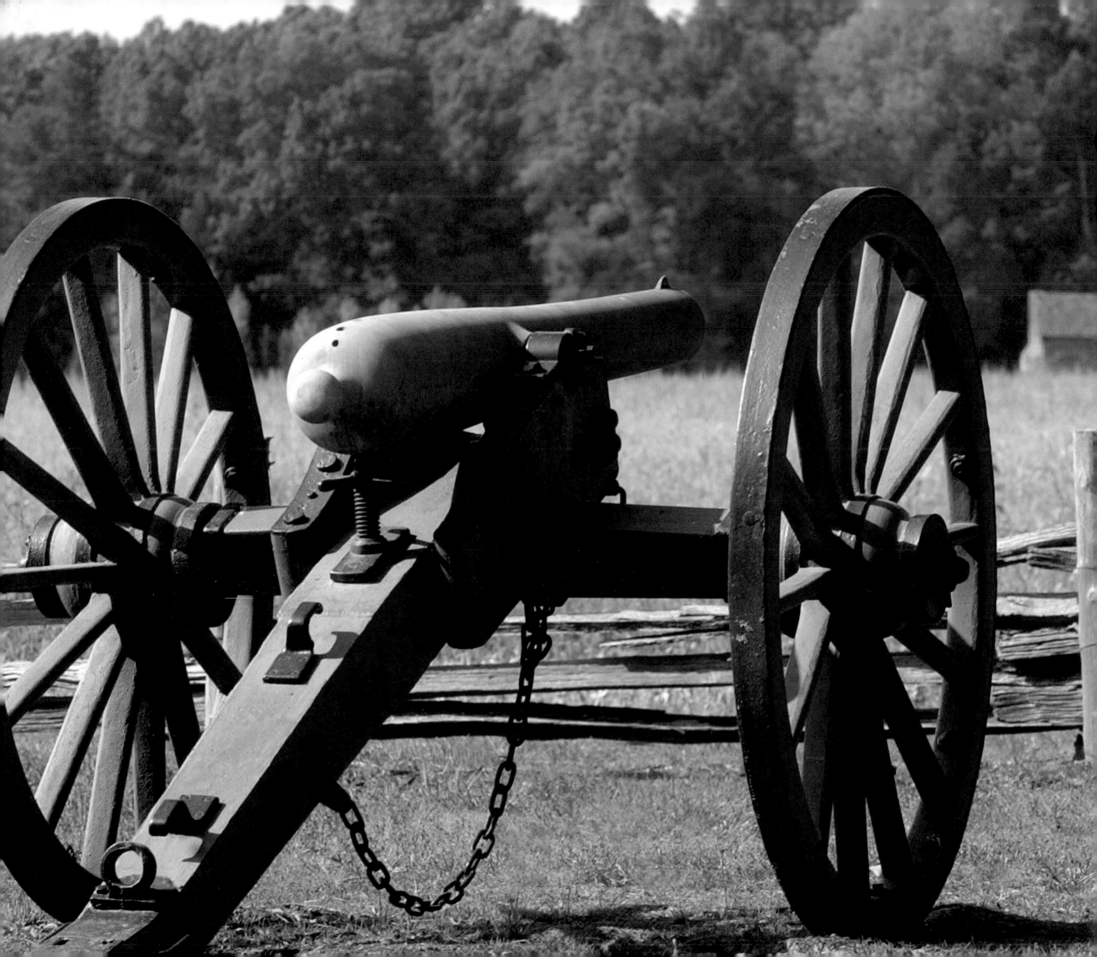

Shiloh and Corinth

Sentinels of Stone

Timothy T. Isbell

University Press of Mississippi / *Jackson*

*Publication of this book was made possible in
part through the support of Dudley J. Hughes.*

www.upress.state.ms.us

Designed by Todd Lape

The University Press of Mississippi is a member
of the Association of American University Presses.

First printing 2007

∞

Library of Congress Cataloging-in-Publication Data

Isbell, Timothy T.
 Shiloh and Corinth : sentinels of stone / Timothy T. Isbell.
 p. cm.
 Includes bibliographical references and index.
 ISBN-13: 978-1-934110-08-9 (cloth : alk. paper)
 ISBN-10: 1-934110-08-6 (cloth : alk. paper) 1. Shiloh, Battle of, Tenn., 1862. 2.
Corinth, Battle of, Corinth, Miss., 1862. 3. Shiloh, Battle of, Tenn., 1862—Pictorial
works. 4. Corinth, Battle of, Corinth, Miss., 1862—Pictorial works. 5. Tennessee—
History—Civil War, 1861–1865—Campaigns. 6. Mississippi—History—Civil War,
1861–1865—Campaigns. 7. United States—History—Civil War, 1861–1865—
Campaigns. I. Title.
 E473.54.I83 2007
 973.7'31—dc22 2007015327

British Library Cataloging-in-Publication Data available

This book is dedicated to my mother, Geraldine Isbell Kynerd. She has been my mother and father, showing courage I didn't know she possessed.

This book is also dedicated to my maternal grandmother, Willowdean Broadfoot Crowder. Known for her great cooking and loving ways, she made Florence, Alabama, feel like my second home. She died when I was very young. Her last trip with my family was to see the Shiloh battlefield.

The battle of Shiloh has been more persistently misunderstood, than any other engagement between National and Confederate troops during the entire rebellion.

–MAJOR GENERAL ULYSSES S. GRANT

ACKNOWLEDGMENTS

Even before the publication of the Vicksburg and Gettysburg *Sentinels of Stone* books, I was already working on my next project. The process of producing the first two books was so enjoyable and educational, I decided to continue to study the battlefields of the Civil War.

The logical choice for my next book was the well-known battle of Shiloh, Tennessee, and the lesser-known campaign for Corinth, Mississippi. Separated by only twenty-two miles, Shiloh was fought because of its proximity to Corinth, an important railroad crossroads for the Confederacy.

The Union army's possession of Corinth opened up the way for Ulysses S. Grant to start his Vicksburg campaign. Given these facts, I thought this book would make a fitting prequel to *Vicksburg: Sentinels of Stone.*

Shiloh also bears special meaning for me. After Vicksburg, Shiloh was the battlefield I visited most as a child. The battlefield was only an hour away from my grandmother's home in Florence, Alabama.

It would be years later that I learned the importance of Corinth and the railroads running through town. Subsequent visits to Shiloh as an adult led to numerous stays in Corinth and a discovery of the town's role in the Civil War. The addition of the new Corinth Civil War Interpretive Center made learning the importance of this crossroads town a necessity.

I am indebted to the help given to me by the staff of the following libraries and museums: the Corinth Civil War Interpretive Center, the University of Southern Mississippi, the State of Mississippi Department of Archives and History, the University of Mississippi, and the Shiloh National Military Park.

It bears repeating that I would like to thank all the Civil War authors who have enriched my life with accounts of the great battles and soldiers who served for both North and South.

I would be remiss if I didn't mention my photography professor at the University of Southern Mississippi, Ed Wheeler. I truly respect his passion for the profession as a photographer and teacher. I consider him a valuable mentor and friend.

I need to thank Craig Gill, Steve Yates, Todd Lape, and Shane Gong for their help on my first two books and for my follow-up book, too. I hope we can keep up the momentum we have started these past few years.

I am deeply indebted to Robert Burchfield for his expertise as a copy editor. We worked together on my first two books, and I was happy to team up with him again. Aside from making my ramblings seem logical, he is a fellow Green Bay Packer fan.

I would like to thank Jeff Shaara for recommending the Catfish Hotel as a place to eat while at Shiloh. It is now a favorite stop for the Isbell family whenever we are visiting Shiloh.

Many thanks go to the numerous volunteers who have come to aid the people of Mississippi's Gulf Coast after Hurricane Katrina. Your help during our time of need, past and present, is a godsend.

I must thank Timothy B. Smith of the Shiloh National Military Park for his many readings of the Shiloh manuscript. His knowledge of the battles of Shiloh, Iuka, and Corinth was helpful to me in writing this book. His patience to read and reread the manuscript numerous times is appreciated.

Finally, I want to thank my family, who hail from Mississippi, Alabama, New Jersey, and Pennsylvania. Your support for my efforts for all these years is deeply appreciated.

I would like to thank my sister, Cindy Huerkamp, for letting me stay at her home during my many visits to Shiloh and Corinth. She tagged along on one of my final shooting assignments at Shiloh.

I will always be indebted to my parents, Geraldine Isbell Kynerd and the late Wiley Travis Isbell, for being such positive influences on my life.

I want to thank my son, Patrick Isbell, for being such a joy for the past seventeen years. I probably don't say it enough, but I'm very proud of you.

ACKNOWLEDGMENTS

The debt that I owe my wife, Judy Isbell, can never be paid. We have been together since our college days in 1981. Judy makes me whole. Once again she was instrumental in the production of this book. Any accomplishments I have achieved through the years are a direct result of her. I love her with all of my heart, and I'm glad I followed her to the University of Southern Mississippi many years ago.

PREFACE

A PLACE OF PEACE

No two battlefields are the same. It would be silly to make Antietam into Vicksburg or Shiloh into Gettysburg. Each field, hallowed by the enormity of lost life, has its own personality.

The best way to understand a battlefield's personality is to simply "walk" the field. Books and journals serve a crucial role in understanding the men and the battle. Without these historical records, it would be difficult to understand what drove men to kill and maim each other in the name of a "cause."

To walk the battlefield of Shiloh brings a different understanding of the enormous tasks assigned mortal men on April 6 and 7, 1862. To walk across Duncan Field toward the Hornet's Nest, one understands the futility of repeated frontal assaults against a strong position. Standing in Hell's Hollow, the foreboding doom of a surrounded Union army is present. Watching deer gently sip water from Bloody Pond as the eastern sky turns blood red, it is easy to imagine soldiers, in blue and gray, crawling across a war-torn landscape in search of their last drink.

A simple wooden cross stands on the roof of a nondescript log building. The battlefield gets its name from this building, a replica of the original Shiloh Meeting House. During April 6 and 7, 1862, a fierce battle raged between the armies of Confederate generals Albert Sidney Johnston and P. G. T. Beauregard and Union generals Ulysses S. Grant and Don Carlos Buell. For many of the soldiers, the battle was their first experience in combat.

The two-day battle was the costliest in U.S. history up to that point. A total of 23,746 men were killed, wounded, captured, or missing, more than the American casualties of the Revolutionary War, the War of 1812, and the Mexican War combined. News of the carnage at Shiloh shocked and bewildered the nation. Both sides had seen the war as one that could be won quickly without great loss of life. Neither side realized that even bloodier battles lay ahead in the next three years of fighting. Ironically, the word "shiloh" is Hebrew for "tranquil."

TODAY'S SHILOH

It doesn't take too much imagination to see how the field at Shiloh once looked. Briar patches and thickets still reign in the trees lining the fields near Pittsburg Landing. Cannonball pyramids and lone cannon barrels that stand upright mark the locations of brave men of both armies. Their heroic deeds are forever recorded on the monuments of Shiloh.

These deeds are also remembered at the National Cemetery at Shiloh. Tombstones dot the rolling hills overlooking the Tennessee River. The graves of the Union soldiers are marked with names and regiments. Some grave markers have one word, "Unknown," an eternal monument to their memory, too.

The soldiers of the South are also remembered with monuments but perhaps more significantly by five mass graves. These graves mark the final resting place of Rebel soldiers who fell during the battle of Shiloh. Having served together in arms, these soldiers are interred together in pits.

THE FORGOTTEN BATTLE

At Corinth, trains still roll on rail lines that were so important to the Confederate war effort. Homes still stand where fateful decisions were made to fight or retreat.

Fortifications that were dug by soldiers of Union and Confederate armies also remain. These fortifications, built to withstand the deadly weapons of war, are now havens for squirrels gathering acorns for a long winter. Monuments stand to remind

future generations of the bravery of men like Confederate colonel William P. Rogers of the 2nd Texas Volunteers.

The town, which was occupied and fought over by two opposing armies, looks forward to a promising future while also remembering its violent past. This is the story of Shiloh, Tennessee, and Corinth, Mississippi, two places forever linked through the carnage of war.

Like my previous two books, I have used the state memorials on the battlefields as a device to tell a compelling story about soldiers, citizens, and regiments.

INTRODUCTION

DIFFERENT THEATERS OF WAR

During the Civil War, the eastern and western theaters were about as different as the beliefs of Northerners and Southerners. In the East, battles were fought in a confined area. The goal was either to take or defend Richmond, Virginia. Towns like Manassas, Fredericksburg, Sharpsburg, and Gettysburg would soon be known for the battles that were fought there. While all these battles were significant, they were relatively close in proximity.

In the West, the Confederacy had to defend an area significantly larger than the area around Richmond. The defensive line in the West stretched along the Ohio River down to the Mississippi River. Whoever had the task of defending the West faced a huge challenge. There were not enough soldiers or arms to defend the entire border, and the rivers served as thoroughfares for the Union army to invade the South.

During their service in the earlier Mexican War, some officers in the western theater had displayed glimpses of their future glory, but most men were unknown quantities. Ulysses S. Grant had left the army and was considered a drunk by the military establishment. William T. Sherman had also left the army while in California and was considered a bit insane. During the first year of the war, Sherman would have a nervous breakdown and have command taken away from him.

Albert Sidney Johnston had made a name for himself after the end of the Mexican War. He led the 2nd Cavalry Regiment in Texas. In 1857, Johnston was tabbed to lead an expedition to Utah to quell the Mormon uprising. Johnston received a brevet promotion to brigadier general for his service in Utah. By the end of 1860, Johnston was in command of the Department of the Pacific in California.

P. G. T. Beauregard was good at many things, but he seemed to truly excel in making President Jefferson Davis mad. Beauregard was in command of Southern troops at Fort Sumter, South Carolina, and during the battle of First Manassas. His personality and ambi-tion guaranteed that he and Davis would lock horns. While it was beneficial to be a "friend of Jeff Davis," it was equally detrimental to be his enemy.

Many officers from the North and South achieved their rank based on who they knew instead of any specific military experience. Leonidas Polk was a friend of Jefferson Davis and was given a general's rank before the war, even though Polk had left the military to become a minister. John McClernand was a friend of Abraham Lincoln. That and the support he brought from the Little Egypt region of Illinois assured him a general's rank in the Union army.

While some of these men would become effective leaders, others were an embarrassment and only got their troops killed.

The foot soldier in the West had a different personality than the soldier in the East. The eastern soldiers tended to be more refined and educated. They came from urban areas where more cultural and educational opportunities abounded. The Union soldiers in the West were usually farmers. Many of these men identified with the agrarian lifestyle of the South.

Battles in the East were given more attention because that was where each country's capital was located. The cry of "On to Richmond" or threat of the Confederates taking Washington, D.C.,

The road to Shiloh brought the nation into the terrible carnage of war. While the casualty figures at Shiloh were staggering, future Civil War battles would have even higher numbers.

brought media focus to the East. While the western battles proved important, the lack of immediate press coverage often made the western theater seem less important. While many eastern generals courted the press, the western generals disliked or avoided the media. Such dislike for the media is probably best summed up by Sherman, "I hate newspapermen. They come into camp and pick up their camp rumors and print them as facts. I regard them as spies, which, in truth, they are. If I killed them all there would be news from Hell before breakfast." Sherman eventually banned reporters from his army.

As the West developed into a theater of war, it was evident where the battles would occur. The fight would not necessarily be in big towns but at forts along the rivers and at important railroad junctions. The rivers and railroads brought life to the Confederate war effort. Victory could not be achieved until this life was choked out of the Confederacy.

AVENUES OF INVASION

Albert Sidney Johnston faced a daunting task. As head of Department No. 2 in the Confederacy, Johnston had to defend the western portion of the Confederate states. He didn't have the number of soldiers needed to perform such a task and had precious few weapons to arm the soldiers he did have. Many of his men were carrying old flintlocks passed down through generations of families and shotguns better used for hunting instead of fighting a war.

His soldiers were little more than a mob. Most had no experience in the military or with its customs. It was important for Johnston to turn his mob of men into soldiers before a major battle occurred.

Even with all the land to defend, the rivers worried Johnston the most. The Ohio River ran the length of northern Kentucky, forming a natural boundary between the North and South. The Mississippi River served as a highway reaching from Minnesota to

the Gulf of Mexico. It was vital to the war effort on both sides. The Cumberland River stretched south through the state of Tennessee, and the Tennessee River meandered through Tennessee, Mississippi, and Alabama. Johnston feared these rivers would serve as avenues of invasion for the Federal river fleet and army.

The Union's plan for victory called for the control of the rivers. Major General Winfield Scott's Anaconda Plan recommended a blockade of Southern ports and control of the Mississippi River. The implementation of this plan was designed to squeeze the life out of the Confederacy like a mighty snake.

William T. Sherman summed up the importance of America's rivers: "Whatever nation gets control of the Ohio, Mississippi and Missouri Rivers, will control the continent."

KENTUCKY AND MISSOURI

When eleven Southern states seceded from the Union in 1861, Kentucky and Missouri declared their neutrality in the coming conflict. While the North and South coveted these states, neither side wanted to offend them. Any undue pressure might send the states to the opposing side. The governor of Kentucky refused to raise troops to subdue the rising Confederacy but steadfastly stood by his state's position of neutrality.

In Missouri, the two factions plunged the state into its own civil war. Kansas Jayhawkers and Missouri Border Ruffians fought each other in an effort to convince Missouri to go either way.

Abraham Lincoln feared losing Kentucky to the Confederacy. Such a move opened up the Ohio River valley to possible invasion.

A Confederate Missouri would all but stop a Federal expansion west. Plus, the Confederates would virtually control all of the Mississippi River and its trade.

Even before the first shot was fired in the Civil War, the battle of words and actions for Kentucky and Missouri raged.

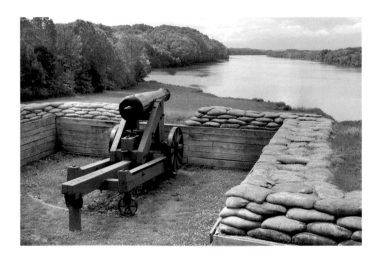

DEBACLE AT FORT DONELSON

If Kentucky would not join the Confederacy, Albert Sidney Johnston was content with a neutral Kentucky. If the state remained neutral, it would act as a buffer between the Union and the Confederacy. When setting up defenses, Johnston was careful not to invade Kentucky. Defensive positions were chosen in Tennessee at Fort Henry on the Tennessee River and at Fort Donelson on the Cumberland River to avoid any undue entry into Kentucky.

Keeping Kentucky neutral proved to be more difficult than any politician could imagine. In September 1861, Leonidas Polk entered Kentucky with his Confederate army, moving to occupy the heights at Columbus. Upon learning of Polk's move, Ulysses S. Grant advanced to Cairo, Illinois, and eventually occupied Paducah, Kentucky.

The Blue Grass State was no longer neutral, as the Union and Confederacy began occupying towns within the state.

As Johnston feared, the rivers soon became the means for the Federal invasion. Ironclads built to navigate the treacherous rivers began to make their way south. Andrew Foote and his Federal fleet, along with help from Grant's army, bombarded the earthen

The Cumberland River flows past a Confederate battery at Fort Donelson.

Fort Henry under the command of Lloyd Tilghman. The surrender of Fort Henry on February 6, 1862, brought the war to Tennessee. Grant marched his army to surround Fort Donelson only twelve miles away, while the Federal river fleet moved down the Cumberland River.

At Donelson, Grant faced a triumvirate of Confederate leadership. John Floyd outranked Gideon Pillow and Simon Bolivar Buckner but had no reason to be called a general. He was a politician who feared prosecution for embezzling funds for his secessionist activities in the administration of President James Buchanan. Pillow was an unlikable man who was prone to petty jealousy and needless arguments. He was the laughing stock of the Mexican War because he had his soldiers dig a trench on the wrong side of the fortifications. Buckner had joined the Confederacy only after troops started entering his native Kentucky.

The three men fought each other as much as they fought against Grant's army. By February 16, 1862, it was apparent that surrender was in order. Lieutenant Colonel Nathan Bedford Forrest refused to surrender and led four thousand men out of Fort Donelson to safety. Pillow and Floyd escaped by their own means, leaving Buckner to surrender the fort and fifteen thousand men.

Johnston became the most likely scapegoat for the debacle at Fort Donelson, but Jefferson Davis stood by his general and friend. Others in the Confederate army sought to place the blame elsewhere. Colonel Josiah Gorgas of the Confederate Ordnance Bureau placed the blame with Davis. "Ten thousand men would have converted Donelson from an overwhelming disaster to a victory—and 18,000 men were literally doing nothing with General Bragg at Pensacola and Mobile. Our President is unfortunately no military genius and could not see the relative value of position. Pensacola was nothing compared to Donelson."

The fall of Fort Henry and Fort Donelson was a severe blow to the Confederate war effort. All of Kentucky and middle Tennessee was relinquished to the Federal army. Johnston, shocked by the

Coast. Leaving his wife and children in St. Louis, Grant began his journey west.

The separation from his family was especially trying for Grant. Missing his family and disliking where he was stationed, Grant turned to the bottle to forget his troubles. In 1854, Grant was a failure as a soldier and an absentee father. He submitted his resignation from the army, which Secretary of War Jefferson Davis accepted.

Grant returned to St. Louis and civilian life and found more heartache and depression. No matter what job he took, he failed miserably at it. He tried his hand at farming and bill collecting, and even sold chopped firewood in St. Louis. By 1860, a destitute Grant was reduced to working as a clerk in his father's tannery in Galena, Illinois.

With the start of the Civil War, Grant sought to attain the rank of colonel of a regiment in the Union army. Given his academic training and Mexican War experience, this wasn't too much to expect.

Grant went to see an old classmate, Major General George B. McClellan, in hopes of attaining a colonelcy. Grant waited for two days, but McClellan refused to see him. Illinois governor Richard Yates offered Grant command of the 21st Illinois Infantry, which Grant heartily accepted.

Unlike many of his more pompous officers, Grant was not flamboyant or self-serving. Governor Yates remembered Grant as "very plain," while his soldiers referred to him as "the quiet man."

Whether he was quiet or not, Grant's military strategy was simple but bold: "Find out where your enemy is, get at him as soon as you can and strike him as hard as you can and keep moving on."

By July 31, 1861, Grant was appointed brigadier general, and six months later he sought permission to launch an offensive campaign. This offensive netted Fort Henry and Fort Donelson. In obtaining the surrender of Fort Donelson, Grant refused to

turn of events, began a massive withdrawal from Tennessee. His army eventually regrouped at Corinth, Mississippi.

A DRUNKARD AND A FAILURE

Ulysses S. Grant had graduated from West Point and displayed a gallant bravery during the Mexican War. But if Grant was known for anything in 1861, it was for his reputation as a drunkard and a failure.

After the Mexican War, Grant married Julia Dent, and the couple had two children. In 1852, he was transferred to the Pacific

The Confederate surrender at Fort Donelson split Albert Sidney Johnston's defensive line.

accept any conditions proposed by his Confederate counterpart. News of this stance earned Grant the nickname of "Unconditional Surrender" Grant in the Northern papers.

By March 1862, Grant was in Savannah, Tennessee, and was poised to start an offensive against Albert Sidney Johnston at Corinth, Mississippi.

THE CROSSROADS OF THE CONFEDERACY

The Civil War might have avoided the town of Corinth, Mississippi, except for two things. The Memphis and Charleston Railroad, stretching east and west, and the Mobile and Ohio Railroad, going north and south, intersected at Corinth.

During the spring of 1862, the little-known town of Corinth was second only to Richmond, Virginia, in strategic importance. Whichever army or government controlled the rail lines at Corinth dictated the amount of supplies going to the soldiers in the field. Without this important junction, the Confederate war effort would be severely crippled.

Albert Sidney Johnston and P. G. T. Beauregard chose to reunite their retreating commands at Corinth. Although the next military step wasn't considered, it was evident that Corinth and the railroads must be protected. "These roads constitute the vertebrae of the Confederacy," said former Confederate secretary of war Leroy Pope Walker.

During the next month, the Confederacy massed an army of forty-five thousand men. This army was destined to become the Army of the Mississippi and to fight at the battle of Shiloh.

PITTSBURG LANDING

William T. Sherman was glad to leave Savannah, Tennessee. The town had become a cesspool as Union soldiers crowded the river-

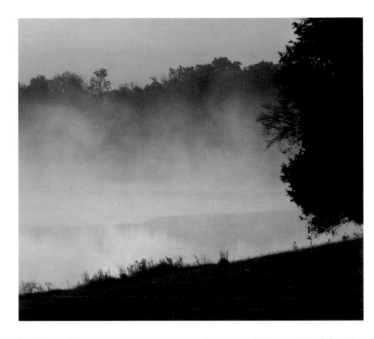

A morning fog hovers over the Tennessee River at Pittsburg Landing. This area gave the Union army a place to stage the upcoming offensive to Corinth.

banks and transports. As more and more soldiers arrived for the upcoming war effort, it became obvious that a landing that could support an army had to be found.

The answer to the Union army's prayer was located nine miles upriver. Pittsburg Landing offered a deep-water landing, along with woods and fields to camp an army.

The river landing meant supplies could arrive on a consistent basis, plus it was only twenty-two miles from Corinth and the Rebel army.

Located about two miles from the landing was a crude log building. The building, called the Shiloh Meeting House by local citizens, also served as a church. The word "shiloh" means "tranquil" in Hebrew, yet it became the scene of determined fighting on April 6 and 7, 1862.

Sherman made his headquarters near the church and went about his daily routine of drilling an army. He was confident that the Southerners were defeated and scoffed at any suggestion that the Confederate army was nearby.

DECISION TO ATTACK

During March 1862, P. G. T. Beauregard was devising a plan that could annihilate the Federal army. It called for a Confederate offensive that would hopefully catch the Union army by surprise at Pittsburg Landing, Tennessee. The hallmark of this plan was to attack and defeat Ulysses S. Grant's Army of the Tennessee before it could be reinforced by Don Carlos Buell and the Army of the Ohio.

Albert Sidney Johnston agreed with the plan's concept. The question now was when to launch the attack.

On April 2, 1862, Beauregard relayed a telegram from Brigadier General Benjamin Cheatham saying the Union army was advancing. Although this proved to be false, it was the impetus to launch the offensive against Grant.

On the morning of April 3, 1862, Johnston's army began to march to Tennessee. To rally his soldiers, Johnston sent the following orders: "Soldiers of the Army of the Mississippi, I have put you in motion to offer battle to the invaders of your country. . . . You can but march to a decisive victory over . . . mercenaries sent to subjugate and despoil you of your liberties, property, and honor."

The march was slow and at times disorganized. It was delayed due to inclement weather. Further aggravating the effort, portions of the army took the wrong road after receiving confusing marching orders. It would not be until April 6, 1862, before Johnston's men launched their attack.

Prior to leaving Corinth, Johnston ordered local woodworkers to start building five hundred coffins for the soldiers who would be killed in battle. Ironically, Johnston would be one of those who died on the first day at Shiloh. Virtually all of the Confederate dead were buried in mass graves by Union soldiers on the fields of Shiloh. Johnston, however, was brought back to Corinth and eventually buried in Texas.

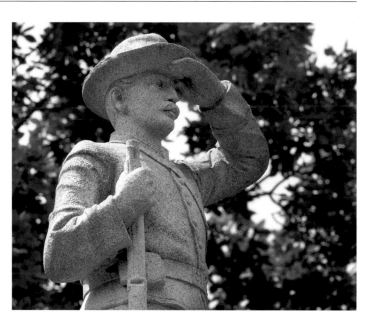

"SEEING THE ELEPHANT"

The vast majority of soldiers at Shiloh, both Union and Confederate, had yet to "see the elephant"—in other words, had yet to see any action on a battlefield. Most had joined their respective armies for the chance to fight on a field of honor and obtain enough glory to last a lifetime.

Unknown to any of the soldiers was the fact that the "Butcher's Bill" would be heavy at Shiloh. By the end of the conflict, the casualty list would be larger than that for all the previous wars in which the United States had fought combined.

The tactics of the day had not caught up with the improvements in weapons. Many of the Civil War generals believed in the Napoleonic principle of massing one's fire against the enemy. To mass the fire, soldiers marched in lines two deep and exchanged volleys. The improvement in weaponry made such tactics obsolete

The battle of Shiloh was the first time many Confederate and Union soldiers "saw the elephant."

and foolish. It was only after the needless loss of life that generals began to alter their tactics.

While at Pittsburg Landing, William T. Sherman assigned camps to each division as it arrived. In doing so, the most experienced soldiers were camped near the Tennessee River. The least experienced were assigned camps three miles inland. The green soldiers would receive the brunt of the Confederate assault.

Overconfidence gripped the Union army, starting with Grant and working its way down to the common soldier. Grant had written Henry Halleck, stating, "Corinth will fall much more easily than Donelson."

Whenever a concerned officer brought up the possibility of Confederates near Pittsburg Landing, he did so at his own peril. Sherman was known to publicly denounce officers for being so cautious.

Both Sherman and Grant were convinced the Union army would have to march to Corinth to get its next victory. Another victory could possibly break the will of the Confederate army and bring about an end to the war.

On the evening of April 5, 1862, Grant wrote Halleck, "I have scarcely the faintest idea of an attack being made upon us."

APRIL 6, 1862

If not for the diligence of a few soldiers, the Confederates might have taken Grant's entire army at Pittsburg Landing by surprise.

Colonel Everett Peabody was one soldier who was concerned about repeated sightings of Confederate soldiers west of Shiloh. Before dawn on April 6, 1862, Peabody sent out a patrol to investigate reports of Confederate activity. The patrol of three hundred soldiers ran into the entire Army of the Mississippi at Fraley Field. With an exchange of shots, the battle of Shiloh started.

On April 6, 1862, the battle of Shiloh began when Confederate soldiers launched an attack against Ulysses S. Grant's army.

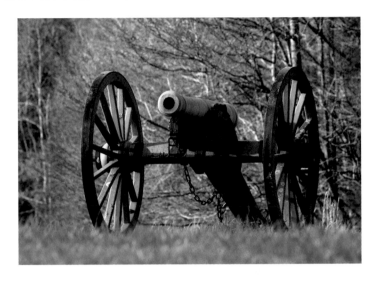

Peabody heard the exchange of fire and ordered more reinforcements forward. As these men marched toward the sound of battle, they were met by wounded soldiers streaming toward the rear. The blue-clad soldiers were amazed to see thousands of Southerners advancing in their direction.

Brigadier General Benjamin Prentiss accused Peabody of bringing on the engagement and swore to hold the colonel "personally responsible." The Federal soldiers formed a defensive line near their camps and held against the initial Confederate charge. The battle of Shiloh had begun and would last two days.

DISASTER AT RHEA FIELD

Colonel Jesse Appler of the 53rd Ohio Infantry was already concerned with the events of the morning of April 6, 1862. That concern was increased when an officer shouted, "Colonel, the Rebels are crossing the field!" These were words Appler didn't want to hear.

For most of the morning, Appler had been trying to convince Brigadier General William T. Sherman that the Confederate army was close at hand. Each warning was met with open ridicule by Sherman.

On the last warning, Sherman sent a reply to Appler, stating, "You must be badly scared over there." If Appler was afraid, that fear was compounded when Confederate brigadier general S. A. M. Wood's brigade moved on the flank of Colonel Peabody's brigade.

Appler aligned his troops to assist Peabody's hard-pressed men, but his attention shifted to the right. Appler saw more gray-clad soldiers, appearing like a specter before his eyes, advancing along Shiloh Branch. A startled Appler gasped, "This is no place for us. Battalion, about face; right wheel."

With that order, Appler's men abandoned their camps and formed on the eastern edge of Rhea Field. At that moment, Sherman arrived to see what was bothering Appler. Sherman was still convinced the fighting was nothing more than a skirmish.

While Sherman surveyed the field, someone yelled for him to look to his right. As he lowered his field glasses, Sherman was surprised to see Confederate soldiers leveling their muskets and firing at him.

An astonished Sherman yelled, "My God, we are attacked!" The Confederate volley hit Sherman's raised right hand and struck his orderly, Private Thomas D. Holliday, in the head, killing him.

Sherman spurred his horse, yelling to Appler, "Hold your position; I will support you."

Appler's 53rd Ohio poured a galling fire into the charging 6th Mississippi Infantry. The charge of the 6th Mississippi served as a precursor of things to come at Shiloh. The Mississippi men charged the 53rd Ohio's lines, only to be pushed back by their deadly fire. On the 6th Mississippi's final charge, they were able to push the Federals from their camps, forcing them to re-form elsewhere.

In half an hour of fighting, the 6th Mississippi lost 70 percent of its soldiers. Approximately 300 out of 425 men had fallen as they assaulted the Union lines.

Like a wave in a storm, Johnston's army kept growing and advancing. Many of the green Union troops broke and ran from their positions.

The Federal rout was on, as soldiers raced for the safety of the bluffs of Pittsburg Landing. The Southerners didn't press their advantage and instead stopped in the Union camps to partake of the breakfast that was still cooking. Many of the Southern soldiers had not eaten in two days.

THE UNION LEFT

Colonel David Stuart's brigade formed the far left of the Union line. Stuart's men were detached from William T. Sherman's 5th Division to hold the flank near the river.

After hearing the initial fighting, Stuart's officers began to form their men in a defensive line. Stuart's men were in good order before the Confederate brigades of Brigadier Generals James Chalmers and John K. Jackson attacked. Chalmers and Jackson enjoyed initial success as Union colonel Rodney Mason and the 71st Ohio ran after receiving two volleys. The 55th Illinois also broke in confusion, running toward the river until Stuart was able to rally the soldiers. The Confederates failed to capitalize on the Union confusion, as many of the Southern soldiers were ransacking the abandoned Federal camps.

Stuart's men tried to link up with the left of Stephen Hurlbut's division east of Sarah Bell's cotton field, but failed to do so. This left Stuart's flanks exposed on both ends. Thanks to a tentative approach by the Confederates and a stubborn defense by Stuart, the Federals were able to hold their position until a retreat was called in the afternoon.

By then, Stuart was wounded, ammunition was low, and the

fight was out of the Federals. The Union soldiers made a hasty retreat toward the rear, with the Confederate soldiers hot on their trail.

"We were right on top of them," said Major M. E. Whitfield of the 9th Mississippi Infantry. "It was like shooting into a flock of sheep. I never saw such cruel work during the war."

THE CROSSROADS

William T. Sherman was able to form a second line with remnants of his 5th Division at the crossroads of the Hamburg-Purdy Road and the Corinth–Pittsburg Landing Road. Sherman's men formed west of the crossroads, while Major General John A. McClernand's 1st Division was east of the intersection.

McClernand's men were veterans of Fort Donelson but were confused as to the whereabouts of Sherman's men. The plan was for McClernand to link up with Sherman's 5th Division and Benjamin Prentiss's 6th Division. Since McClernand failed to achieve this, his left flank was "in the air."

Brigadier General W. H. L. Wallace's 2nd Division moved to the right of Prentiss, but McClernand's left was still exposed. As the Southerners approached the Union lines, an intense fight

Many sons of Tennessee marched to the Volunteer State only to die on their native soil.

ensued. The center of McClernand's line was the first to give way under the Confederate advance.

Wilbur Crummer, of the 45th Illinois infantry, recalled the vicious fighting: "The underbrush is mowed down by bullets. Men are shot in several places in the body in a moment. The dead lie where they fall, and the wounded drag themselves to the rear. . . . With unearthly yells the enemy charges the battery. The gunners fight like heroes, manning their guns until bayoneted."

THE HORNET'S NEST

After falling back from their initial lines, many Union soldiers made a mad dash to Pittsburg Landing and safety. Benjamin Prentiss was able to gather remnants of his command along with soldiers from W. H. L. Wallace's and Stephen Hurlbut's divisions to form a line on the sunken road.

The Union soldiers were instructed to lay prone behind the split rail fence to offer them cover against the Confederate charge that was sure to come.

While Prentiss tried to rally the Union soldiers, even more raced to Pittsburg Landing. For these men, the battle of Shiloh was already lost, and escaping with their lives was the most important thing. One Union colonel cried, "We're whipped, we're whipped; we're all cut to pieces."

On the sunken road, the Union soldiers held their fire as the first of many Confederate advances ensued. Since the Confederate attacks were uncoordinated, the Federals could concentrate their fire on the soldiers who were attacking.

By midmorning, the Union line consisted of Sherman's division on the far right, followed by McClernand's division and units from Wallace's division. Prentiss's men formed the center of the Union line, while Jacob Lauman and Nelson Williams of Hurlbut's division positioned their men on the Union left.

After one charge of the sunken road, a Confederate soldier quipped that the lead flying around that area reminded him of a nest of angry hornets. From then on, the Union line at Shiloh was referred to as the Hornet's Nest.

THE PEACH ORCHARD

By midmorning, Brigadier General Stephen Hurlbut formed his 4th Division just south of a peach orchard to the right of the Hornet's Nest. Hurlbut put Colonel Nelson Williams's brigade in front of the orchard, while Brigadier General Jacob Lauman positioned his brigade to the right of Williams.

Williams was wounded early in the fighting, and command of the brigade passed to Colonel Isaac C. Pugh, a veteran of the Mexican War.

Brigadier General John McArthur, detached from Wallace's 2nd Division, formed on Hurlbut's left, just east of the Hamburg-Savannah Road. This gave Hurlbut an excellent defensive line to withstand repeated Confederate attacks. Hurlbut held this position for several hours. It wasn't until General Albert Sidney Johnston personally led the Confederate attack that Hurlbut was forced to fall back.

DEATH OF JOHNSTON

From the start of the battle, Albert Sidney Johnston was leading his men from the front lines. In contrast, P. G. T. Beauregard was at the Shiloh Church allocating regiments to the fighting. For many of the generals, the standing order was to send the men to the "sound" of the harshest fighting.

Although Beauregard planned the fight, he seemed to have lost his nerve in the predawn hours of April 6, 1862. The leading generals were trying to decide what to do when the first shots were

The Confederate strategy was one of failed tactics. Major General Braxton Bragg ordered Colonel Randall Lee Gibson's brigade to attack without the support of artillery. Gibson's brigade was severely punished in the assault. Instead of ordering artillery to support the infantry, Bragg ordered three more headlong assaults for Gibson's brigade. Each charge brought forth dreadful carnage.

W. H. L. Wallace's soldiers, along with remnants of Benjamin Prentiss's division, held the Confederate army at bay for six hours at the Hornet's Nest.

fired. Johnston was hungry for a victory to wash away the stench of failure that had been hanging over him since Fort Donelson.

As he mounted his horse, Johnston told his officers, "Tonight we will water our horses in the Tennessee River."

While the fighting raged, Johnston concentrated his forces on the Peach Orchard. He ordered a charge but soon found trouble in the making. Some soldiers in John C. Breckinridge's Reserve Corps refused to make the charge.

Johnston vowed to help Breckinridge get his men in motion and spurred his horse down the battle line. Johnston, talking firmly, touched the soldiers' bayonets, telling the men to use them in their charge against the Union line. When Johnston reached the center of the line, he vowed to lead the soldiers personally in their charge.

The Southern soldiers responded with a tremendous charge that pushed the Union line out of the Peach Orchard and back toward the Sunken Road. An excited Johnston showed Tennessee governor Isham Harris the flapping boot sole that had been hit by a minié ball. Johnston's uniform also bore nicks from other shots.

Johnston dispatched his aides to carry further orders to his army as he remained near the Peach Orchard. When Harris returned from delivering his message, he found Johnston reeling in his saddle.

Harris grabbed the general and asked Johnston if he was hurt. A pale Johnston answered, "Yes, and I fear seriously."

Harris moved the stricken general to a safe place and began looking for a wound on Johnston's body. He found what was deemed a "minor" leg wound, and Johnston's boot was full of blood.

Orders were sent out for Johnston's doctor to assist the fallen general. Earlier in the battle, Johnston had sent his doctor to care for wounded Union soldiers. The doctor would not reach Johnston in time.

Johnston died with victory almost within his grasp. Back at the Shiloh Church, Beauregard did not know about Johnston's death or about the near breakthrough at the Peach Orchard.

Inside Johnston's coat pocket was a tourniquet. If it had been applied, Johnston's wound would not have been fatal.

RUGGLES ATTACKS

It wasn't until late afternoon, when Brigadier General Daniel Ruggles aligned fifty-seven cannons to blast the Hornet's Nest, that the Confederates were able to drive back their Union foes. When the bombardment started, all the Federals could do was get even closer to the ground. One Union soldier compared the shelling to "a mighty hurricane sweeping everything before it."

On the next Confederate charge, the Union lines on the right and left of Prentiss and Wallace wavered, which exposed the Federal flanks. The Confederate army struck the flanks, forcing Prentiss to bend his line inward. Wallace was mortally wounded while trying to lead his men out of Hell's Hollow. As the Confederate soldiers swept in from all directions, Prentiss raised a white flag to surrender.

After holding the line for six hours against eight Confederate charges, Prentiss and his twenty-two hundred soldiers surrendered. The spirited defense shown by the Federals had bought time for Ulysses S. Grant to form one final line to defend against Confederate attacks.

BUELL ARRIVES

Grant's last line of defense rested on the crest of the bluff overlooking the Tennessee River. Cannons from various batteries were placed in position to withstand the Confederate's final push of the day.

The gunboats *Tyler* and *Lexington* pounded the Rebel lines from their positions on the Tennessee River. There was bedlam all around Pittsburg Landing, with soldiers of a defeated army milling at the river's edge, hoping to find a way across to safety.

River to reinforce Grant's troops. Nelson's soldiers had to keep the skulkers away by prodding them with their bayonets. That evening, Buell seriously questioned bringing any more of his soldiers to Pittsburg Landing.

Sherman worried that Buell might not bring his men across the river. "Buell seemed to mistrust us, and repeatedly said he did not like the looks of things and I really feared he would not cross over his army that night, lest he should become involved in a general disaster."

Grant's own Waterloo was unfolding before Buell's eyes. Buell viewed himself as the savior of Grant's army, while Grant still focused on victory. The two men had a history of not getting along, so it was not too surprising that they disagreed on the next steps to take.

Buell asked Grant if any preparations were made for retreating, to which Grant replied, "I have not yet despaired of whipping them, General." With that, Buell finally relented and began sending his soldiers to Pittsburg Landing.

Standing in stolen Union rain slickers at Pittsburg Landing, Southern cavalrymen under the command of Nathan Bedford Forrest watched as Buell's reinforcements arrived. Forrest knew the Confederate army would have to fight the united armies of Grant and Buell the following day.

APRIL 7, 1862

The Southern army spent the night in the abandoned camps of their Union foes, which provided some shelter from a drenching rain. The Federal soldiers slept in the elements. Their spirits had been raised by the arrival of Union reinforcements. Grant likened Shiloh to Fort Donelson. He had snatched victory from the hands of defeat there and thought he could do the same at Shiloh.

Confident that the Union army was finished, many of Beauregard's officers failed to resupply their soldiers with ammunition.

While the soldiers huddled at Pittsburg Landing, portions of Don Carlos Buell's army were arriving across from the landing. William "Bull" Nelson's division had marched through mud and swampland to reach their destination.

Transports began to take Nelson's men across the Tennessee

After the first day of fighting, weary soldiers from the North and South are said to have sought water from Bloody Pond.

Many thought there would be time in the morning for such a task. Braxton Bragg lamented that the army was "most out of ammunition and though millions of cartridges were around them, not one officer in ten supplied his men, relying on the enemy's retreat."

The Southern army was surprised to be awakened by a predawn attack by the combined armies of Grant and Buell. The Confederate army was still disorganized from the previous day's fighting. Regiments were split, and generals had to command forces that really were not theirs to command. There was no cohesion of command in Beauregard's army.

The looming problem for the Southern army was not lost on its soldiers. They immediately realized they were fighting Grant and Buell. Private Henry Stanley of the 6th Arkansas said, "Even to my inexperienced eyes, the troops were in ill-condition for repeating the efforts of Sunday."

Despite the less than ideal situation, Beauregard's men made a gallant stand and even launched a few counterattacks into the Union lines. By late afternoon, it was evident that the Confederate army could not withstand the continual push from the Federals. Beauregard called a retreat, and his army limped back to Corinth.

CONFEDERATE RETREAT

The Confederate army got a day's head start on their retreat. Grant deemed his men "too much fatigued from two days' hard fighting and exposure . . . to pursue immediately."

Beauregard entrusted John C. Breckinridge with the duty to guard the retreating army, telling Breckinridge that "this retreat must not be a rout." Beauregard's army braved the rain and traversed roads that resembled rivers of mud to reach the safety of Corinth.

William T. Sherman had one brief encounter with Forrest at Fallen Timbers, finding out that the little-known Confederate colonel made a formidable foe.

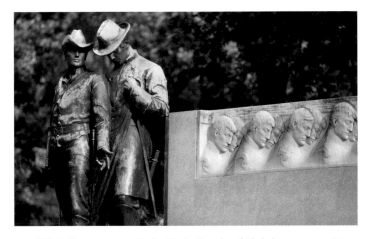

With the pursuit called off, the battle of Shiloh was over. Now the task of burying the dead remained.

HALLECK TAKES OVER

Henry Halleck was shocked to hear that there had been a battle at Shiloh and was even more alarmed by the casualties the Federal army suffered. Since the start of 1862, Halleck had been able to hand victories at Fort Henry, Fort Donelson, Pea Ridge, Island No. 10, and Shiloh to Abraham Lincoln.

The Union general was incensed about the near defeat at Shiloh and the condition of Grant's army. Halleck had planned to lead Grant and Buell on the advance to Corinth. He could ill afford for Grant to get even more glory with another victory, no matter how gruesome the casualty toll.

Once at Shiloh, Halleck saw signs of intense struggle between the armies of the North and South. Halleck openly scolded Grant in what one soldier called "a loud and haughty manner."

Halleck began reorganizing the Union army by merging three armies in the West into one. Don Carlos Buell retained command of the Army of the Ohio, and John Pope was ordered to bring his army to Shiloh. George Thomas was given command of Grant's army. By

On the second day of fighting, P. G. T. Beauregard called a retreat for the Confederate army back to Corinth.

combining the three armies, Halleck amassed over one hundred thousand soldiers to begin a march on Corinth, Mississippi.

Absent in Halleck's plans was Grant. Although Halleck promoted Grant to his second in command, the rank was in title only. Grant's new rank resembled a soldier under house arrest. "I never saw a man more deficient in the business of organization," Halleck said. "Brave and able in the field, he has no idea of how to regulate and organize his forces before a battle or to conduct the operations of a campaign."

During the Corinth campaign, Grant served little to no purpose at all. "I was little more than an observer. Orders were sent directly to the right wing or reserve, ignoring me, and advances were made from one line of entrenchment to another without notifying me," Grant said.

As the Corinth campaign moved at a snail's pace, Grant gave serious thought to resigning. Sherman convinced Grant to stay with the army instead of leaving.

FORTIFYING CORINTH

P. G. T. Beauregard knew his shattered Army of the Mississippi was in no condition to face Henry Halleck's huge army. Many of Beauregard's soldiers were wounded or too sick to serve. Instead of facing Halleck in the open field, Beauregard chose to strengthen the entrenchments located north and east of Corinth.

Beauregard's fortunes were improved with the arrival of Earl Van Dorn's Army of the West, but even with the reinforcements, the Southern army could not match the Federals. Therefore, the entrenchments around Corinth served as an equalizer between the two armies. Halleck had the numbers, but Beauregard was choosing the ground.

Even with the entrenchments, Beauregard feared the coming fight. He continually beseeched Richmond for more reinforce-

ments. In one message, Beauregard said of Corinth, "If defeated here, we lose the Mississippi Valley and probably our cause."

CONFEDERATE EVACUATION

Halleck's army inched forward at a painfully slow pace, giving the Confederate army time to seek reinforcements from anywhere possible. Halleck did not want to suffer another Shiloh. Therefore, he had his army entrench everyday after their march toward Corinth. The Union army was averaging less than a mile each day in their painfully slow march to Corinth.

Poor weather conditions were also slowing the Union advance. Roads turned into mud pits. Halleck was forced to corduroy the roads with timbers to make them passable. With every Union delay, Beauregard tried to better his position at Corinth. Beauregard planned to attack as late as May 22, 1862, but eventually decided on a Confederate retreat to Tupelo, Mississippi.

Since the battle of Shiloh, Corinth's sanitary conditions were at best terrible. The water was contaminated, and the town wasn't a safe place to live for those wounded or healthy.

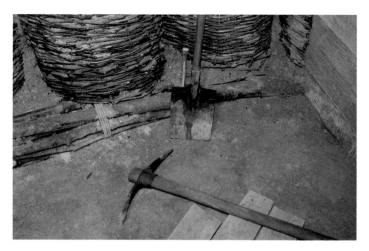

The pick and shovel were just as important as the rifle during Henry Halleck's approach to Corinth.

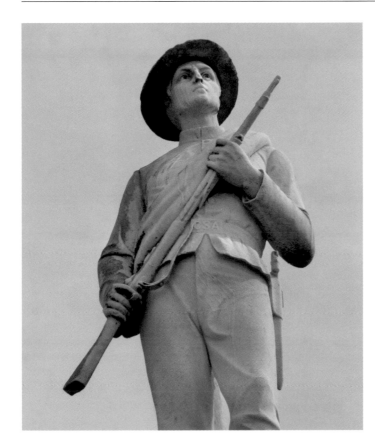

After retreating from Corinth, Beauregard's Army of the Mississippi redeployed near Tupelo, Mississippi.

The Union army seemed to dread another conflict with the Southern army. "Corinth was about thirty miles distant, and we all knew that we should find there the same army with which we had so fiercely grappled at Shiloh, reorganized, reinforced and commanded in chief by General Beauregard," said Sherman.

By the end of May, Beauregard decided to withdraw to Tupelo, Mississippi. In order to do this, he had to fool Halleck's army. On the night of May 29, 1862, Beauregard began evacuating the sick and wounded. To continue his ruse, Beauregard ordered his soldiers to cheer at each arrival of trains to take the soldiers from Corinth.

The Union high command heard these cheers and were convinced reinforcements were arriving. The following day, Halleck's army entered the town of Corinth. It had taken Halleck thirty days to travel twenty-two miles. Halleck, called "Old Brains" by his soldiers, had his almost bloodless victory in the field.

OCCUPIED TOWN

With the successful Corinth campaign completed, things began to change for Halleck's army. Secretary of War Edwin Stanton called the capture of Corinth a "brilliant and successful achievement." Halleck was promoted to general in chief and transferred to Washington, D.C., to serve President Lincoln. The president needed someone to administrate the army, and Halleck was his man.

Don Carlos Buell's army moved east to Chattanooga, Tennessee, and John Pope was picked to replace the ineffective George B. McClellan, who had just been defeated by Robert E. Lee during the Peninsula campaign. Just a few months later, Pope would feel the sting of defeat thanks to Lee, Thomas "Stonewall" Jackson, and James Longstreet at Second Manassas.

Grant returned to command of the District of West Tennessee, staying in the Corinth area. William Rosecrans was assigned to the army defending Corinth.

While the Corinth campaign led to a promotion for Halleck, it caused Beauregard to lose command of the Army of the Mississippi. Jefferson Davis replaced the Creole general with Braxton Bragg, who promptly switched the focus to Chattanooga, Tennessee. Before moving east, Bragg reorganized the command he was leaving. Brigadier General John Forney would command the District of the Gulf. His marching orders were to defend Mobile, Alabama. Earl Van Dorn's command was at Vicksburg, as Bragg created the District of Mississippi. Sterling Price was given command of the

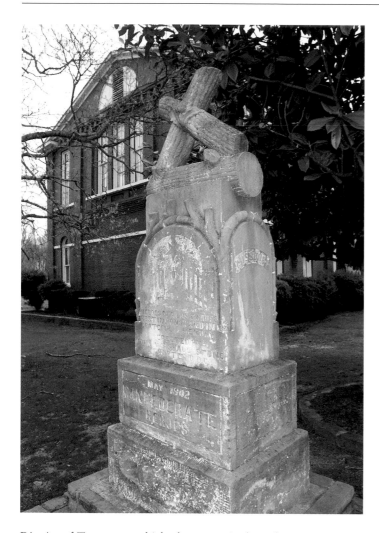

District of Tennessee, which also comprised northeast Mississippi and northwest Alabama.

BATTLE OF IUKA

September and October 1862 proved to be the time of the great Confederate offensive. Robert E. Lee, fresh from victory at Second

Manassas, marched his Army of Northern Virginia into Maryland, ultimately fighting a rehired George B. McClellan at the battle of Antietam.

In an effort to pull the Union army out of Tennessee, Braxton Bragg launched an offensive into the heart of Kentucky. Bragg and Don Carlos Buell were destined to meet at the battle of Perryville in October 1862.

Bragg expected Van Dorn and Price to work together to keep Rosecrans occupied. In fact, Van Dorn was not interested in Bragg's plan. He was still recovering from a failed expedition to take Baton Rouge, Louisiana. He began moving his army north, but his plans didn't necessarily mesh with Bragg's. Price fretted about what to do without Van Dorn's help. While Price's command was at Saltillo, Mississippi, Van Dorn was concentrating his forces at Holly Springs, Mississippi. Van Dorn wanted Price to join him for a thrust against Corinth and possibly Memphis.

In early September, Price received orders from Bragg to "move rapidly for Nashville." Price doubted he could advance to Nashville, but he could fight Rosecrans's Federal army in Mississippi. A battle in Mississippi would keep Rosecrans from uniting with Buell's Army of the Ohio. Price began to march his Army of the West to Iuka, Mississippi.

Grant did not want Price to reinforce Bragg, so he sent Rosecrans and Major General E. O. C. Ord to occupy his attention. Price beat Ord and Rosecrans to Iuka, but would have to fight the Federal army in order to keep the town. Price's immediate attention was on Ord, who was forming his soldiers west of town.

Grant attempted to entice Price to surrender without bloodshed. The Union general had received a telegram stating Lee's army had been severely defeated at Antietam, Maryland. The telegram also stated that Major General James Longstreet's corps was destroyed and Major General A. P. Hill killed. Although this proved to be false, Grant told Ord to pass it through the lines and to ask Price to surrender.

A solitary monument stands in honor of Sterling Price and his Army of the West.

Price refused, assuring Ord that such news "would only move him and his soldiers to greater exertions on behalf of their country."

On the same day, Price also received a dispatch from Van Dorn suggesting a rendezvous at Rienzi, Mississippi, for proposed attacks near Corinth.

Price prepared to march to Rienzi the following day but was surprised by Rosecrans's late-arriving army. Price found his army caught between two converging Union forces. While Price faced Ord's troops, he sent Brigadier General Lewis Henry Little to contend with Rosecrans.

Little rushed to counter Rosecrans's advance. Little had advised Price earlier in the campaign not to march to Iuka, fearing the move left the heart of Mississippi open for invasion. Now that the fighting had started, Little focused on stopping the Union forces.

Little ordered the 37th and 38th Mississippi infantries, part of Colonel John D. Martin's brigade, into the fight. The 3rd Texas Dismounted Cavalry, of Louis Hebert's brigade, joined the advancing Confederate soldiers. The Southerners pushed up a ravine using the dense underbrush as cover to attack the Federals at the crest of the hill.

The 11th Ohio Battery bore the brunt of the Confederate assault. Colonel John B. Sanborn had ordered Lieutenant Cyrus Sears, of the 11th Ohio Battery, to "form a battery" on the Jacinto Road and to "await further orders." The orders never came, but the 3rd Texas Dismounted Cavalry did.

The Ohioans held their position, awaiting orders and hoping Ord's troops, forming the other half of the Union pincer, would join the fight. Grant had instructed Ord to wait until the sound of Rosecrans's fighting to join the fray. Ord didn't join the fight, claiming he never heard the sound of battle. This left Rosecrans's army to fight Price's Southerners alone.

The 11th Ohio Battery bravely stood by their guns as minié balls zipped past their heads. Sears assumed the responsibility to save his men and ordered canister fired into the gray-clad soldiers. He then switched to double canister, which seemed to obliterate the Rebel line. Sears entertained the idea that his battery could possibly hold against the Texans.

Any hope of holding the Confederates evaporated when the 5th Iowa, 26th Missouri, and 48th Indiana infantries retreated from the fight. These soldiers supported Sears's battery. Without them, the 11th Ohio Battery was doomed to be captured.

The Ohio men resorted to hand-to-hand combat as the 3rd Texas Dismounted Cavalry, along with the 3rd Louisiana Infantry, 40th Mississippi Infantry, and 1st Texas Legion, overran their position. Many of the Ohio men were reduced to using their battery sponges as weapons. The Ohioans marched into combat with ninety-seven men. On that night, the severity of the fight was evident, with eighteen dead and thirty-nine wounded. Only three of the battery's horses were unhurt, while forty-two died. A few of the Ohioans were taken prisoner by the Texans but later released. One Rebel soldier stated, "Those battery boys had so much spunk that we took pity on the few who were left."

While the battle with Rosecrans was at hand, Price arrived to watch the Confederate advance. Price immediately looked to find Little. Amazed by the bitter fighting, Price said, "The fight began, and was waged with a severity I have never seen surpassed." Price found Little near the Jacinto Road, and the two men conferred while sitting on their horses. As Price was telling Little to bring up the rest of his division, a minié ball passed under Price's arm and slammed into the Little's head. The ball struck just above his left eye, traveled through his brain, and stopped at the back of his head, killing him instantly.

Price was visibly upset and wept over the body of his slain friend. Little's body was placed in an ambulance and taken to Price's headquarters in Iuka. With their leader down, Little's soldiers fought gallantly throughout the afternoon and into the night.

Late that evening, Price met with his generals. Even though

Price favored staying and fighting, his generals thought it more prudent to link up with Major General Earl Van Dorn's army. The decision was made to withdraw, but one final deed had to be done.

Soldiers dug a grave in a rose garden at the J. M. Coman house, and Little was buried with little fanfare by a small group of his friends. A pine board marked "General Henry Little" was placed at the grave.

At the Shady Grove cemetery, a mass grave holds the remains of 263 Confederate soldiers who died at Iuka. Little's body no longer rests in the Coman garden. After the war, family members reinterred Little in his native Baltimore.

The battle of Iuka, part of the Confederate offensive of 1862, ended in a stalemate. While Price had delivered a staggering blow to Rosecrans's army, he remained in peril from the Union pincer. Price decided to withdraw and join Van Dorn's army. Once the two armies had joined, they marched in an effort to retake Corinth.

After Price's army had left the area, a poignant discovery was made. John Dean, a driver for the 11th Ohio Battery, had been ordered to hold the battery's horses during the fighting. He was found the next morning dead, with the bridles still in his hand. All around him were his dead horses.

BATTLE OF CORINTH

Sterling Price and his troops united with Earl Van Dorn's army near Ripley, Mississippi. Van Dorn proposed an offensive to retake the town of Corinth, which had been lost in May 1862.

On October 2, 1862, Grant, whose headquarters was in Jackson, Tennessee, wired William Rosecrans to get ready for an attack at Corinth. Rosecrans had sensed the possible danger of a Rebel attack at Corinth and called all Union forces on outpost duty back to the "Crossroads of the Confederacy."

Rosecrans utilized the fortifications that were about one and

a half miles from Corinth. These batteries, known as Beauregard's defensive line, were built to keep the Union army out of Corinth. After the Confederates evacuated the town in May 1862, the Union army prepared for a Confederate attack on the town. They con-

William Rosecrans's Union army faced the combined forces of Earl Van Dorn and Sterling Price at Corinth.

structed redoubts that were called Halleck's line. These new lines were located west and south of Corinth.

On October 3, 1862, Van Dorn's attempt to retake Corinth began as his army approached the town from Chewalla, Tennessee. Major General Mansfield Lovell's division marched toward the western outer defenses.

Van Dorn's plan was a double envelopment, with Lovell's division striking Brigadier General Thomas McKean. Van Dorn hoped Rosecrans would send reinforcements to McKean, thereby weakening the Federal right. With this action, Van Dorn planned to send Price's soldiers through the weakened Union lines into Corinth.

THE WHITE HOUSE

Major General William Rosecrans was confused by Van Dorn's moves. Rosecrans's soldiers were still marching in from the various outposts around Corinth. As they entered the town, the Federals were deployed to face the Confederate threat.

Rosecrans had yet to ascertain where the real attack was going to occur. During much of the morning, Rosecrans was convinced that Bolivar, Tennessee, was the target of the attack and not Corinth. Now that the Confederates were advancing toward Corinth, Rosecrans finally realized which town was under attack.

Rosecrans's hasty plans would utilize the fortifications already built by the Confederate soldiers. He placed his skirmish line in front of the outer works. This allowed the Federals to fall back through two defensive lines before they reached Corinth. The Confederate army would have to fight through these lines before they could take the town.

Brigadier General Thomas Davies found himself in a precarious situation. He had to defend the initial Confederate attack at Corinth and deal with Rosecrans's vague orders. At first Rosecrans had ordered Davies to stop short of the outer breastworks of Corinth, only to change those orders later in the morning. Now,

Sterling Price's Army of the West fought at Iuka and Corinth.

Davies was to take the breastworks and not let the enemy penetrate beyond those works.

Davies had hoped to fight a delaying action but entered the breastworks overlooking the Columbus Road. His fifteen hundred men were expected to hold a two-mile-long front while keeping touch with Brigadier General John McArthur's brigade on his left.

Lovell's division struck McArthur's line along the Memphis and Charleston Railroad tracks, while Dabney Maury's division advanced down the Memphis Road. The Confederate assault pushed the Federals from their initial lines. Lovell's men pushed toward Battery F, while Maury forced Davies to fall back to the White House, a home overlooking a field on the Memphis Road. This would be Davies's final line.

Davies's redeployment to the White House was done on his own initiative. He had yet to receive additional orders from Rosecrans. Davies's deployment was sound, but his troops' were in a dire situation due to the unrelenting hot weather. Many soldiers who had made the forced march to their position had dropped on the side of the road—victims of the sun, not Rebel bullets.

With the Federal soldiers deployed in line, a crisis in leadership developed along Davies's front. Colonel August Mersy was too drunk to fight, and Colonel Thomas Morton slipped away before the next Confederate assault began.

Rosecrans sent out more orders that only added to the confusion of Davies and Brigadier General Charles Hamilton. Meanwhile, a gap existed between Davies's and Hamilton's lines that would be exploited by the Confederate army.

Martin Green's brigade of Mississippi and Missouri soldiers swept across the field to Davies's line. The Federals held, delivering a galling fire into the 43rd Mississippi and 6th Missouri infantries. Both regiments were virtually annihilated by the Federal fire.

The Union line continued to hold despite repeated Confederate attacks. It wasn't until after the Union troops broke that Davies was eventually forced to order his men to fall back. Most of the men in Davies's division were crazy for water. Many of them had not had any since that morning.

Davies continued to fall back to new lines throughout the day, with the White House as his last defensive position. Davies's defense at the White House stalled the final Confederate advance of the day.

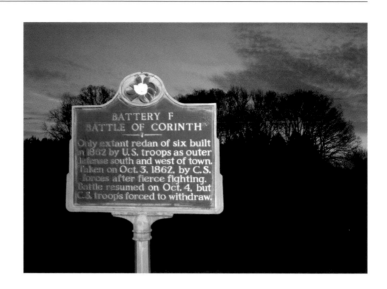

BATTERY F

Colonel Marcellus Crocker's Iowa Brigade supported the cannons at Battery F and was facing an initial onslaught from Brigadier General John Creed Moore's Mississippi, Alabama, and Arkansas soldiers. Moore hit Crocker's line. Moments before the fight, Crocker had been given orders to withdraw. Crocker chose to withdraw in stages instead of opening up his end of the Union line. The Iowa soldiers were holding their line when Brigadier General John S. Bowen's 1st Missouri Infantry appeared on Crocker's left flank.

The Iowans beat a hasty retreat to form a new line against the advancing Rebels. The gray-clad soldiers stopped to plunder the Union camp, which gave Crocker's men time to redeploy.

Battery F was now in the hands of the Confederate army. Moore's and Bowen's 1st Missouri and Mississippi sharpshooters celebrated the capture of the battery and some of its guns.

Bowen observed that the chance to take Corinth was unfolding before his eyes: "The enemy's center was broken near the rail-

Battery F is one of six redans built by Union soldiers on the outer edge of Corinth.

road. I saw it retiring in confusion, pursued simply by a line of skirmishers. If Lovell's division had moved directly forward, we could have entered pell-mell with them into town."

Inexplicably, Lovell chose to remain idle as Moore and Bowen assaulted Battery F. Bowen personally implored Lovell to allow him to take the rest of his brigade into the works. Lovell, who was not in favor of the Corinth campaign, did not support his brigadier general but ordered him to recall his advance units.

During the two hours that Moore had been fighting, Lovell was idle. Lovell didn't advance until ordered to do so by Van Dorn. Even then, Lovell only advanced far enough to make contact with Moore's brigade. With the Confederates in control of the White House fields, Van Dorn met with Generals Price and Maury.

Van Dorn and Maury were for pressing their advantage, while Price favored waiting until the following day. His men were exhausted and had borne the brunt of the first day's fight. Price was also incensed by the lack of support from Lovell. He thought that his men would have taken the town if Lovell had truly engaged the Federals.

Price didn't think his men could continue without the proper support from Lovell.

Van Dorn called off the attack as the sun began to sink in the western sky. In his report, Van Dorn said, "One hour more of daylight and victory would have soothed our grief for the loss of the gallant dead who sleep on that lost but not dishonored field."

BATTERY POWELL

Rosecrans's army had been treated roughly by Van Dorn's Confederate army during the first day of fighting. Van Dorn had missed opportunities that could have led to victory and made the second day of fighting unnecessary.

During the night of October 3, both sides tried to regroup and recover from the first day of fighting. Soldiers from both the North and South knew another day of fighting lay ahead.

From the crack of dawn until the sun was shining over the battlefield, Confederate batteries pummeled the Union lines. Van Dorn had planned for Louis Hebert to lead the headlong assault on the fortified Union lines. Hebert said he was "too sick" to lead the charge, forcing Brigadier General Martin Green to lead the advance.

The change in command delayed the assault by two hours, giving the Federals even more time to entrench. All along the Union line, soldiers prepared for the advance of the Confederates.

Battery Powell was an earthen fort located east of the Mobile and Ohio Railroad. Inside the fort, Federal cannons were positioned to cover the Rebel advance. The Confederate soldiers knew they would have to weather a hailstorm of Federal batteries before they could assault the lines. The shortest distance to cover belonged to Colonels William H. Moore's and Elijah Gates's soldiers, with only half a mile of open ground to cover.

With shells shrieking over their heads, the 64th Illinois Sharpshooters lay prone, watching the oncoming Rebels. Rosecrans had covered his front with skirmishers, which in effect blocked the fields of fire for the guns at Battery Powell. It wasn't until the Confederates were only four hundred yards away that the battery could deliver its deadly fire.

Moore's and Gates's men fired a volley into the Union line, which had the desired result. Much of the Union line evaporated as the blue-clad soldiers raced to the rear. Whole units gave up the fight. Rosecrans was swept up in the mob of fleeing soldiers. He swore at the retreating soldiers, trying to get the men to regroup and face the Confederate attack.

Brigadier General Thomas Davies was reduced to killing one of his own men when the soldier refused to return to the front. The cannoneers at Battery Powell showed great courage as they defended the redoubt, but the Rebels kept coming.

Colonel J. A. Pritchard's 3rd Missouri Infantry scaled the

walls of Battery Powell and raced into the redoubt. The interior of the earthen fort was the scene of unimaginable violence. Dead and wounded soldiers and horses littered the ground.

Gate's men had ripped a hole in the Union line, and Moore's men were poised to advance into the town. While the line had been breached, Gates's and Moore's men were too worn out to exploit it. They needed support to come to their aid.

Brigadier General Martin Green had failed to call up Brigadier General William Cabell's brigade, which had been held in reserve. The moment was right for Cabell to advance, but his brigade remained at the Memphis and Charleston Railroad.

A Union counterattack began to deliver a hellacious fire on Gates's and Moore's men. While most of these men fought to hold the line, some soldiers advanced into town. These men were met by double canister fire from the 12th Wisconsin Battery. Their fire stopped the Rebels and sent many of them fleeing in the opposite direction.

Most of Gates's men didn't stop running until they reached the safety of the Memphis and Charleston Railroad. Others chose to surrender instead of running the gauntlet of Union fire back to safety.

While Gates's men ran to safety, Moore's soldiers entered Corinth. House-to-house fighting ensued, with Rosecrans in the middle of the melee. He tried in vain to rally his fleeing soldiers. For a moment, Rosecrans had lost his fiery temper and his army. It seemed that Corinth was lost.

Cabell's brigade finally joined the assault, but it was too little too late. The 52nd Illinois had re-formed and manned the guns in Battery Powell. Cabell's brigade was stymied by the rejuvenated Union line.

By midday, the fight for Battery Powell was over. While most of the Confederate soldiers retired to their original lines, Moore's men were still fighting through the streets of Corinth. Van Dorn needed a breakthrough somewhere in the Union lines to support these soldiers.

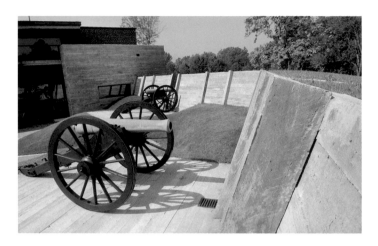

BATTERY ROBINETT

Located west of the Mobile and Ohio Railroad, Battery Robinett was another earthen fort along the Union lines. The soldiers in and around Battery Robinett braced for an attack they knew was coming.

Alongside Robinett were soldiers from the 11th Missouri, 47th Illinois, and 27th, 43rd, and 63rd Ohio. These men knew that they would soon hear the shrill Rebel yell and feel the brunt of the Confederate attack.

The 63rd Ohio was stationed in front of Battery Robinett and was virtually annihilated by the oncoming gray tide.

Colonel William P. Rogers led the 2nd Texas, 42nd Alabama, and 35th Mississippi in a headlong charge against Battery Robinett. The Southerners braved a sea of canister to scale the walls of the redan. Cloyd Bryner of the 47th Illinois Infantry described the scene: "Grape and canister tore terrible lanes through the Confederate ranks . . . but the determined men of Arkansas, Texas and Mississippi never faltered."

The Southerners continued their assault until they reached the battery's parapet. As the Rebels seized the guns, Captain George Williams at nearby Battery Williams fired into Robinett in an effort

The fighting at Battery Robinett proved to be the turning point of the battle of Corinth.

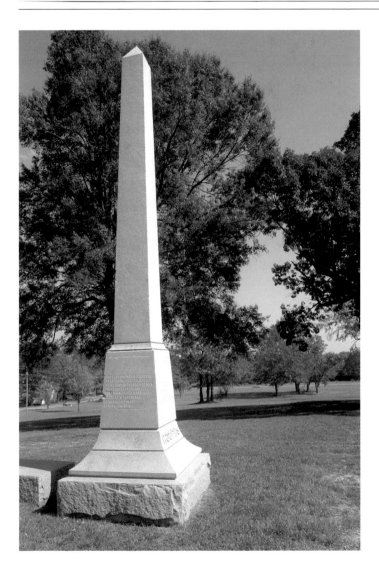

An obelisk marks where William P. Rogers was buried after the battle of Corinth.

dred feet the bodies lay so close it was almost impossible to walk between them."

The assault on Battery Robinett was the best hope to reach Moore's Confederates in Corinth. While Moore's men did pierce the Union lines and even fought in the streets of Corinth, their attack was repulsed at the Tishomingo Hotel and on the famous railroad crossroads of Corinth.

The Confederate soldiers were doomed to defeat due to lack of support. Union reinforcements arrived, and the Confederate soldiers were reduced to fighting their way out of town and back to their lines.

Major General Sterling Price wept when he saw his brave soldiers running back to the Rebel lines.

CONFEDERATE RETREAT

By the afternoon of October 4, 1862, Van Dorn's defeated army was in full retreat from Corinth, marching north toward Chewalla, Tennessee. Van Dorn had lost 473 killed, 1,997 wounded, and 1,763 captured or missing, compared to Rosecrans's 355 killed, 1,841 wounded, and 324 captured or missing.

Although Grant wanted Rosecrans to pursue Van Dorn immediately, Rosecrans didn't start his pursuit until the following day. Leading this effort was Brigadier General James B. McPherson's division, which had arrived from Jackson, Tennessee, on October 4.

Grant also sent Major General E. O. C. Ord from Memphis, Tennessee, to cut off the Confederate retreat. With any luck, the converging Federals could trap Van Dorn.

FEDERAL TRAP

to stem the Confederate attack. Colonel John W. Fuller's Ohio soldiers stymied the Southern attack inside Robinett. Rogers fell mortally wounded.

All around Battery Robinett, the carnage of the attack was evident. Bryner described the scene: "In front of Fort Robinett the Confederate dead lay piled from three to seven deep; for a hun-

Van Dorn realized his army was caught in a closing Union vice between the Hatchie and Tuscumbia rivers. The embattled general

faced the possibility of the destruction of his army. Ord reached Metamora, Tennessee, which overlooked the Davis Bridge on the Hatchie River. The Confederates had used this bridge on the way to Corinth. Now, Ord blocked their escape across the Hatchie.

While Van Dorn desperately searched for a place to ford the Hatchie, Major General Sterling Price once again faced Ord. A combination of Ord's soldiers and Major General Stephen Hurlbut's 4th Brigade pushed Price's Army of the West back across the Davis Bridge. Some of Ord's men actually crossed the bridge, only to be raked by a murderous fire from the Confederate soldiers. Ord was wounded while on the bridge, and command shifted to Hurlbut.

With the sound of battle echoing from the west, Brigadier General John S. Bowen's two thousand soldiers held off McPherson's division at Young's Bridge on the Tuscumbia River.

Bowen's men set up a defensive line and peppered the Union soldiers with a staggering fire. Both Bowen's and Price's soldiers stopped the advancing Federals long enough for Brigadier General Frank Armstrong's cavalry to build a crude bridge at Crum's Mill. The rickety structure served as the avenue of escape for Van Dorn's soldiers.

Once across the Hatchie River, Van Dorn's retreat continued toward Holly Springs, Mississippi. Bowen's brigade served as the rear guard for the duration of the Confederate retreat.

Van Dorn's attempt to retake Corinth ended in disaster. Not only was his army beaten, but the citizens of Mississippi turned against Van Dorn, a native son of the state. They had grown tired of his philandering ways and his brilliant schemes that ended in Confederate defeats.

VAN DORN'S COURT-MARTIAL

Incensed by what he deemed poor leadership by Van Dorn, Bowen filed charges against the Confederate general for gross neglect of duty for the debacles at Corinth and at Pea Ridge, Arkansas. Van Dorn blamed the Confederate defeat on Louis Hebert's failure to open the battle on time. The embattled Van Dorn insisted on a court-martial with hopes of clearing his name.

A trial was held, and the court was stacked in Van Dorn's favor. Although Van Dorn was cleared of the charges, he never commanded an entire army again. Lovell, whose inactivity at Corinth hurt the Confederate effort, was removed from command by Van Dorn.

NEW COMMANDER

After Van Dorn's loss at Corinth, Jefferson Davis named a new man to lead the District of Mississippi. John C. Pemberton, a Pennsylvanian by birth, was chosen to organize the defense of the state.

Pemberton immediately began strengthening the defenses around Vicksburg. Pemberton's fate was to face Grant in an epic

John C. Pemberton was appointed by President Jefferson Davis to lead the District of Mississippi. Pemberton's destiny called for him to defend and ultimately surrender at Vicksburg.

struggle for Vicksburg, the Confederate Gibraltar. Mississippians waited with anticipation since they knew the war was coming to their home state.

After the battle of Corinth, Rosecrans was the hero of the Northern press. He was rewarded for his victory by being given command of Buell's Army of the Ohio. Buell had failed to pursue a retreating Braxton Bragg at the battle of Perryville, Kentucky. Rosecrans's new command was renamed the Army of the Cumberland.

Rosecrans was destined to fight Bragg's Army of Tennessee at the battle of Stones River. He would maneuver Bragg out of Tennessee during the Tullahoma campaign, only to suffer his Waterloo at the battle of Chickamauga almost a year after his victory at Corinth.

ONE FINAL VICTORY

Stripped of command in the District of Mississippi, Van Dorn had no significant authority. In December 1862, the beleaguered general was presented with one final chance for glory. Van Dorn was tapped to lead three cavalry brigades comprised of horsemen from Texas, Missouri, and Mississippi in a raid into northern Mississippi.

An arsenal for Grant's upcoming overland campaign against Vicksburg was located in Holly Springs, Mississippi. The Federals were so certain of the town's safety that the paymaster and quartermaster were based in Holly Springs. Grant's wife and son were also staying in the Mississippi town.

Van Dorn's raid on Holly Springs caught the Union army by surprise. Thousands of cotton bales lined the streets, ready for shipment to Northern merchants. Huge supplies of flour and bacon, as well as railroad cars filled with supplies, were burned by the Southerners. The Confederates took fifteen hundred prisoners, whom they immediately paroled.

Ulysses S. Grant's Vicksburg campaign is considered a masterpiece for the general many considered a failure before the Civil War. Grant's fame continued to grow, even after the end of the war. He was elected president in 1868. This statue of Grant is at the Vicksburg National Military Park.

With his supplies destroyed, Grant chose to abandon an overland campaign against Vicksburg. He shifted his forces to Memphis, Tennessee, to utilize the Mississippi River as his line of advance.

Van Dorn's raid accomplished in one night what he couldn't do as a corps commander at Corinth. For a brief moment, Van Dorn had pushed Grant out of Mississippi. The raid covered Van Dorn with the glory that he had always sought.

Van Dorn's fame would be short-lived, as his adulterous ways finally caught up with him. He was murdered on May 7, 1863, by Dr. George Peters at Spring Hill, Tennessee. Peters had accused Van Dorn of having an affair with his wife.

Van Dorn was buried in his hometown of Port Gibson, Mississippi.

DESTINY BECKONS

By the end of 1862, Ulysses S. Grant was in Memphis, planning his next attempt to capture the Confederate stronghold at Vicksburg.

During 1862, Grant commanded victorious armies at Fort Donelson and Shiloh. These victories secured most of north and

central Tennessee for the Union army. He provided sound advice for his subordinate commanders during the battles of Iuka and Corinth. Although hit with a momentary setback at Holly Springs, Grant was poised to begin his Vicksburg campaign in November 1862. This campaign was destined to become Grant's masterpiece as a general.

Success at Vicksburg was followed by another victory at Chattanooga, Tennessee, before moving to command in the eastern theater and eventual victory at Appomattox, Virginia.

After the battle of Shiloh, people, appalled by the high number of casualties, called on President Lincoln to get rid of Grant. Lincoln responded by stating, "I can't spare this man. He fights!"

More than any other general, Ulysses S. Grant helped bring an end to the Civil War.

Shiloh and Corinth

"CROSSROADS OF THE CONFEDERACY"

The important role that Corinth played in the Civil War was decided by two rail lines that converged in the Mississippi town. The steel rails brought commerce to an emerging community, but during the Civil War the same rails brought death and destruction.

Corinth was originally settled in 1854 on what had been Chickasaw land. At first, Corinth was referred to as Cross City, due to the fact that the longest railroads in the nation in the 1860s intersected there. The Memphis and Charleston Railroad, completed in 1857, ran east and west. This was the only rail route stretching from the Mississippi River to the Atlantic Ocean. The Mobile and Ohio Railroad stretched from Mobile, Alabama, to Columbus, Kentucky. It was the longest north-south railroad in the South.

The railroads brought prosperity and even more settlers to the area. By 1861, the population of Corinth was fifteen hundred people, with five churches and three hotels. Residents built a number of nice homes and Corona College, a school for young women located on the northern edge of town.

The early boomtown years of Corinth were short-lived. The nation was gripped by a cancer that threatened to rip the country apart. The issue of slavery was bringing the country to war.

The election of Abraham Lincoln galvanized the antislavery movement in the North and brought about secession in the South. On December 20, 1860, A. E. Reynolds, W. W. Bonds, T. P. Young, and J. A. Blair were sent to Jackson, Mississippi, to serve as delegates for Corinth and Tishomingo County. Sent to oppose secession, each man cast a "nay" vote. The ordinance to secede passed by a vote of eighty-four to fifteen.

On January 9, 1861, Mississippi became the second state to secede from the Union. The Declaration of Secession for Mississippi stated: "Our position is thoroughly identified with the institution of slavery—the greatest material interest of the world. Its labor supplies the product which constitutes by far the largest and most important portions of commerce of the earth."

Although most of the Corinth population opposed secession, they rallied around their state. Four armed companies, known as the "Corinth Rifles," formed what eventually became part of the 9th, 26th, and 32nd Mississippi infantries as well as the 12th Mississippi Cavalry.

From the start of the war until the spring of 1862, the town was an important supply hub for the Confederacy. The railroads brought needed men and supplies to the Confederate armies.

The importance of the railways didn't go unnoticed, as the Union army targeted the crossroads in Corinth for capture or destruction. After Union victories at Fort Henry and Fort Donelson, Major General Ulysses S. Grant's Union army was camped at Pittsburg Landing, Tennessee.

While Grant's army was only twenty-two miles away, the Confederate army of Major General Albert Sidney Johnston was in Corinth. The northeast Mississippi town became the home for thousands of Rebel soldiers from the trans-Mississippi region, the Gulf Coast, western Kentucky, and Tennessee. These soldiers assembled to stop the advancing Union army.

Johnston wanted to destroy Grant's forces before they could unite with the Army of the Ohio under the command of Major General Don Carlos Buell. To be successful, Johnston had to fight these armies separately, since his Confederates could not stop the two once they were together.

On April 6, 1862, Johnston launched a surprise attack on Grant's Union forces. The battle of Shiloh was fought because of the strategic importance of nearby Corinth, Mississippi. The battle produced appalling numbers of casualties. Afterward, Corinth was inundated by wounded soldiers. On May 29, 1862, the Confederate army, now under the command of Major General P. G. T. Beauregard, evacuated Corinth, leaving it to Major General Henry Halleck's Union army.

In a span of a few months, Corinth had been occupied by two warring armies. In a mere five months, Corinth would once again be vied for by the North and South, with the fate of the "Crossroads of the Confederacy" being decided on the hills outside of Corinth and even on the town's streets.

The Memphis and Charleston Railroad crosses the Mobile and Ohio Railroad, forming the "Crossroads of the Confederacy" at Corinth.

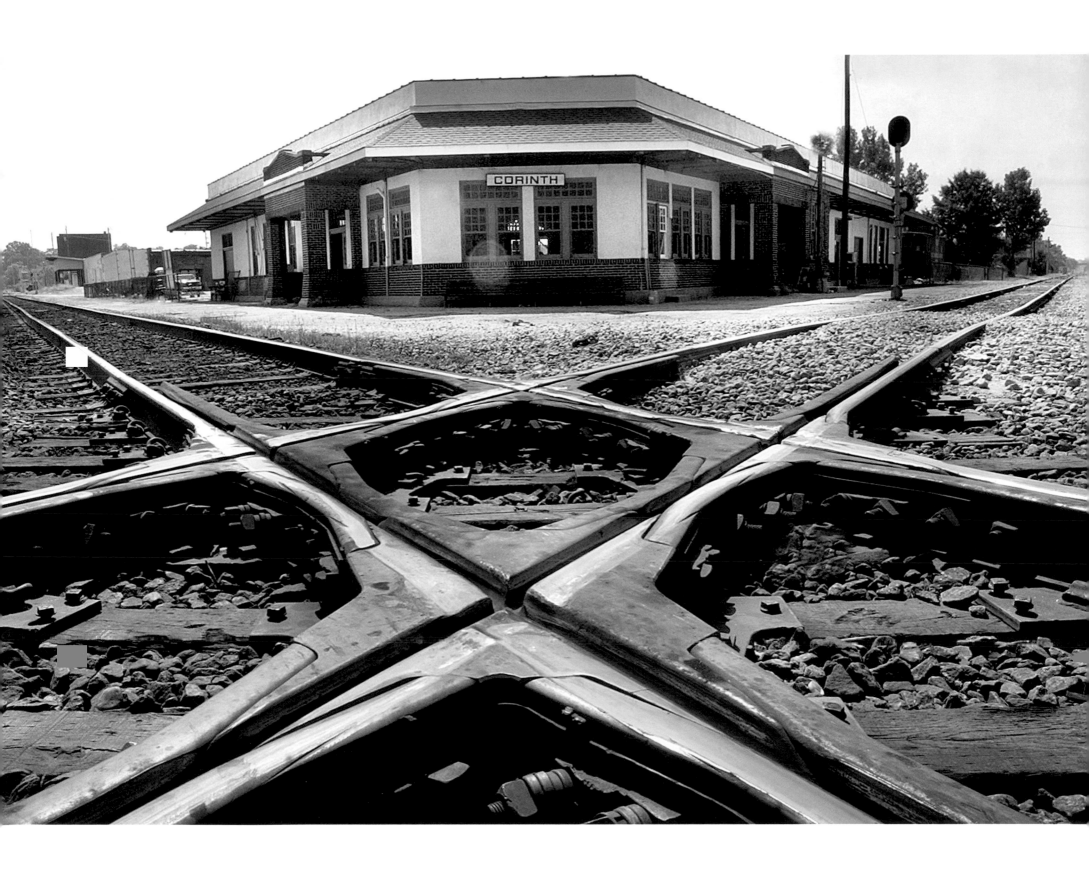

LEONIDAS POLK

In March 1862, Major General Leonidas Polk arrived in Corinth, Mississippi. The prospect of coming to the "Crossroads of the Confederacy" didn't sit well with Polk. He still harbored resentment for being ordered to withdraw from Columbus, Kentucky. As armies from across the western Confederacy gathered at Corinth, Polk wondered what might have been in Kentucky.

Polk's life was one of stark contrasts. He had attended the U.S. Military Academy at West Point and was a classmate of Jefferson Davis and Albert Sidney Johnston. Six months after his graduation, Polk resigned from the army in order to study for the ministry.

In 1830, Polk was ordained in the Episcopal Church, and he became bishop of Louisiana in 1841. During the next twenty years, Polk tended to his flock in Louisiana while the country quarreled over a state's right to choose to be a slave state or free state. In June 1861, Polk was commissioned as a major general in the Confederate army.

Polk was given command of Department No. 2 and charged with defending the Mississippi River. Polk's fervor was evident in his General Orders to his troops on July 13, 1861: "We have protested, and do protest, that all we desire is to be let alone, to repose in quietness under our own vine and under our own fig tree. . . . They have sought to deprive us of this inestimable right by a merciless war, which can attain no other possible end than the ruin of fortunes and the destruction of lives.

Once Johnston and P. G. T. Beauregard were sent west, Polk became their subordinate. Polk didn't like being a subordinate to any man, which often put him at odds with his superiors. In 1861, acting on his own accord, Polk invaded Kentucky. The state of Kentucky had declared its neutrality in the Civil War. While both sides coveted the state, they also knew any occupation might send the state to the opposing side. A neutral Kentucky actually helped the Confederacy in providing a shield from the states of the Union.

Polk thought the area around Columbus, Kentucky, would provide an excellent locale to defend the Mississippi River. Rumors were running rampant that Grant's Union army was going to occupy Columbus.

Against the wishes of Davis and Tennessee governor Isham Harris, Polk invaded Kentucky and seized the ground around Columbus on September 3, 1861. Polk would fortify and hold Columbus through the remainder of the year. The collapse of Fort Donelson, Tennessee, caused Beauregard to order Polk out of Kentucky.

Polk resisted Beauregard's order, calling Columbus the "Gibraltar of the West." He even took his argument to President Davis, stating in a letter that his citadel was "well-nigh impregnable."

In March 1862, Polk grudgingly marched his army out of Kentucky and brought his seven thousand soldiers to Humboldt, Tennessee. Polk eventually made his way to Corinth and established his headquarters at the Oak Home on Fillmore Street, a house built in 1857 for Judge W. H. Kilpatrick. While in Corinth, Polk participated in the planning for the Confederate attack at Pittsburg Landing, Tennessee.

On April 4, 1862, Polk, commanding a corps, and Major General William Hardee marched their troops north toward Tennessee. Two days later, they would command at the battle of Shiloh.

After Shiloh, Polk continued to butt heads with Major General Braxton Bragg. Polk was transferred to Mississippi and later took command of the Department of Mississippi, Alabama, and East Louisiana. He rejoined the Army of the Tennessee to participate in the battle of Chickamauga and siege of Chattanooga. He served under Major General Joseph E. Johnston during the Atlanta campaign.

On June 14, 1864, Polk was cut in half by a Union cannonball while standing on Confederate fortifications at Pine Mountain, Georgia. Polk was having a conference with Hardee and Johnston. He had been warned to take cover, but he did not, and it cost him his life.

The Oak Home served as the headquarters for Leonidas Polk during his stay in Corinth.

THE GATHERING ARMY

The middle defense of General Albert Sidney Johnston's Kentucky line was shattered. The fall of Fort Henry and Fort Donelson caused the immediate evacuation of William Hardee's force and the loss of Kentucky and most of Tennessee. A devastated Johnston wired General P. G. T. Beauregard, "At 2 A.M. today Fort Donelson surrendered. We lost all."

Even before the fall of these forts, things had been bad for Johnston, who was charged with protecting the western front. To keep the Union army at bay, Johnston decided to station his soldiers in Kentucky and just over the border in Tennessee.

Union brigadier general Ulysses S. Grant had taken Paducah, Kentucky, in response to Confederate major general Leonidas Polk's fortifications at Columbus, Kentucky. Johnston sent Brigadier General Simon Bolivar Buckner to occupy Bowling Green, Kentucky, and Felix K. Zollicoffer protected the Cumberland Gap. Covering such a wide area was daunting. Johnston had fewer than two hundred thousand men to protect his long defensive front. Many of these men were using shotguns for weapons. The Confederate Army of the West was lacking in arms, men, and matériel.

Given these challenges, Johnston believed he had adequately defended his front. His main concern was that the Union forces would use the rivers to invade Tennessee. Johnston's fears were realized with the surrender of Fort Henry on the Tennessee River and Fort Donelson on the Cumberland River. The road to Nashville was now open for the Union army.

Beauregard headed west to assist in the withdrawal of forces. He ordered Polk to leave the fortifications of Columbus, Kentucky, while Johnston's troops moved toward Murfreesboro, Tennessee. Initially, Johnston had decided to withdraw to Stevenson, Alabama, in order to protect Chattanooga, Tennessee.

During the retreat, Johnston began to change his mind and moved toward Decatur, Alabama, located halfway between Chattanooga and Corinth, Mississippi.

Both Johnston and Beauregard agreed to concentrate the Confederate army at Corinth. On February 24, 1862, Johnston wired President Jefferson Davis, stating he was moving his army "to the valley of the Mississippi." The important railroad junction at Corinth allowed the concentration of Confederate troops from across the South.

Beauregard arrived in Corinth from Jackson, Tennessee, and Johnston entered the town on March 22, 1862. William Inge offered his home, the Rose Cottage, to serve as the general's headquarters. Two days later, in a conference with Beauregard, Polk, and William Hardee, Johnston decided to strike Grant's army before it could unite with Don Carlos Buell's Army of the Ohio. Grant's army numbered fifty thousand, and it was believed Buell had a similar number of troops, but Johnston needed more soldiers to deliver a blow to the Union advance.

Southern soldiers began to arrive from all directions. Hardee's thirteen thousand men continued to arrive, followed by Major General John C. Breckinridge's soldiers. Approximately ten thousand soldiers under the command of Major General Braxton Bragg arrived from Pensacola, Florida. Among those arriving from Pensacola was the 9th Mississippi Infantry, which included members of the Corinth Rifles. Bragg's numbers increased with the arrival of Brigadier General Daniel Ruggles's five thousand soldiers from New Orleans.

By early April 1862, there were close to forty thousand Confederate soldiers in Corinth. The majority hailed from Mississippi, Alabama, Tennessee, Arkansas, Missouri, Louisiana, and Kentucky.

These men looked like anything but soldiers. They wore homespun clothes of various colors; some even wore blue. Their weapons varied from flintlocks and squirrel rifles to shotguns. Each command seemed to have its own battle flag.

Beauregard tried to standardize the flags by adopting a design he had introduced in the eastern theater. The flag consisted of twelve white stars on a blue St. Andrews cross on a field of red. These flags were issued to Bragg's corps.

By 1862, there were close to 40,000 soldiers around Corinth. These soldiers hailed from Mississippi, Alabama, Tennessee, Missouri, Louisiana, and Kentucky.

THE VERANDAH HOUSE

The sound of boots echoed through the long hall of the Verandah House. Confederate generals Albert Sidney Johnston and Braxton Bragg gathered in the home to decide upon a plan to change the misfortunes of the Confederate army. Events had been going badly ever since the fall of Fort Donelson two months earlier. The fateful decision made in the home of Hamilton Mask led to the battle of Shiloh.

Built in 1857, Mask's home was known as the Verandah House due to the wrap-around porches. The Greek Revival structure became Bragg's headquarters upon his arrival in March 1862.

Beauregard had traveled west to assist Johnston's withdrawal after the disaster at Fort Donelson. Beauregard was ailing due to throat surgery he had before leaving Virginia. The aftereffects of the surgery left him with a fever and laryngitis. By early March 1862, Bragg arrived in Jackson, Tennessee, to find Beauregard out of sorts. Ailing from the throat surgery, compounded with the debacle at Fort Donelson, Beauregard was nearing a nervous breakdown.

Bragg's corps had arrived from Pensacola, Florida. The irascible general long realized the importance of the Mississippi Valley and had volunteered a large number of his troops for its defense. After the fall of Fort Donelson, Bragg wrote the War Department, stating, "We are being whipped in detail when a vigorous move with our resources concentrated would be infinitely more damaging to the enemy."

Bragg assisted Beauregard in bringing cohesion to the scattered forces that were arriving. The forces were combined to create the Army of the Mississippi.

While at Corinth, Bragg worked to instill discipline in soldiers. He was known for his organizational skills and for being a taskmaster, creating discipline in unruly soldiers. The North Carolina native considered many of the soldiers gathered around Corinth more of a "mob" than an army.

Bragg was also known for his quick temper and for his inflexibility once he made up his mind. He frequently suffered from migraine headaches, which could explain part of his behavior.

During the Mexican War, Bragg was noted for courageous conduct in the battle of Buena Vista. He was credited with saving the Americans from defeat by repulsing a frontal assault and holding off an attack on General Zachary Taylor's flank through effective use of his artillery. Although gallant in battle, Bragg earned a number of enemies. An attempt was made on his life by a soldier exploding a twelve-pound shell at the foot of Bragg's bed.

After a brief retirement in the late 1850s, Bragg returned to serve in the Louisiana militia, until he was appointed brigadier general by the Confederate States of America in 1861.

Johnston's arrival in Corinth brought about a conference of the leading generals. With Generals Johnston, Beauregard, Bragg, Hardee, and Polk present, talks began on how to stop the Union army. Offensive and defensive strategies were discussed, and Johnston's old Army of Central Kentucky was consolidated into the Army of the Mississippi.

Beauregard was leaning toward an offensive operation, while Johnston was concerned about the army's inexperience and lack of arms. Bragg had misgivings about the overall discipline of the army.

Eventually, they decided to strike Grant's army before it could be reinforced by Buell. On April 2, 1862, Beauregard forwarded a telegram from Major General Benjamin Cheatham claiming the Union army was advancing down the Purdy Road.

Beauregard endorsed Cheatham's telegram, writing, "Now is the moment to advance and strike the enemy at Pittsburg Landing," and forwarded it to Johnston. Next, Johnston brought the telegram to Bragg's headquarters, rousting the general from his sleep. While sitting in his nightshirt, Bragg decided with Johnston the time when the Army of the Mississippi would strike the Federal army.

Today, the Verandah House still stands at the corner of Jackson and Childs streets. Cars have replaced horses and buggies, but one can still hear trains moving across the "Crossroads of the Confederacy."

The Verandah House served as the headquarters for Braxton Bragg and was the location of the decision to fight at Shiloh.

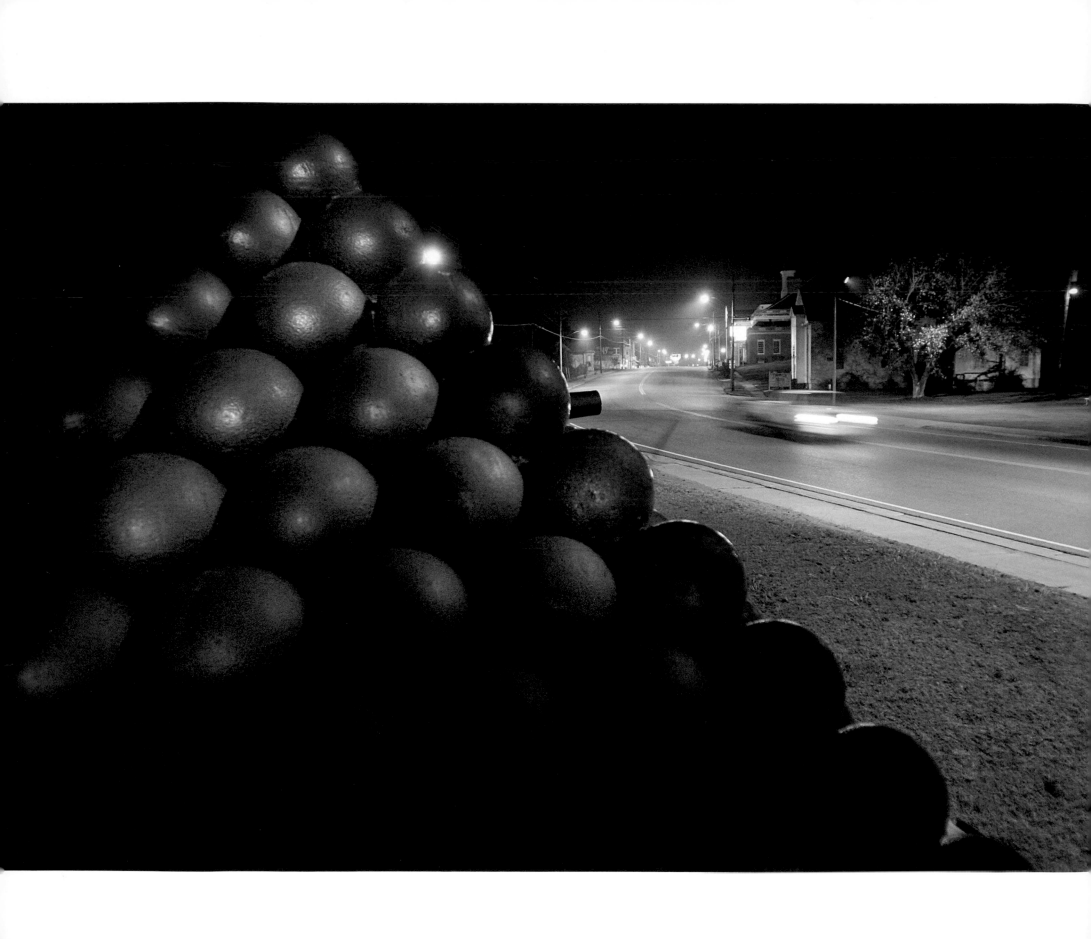

SAVANNAH, TENNESSEE

In March 1862, the town of Savannah, Tennessee, couldn't contain the massive growth it experienced as it became the hub of Major General Ulysses S. Grant's Army of the Tennessee. The town was spilling over with soldiers and the tools of war. On April 6, 1862, the citizens of Savannah could hear the boom of cannons to the south as Grant's army received the initial attack at Shiloh.

The town of Savannah was the seat of Hardin County. Sitting on a bluff overlooking the Tennessee River, Savannah had a population of one thousand people. It was a town that only had the basics of life. There was no newspaper or telegraph. One Union officer called Savannah "a quiet sober looking old town with a single street, a square brick courthouse, a number of buildings scattered along the street, with some pretty and rather stylish residences in the suburbs."

The surrounding Hardin County was an area that supported small-acreage farmers. The farms in this rural county of 11,214 people were typical of those in this part of the South. Most farmers struggled to make ends meet. Of these Hardin County farmers, only five owned more than five hundred acres, and just fourteen owned slaves. The slave population was 1,623, and there were thirty-seven freed blacks.

The overriding sentiment in Hardin County was Unionism. In 1861, the people of the county voted to remain in the Union. Even during the war, most people in eastern Hardin County strongly supported the Union cause, while western Hardin County was pro-Confederate.

In 1862, news of the fall of Fort Henry, on the Tennessee-Kentucky border, startled many of Savannah's residents. This opened the Tennessee River for the Union army to push farther south.

During March, the size of Savannah grew in massive proportions, as the Union Army of the Tennessee began to arrive. The procession of Union boats was the subject of many letters home from the soldiers. The strong Federal presence also allowed citizens of Savannah to demonstrate their true Union sentiment without fear of retribution.

By March 1862, many men from Hardin and Wayne counties traveled to Savannah and volunteered for Union service. These men joined Ohio, Illinois, and Indiana units stationed with Grant at Savannah.

The shoreline of Savannah couldn't handle the number of Union vessels arriving. With little to no space left in town, many of the boats were tied to each other. The banks of the Tennessee River were lined with over a hundred vessels, sometimes tied as many as four deep.

These vessels were loaded with thousands of soldiers, as well as their horses. Proper sanitation was virtually impossible. One Illinois officer complained, "We have to use the muddy water for drinking and cooking." The same water that was used for sanitation was also used for cooking and cleaning. Before long, illness engulfed the Union army, as sanitary conditions continued to decline.

Brigadier General William T. Sherman was happy when his division was sent to Pittsburg Landing, therefore saving his men from the squalid conditions at Savannah. When Grant arrived at Savannah, Sherman argued the entire army should be moved to that more strategic location. Grant agreed and ordered all of the troops still on the transports to redeploy at Pittsburg Landing. This left only Major General John McClernand's division encamped around Savannah.

After April 6, 1862, the townspeople could see hospital boats heading north, carrying the soldiers to Savannah and beyond. At Pittsburg Landing, the wounded were housed in makeshift hospitals. Hospital boats from the north arrived to help the townspeople care for the fallen soldiers.

Today, Savannah still rests on the bluffs of the Tennessee River. The town has grown from one street to numerous thoroughfares stretching in all directions. The citizens of Hardin County, east and west, still rally around one flag—the U.S. flag.

Savannah, Tennessee, was known for its Union sympathies, making it a welcomed staging area for the Tennessee River campaign.

PITTSBURG LANDING

Pittsburg Landing was nothing more than a log cabin overlooking the Tennessee River during the Civil War. The strategic importance of the region was that it presented an excellent staging area to unload troops for the eventual advance toward Corinth, Mississippi.

Early in the war, Confederate general Albert Sidney Johnston feared the rivers of the West would become avenues of invasion. Johnston's fears were realized with the fall of Fort Henry and Fort Donelson. In 1862, the Union army was poised to continue its offensive into the Mississippi Valley.

The Tennessee River proved an especially inviting avenue. The Tennessee begins around Knoxville, Tennessee, and flows south into eastern Alabama. The river takes a westerly course as it flows across northern Alabama before forming the extreme northeastern border of Mississippi and Alabama. From there, it bends north back into Tennessee, passing by Pittsburg Landing.

Pittsburgh Landing provided an eighty- to one hundred–foot-high bluff connecting to a road leading to Corinth just twenty-two miles south. The bluff was high enough to withstand springtime floods and allowed enough space for an entire army to camp. The Army of the Tennessee needed such an area while waiting for the arrival of Don Carlos Buell and the Army of the Ohio.

A small detachment of Confederate soldiers had occupied Pittsburg Landing until they were shelled by Union gunboats. On March 14, 1862, two brigades arrived at Pittsburg Landing. Major General William T. Sherman landed first, while Brigadier General Stephen A. Hurlbut's men remained on the transports.

The following day, Major General Charles F. Smith, temporarily commanding the Army of the Tennessee, sent Sherman to select ground near Pittsburg Landing to support a whole army. Smith and Sherman thought the Confederates were whipped and incapable of any offensive campaign. Therefore, the Union camps resembled a bivouac instead of a fortified position with flanks protected.

The importance of Pittsburg Landing was not lost on the Union generals, and soon transports were unloading scores of Union soldiers for the eventual advance on Corinth.

By mid-March, Grant once again resumed command of the Army of the Tennessee and transferred it to Pittsburg Landing. The laborious project of unloading of soldiers took nearly a week and a half to complete. Approximately thirty-five thousand soldiers comprising five divisions were camped on land stretching two and a half miles from Pittsburg Landing. Another division was six miles north at Crump's Landing.

Henry Halleck ordered the two generals to link their armies before there was an advance on Corinth. Winter was beginning to loosen its hold on the area, and signs of spring were evident.

The 16th Iowa Regiment arrived at Pittsburg Landing on April 5, 1862, and began setting up camp. On April 6, soldiers forming the 15th Iowa Regiment arrived at Pittsburg Landing, filing off their boats in the early morning. Ann Wallace, wife of Brigadier General W. H. L. Wallace, also arrived at Pittsburg Landing on a surprise visit to see her husband.

The Iowa soldiers were new recruits who had yet to even load their weapons. Despite their inexperience, they were confident soldiers. "We were all spoiling for a fight, and there was no little amount of grumbling done by members of the Regiment on account of the fear that we would not be there in time to take part in the battle," said W. P. L. Muir of the 15th Iowa.

Captain James G. Day of the 15th Iowa commented on that Sunday morning, "It was a most invigorating, peaceful, quiet Sabbath morning. Not a sound fell upon the ear."

The morning was soon interrupted by the unmistakable sounds of battle filling the air. Johnston's Army of the Mississippi had launched a surprise attack on the unsuspecting Union forces.

For the next two days, Union and Confederate soldiers fought desperately to claim victory. Pittsburg Landing played a vital role in providing a loading area for Union reinforcements. Prior to the arrival of these troops, Pittsburg Landing was the last safe haven for soldiers unwilling to fight.

The river was lined with soldiers who had given up the fight and ran to the rear trying to escape the Confederate onslaught.

Pittsburg Landing provided a deep-water staging area for Ulysses S. Grant's Union army.

ALBERT SIDNEY JOHNSTON

Enraged Tennesseans stormed Richmond, Virginia, demanding to see President Jefferson Davis and seeking the removal of General Albert Sidney Johnston. The Tennesseans needed someone to blame for the fall of Fort Donelson, and Johnston seemed the logical choice. Davis, offended by the suggestion, dismissed the Tennesseans, stating, "Gentlemen, I know Sidney Johnston well. If he is not a general, we had better give up the war for we have no general."

Davis wasn't the only person to have a high opinion of Johnston. He was well regarded by both North and South. At fifty-eight-years-old, standing six feet tall, and sporting a handsome mustache, Johnston looked every bit the soldier. After Robert E. Lee turned down command of the Union army, Johnston was the next choice for General Winfield Scott, who had described him as "a godsend to the army."

Johnston graduated from the U.S. Military Academy and served in the 6th Infantry during the Black Hawk War. In 1834, he resigned from the army when his wife, Henrietta, was dying of tuberculosis. After her death, Johnston moved to St. Louis with his son and daughter.

In 1836, Johnston moved to Texas and was made a general in the Texas army by Sam Houston. Johnston's sudden advancement in the Texas army angered Felix Huston, and the two faced off in a duel. On the fifth exchange of shots, Johnston was shot in the hip, causing a lifelong loss of sensation in one leg. The wound all but ended his career in the Texas army and would play a significant role in his death at the battle of Shiloh, as he was unaware of a nicked artery in his injured leg.

Johnston served in the Mexican War, leading a regiment of Texas volunteers. He had promised his second wife he would not remain in the army and was true to his word. After the war, Johnston tried to become a planter, but this venture ended in bankruptcy.

In 1855, Secretary of War Jefferson Davis had Johnston appointed colonel of the 2nd Cavalry in Texas. Two years later, Johnston relinquished command to Robert E. Lee. Johnston's next command was to lead the Utah expedition to suppress the Mormon Rebellion. Three years later, Johnston was in command of the Department of the Pacific in San Francisco. Upon hearing that his adopted state of Texas had seceded, Johnston resigned his commission.

The trip to Texas was a harrowing journey for Johnston and a group of fellow Southerners. While in Los Angeles, Johnston was kept under surveillance by Union soldiers. If he gave any indication of joining the Confederacy, he was to be arrested. Johnston joined a party of men led by Alonzo Ridley, a Northerner by birth who had Southern sympathies. Ridley planned on going to Texas. To mislead the Union soldiers, word was put out that Johnston would leave on June 25, 1861. Instead, Johnston's group left on June 16 to begin an eight hundred–mile journey.

Johnston's trek across the desert Southwest was fraught with peril. His band of men had to cross a desert, where temperatures reached 120 degrees. They were traveling through hostile Apache and Navajo territory. The worst danger proved to be the Union army; Winfield Scott had called for Johnston's arrest in early June. Johnston finally reached El Paso, Texas, on August 8, 1861. From there, it was on to Richmond and command of the Confederate Department No. 2.

The fall of Fort Donelson shook Johnston's confidence, but he bore the contempt and abuse from the Southern press and people with his usual dignity.

Prior to the battle of Shiloh, Johnston offered command to General P. G. T. Beauregard, claiming he had lost confidence in the army and the people. The following day Beauregard declined the offer, stating, "I could not think of commanding on a field where Sidney Johnston was present."

Johnston continued to command, leading his army against Grant at the battle of Shiloh. In doing so, Johnston gained his ultimate fate as a Confederate hero slain while within the grasp of victory.

A profile of Albert Sidney Johnston is carved into the Confederate memorial at Shiloh.

CHARLES FERGUSON SMITH AND THE CHERRY MANSION

Sitting on a bluff overlooking the northerly flow of the Tennessee River, the William H. Cherry mansion served as headquarters for Major General Ulysses S. Grant and a deathbed for Grant's mentor, Major General Charles F. Smith.

The Cherry mansion was built in 1830 by David Robinson, who gave the home to his daughter, Anne Irwin, on her marriage to William Cherry. In a cruel twist of fate, Cherry and his wife chose opposite sides during the Civil War. Cherry was a wealthy planter, merchant, and slave owner and the county's most ardent Unionist. His wife was pro-Confederacy. She is rumored to have passed any information she heard in her home to a nearby Confederate cavalryman.

Sharing the eight-room home with the Cherrys were Grant and Smith. Grant idolized Smith, who had been his mentor at the U.S. Military Academy, serving as commandant of cadets. Although Grant was Smith's commanding officer, he found such an arrangement troubling. "It does not seem quite right for me to give General Smith orders," Grant said. Smith served Grant well at Fort Donelson, and both men emerged from the battle as national heroes. It was Smith who launched a timely counterattack at Fort Donelson.

Smith advised Grant to give "no terms to traitors" at Fort Donelson. This unwavering surrender demand earned Grant his early war nickname, "Unconditional Surrender" Grant. Grant was well aware of Smith's role at Fort Donelson, stating that "he owed his success at Donelson emphatically to him." In Smith, Grant and Henry Halleck, the commander of the department, found something the two could agree on. Halleck wired Union major general George B. McClellan, saying of Smith, "His coolness and bravery at Fort Donelson when the battle was against us, turned the tide and carried the enemy's outworks; make him a major-general. You can't get a better one. Honor him for this victory, and the country will applaud."

Both Grant and Smith became major generals after Fort Donelson, but their command was switched. Halleck, a longtime foe of Grant, sought to remove some of the credit Grant was receiving. Claiming Grant was unorganized and insubordinate, Halleck gave Smith command of the Tennessee River expedition.

The expedition took Smith to Savannah, Tennessee, where he sent two expeditions to cut Confederate communications and suffered an unlucky misfortune that would ultimately end his life. The waterfront at Savannah was filled with Union transport boats. Many of these boats were tied side by side, waiting to unload the soldiers once a camp was designated. While climbing into a small rowboat, Smith missed the gangplank, cutting his shin. The wound would not heal and ultimately became infected.

The injured leg and the infection that ensued incapacitated Smith, keeping him from riding his horse or walking. When he visited the front, Smith did so by riding in an ambulance. By the end of March, Smith was confined to his bed, often staying at the Cherry mansion.

The bad climate around Savannah, coupled with a cold that he had taken at Donelson, sapped Smith of any energy. On March 13, 1862, command of the army was once again given to Grant due to Smith's condition. On April 3, 1862, command of Smith's 2nd Division was given to Brigadier General W. H. L. Wallace.

From his bed at the Cherry mansion, Smith could hear the boom of artillery downriver at Shiloh, Tennessee. It was unbearable for Smith to know that his army was fighting a desperate battle while he was bedridden. When the news of the Union victory reached Smith, he was proud of Grant and his men. The Union cause had been given a blessing with their victory at Shiloh.

On April 25, 1862, Smith died from the infection that had begun because of a scrape on his shin. "There was no better soldier in the army than General Smith," said his hometown newspaper, the *Philadelphia Inquirer*. Perhaps the most fitting tribute to Smith came from William T. Sherman, who stated that if Smith had lived, "no one would have heard of Grant or himself."

In 1934, Bob Guinn, a local Savannah businessman, purchased the Cherry mansion. It has been changed from its 1862 appearance.

Ulysses S. Grant was eating in the dining room of the Cherry mansion when news of fighting at Shiloh arrived. He traveled by transport down the Tennessee River to the battle.

FRALEY FIELD

Before sunrise, the crack of gunfire erupted from the pickets of Major General William Hardee's Confederate soldiers. The still of the night was shattered when a patrol led by Major James Powell stumbled into Rebel pickets. The battle of Shiloh had begun.

Frustration was clearly evident on the face of Colonel Everett Peabody. He kept getting reports of enemy activity in front of his camp. Any attempt to warn Brigadier General Benjamin Prentiss was met with open disdain. The leaders of the Union army didn't believe the Confederate army had the capacity or will to launch an offensive attack.

Peabody took responsibility and ordered Powell to take 250 men from the 25th Missouri and 12th Michigan infantries to patrol the woods southwest of a log church called Shiloh. The patrol disappeared into the predawn darkness.

The Confederate soldiers were confident and ready for a fight. They had marched out of Corinth, Mississippi, on the morning of April 3, 1862. Pittsburg Landing was only twenty-two miles from Corinth, but the march had been trying for the soldiers. Although planned to start in the morning, the march north, hampered by slow-moving generals, began around noon. A drenching rain further slowed the Southerners' progress, turning roads into rivers of mud.

Twice the battle had been postponed due to the inclement conditions and the slow-moving Confederate army. On the evening of April 5, 1862, Hardee's men were in a line of woods only a mile away from Shiloh Church.

That night, Johnston had an informal council of war with General P. G. T. Beauregard, Major Generals Braxton Bragg and Leonidas Polk, and Brigadier General John C. Breckinridge. Much to Johnston's surprise, Beauregard favored a return to Corinth. The Creole general believed that the element of surprise had been compromised. Beauregard thought the Federals were probably entrenched and waiting for the Rebel army. It had been Beauregard who earlier had favored an advance against Grant.

Bragg agreed with Beauregard, thinking the attack to be suicide. Johnston disagreed with their assessment, with Polk siding with him. Johnston ended the discussion, informing his generals, "Gentlemen, we shall attack at daylight tomorrow." As Johnston mounted his horse, Fireater, he told Colonel William Preston, "I would fight them if they were a million."

While Hardee's men slept on the line, Powell's soldiers walked westward in the woods lining John C. Fraley's cotton field. When Powell's men stepped from the woods into the field, they were met by smoothbore fire from Major Aaron B. Hardcastle's 3rd Mississippi Battalion.

Hardcastle's men were new to war. They had been recruited the previous winter from Grenada, Mississippi. The battalion, numbering about 280 men, was located on a slight rise in the southwest corner of Fraley Field. As the Confederates traded shots with Powell's men, the darkness was shattered by a wall of flame coming from the muzzles of the Mississippians' guns.

For the next hour, both sides fired wildly, as Powell's men began to give ground. The Union soldiers were astonished to see Hardcastle's men reinforced by over nine thousand soldiers forming a line marching in their direction. A wave of butternut and gray was poised to sweep Powell's men from the field.

Leading the Confederate soldiers from Arkansas, Tennessee, Mississippi, Alabama, and Louisiana were Brigadier Generals Patrick Cleburne, Thomas Hindman, Adley Gladden, and Sam Woods, and Major General William Hardee.

Johnston and Beauregard arrived on the field and met briefly as the Southern soldiers marched toward the Union camps. Once again, Beauregard urged Johnston to retreat. The crack of gunfire settled the issue, with Johnston informing Beauregard, "The battle has opened, gentlemen, it is too late to change our dispositions."

It was decided that Beauregard would be in charge at Headquarters No. 1, while Johnston would lead from the front. As Johnston rode to the front, he said to his officers, "Tonight we will water our horses in the Tennessee River."

Union soldiers stumbled upon Confederate pickets at Fraley Field, bringing on the first shots of the battle of Shiloh. Fraley Field is at the end of the trail above.

SHILOH MEETING HOUSE

On March 16, 1862, Brigadier General William T. Sherman arrived at Pittsburg Landing. Sherman's 5th Division of the Army of the Tennessee immediately marched inland to find a suitable area to make camp. Sherman selected the area just north of a one-room log-hewn structure known as the Shiloh Meeting House. The blue-clad soldiers simply called the cabin "Shiloh Church." In less than three weeks, Shiloh Church and the cemetery nearby were the scene of vicious fighting and grisly death.

Sherman's selection of the Shiloh Meeting House made sense. It was on a vital crossroad. One road ran from Pittsburg Landing to Corinth, Mississippi, while the other ran toward Purdy, Tennessee. Since the crossroads town of Corinth was the Union army's ultimate goal, the Shiloh Church made a logical starting point for Sherman's men.

The Shiloh Meeting House was a primitive structure but had served its congregation well for a decade. In 1851, John J. Ellis donated four acres to the Southern Methodist Episcopal Church for a house of worship. The original church was constructed in 1853.

Sherman made his headquarters near the church while the rest of the men made camp. Due to Sherman's and Grant's overconfidence, the Union soldiers failed to fortify their position. Despite repeated warnings from some of his officers, Sherman maintained the Southern army was twenty-two miles away, safe in the fortifications of Corinth.

Grant, whose headquarters were nine miles away in Savannah, Tennessee, relied on Sherman's instincts to stay on top of the situation at Shiloh. Grant shared Sherman's conviction about the Confederate position, sending a telegram to Major General Henry Halleck, stating, "I have scarcely the faintest idea of an attack being made upon us, but will be prepared should such a thing take place."

Sherman and Grant did not realize that General Albert Sidney Johnston's Army of the Mississippi was camped less than two miles away from the Union lines. On April 6, 1862, Johnston launched an attack that caught the Union army by surprise.

Sherman's belief that the Confederates were not nearby lasted up to the point that Southern soldiers raised their weapons to fire at him. The surprised general exclaimed, "My God, we are attacked!" Sherman was shot in the hand, while his aide, Private Thomas D. Holliday, was killed instantly with a shot to his head.

Sherman raced to rally his soldiers at Shiloh Church as the battle reached a fevered pitch. Following closely behind Sherman were the soldiers of Confederate brigadier generals Patrick Cleburne, Patton Anderson, and Bushrod Johnson.

For the rest of the day, Sherman commanded the division from the front, often exposing himself to repeated fire from Confederate soldiers. Sherman had four horses shot from under him during the fight at Shiloh.

The Union army repeatedly withstood Confederate attacks near Shiloh Church for two hours, until Sherman's left flank collapsed when soldiers from the 57th and 77th Ohio broke and ran toward Pittsburg Landing. Allen C. Waterhouse's battery tried to fill the gap but lost three cannons to the 12th and 13th Tennessee regiments. Instead of losing his division, Sherman called for his men to fall back to the Hamburg-Purdy Road, forming his second line of battle.

Although the Federals had been caught by surprise, Major General Leonidas Polk praised their defense around Shiloh Church, stating that Sherman's and John McClernand's forces "fought with determined courage, and contested every inch of ground."

For the remainder of the day and night, Confederate general P. G. T. Beauregard used the church as his headquarters. After the battle of Shiloh, the church was used as a hospital but collapsed several weeks later. The structure on today's battlefield is a replica of the original church.

The Shiloh Meeting House was a crude log building where some of the harshest fighting occurred.

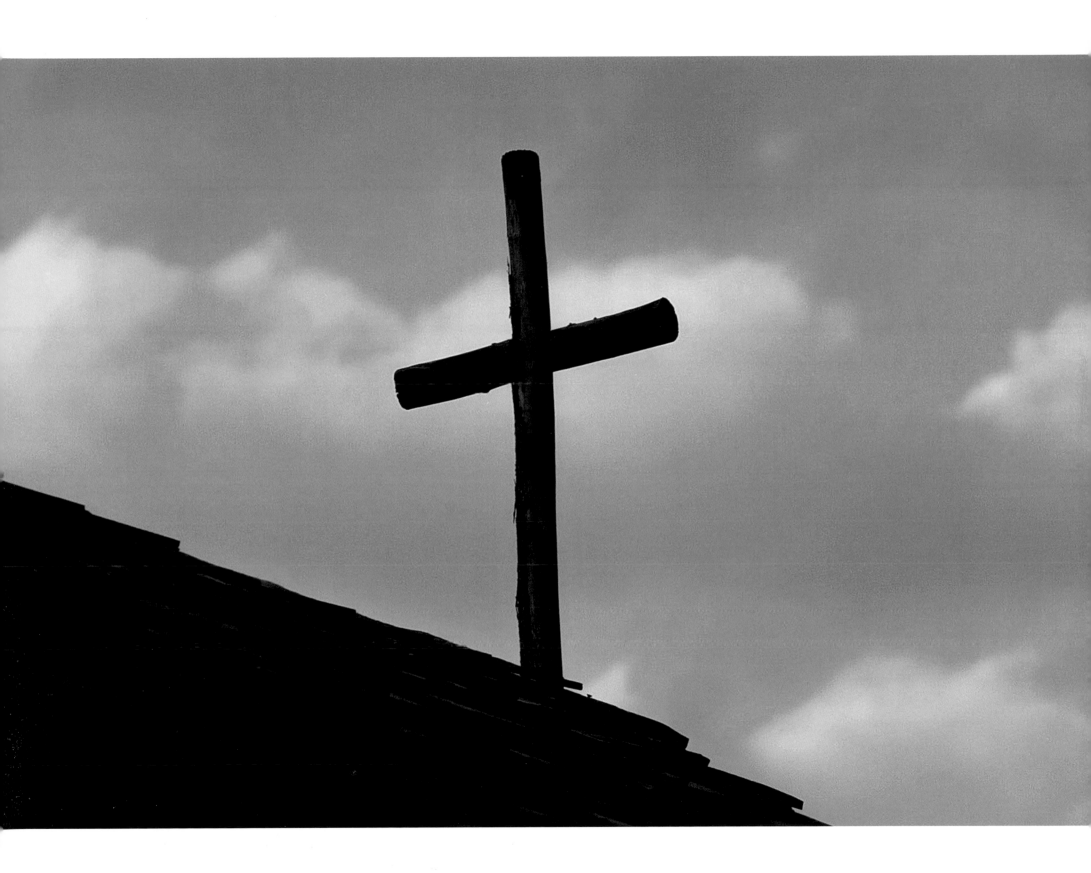

CRUMP'S LANDING

The mud-stained division of Major General Lew Wallace marched into the Union camp at Pittsburg Landing, Tennessee. As they marched, Wallace's soldiers saw a defeated Union army huddled around the landing. The daylong fight at Shiloh left the Union Army of the Tennessee in shambles. Soldiers stared at Wallace's men. They had been expected on the battlefield six hours earlier.

On April 6, 1862, Wallace and his division of seven thousand men were camped at Crump's Landing on the Tennessee River. Wallace could hear massive cannon fire coming from Pittsburg Landing only six miles to the south. Wallace concentrated his division at Stoney Lonesome. If the attack came from Purdy, this location allowed Wallace a place to defend Crump's Landing or march to Pittsburg Landing.

By 7 A.M., Wallace met briefly with Major General Ulysses S. Grant when Grant's steamboat *Tigress* stopped at Crump's Landing. Both Grant and Wallace were concerned that an attack might be made on this lone division and the provisions nearby.

Grant directed Wallace to get his troops in line ready to execute any orders that he might send. Wallace replied that his soldiers were already under arms and prepared to move. Having communicated with Wallace, Grant, still aboard the *Tigress*, headed toward Pittsburg Landing. When Grant arrived at Pittsburg Landing, it was clearly evident that this was the location of the hotly contested engagement. Wallace's role in the battle of Shiloh and the controversy that followed began with orders from Grant.

Grant dispatched a courier to order Wallace to move his division up to support the division of Brigadier General W. H. L. Wallace, who was under attack near Shiloh Church. This order was the key to the Grant-Wallace controversy. Unfortunately, the orders were lost during the march to Shiloh.

Wallace claimed Grant's orders were unsigned, hastily written, and overly vague. He also claimed the orders told him to support Brigadier General William T. Sherman. Wallace had the choice of two roads to take his men to Shiloh. Grant insisted that his orders specified the River Road as the route to take. The River Road led directly to Pittsburg Landing but was muddy due to recent rains. Wallace had tried to improve the Shunpike Road to speed up communication and assistance between Crump's Landing and Pittsburg Landing. Wallace chose the Shunpike Road, which would take the division near Shiloh Church.

Wallace's choice of the Shunpike Road turned the march into a daylong odyssey. While the battle of Shiloh continued to rage, an impatient Grant was expecting Wallace on the River Road. He sent three different couriers to locate Wallace. The first courier found Wallace and his division at Clear Creek, still a good march from Shiloh.

Wallace ordered a time-consuming countermarch on the River Road, with hopes of reaching Pittsburg Landing before dusk. Wallace's first units didn't reach Pittsburg Landing until 7 P.M. A six-mile march had taken all day and kept Grant from using these fresh troops on a day that his army was nearly pushed into the Tennessee River.

Wallace's soldiers were part of the counterattack against the Confederates during the second day at Shiloh. Wallace, with his long march from Crump's Landing, was a great source of irritation for Grant. Wallace was blamed for incompetence during the daylong march when he was needed at Shiloh.

Wallace was relieved of command and assigned to obscure duty on the East Coast. Wallace's army was defeated by Confederate major general Jubal Early at the battle of Monocacy, but the fight delayed Early's advance toward Washington, D.C.

The specter of Shiloh continued to haunt Wallace. When Grant was writing his *Memoirs*, Wallace begged him to "set things right." Grant refused, and Wallace's war reputation was forever damaged. Wallace is best remembered for writing the novel *Ben-Hur: A Tale of the Christ*. It was America's best-selling novel until Margaret Mitchell's *Gone with the Wind* was published in 1936.

Ulysses S. Grant stopped at Crump's Landing to confer with Lew Wallace before heading toward the fighting at Shiloh.

HENRY STANLEY AND THE 6TH ARKANSAS INFANTRY

When the soldiers of the 6th Arkansas Infantry emerged from the trees west of Duncan Field, it was the beginning of only their second experience in battle. For Henry Stanley, a twenty-one-year-old immigrant from Wales, the battle of Shiloh was just one chapter in a life full of hair-raising experiences.

Stanley was born John Rowlands in Wales. He took his name from a New Orleans cotton merchant, Henry Stanley, who employed the young Rowlands. Rowlands had immigrated to the United States in 1859 and eventually settled in Little Rock, Arkansas. At the start of the Civil War, he enlisted as Henry Stanley in Company E of the 6th Arkansas Infantry.

At Shiloh, the 6th Arkansas formed the center of the first wave of Confederate soldiers. While in line, a seventeen-year-old soldier standing next to Stanley began to pick violets and placed them in the band of his hat. The youth thought the "Yanks" wouldn't shoot him if they saw him wearing the flowers. Thinking it a plan worth trying, Stanley placed some of the flowers on his hat as well.

The Confederate soldiers advanced on an old road that had been worn down through the years. The Union army had rallied at the Sunken Road after they had been chased from their camps. If the soldiers lay down, the Sunken Road offered some protection from the deadly aim of the Southern soldiers. This section of the road was renamed the Hornet's Nest because the shot and shell coming from the road reminded the Southern soldiers of a nest of mad hornets.

The Confederate army made repeated charges into the Hornet's Nest and the Review Field. On one such charge, the 6th Arkansas charged the cannons of Major John Wesley Powell, a future explorer who would one day navigate the Grand Canyon. During the charge, Stanley was hit in the stomach. Looking for a wound, Stanley only found a bullet-size dent in his belt buckle.

Stanley described the charge on the Union lines as the "world bursting into fragments." He explained further, "I likened the cannon, with their deep bass, to the roaring of a great herd of lions; the ripping, cracking musketry, to the incessant yapping of terriers; the windy whisk of shells, and zipping of minié bullets, to the swoop of eagles, and the buzz of angry wasps. All the opposing armies of Gray and Blue fiercely blazed at each other."

After a thunderous artillery barrage, the 6th Arkansas assaulted the Union lines once more. The late afternoon attack finally had the desired effect, as a large body of Union soldiers surrendered, while the rest withdrew closer to the Tennessee River.

An exhausted Stanley and his fellow 6th Arkansas soldiers slept in tents formerly used by Union soldiers and ate food they had left scattered during the Confederate surprise attack.

During the night, the defeated Union army's spirits were raised by the arrival of Don Carlos Buell's Army of the Ohio. The Union counterattack the next day overwhelmed the Confederate army, which began a slow retreat toward Corinth, Mississippi. During the day's fighting, Stanley was taken prisoner by Union soldiers. Stanley was sent to Camp Douglas in Chicago, where he obtained his freedom by enlisting in the Union army.

After the Civil War, Stanley became a journalist, working for the *New York Herald*. He ultimately made many trips to Africa, where he found the long-missing Dr. David Livingstone. It was Stanley who uttered the famous words, "Dr. Livingstone, I presume?"

Upon the death of Livingstone in 1873, Stanley quit journalism and became a famed explorer of the Congo River in Africa. His books chronicling his exploration of Africa became best sellers. Stanley, the child of a chambermaid mother and an unknown father, was an international hero.

Stanley continued to write and speak on various issues, ranging from white male superiority to Irish self-determination. He earned several honorary degrees, as well as a knighthood, and was elected as a member of Parliament.

A Confederate soldier on the Arkansas state monument stares toward the Hornet's Nest at Shiloh.

RHEA SPRING

At Shiloh, the majority of soldiers of both the North and South were experiencing battle for the first time. "Seeing the elephant" brought forth great acts of courage as well as desperate headlong retreats away from the fighting.

Colonel Jesse Appler's 53rd Ohio Volunteers was the only regiment camped south of Rhea Springs on the eastern fork of Shiloh Branch. Most of the soldiers were gathered near Brigadier General William T. Sherman's headquarters near the Shiloh Meeting House. The exposed position worried Appler.

Having no formal military training or experience, Appler often faced the scorn of the temperamental Sherman. Appler's men arrived at Shiloh without being drilled, a detail that was sure to draw Sherman's ire. To compound matters, Appler was easily frightened. He had sounded so many false alarms that his regiment was given the moniker "the Long Roll Regiment," the "long roll" referring to the extended drum cadence calling the men to battle.

On April 5, 1862, Appler seemed especially rattled. He was convinced the Confederate army was nearby. Upon seeing mounted men on the southern edge of Rhea Field, Appler ordered the long roll and sent the quartermaster to alert Sherman.

Before the soldiers got into formation, the quartermaster returned, stating in a booming voice that General Sherman said, "Take your damn regiment back to Ohio. There is no enemy nearer than Corinth." The formation of Union soldiers erupted into laughter and broke ranks before waiting for orders. Although Appler had been embarrassed by his commanding officer, his fears became a reality the following day.

On April 6, 1862, Appler still felt fearful. If anything, his fears were even worse. During the night, Appler had heard firing along the Federal picket line. Early that morning, a scouting detail reported the sound of heavy fighting to the south. Remembering his treatment by Sherman the previous day, Appler was uncertain what he should do. His mind was made up by a bleeding soldier of the 25th Missouri Infantry. The soldier cried out to Appler, "Get your soldiers in line, the Rebels are coming."

Once again Appler ordered the drummer to beat the long roll and sent word to Sherman. The messenger returned with Sherman's reply, stating, "You must be badly scared over there."

At that moment, the gray-clad soldiers of Brigadier General S. A. M. Woods's brigade appeared on the southern edge of Rhea Field. The moment that Appler had been dreading was now at hand. Appler tried to shift his line to the south to confront the oncoming Confederates. No sooner had he done so than a long line of Rebel soldiers was spotted to the west. Appler gasped, "This is no place for us. Battalion, about face; right wheel." Appler's troops withdrew to a line on the other side of the Union camps.

The scene was utter pandemonium, as Union soldiers just waking up scattered to evade the oncoming Confederate assault. Sherman arrived on the scene to see why Appler was so upset. Sherman, however, thought the soldiers were a prelude to a skirmish and nothing more.

While Sherman looked across the field with his field glasses, a soldier cried, "General, look to your right." Sherman lowered his field glasses and looked in the direction of Shiloh Branch just in time to see a line of Confederate soldiers emerge from cover less than seventy-five yards away and lower their rifles for a volley. "My God, we are attacked!" cried Sherman.

The Confederate volley hit Sherman's raised right hand and slammed into the head of his orderly, Private Thomas D. Holliday, who fell from his horse, dead. The general wheeled his horse and was off at a gallop for his headquarters, shouting to Appler as he passed, "Hold your position. I will support you."

Appler's 53rd Ohio resisted three assaults by the 6th Mississippi infantry under the command of Brigadier General Patrick Cleburne. The 6th Mississippi lost 300 of 425 men in the fight.

As Cleburne's men regrouped for another assault, Appler broke, shouting to his men, "Retreat and save yourselves." His regiment raced to the rear in disorder.

Confederate and Union soldiers clashed at Rhea Springs on the morning of April 6, 1862.

COLONEL EVERETT PEABODY

Concern was etched across the face of Union colonel Everett Peabody. He had dispatched Major James Powell and 250 men to patrol the woods southwest of the Shiloh Church. The predawn hour was suddenly interrupted by the sharp crack of musket fire. The attack that Peabody feared and predicted was under way.

Standing over six feet tall, Peabody presented a forceful appearance. That appearance was backed by a strong disposition and quick temper. Peabody grew up in Springfield, Massachusetts, and graduated from Harvard in 1849. He used his engineering skills to help build railroads in Kansas and Missouri.

Peabody made St. Joseph, Missouri, his adopted home while he worked on the Platte County Railroad. At the start of the Civil War, Peabody volunteered as a major of the 13th Missouri Infantry, becoming a colonel by the time the regiment was formally mustered.

During the siege of Lexington, Missouri, in 1861, Peabody was wounded twice in battle. The first shot struck him in the chest. His men tried to carry him from the field, but he was hit in the ankle and was captured. Hobbled and unable to walk without the use of crutches, Peabody was paroled by Major General Sterling Price's army.

Upon his return to the Union army, Peabody became colonel of the 25th Missouri Infantry and was placed under the command of Benjamin Prentiss.

By April 1862, Peabody and the 25th Missouri had camped at Pittsburg Landing, Tennessee, located on the banks of the Tennessee River. Peabody and his men made camp near a crude one-room log structure known as Shiloh Church.

The atmosphere at Pittsburg Landing was relaxed and confident. The relatively easy victories at Fort Henry and Fort Donelson convinced the Union soldiers that the Confederate army was whipped and incapable of offensive activity.

In fact, the Confederate army of General Albert Sidney Johnston lay less than a mile from the Union soldiers. They had marched from Corinth, Mississippi, and were poised to launch a surprise attack on Pittsburg Landing.

Union soldiers had passed the word that there was some sort of activity on their front. The Union leadership scoffed at the mention of such activity. When Peabody expressed his concerns to Prentiss, the Union general "hooted" at the thought of a Confederate attack. Undeterred, Peabody sent out a patrol at 3 A.M. on April 6, 1862, to scour the woods for the Confederate army.

As the sound of gunfire rattled from the woods, Peabody, on his own responsibility, called for the drummer to sound the long roll calling the Union army to arms. As the soldiers began to form their lines, an angry Prentiss confronted Peabody, wanting to know if he had provoked an attack by sending out troops without orders.

Peabody informed Prentiss he had sent out a reconnaissance patrol, which further infuriated the general. Prentiss shouted for all to hear, "Colonel Peabody, I will hold you personally responsible for bringing on this engagement."

The hastily formed Union line held against the initial Confederate attack, but the relentless assault finally had the desired effect, sending the Southerners racing through the Union camps.

Peabody directed his soldiers from his horse, already bleeding from several wounds. Suddenly, a minié ball struck him in the mouth, passing out the back of his head and killing him instantly.

Peabody's decision to send out soldiers saved the Union army from a complete surprise attack and total annihilation. His death, combined with Prentiss's slight of the colonel in the official report, caused Peabody to fade in obscurity. For common soldiers who were on the front line that day, Peabody's role was hard to forget. "Probably no man of our armies in our entire history has rendered his country at one time more valuable service, and yet outside the few survivors of his regiment, his name is hardly known and is unhonored and unsung," said Missouri private Charles Morton.

A pyramid of cannon balls marks the spot where Everett Peabody was mortally wounded while trying to rally his men against the Confederate army.

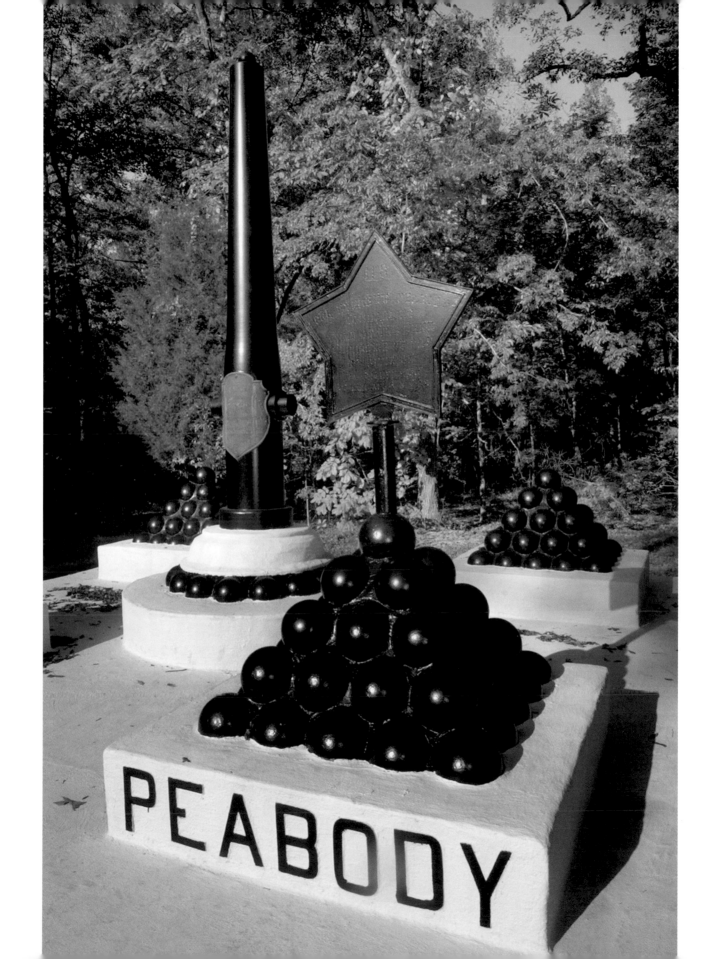

PATRICK CLEBURNE AND 2ND TENNESSEE INFANTRY

Through the smoke of battle, soldiers of the Union army saw a distinctive flag. The blue banner with a full moon in the center was designed by Major General William Hardee and first used at Shiloh. The Hardee flag was made famous by his most capable officer, Brigadier General Patrick Ronayne Cleburne.

The Irish immigrant made Helena, Arkansas, his adopted home. He embraced the culture of the South and joined the Confederacy. Cleburne enlisted as a private, and only a year later was made a brigadier general. At Shiloh, Cleburne led the 15th Arkansas, 6th Mississippi, and 2nd, 5th, 23rd, and 24th Tennessee infantries. Cleburne's brigade was the extreme left flank of the initial Confederate line.

The battle of Shiloh was Cleburne's first combat experience in the Civil War, and he was encountering problems at Shiloh. Cleburne and his men had trouble navigating an area of Shiloh Branch. Known as the "morass," it was an area of deep mud and tangled vines. While clogging through the morass, Cleburne was thrown from his horse, the mud cushioning his fall. Ever the hands-on commander, Cleburne remounted his horse, riding up and down the front of the 6th Mississippi and 23rd Tennessee.

While navigating the morass, Cleburne's troops became separated. The 6th Mississippi and 23rd Tennessee fought against the 53rd Ohio Infantry at Rhea Field. The remaining regiments, the 15th Arkansas and 2nd, 5th, and 24th Tennessee, moved farther to the northeast and encountered Major General William T. Sherman's division near the Shiloh Meeting House.

Leading the 2nd Tennessee was Colonel William Bate of Bledsoe's Lick, Tennessee. Bate, like Cleburne, enlisted in the army a year earlier as a private. Thanks to their dedication and leadership, both men had risen through the ranks.

The 2nd Tennessee encountered stiff resistance from Colonel Ralph Buckland's brigade, which had formed on a ridge just south of the Shiloh Meeting House. Bate, always the aggressive leader, sought to move Buckland's men from the ridge and initiated a Confederate advance. For two hours, the 70th Ohio Infantry held off the assaults of Bate and his 2nd Tennessee. With the ranks thinning with each advance, Bate rose for a third charge on Buckland's line. A minié ball slammed into Bate, breaking his leg. The attack stalled, and the 2nd Tennessee was caught in a deadly cross fire from the Union army.

To alleviate the effects of the cross fire, Cleburne called for yet another advance. Along with parts of Patton Anderson's brigade, Cleburne led another charge against the Union lines. Events at Rhea Field caused a domino effect to hit the Union line, allowing the Confederate soldiers to take the ridge near the Shiloh Church.

After Colonel Jesse Hildebrand's brigade collapsed, the Southern soldiers seized the Shiloh Church and Sherman's headquarters. Hildebrand's fall negated any hope Buckland had for holding the ridge. Instead of getting flanked by the Rebels, Buckland's troops withdrew to the Hamburg-Purdy Road.

The Union soldiers were not happy to see the gray-clad Rebels enter their camp. "The Rebels raised their cornbread yelp, and making a desperate charge, captured our camp; taking full possession of our tents, our blankets, knapsacks and all of our love letters," said Private Thomas W. Connelly of the 70th Ohio.

Both Cleburne and Bate survived Shiloh to fight yet again. Cleburne improved as a general and was referred to as the "Stonewall of the West." His military career stagnated after he suggested to President Jefferson Davis that slaves should be given their freedom if they pledged to fight for the Confederacy. After that suggestion, Cleburne never rose above the rank of major general. Cleburne was killed in an ill-advised charge at the battle of Franklin, Tennessee.

Bate survived the war, even though he was wounded three times and had six horses shot from under him. He served two terms as governor of Tennessee. He was serving in the U.S. Senate when he died in 1905.

The 2nd Tennessee entered Shiloh with 385 effectives, and lost 235 men killed, wounded, or missing, accounting for 65 percent of the regiment.

A lone soldier marks the position of Colonel William Bate's Tennesseans. The monument is located just south of the Shiloh Church.

JOHN McARTHUR

In the Civil War, Scotsmen served for both the North and South. Many of these men rose in the ranks to lead on great fields of battle. Brigadier General John McArthur, fearless on the battlefield at Shiloh, garnered the respect of his fellow Scots in the Chicago Highland Guards.

McArthur was born in Erskine, Scotland, on November 17, 1826. To family members, McArthur was a born soldier. The lad listened intently to stories about his Scottish clans and ancestors. It was said he never knew the meaning of the word "fear." After finishing his schooling, McArthur was offered a scholarship to the University of Edinburgh on the condition he study for the ministry. McArthur refused, opting to become an apprentice at his father's blacksmith shop.

Standing six feet tall with broad, strong shoulders, McArthur carried an intimidating air. He became enamored with America after reading accounts of the Mexican War. With his wife, Christina Cuthbertson, the two immigrated to the United States in 1849.

They settled in Chicago, where McArthur became a mechanic, learning how to construct engines and boilers. In 1856, he joined the Chicago Highland Guards and became its first commander. Under McArthur's leadership, the Guards became one of the better disciplined units of that time. Comprised of transplanted Scotsmen, the Guards borrowed from their native land, as they wore tall, bearskin caps and the kilt of the McArthur clan. The company was the pride of Chicago.

One of the first companies to answer President Abraham Lincoln's call to arms after Southern forces fired on Fort Sumter, the Guards became part of the 12th Illinois Regiment, of which McArthur served as colonel.

In February 1862, McArthur commanded a brigade during the fighting at Fort Donelson. For his gallant service, McArthur was promoted to the rank of brigadier general.

During the first day of fighting at Shiloh, McArthur led the second brigade made up of the 9th and 12th Illinois, the 81st Ohio, and the 13th and 14th Missouri infantries. When Brigadier General W. H. L. Wallace was mortally wounded, Colonel James Tuttle led the 2nd Division on the second day at Shiloh. Afterward, McArthur was selected to command the 2nd Division of Major General Ulysses S. Grant's Army of the Tennessee.

While defending the Union line at Shiloh, McArthur was wounded in the foot. His injury was so severe that he had to be carried from the field. The wound became inflamed, and for a while doctors feared McArthur might lose his leg.

McArthur's leadership had earned him the respect of his superior officers, but his exploits on the battlefield turned him into a celebrity in Chicago. People could not get enough news of McArthur and the Highland Guards.

After recovering from his wound, McArthur rejoined the Union army, now under the command of Major General William S. Rosecrans, at Corinth, Mississippi. During the battle of Corinth, McArthur was given command of the 6th Division. Making sound decisions throughout the two days of fighting, McArthur was instrumental in repulsing the Confederate army of Major General Earl Van Dorn. He later served in Grant's Vicksburg campaign.

On December 15, 1864, McArthur was brevetted major general of volunteers. He was mustered out of service on August 24, 1865, and returned to Chicago. During his four years of service in the Civil War, it was said that McArthur "never disappointed his superiors in command or took his men off the field of battle in confusion."

After the war, McArthur was president of the Illinois Saint Andrew Society from 1869 to 1871. He was president when the Great Fire in Chicago occurred.

McArthur died on March 16, 1906, and his funeral was a day of bereavement for the city of Chicago. He was buried in the Rosehill Cemetery in Chicago.

John McArthur made Chicago his home after emigrating from Scotland. At Shiloh, he led the 9th and 12th Illinois, 81st Ohio, and 13th and 14th Missouri regiments.

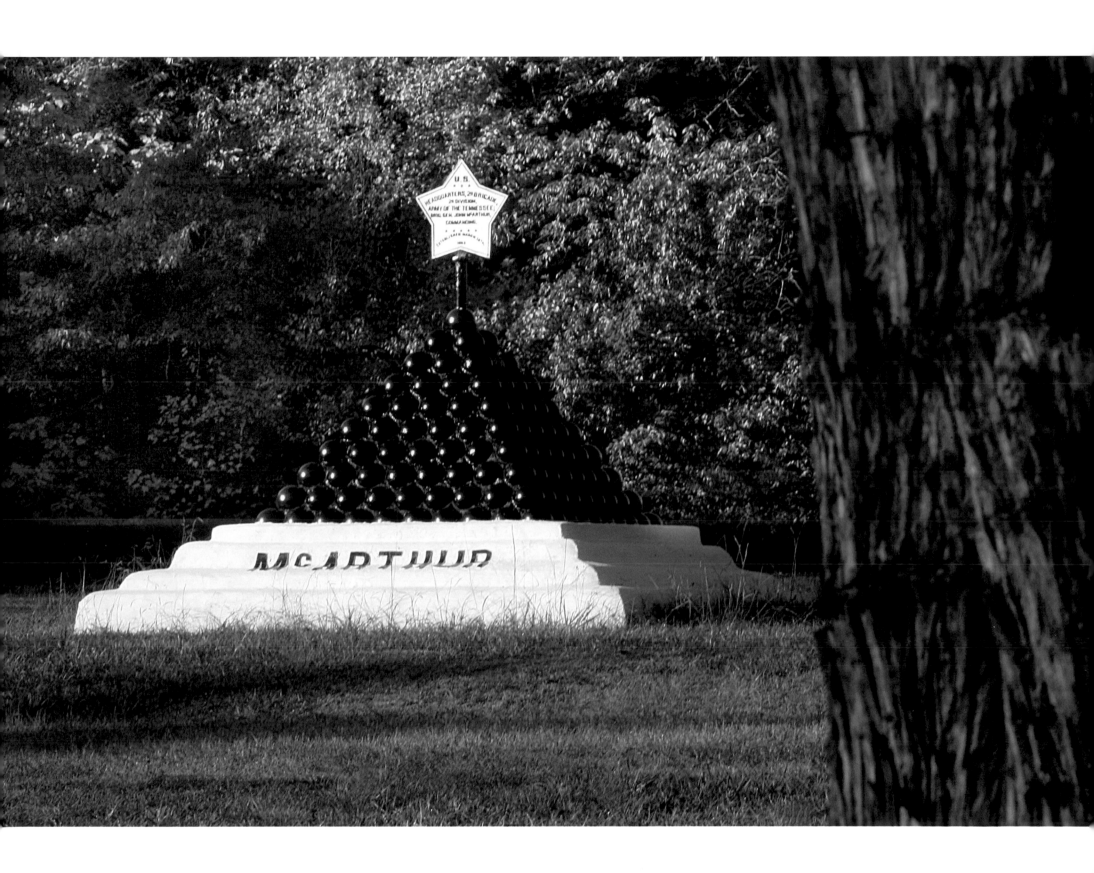

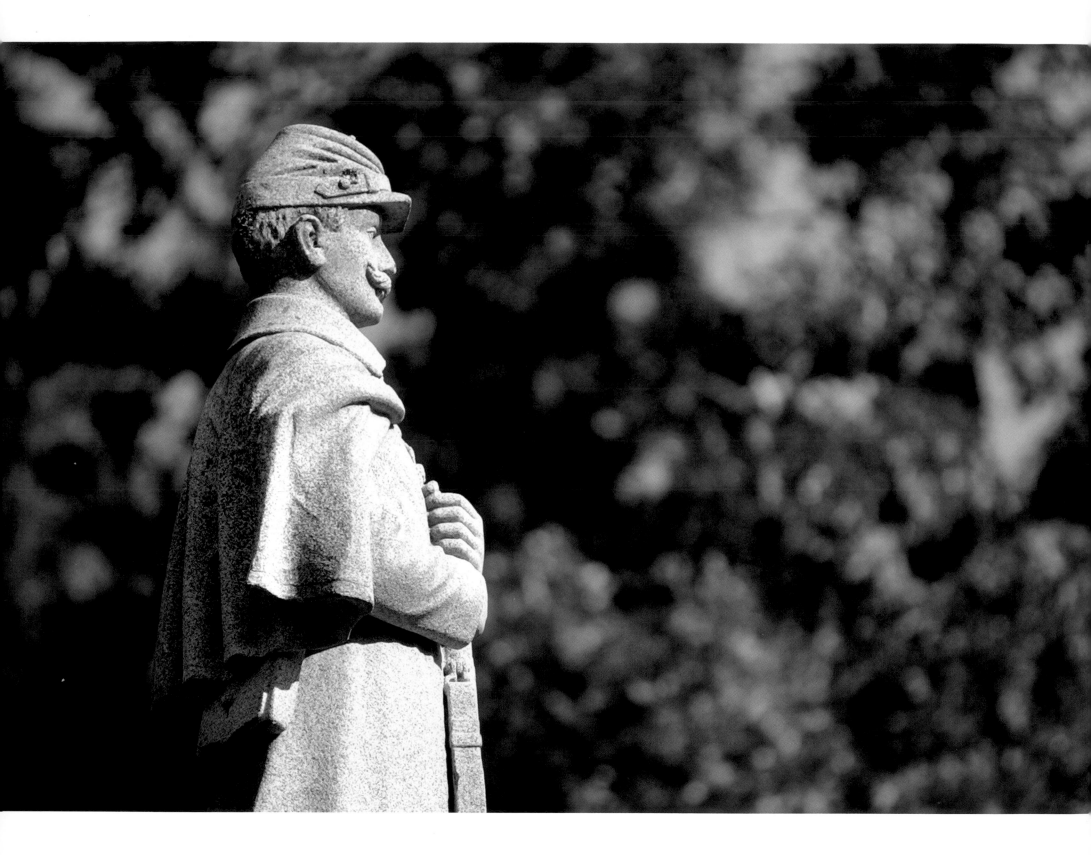

15TH MICHIGAN INFANTRY

Newly arrived from their hometown of Moore, Michigan, the 15th Michigan Infantry was thrown into combat without a moment's notice. Yet the Michigan Wolverines performed gallantly on the fields of Shiloh.

With 869 names on its roll, the 15th Michigan Infantry marched from its rendezvous on March 20, 1862. The newly formed regiment, under the command of Colonel John M. Oliver, was destined to serve in Major General Ulysses S. Grant's Army of the Tennessee.

Presently, Grant was stationed at Savannah, Tennessee, and used the Tennessee River as a thoroughfare leading deeper into the Southern Confederacy. Grant and many of his generals deemed the Confederate army of General Albert Sidney Johnston whipped. Grant thought that one more Union victory could possibly doom the Confederacy and end the war.

The 15th arrived at Pittsburg Landing, Tennessee, on April 5, 1862, and was assigned a position beside the 18th Wisconsin in Brigadier General Benjamin Prentiss's division. The 15th bivouacked near the landing for the night but planned to join Prentiss the following morning. Prentiss's division was camped the farthest inland.

This division was rudely awakened the morning of April 6 by a surprise attack by Johnston's Army of the Mississippi. Thousands of screaming Confederates slammed the Union pickets, sending them running away from the fight. The gray-clad wave continued until it began to envelop the exposed camps of the Union soldiers.

Soldiers of the 15th Michigan heard scattered gunfire during the morning hours. Some soldiers inquired about the shooting, only to be told that the pickets must be "shooting squirrels."

Not far from the bivouac, soldiers of the 15th came upon a wounded man being helped to the rear. When asked about the pickets "shooting squirrels," the soldier displayed a bloody hand, stating they were the "funniest squirrels" he had ever seen.

The men from Michigan quickly realized a fight was on their hands. They advanced in the direction of Prentiss's camp. The 15th

was told to fall in next to the 18th Wisconsin, forming the extreme left flank of Colonel Madison Miller's brigade.

As the 15th prepared for battle, they could see a line of soldiers forming on the opposite ridge. As the Confederate soldiers approached the 15th, they leveled their guns, firing into the ranks of the Michigan soldiers.

Soldiers from the 15th began to fall in their ranks, but surprisingly, no return shots were fired. The 15th had marched to battle without any ammunition and were unable to return fire. "We stood at order arms and looked at them as they shot," said a private of the 15th Michigan. The soldiers were told to about face and marched to the rear, where they stayed out of the fighting until later that day.

On April 7, the 15th Michigan served temporarily with Brigadier General Alexander McCook's division and advanced against the Confederate lines. With ammunition handy, the 15th fought gallantly as the Army of the Mississippi was forced to retreat from Shiloh.

The 15th Michigan received special mention in McCook's official report. Citing their bravery, McCook wrote, "I take great pleasure in calling your attention to the conduct of Colonel Oliver and a portion of his regiment, the 15th Michigan. When my division was marching on the field, Colonel Oliver, at that time unknown to me, requested the privilege to place himself under my command. His regiment was attached to General Rousseau's brigade, and during the day was under the hottest fire, when he and his officers and men acted with conspicuous gallantry."

The Michigan state monument commemorates the service of the 12th and 15th Michigan infantries and Ross's Battery B, Michigan Light Artillery. The soldier on the monument faces south toward the ultimate goal, Corinth, Mississippi.

The 15th Michigan Infantry was so new to Shiloh that they marched into the battle without ammunition for their guns. The Michigan state monument faces south toward its goal of Corinth.

ADLEY GLADDEN

After achieving tactical surprise, the Confederate Army of the Mississippi looked to sweep the Union soldiers from the field at Shiloh. Brigadier General Adley Gladden, who commanded the 21st, 22nd, 25th, and 26th Alabama and the 1st Louisiana infantries, encountered a spirited defense from Colonel Madison Miller's Union soldiers. When the day was over, one army would stubbornly cling to a last line of defense, while another would lose the services of a veteran leader.

Gladden was born on October 28, 1810, in the Fairfield District, South Carolina. Before the Civil War, he was a cotton broker and served in the Seminole War. After the Seminole War, Gladden became postmaster of Columbia, South Carolina. During the Mexican War, Gladden was a major in the famed Palmetto Regiment. He assumed command of the regiment during the assault at Churubusco after the regiment's colonel and lieutenant colonel were killed. Gladden became colonel of the regiment and was wounded during the fighting at the Belen Gate in Mexico City. After the Mexican War, Gladden made his home in New Orleans.

At the start of the Civil War, Gladden offered his services to the newly formed Confederate government. He served as colonel of the 1st Louisiana Regiment at Pensacola, Florida, and was present during the siege of Fort Pickens. While in Pensacola, Gladden caught the eye of Braxton Bragg.

Bragg created a brigade under Gladden's command to serve as a model of discipline in the Confederate army. Although the Confederate government did not accept Bragg's plan, Gladden was promoted to brigadier general and was transferred to Corinth, Mississippi. On April 6, 1862, Gladden led his men in the first wave of the Confederate assault at Shiloh.

Gladden's men quickly ruined breakfast for Miller. He planned to inspect his newly arrived troops after his meal. Brigadier General Benjamin Prentiss rode into camp, shouting for Miller to ready his men for a Confederate attack. Prentiss placed Miller's three regiments on the southern edge of Spain Field.

Gladden's brigade protected the right flank of Major General William Hardee's Confederate attack. As they advanced along Lick Creek, Gladden's men encountered difficulty with the terrain, which ruined their alignment with the attack.

Miller's men stung the Rebels with a vicious salvo that caused the gray-clad soldiers to fall back and regroup. The two armies continued their fight with long-range firing for the next hour. Unexpectedly, Prentiss ordered Miller to fall back. Seeing the Union army give ground, Gladden ordered a charge.

While his soldiers formed for their assault, Gladden rode forward to get a better view of the Union line. A haze of smoke covered the field, but Gladden was an inviting target sitting on his horse. The Federal cannons belched forth a deadly dose of shot and shell. At one moment, Gladden's men saw him astride his horse, and the next he was on the ground, severely wounded.

The projectiles had nearly severed Gladden's left arm. Staff officers tried in vain to save their fallen leader. Gladden's arm was amputated on the battlefield. Weakened by the loss of blood, Gladden was taken from the field and returned to General P. G. T. Beauregard's headquarters in Corinth. Gladden died six days later. In his report, Beauregard lamented Gladden's loss, writing, "We early lost the services of the gallant Gladden, a man of soldierly aptitudes and experience."

Command of Gladden's brigade fell to Colonel Daniel Adams, who continued to press Miller's lines. Continued small arms fire and canister compelled the Confederate soldiers to fall back to the southern edge of Spain Field. Adams brought up a battery to pound the Union lines. With the battery having the desired effects, Adams ordered another charge.

This advance forced Miller to retreat, leaving his battery unprotected. Only two guns were lost thanks to the efforts of the Union gunners to save their battery. A combined attack by Davis's and Brigadier General James Chalmers's men sent Miller's soldiers running toward Pittsburg Landing.

Adley Gladden was buried in Magnolia Cemetery in Mobile, Alabama.

Adley Gladden was mortally wounded during the Confederate advance on Spain Field. His arm was amputated on the field, but Gladden later died.

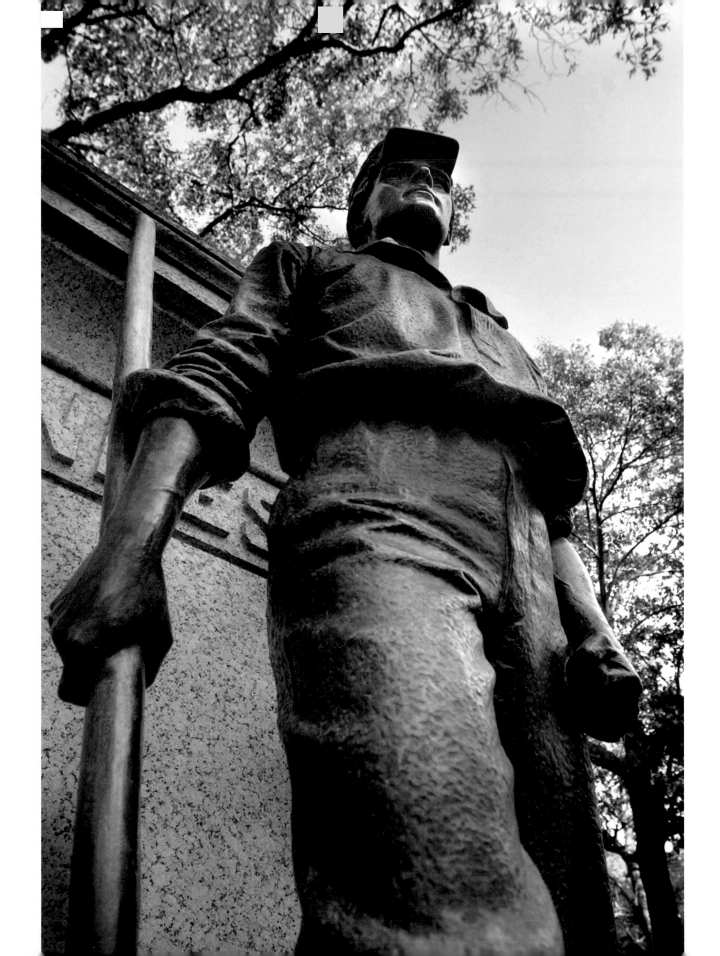

1ST MINNESOTA LIGHT ARTILLERY

The Civil War was basically an infantry conflict. Using the Napoleonic standard of massing fire into one's enemy, armies stacked their men in formation, pouring a devastating fire into the ranks. The same doctrine held that the way to decide a battle was to assault the enemy with bayonets and press them until they broke and ran. The use of artillery proved to be the deciding factor in many of the battles.

The 1st Minnesota Light Artillery, under the command of Captain Emil Munch, helped sustain the Union line during six hours of fighting at the Hornet's Nest. Their repeated fire of canister and double canister helped repulse wave after wave of Confederate charges.

The 1st Minnesota was organized in October 1861 and trained at St. Louis. From there, the 1st Minnesota was ordered to report to Major General Ulysses S. Grant at Pittsburg Landing, Tennessee.

Munch was born in Halberstadt, Prussia, on December 12, 1832. He immigrated to the United States in 1849, settling in Taylor's Falls, Minnesota. By 1857, Munch was living in Pine City, Minnesota, where he served in the Minnesota House of Representatives in 1860 and 1861.

With the advent of the Civil War, Munch was one of many Prussians who offered their service to the armies of the North and South. Carl Schurz and Franz Sigel served the Northern cause during the Civil War. Schurz fought at the battle of Gettysburg in 1863.

Perhaps the best-known Confederate Prussian was Major Heroes Von Brocke, who served as an aide to Major General J. E. B. Stuart. Von Brocke was a beloved figure in Stuart's cavalry and throughout the South. After the Civil War, he returned to his native land and inherited a castle estate in Germany. Always the Confederate, Von Brocke flew the Confederate flag over the castle battlements.

During the fighting at Shiloh, Munch and the 1st Minnesota began their day at Spain Field. When the Confederate army burst onto Spain Field, the 1st Minnesota anchored the right flank of Colonel Madison Miller's brigade. Munch rushed to set up opposite Captain Andrew Hickenlooper's 5th Ohio Battery. Hickenlooper lost two guns to the onrushing Rebels before Munch and his men could set up an effective fire.

Munch's guns were a desired trophy for the charging Rebels. Munch called for the 1st Minnesota to retreat as the Rebels closed in. Munch's horse was shot out from under him. As he struggled to regain his feet, Munch was shot in the thigh. He was able to save all six of his guns, although two were disabled.

The Union line reformed on a dirt road near Duncan Field, and the 1st Minnesota Light Artillery fought for six hours, repulsing charge after charge.

One of the best tools for such close-up fighting was to fire canister and double canister. This type of ordnance had the same effect as a shotgun shell. When fired, the guns sprayed hundreds of pieces of metal shrapnel. This method of fire was sure to rip large holes in an advancing army's lines.

To counter the artillery's effectiveness, Southern sharpshooters began to systematically pick off members of the gun crews as they performed the tasks of loading and firing the cannons.

As a result of wounds received at the battle of Shiloh and subsequent exposure while on march, Munch resigned his commission in December 1862. He served in Minnesota during the Dakota Conflict. In August 1863, he accepted an appointment to the Veteran Reserve Corps (also known as the Invalid Corps) and remained with that unit until the war's end.

The 1st Minnesota Light Artillery continued to serve in the Union army. Its soldiers participated in Major General William T. Sherman's Atlanta campaign and March to the Sea.

Munch returned to St. Paul, Minnesota, and married Bertha Segar. He served as deputy state treasurer and treasurer and later began a lumber business. He died on August 30, 1887.

During the first day at Shiloh, the 1st Minnesota Light Artillery began their fighting in Spain Field before holding their position at the Hornet's Nest.

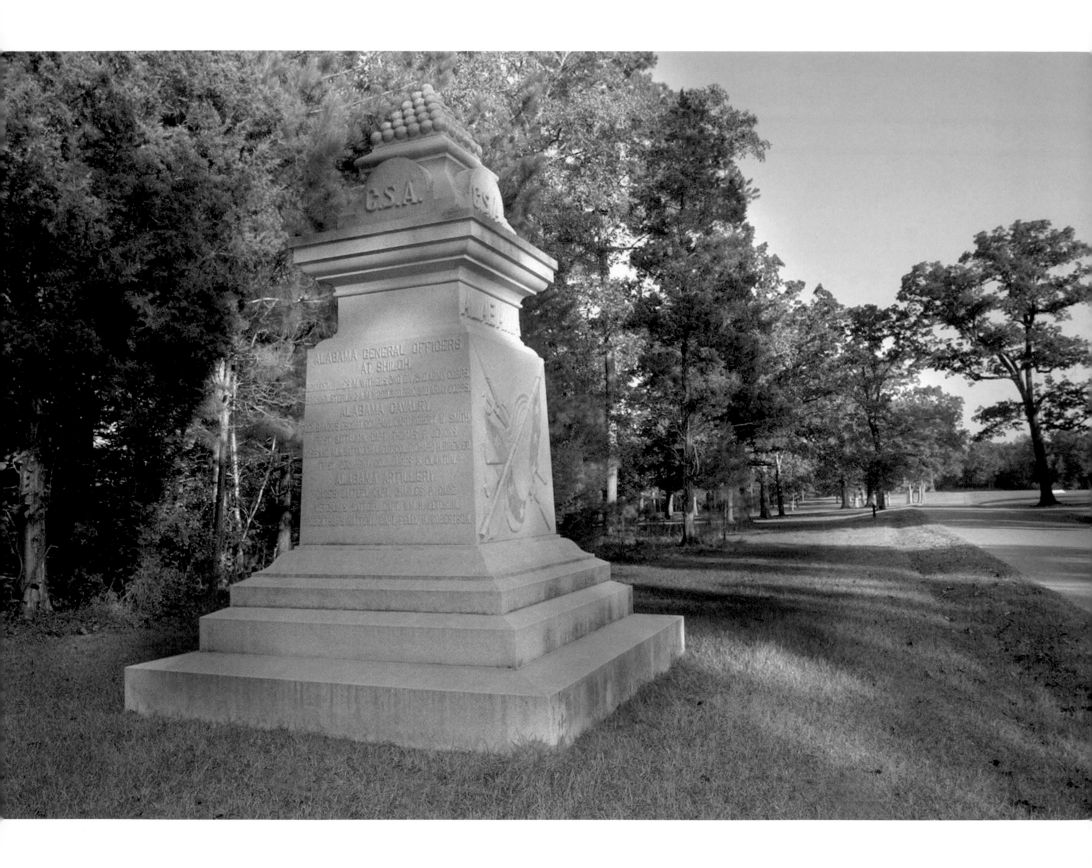

GEORGE DIXON AND THE 21ST ALABAMA INFANTRY

As Lieutenant George Dixon stepped out of the woods lining the southern edge of Spain Field, his men of Company E, 21st Alabama Infantry, could see blue-clad soldiers rushing to fill their lines. With one look, Dixon could tell that the Confederate army had achieved tactical surprise over its foe. Dixon lost many men during charges across Spain Field. A token of love from his sweetheart would ultimately save Dixon's life during the fighting at Shiloh.

Dixon and the men of the 21st Alabama hailed from the Mobile, Alabama, vicinity. They were mustered into the Confederate army on October 13, 1861, and stationed at Fort Gaines near Mobile. The 21st Alabama was ordered to Fort Pillow, Tennessee. By March 1862, the 21st was in Corinth, Mississippi, as part of the Army of the Mississippi.

On April 6, 1862, the 21st Alabama was part of Brigadier General Adley Gladden's brigade, which was the right flank of Major General William Hardee's line. Their initial assault was received by Colonel Madison Miller's brigade. The Union line held against the first assault. For a while, the two sides were content to trade licks through long-range shelling.

Miller was ordered to fall back, which left the cannons of the 5th Ohio Artillery and the 1st Minnesota Light Artillery without support. Seizing on the opportunity, Gladden ordered a charge. During this charge, Gladden was mortally wounded.

The fighting was vicious, as both sides suffered from the intense battle. Dixon was at the head of the 21st Alabama, leading the way. The 21st was hit especially hard, as six color bearers fell in succession. Dixon was shot in the left leg but was saved by a memento that was given to him by his sweetheart, Queenie Bennett of Mobile.

Prior to leaving for Fort Pillow, Bennett gave Dixon a $20 U.S. gold piece for luck. The coin was minted in 1860. Lady Liberty appeared on one side and the Federal shield and eagle symbol on the other. It was said that Dixon always kept the coin in his pants pocket. Bennett's token of love proved lucky, as the minié ball that hit him actually struck the coin. The impact of the ball bent the coin, but it did not go any farther. The coin saved Dixon's leg and probably his life during the first day of fighting at Shiloh. Dixon had the words "my life preserver" inscribed on the misshapen coin.

By the summer of 1862, the 21st Alabama was back at Mobile. During this time, Dixon and members of the 21st Alabama volunteered to be the crew of the experimental vessel the C. S. S. H. L. Hunley. This unique vessel was a submarine for the Confederate navy. The Hunley had replaced the American Diver, which had sunk in Mobile Bay.

The Hunley was shipped to Charleston, South Carolina, arriving in August 1863, with Dixon and a crew following their vessel. At Charleston, Dixon and the crew continued to train in the submarine. The Hunley was powered by an eight-man crew. It could submerge or surface using ballast tanks that could be flooded or pumped dry.

On February 17, 1864, the Hunley attacked the USS Housatonic in the entrance of Charleston Harbor. The Hunley rammed the vessel, and its torpedo embedded in the ship's wooden hull. An electric charge detonated the explosives, and the Housatonic sank in five minutes. The Hunley also sank. It became a tomb for Dixon and his entire crew.

On August 8, 2000, the Hunley was raised, with the sub breaking the surface of the water for the first time in 136 years. Identifying the men of the Hunley was difficult except for one man. The story of Dixon and his lucky coin had stood the test of time. When the remains of the crew were searched, one corpse had a misshapen coin in his pants pocket. "The presence of the coin absolutely confirms the identity of Lieutenant George E. Dixon," said Warren Lasch, chairman of the Friends of the Hunley.

George Dixon of the 21st Alabama was spared from injury when a minié ball struck a coin given to him by his sweetheart. The Alabama state monument stands near Cloud Field.

81ST OHIO INFANTRY

For most of the men of the 81st Ohio Infantry, Shiloh proved to be their first true combat. In the two days of fighting, the Ohio Buckeyes conducted themselves with honor, defending the Union right flank.

In 1860, many Ohioans wondered what the election of Abraham Lincoln would mean for the country. For the Northern states, Lincoln seemed to mean a stop to the spread of slavery. In the South, the election was viewed as an act of war, causing states to leave the Union. The country for which Northern and Southern ancestors fought was unraveling with the election of one man.

Morton's Independent Rifle Regiment, under the command of Thomas Morton, included men recruited from the counties surrounding Wyandot County. Company D, under the command of Captain Peter A. Tyler, was made up entirely of Wyandot men.

These Buckeyes, brought together to defeat the insurrection in the South, formed what would become the 81st Ohio Infantry. Morton's men were ordered to Benton Barracks in St. Louis. After receiving their training, the 81st Ohio became part of Major General John C. Frémont's force in the state of Missouri.

Frémont was one of four major generals appointed by Lincoln at the beginning of the Civil War. Lincoln gave Frémont the Department of the West.

Known as the "Pathfinder" due to his exploits in wresting California away from Mexico, Frémont was also known for his staunch antislavery views. In 1856, Frémont had been a presidential candidate. The South had threatened secession if he were elected. Since James Buchanan ultimately won the election, the Civil War was postponed until the election of Abraham Lincoln.

From September 1861 until March 1862, the 81st Ohio was ordered to northern Missouri to protect railroads and citizens from marauding Missouri guerrillas. During this time, Frémont overstepped his bounds by issuing a proclamation that declared martial law in Missouri and freed the slaves. Lincoln, concerned that the abolition of slavery might weaken the war effort, ordered Frémont to alter the proclamation. Frémont refused, and Lincoln rescinded the proclamation and removed Frémont from command.

Afterward, the 81st Ohio was sent back to St. Louis, where they were given new Enfield rifles. These guns would be used in the upcoming campaign in the Tennessee Valley. In March 1862, the 81st was sent on Brigadier General William T. Sherman's Tennessee River expedition, which eventually settled at Savannah, Tennessee. The 81st was aboard the transport *Meteor*, where a party atmosphere prevailed. Governor Richard Yates of Illinois was aboard with a host of women. The 81st arrived at Pittsburg Landing, Tennessee, on March 17, 1862, and was placed in Brigadier General John McArthur's 2nd Brigade.

On April 6, 1862, the 81st Ohio was on the extreme right of the Union lines. Their charge was to guard the Snake Creek Bridge, but they were later told by Major General Ulysses S. Grant to reinforce the Union left. Their marching orders brought them to Cloud Field. Unfortunately, the Federal line had already dissolved, and the 81st unknowingly marched into the face of a Confederate advance. As the men of the 81st emerged on the clear ground, they were greeted by a barrage of artillery fire. They quickly dropped to the prone position and prepared to give battle.

Morton saw a heavy concentration of Confederate forces to his front and cavalry sweeping around his rear. Realizing the futility of the situation, he called for a retreat.

The following day, the 81st Ohio participated in Grant's advance, which forced the Confederates to retreat from Shiloh. During the fighting, the 81st captured a Confederate battery but found they lacked sufficient ammunition to hold the guns. While fighting for the Rebel guns, Corporal Charles Wright noticed a black man, carrying his own rifle and cartridge box, who stepped into the 81st Ohio's line and joined the fighting. The man was probably one of a large number of runaway slaves who sought refuge with the Union army.

After Shiloh, the 81st Ohio served in the fighting for Iuka and Corinth, Mississippi. They remained in the Corinth area until June 1863. In the spring of 1864, the 81st Ohio joined Sherman's campaign to Atlanta, followed by the March to the Sea.

On April 6, 1862, the 81st Ohio infantry began the day on the Union right, but would later face the Confederate onslaught at Cloud Field.

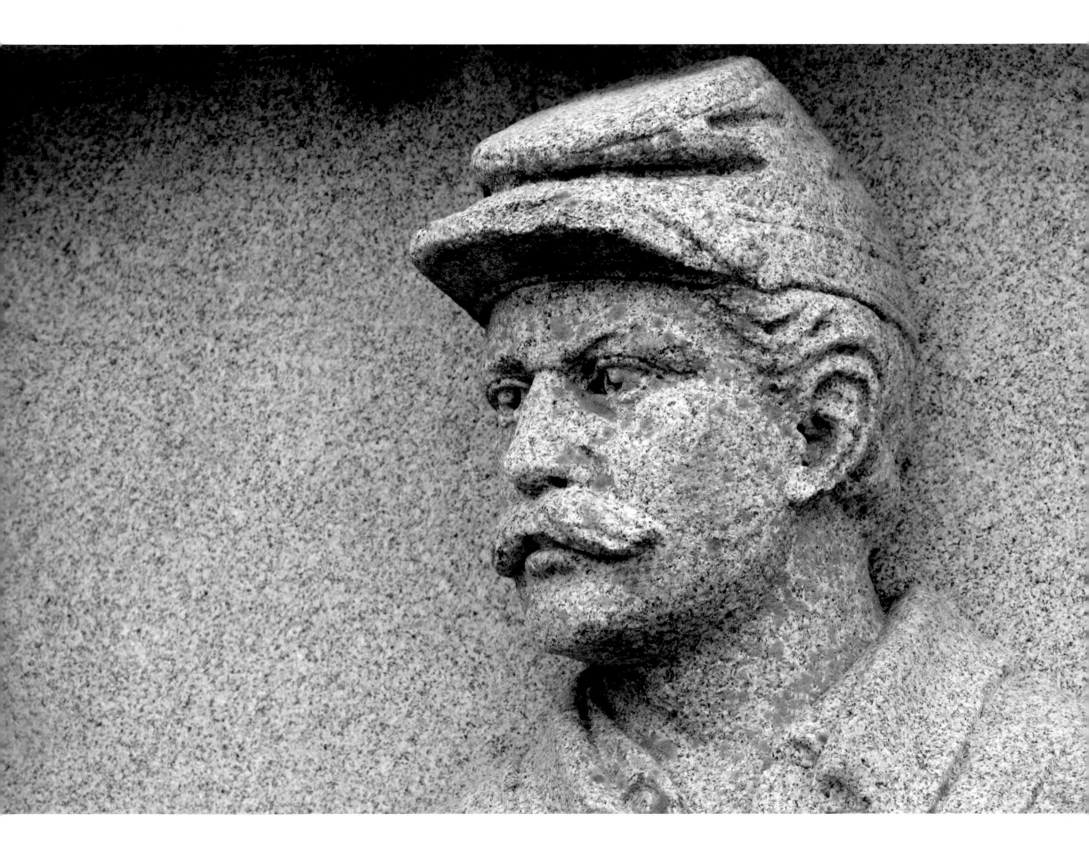

SONS OF TENNESSEE

On April 3, 1862, the Confederate Army of the Mississippi began a march north toward Pittsburg Landing, Tennessee. Although the roads were clogged and the weather was terrible, the sons of Tennessee were glad to be marching north. The Tennesseans had longed to return to their native state after the debacle at Fort Henry and Fort Donelson. With each step, the Tennessee men got closer to their home state. Many Tennesseans would die on the fields of Shiloh.

Major General Benjamin Cheatham commanded the 2nd Division of Major General Leonidas Polk's 1st Army Corps. Born in Nashville, Tennessee, Cheatham had a reputation for boldness and ferocity as a fighter. Prior to the Civil War, he was a farmer who always had a strong interest in military matters. He served as a colonel in the Mexican War.

Cheatham received the rank of major general in the Confederate army in March 1862. Less than a month later, Cheatham led his Tennesseans at Shiloh.

Cheatham was the idol of his Tennessee soldiers. These men appreciated the way Cheatham looked after his soldiers and respected the confidence that he instilled in his men. Cheatham never issued an order that he wasn't willing to lead in person.

At Shiloh, Cheatham's men were moving toward the action. General P. G. T. Beauregard had instructed his aide, Colonel Thomas Jordan, to direct any available men to the sound of the fighting. Beauregard wanted to mass his firepower to drive the Union army to the Tennessee River.

Cheatham sent Bushrod Johnson's brigade to attack Sherman along the Corinth Road. Cheatham remained with the 2nd Brigade under the command of Colonel William H. Stephens. Jordan, upon finding Cheatham, told him to launch an attack across the open field in front of the Sunken Road. Stephens's brigade only had three regiments available and was virtually alone at that moment.

Cheatham ordered his men forward, thinking a body of men arriving from the rear would support Stephens's brigade. Instead, those men stopped and watched the Tennesseans march to battle.

The Sunken Road was about 300 yards in the distance. Cheatham's men marched confidently toward the Union line. At a range of 150 yards, Federal cannons raked Cheatham's lines with a crippling cross fire. Staggered but not down, Cheatham's men kept advancing at a run. At a range of 30 yards, the 12th and 14th Iowa infantries delivered a deadly fire directly into Cheatham's men. Colonel William T. Shaw of the 14th Iowa stated, "The enemy's first line was completely destroyed."

The following day, Cheatham's division fought near Water Oaks Pond. For four hours, Cheatham's men fought valiantly against the fresh soldiers of Brigadier General Alexander McCook. Cheatham deemed the conflict "the most hotly contested I ever witnessed." Polk hailed the conduct of Cheatham and his men, stating, "In the operations of this morning, as well as the day before, those of my troops under the immediate orders of Major General Cheatham bore themselves with conspicuous gallantry. One charge particularly was made under the eye of the commander in chief, and his staff drew forth expressions of the most unqualified applause."

Approximately 14,200 sons of Tennessee were present during the two days of fighting at Shiloh. The overwhelming majority of these men served in the infantry, followed by artillery and one regiment of cavalry. Cheatham carried into battle 3,801 officers and men. He lost 1,213 killed and wounded, nearly one-third of the command.

Tennessee, like the nation, was split by the Civil War. The state provided men for regiments on both sides. Tennessee was second only to Virginia in the number of battles fought in the state. Even after the Civil War, Tennesseans loyal to the Union and Confederacy continued to clash, creating a bloody peace for the Volunteer State.

The Tennessee monument was dedicated at Shiloh on June 3, 2005. The monument depicts three Confederate soldiers. One soldier holding the Stars and Bars kneels over a fallen comrade. A third soldier stands ready to fight. It is the newest monument on the field.

The Tennessee state monument is the most recent memorial placed on the battlefield of Shiloh. It is located near Water Oaks Pond.

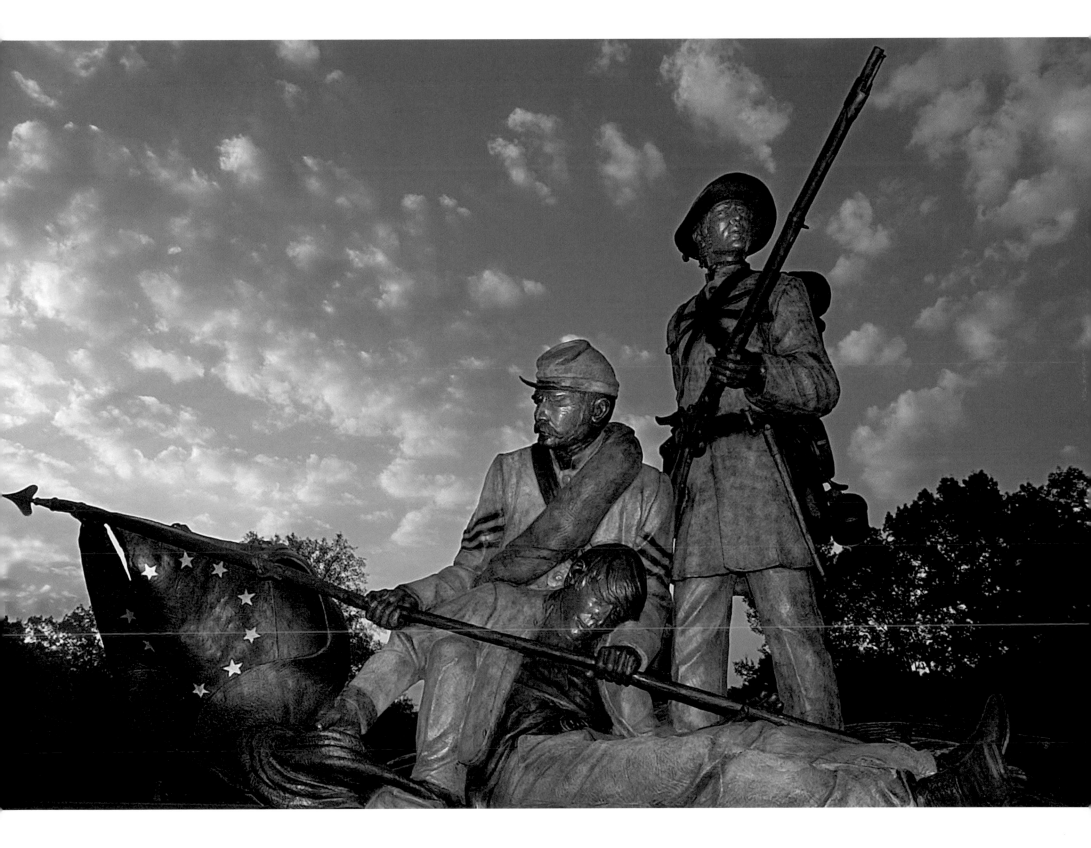

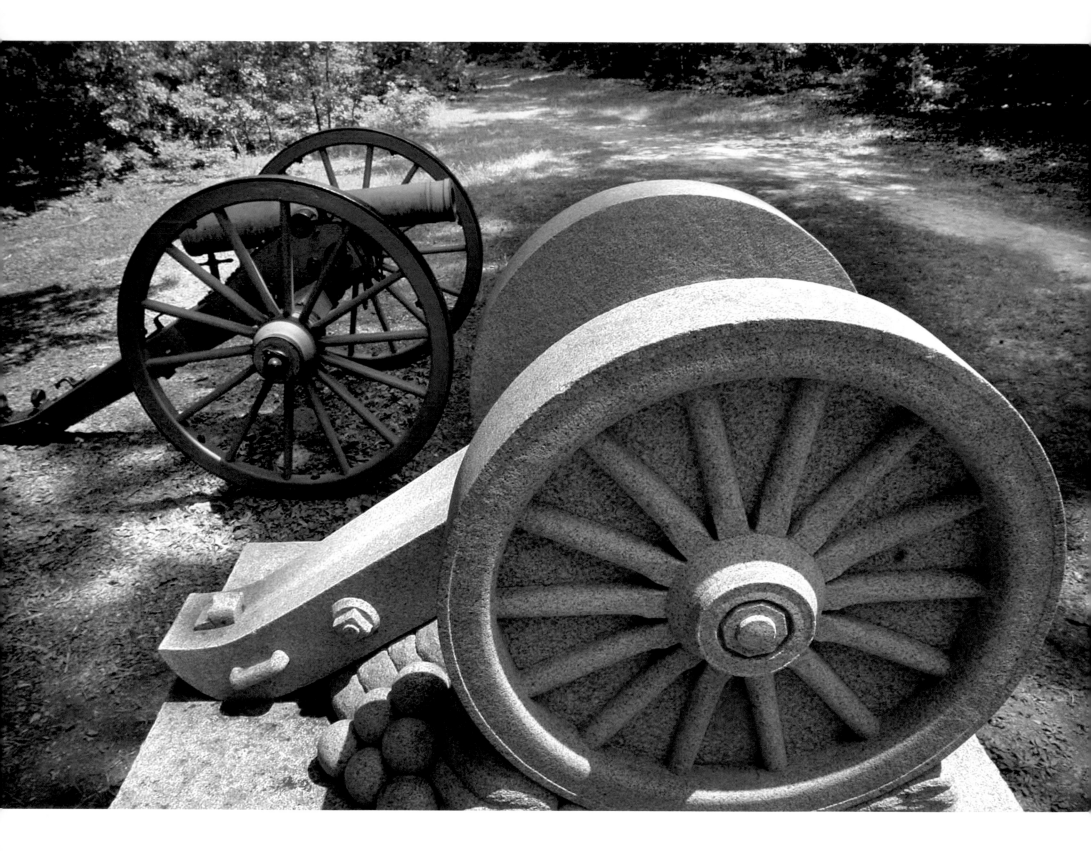

ANDREW HICKENLOOPER

On April 5, 1862, Captain Andrew Hickenlooper and the 5th Ohio Independent Battery arrived at Shiloh. They made their camp in a cedar grove. The unseasonably warm temperatures were a welcome change from the colder weather they had experienced in Missouri. Little did they know that on the following day, they would be in a fight for their lives.

Hickenlooper organized the 5th Ohio on September 22, 1861. The 5th Ohio was originally sent to duty in Missouri under Major General John C. Frémont. With the arrival of spring, a Union offensive was anticipated, and the 5th Ohio was sent to Major General Ulysses S. Grant's Army of the Tennessee.

On April 6, 1862, Hickenlooper's battery was camped near Spain Field. Hickenlooper remembered waking before dawn with the promise of a good day. Breakfast was cooking, and the troops were moving around in preparation for another day of drill. The sudden appearance of Brigadier General Adley Gladden's Alabama soldiers signaled a surprise attack by General Albert Sidney Johnston's Army of the Mississippi.

Brigadier General Benjamin Prentiss personally placed two of Hickenlooper's guns in advance of the Union camp. Hickenlooper brought up the rest of the battery to support those guns. The sound of bugles blowing, drums beating, and soldiers running in different directions echoed across the field, as the Union army desperately raced to repel the Confederate attack.

The Confederate soldiers advanced on the exposed flank of Hickenlooper's battery, as Brigadier General James Chalmers arrived to reinforce the initial attack. The Union lines gave way, and panic-stricken soldiers raced past Hickenlooper's battery.

The men of the 5th Ohio Independent Battery were forced to retreat, firing as they fell back through the woods. In the process, they lost two of their guns when most of the battery's horses were killed. Hickenlooper's horse, Gray Eagle, was hit three times in the neck. The horse fell and, in the process, threw his rider. Hickenlooper fled on foot to the new Federal position.

Gray Eagle regained his footing and followed the retreating Federals. With blood smeared on his legs and neck, Gray Eagle found his rider. A surprised Hickenlooper mounted the horse and rallied his men.

The Union line re-formed on the sunken road that ran along a fence line at Duncan Field. During the next five hours, the Union soldiers along this road repelled eight Confederate frontal assaults.

While riding along the lines, Hickenlooper was stunned to see his father at the Hornet's Nest. Unknown to Hickenlooper, his father had joined an Ohio cavalry regiment in an effort to be near his son. The elder Hickenlooper's cavalry was serving as Grant's escort. Father and son had a brief reunion between Confederate attacks.

As each Confederate attack intensified, Hickenlooper responded with an endless fire from his battery. Firing canister and double canister, Hickenlooper kept up this "dance with death."

Hickenlooper later recalled the scene at the Hornet's Nest: "The ear-piercing and peculiar 'Rebel yell' of the men in gray and the answering cheers of the boys in blue rose and fell with the varying tide of battle; and with the hoarse and scarcely distinguishable orders of the officers, the screaming and bursting of shell, the swishing sound of canister, the roaring of volley-firing, the death screams of the stricken and struggling horses, and the cries and groans of the wounded formed an indescribable impression, which can never be effaced from memory."

During the first day's fighting, the 5th Ohio Independent Battery lost one killed, eighteen wounded, sixty-five horses, and all their camp equipment. Two guns were lost in Spain Field, and another was disabled.

Hickenlooper and the 5th Ohio continued to be part of Grant's army, serving with distinction during the Vicksburg campaign.

Hickenlooper survived the war and in 1880 was elected lieutenant governor of Ohio.

Andrew Hickenlooper and the 5th Ohio Independent Battery's defense of the Hornet's Nest was an inspiring effort against multiple advances by the Confederate army.

COLONEL JAMES S. ALBAN AND THE 18TH WISCONSIN INFANTRY

Possessing an unwavering eye coupled with strict bearing, Colonel James S. Alban of the 18th Wisconsin Infantry embodied the unbending principles that caused two sections of the country to battle each other. At Shiloh, Alban gave his life in honor of these beliefs.

Alban was born in Jefferson County, Ohio, to a pioneer family of substantial means. Always aware of his standing, Alban studied law and looked for his chance to advance even further in society.

After the death of his first wife, Alban settled in Plover, Wisconsin, and began a legal practice. As the nation struggled over the issue of slavery, Alban created the *Plover Herald*, a newspaper with decided political leanings. With the slogan of "Union Forever/ Slavery Never," the *Plover Herald* was an unabashed supporter of the abolition movement and the newly formed Republican Party and its presidential candidate, Abraham Lincoln.

Lincoln's election brought about Southern secession and ultimately the Civil War. Alban, using his social position, wrangled a colonel's rank and command of the 18th Wisconsin Infantry. The men of the 18th Wisconsin received their military training at Camp Trowbridge in Milwaukee.

On March 30, 1862, the 18th left Wisconsin destined for battle. Many of the soldiers thought they were heading to the East, where they would serve under Major General George B. McClellan. The transports kept going south, however, to Savannah, Tennessee. Instead of McClellan's command, the 18th Wisconsin served in Major General Ulysses S. Grant's Army of the Tennessee. On April 5, 1862, Alban and the 18th Wisconsin, numbering 862 strong, arrived two miles southwest of Pittsburg Landing, Tennessee.

They were ordered to report to Brigadier General Benjamin Prentiss's 6th Division and were posted in camp two miles southwest of Pittsburg Landing. The 18th Wisconsin and the rest of Prentiss's division weathered the initial onslaught of General Albert Sidney Johnston's surprise attack on April 6, 1862.

As they stared down the barrels of their Austrian rifles, the soldiers of the 18th faced combat for the first time. Their only prior experience with the rifles had been shooting at logs on the Tennessee River during their trip south.

After repelling the initial attack, Prentiss's lines faltered under the unrelenting pressure of the Confederate army. The camps of the Union army were abandoned as the soldiers raced from the charging Confederates. The 18th Wisconsin's regimental banner was still in Alban's tent. The flag and other mementos soon became souvenirs of the Southern soldiers.

Johnston ridiculed a Confederate soldier leaving the 18th Wisconsin camp with his arms full of booty, "None of that, sir, we are not here for plunder!" Noticing the crestfallen look on the soldier's face, Johnston grabbed a tin cup, stating, "Let this be my share of the spoils today."

Alban and the 18th Wisconsin re-formed with 6th Division soldiers of Missouri, Michigan, Illinois, and Wisconsin along a worn dirt path running beside a split rail fence. This road, forever known as the Hornet's Nest, provided sufficient cover for the Union troops to withstand repeated frontal attacks.

A minié ball pierced Alban's body, mortally wounding the 18th Wisconsin's leader. The men of the 18th Wisconsin continued to hold their ground until they were surrounded by the Confederate army. Approximately two hundred men of the 18th Wisconsin became prisoners of war when Prentiss surrendered.

In their baptismal fire at Shiloh, nearly half of the regiment's compliment of soldiers were killed, wounded, or missing. Another two hundred were taken prisoner. Alban, wounded leading his men at the Hornet's Nest, died the following day, having served seven hours in combat.

By the summer of 1862, only three hundred men of the original 18th Wisconsin Infantry remained fit for duty. The 18th Wisconsin continued to serve in combat at Iuka and Corinth, Mississippi.

The Wisconsin state monument commemorates the soldiers of the 14th, 16th, and 18th Wisconsin regiments. The monument is located at the Hornet's Nest.

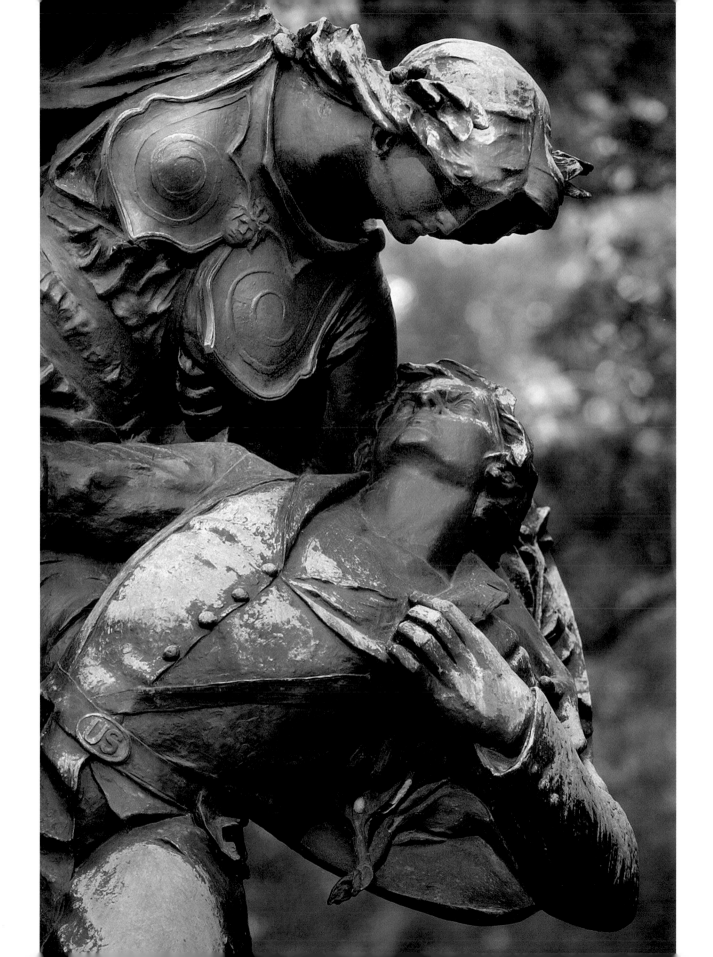

KETCHUM'S BATTERY

Captain William Ketchum's battery helped form a thunderous display of artillery that pounded the Hornet's Nest. Since the start of battle, Ketchum's men had come to the aid of a Confederate regiment trapped in a murderous cross fire, participated in the "Great Artillery Duel," and finally softened the Union line, helping to bring about the Union's surrender of the Hornet's Nest.

The Alabama State Artillery Battery, also known as Ketchum's-Garrity's Artillery Battery, was organized on May 4, 1861. Alabama had seceded from the Union on January 11, 1861, and men from across the state volunteered for service in the artillery, infantry, and cavalry. The men who formed Ketchum's Battery were from the area around Mobile. After a brief stay in Pensacola, Florida, Ketchum's Battery was ordered to Corinth, Mississippi.

At Shiloh, Ketchum's Battery served in Colonel Preston Pond's brigade of Brigadier General Daniel Ruggles's division. The battery consisted of four six-pound smoothbores and two twelve-pound howitzers. During the early morning of April 6, 1862, Ketchum's Battery supported the deployment of Pond's infantry. Pond's men became caught in a cross fire that was severely punishing the Southern soldiers. With the help of artillery, Pond's men were able to withdraw from their predicament and redeploy near the Purdy-Hamburg Road. Pond credited Ketchum's Battery with saving his brigade.

By 2 P.M., Ketchum's Battery launched a long-range bombardment with Captain Edward Bouton's Battery I, 1st Illinois Light Artillery. The two batteries fought for over an hour in what was labeled the "Great Artillery Duel."

The death of General Albert Sidney Johnston brought about a change in command at the Hornet's Nest. Major General Braxton Bragg was moved to the Confederate right wing. This meant that Ruggles took over the Confederate soldiers around the Hornet's Nest. Bragg's approach to the Union stronghold was continual headlong infantry charges on the Federal lines. Such charges were costly to the lives of the soldiers and had yet to prove they could be successful.

Ruggles sent his staff to round up as many cannons as they could find. Parts of eleven Confederate batteries formed to present a line of cannons over fifty strong. These cannons were lined side by side, facing the Hornet's Nest. The massed artillery was the largest battlefield concentration of field artillery on the North American continent up to that time.

The artillery consumed the Hornet's Nest "with the force of a hurricane," and continued to relentlessly pound the Federal line. Brigadier W. H. L. Wallace's flanks were "in the air," and the Confederate army began to surround the Hornet's Nest.

The following day, Ketchum's Battery tried valiantly to stop the Union advance, and they were in the thick of the fighting when Beauregard announced the call for retreat. As the rest of the Southern army marched to Corinth, Ketchum's Battery served in the rear guard action.

Driving rainstorms turned the Corinth road into a muddy quagmire. The soldiers had taken the wrong road, and they had to retrace their steps to get on the right road. Lieutenant Phil Bond of Ketchum's Battery recalled the Confederate retreat, stating that the men "looked as if they did not have life enough left in them to move. I was standing completely saturated with rain and was standing in the mud ankle deep all night."

After the battle of Shiloh, Ketchum's Battery was assigned to Ruggles. It would fight at Farmington, Mississippi, and served in Major General Braxton Bragg's invasion of Kentucky in the fall of 1862. Ketchum's Battery also fought at Chickamauga, Georgia, and Missionary Ridge, Tennessee. During Major General William T. Sherman's Atlanta campaign, Ketchum's Battery continually clashed with the Union general. The Alabamians also fought in the disastrous battle of Franklin, Tennessee. The battery, numbering about eighty men, surrendered at Meridian, Mississippi, in 1865.

William Ketchum's Alabama battery was part of Daniel Ruggles's fifty-seven-cannon bombardment of the Hornet's Nest.

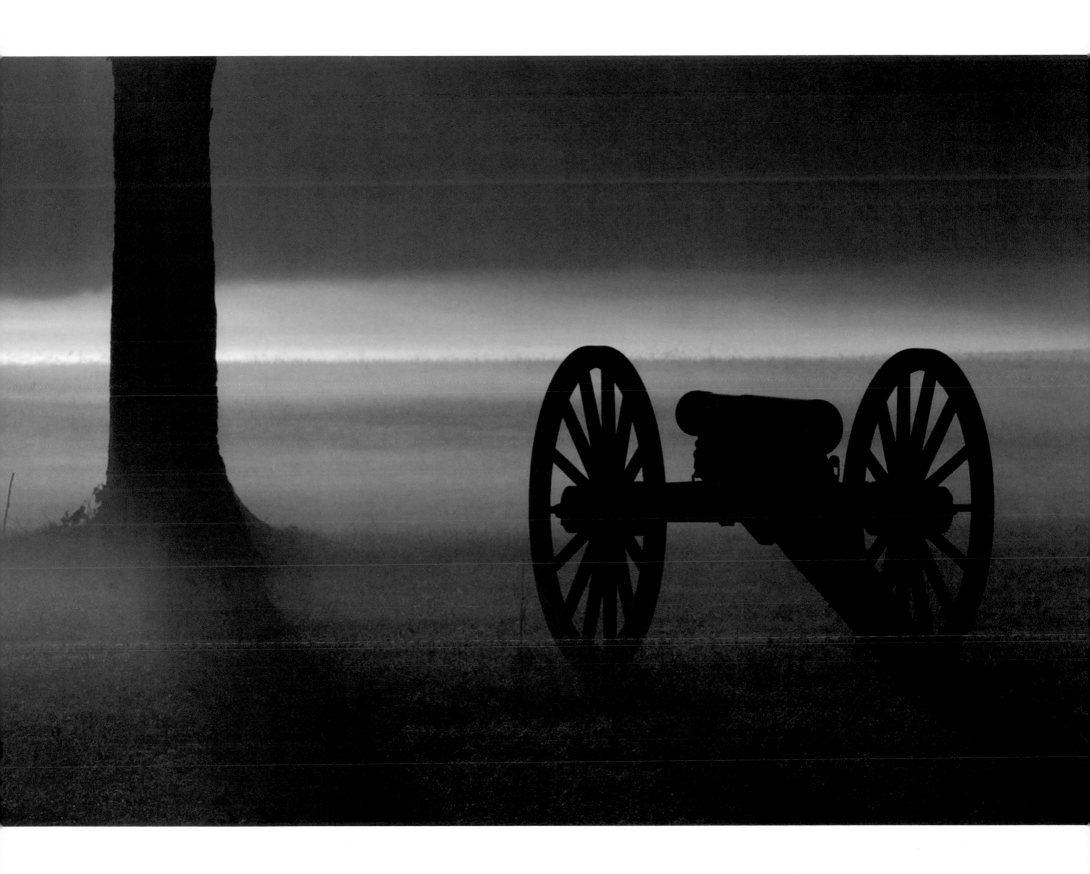

46TH ILLINOIS INFANTRY

After weeks of training, the 46th Illinois Infantry's journey to battle in the Civil War began at Cairo, Illinois. From there, they boarded the steamboat *Belle Memphis*, floating east on the Ohio River and then south on the Tennessee River. They joined the army of Major General Ulysses S. Grant at Fort Donelson, Tennessee. The brutal fighting at Fort Donelson proved to be the 46th Illinois's baptism under fire.

Upon the arrival of the 46th Illinois, Grant's army swelled to 27,500 soldiers. Victory at Fort Donelson allowed the 46th Illinois to perform garrison duty at Fort Henry, located nearby.

The 46th had suffered from the elements at Fort Donelson. Due to a supply mix-up, the men of the 46th arrived with only the clothes on their backs. They had no tents to protect them from the elements. On their first night at Fort Donelson, the men stood shivering in a driving snow as temperatures plummeted. The soldiers had little more than blankets to keep them warm. The sons of Illinois prevailed against the elements and the Confederate army.

The 46th was ordered into the brigade of Colonel James Veatch and moved south into the Tennessee Valley. They arrived at Pittsburg Landing on March 19, 1862, and camped a mile northeast of the Shiloh Meeting House.

During the fighting at Shiloh, the 46th Illinois, under the command of Colonel John A. Davis, was placed in a defensive position near Water Oaks Pond adjacent to the Corinth Road. The 46th could see an oncoming tide of gray and butternut soldiers advancing. The soldiers of the 46th were stunned when the Federal regiment in the front turned tail and ran. The rattled soldiers broke through the ranks of the 46th Illinois in an effort to escape the Confederate juggernaut.

The 46th opened fire and stunned the advancing Confederates. Several more volleys forced the Southern soldiers to stop. The 46th's good showing on the battlefield was once again diminished as a regiment to its right broke and ran from the fight. The soldiers of the 46th were caught in a devastating cross fire. They suffered heavy losses but still held their ground; eventually, Davis withdrew the 46th to a safer position.

After their withdrawal, the men of 46th were sent to reinforce the brigade of Brigadier General William T. Sherman at Jones's Field. Sherman was desperately trying to slow down the Confederate advance and called upon the 46th for help. The soldiers of the 46th advanced to within a hundred yards of the Confederates and delivered a destructive volley upon the enemy.

Davis realized that the 46th was running low on ammunition and withdrew the regiment from the field. The soldiers marched back to camp, resupplied, and ate lunch as the sounds of battle echoed all around them. That night the Illinois soldiers slept in a driving rainstorm with their arms nearby.

On April 7, 1862, the Union army renewed the fighting at Shiloh. Grant's army had been staggered by a relentless Rebel attack the previous day. Now, with reinforcements arriving from Major General Don Carlos Buell, Grant was ready to launch an attack to drive the Rebels from Shiloh.

During the fighting, the 46th began to falter under a withering Southern fire. Davis grabbed the colors, seeking to rally his men. He was severely wounded when a shell fragment ripped through his left side. Reinforcements arrived to help drive the Confederates past Shiloh Church.

In his report on the battle, Veatch mentioned the 46th Illinois: "Colonel Davis, Lieutenant Colonel Jones and Major Dornblaser of the Forty-sixth Illinois Infantry, each displayed coolness and courage in resisting the heavy columns thrown against them. Major Dornblaser was wounded and compelled to leave the field early on the first day. Colonel Davis was severely wounded on the second day while gallantly fighting in Colonel Marsh's brigade and was carried from the field."

A relief sculpture depicting the fighting during the battle of Shiloh is a part of the Illinois state monument.

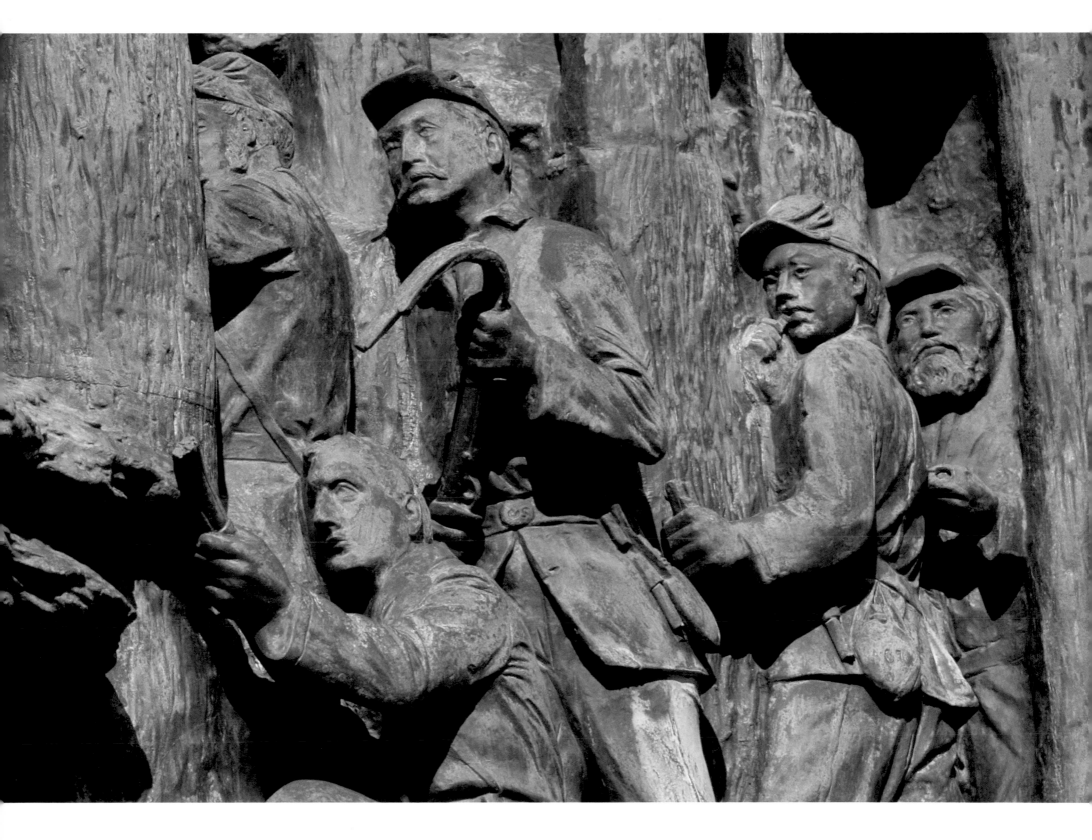

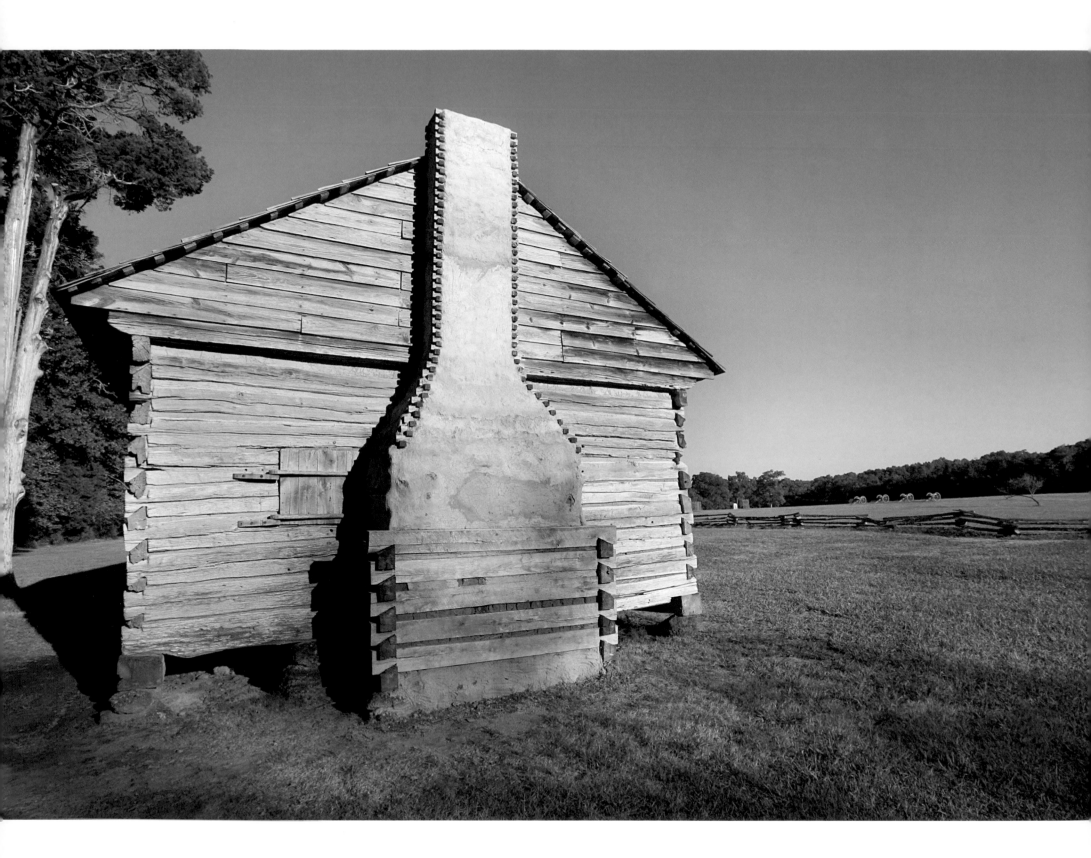

THE WILLIAM MANSE GEORGE CABIN

Brigadier General Stephen Hurlbut's soldiers marched to the sound of battle. Soldiers in the brigade of Brigadier General Jacob Lauman were amazed to see beaten Federal soldiers walking to the rear. Many of these soldiers had dropped their weapons and had run to avoid the Confederate onslaught. As they passed Lauman's men, these soldiers shouted words of warning, "You'll catch it—we are all cut to pieces—the Rebels are coming."

Eventually, Lauman deployed his men on a line stretching down a sunken dirt road. Lauman's portion of the road was near a weathered cabin that was owned by William Manse George. Lauman's position connected Hurlbut's division with Brigadier General Benjamin Prentiss's line.

Lauman was born in Maryland but moved to Iowa by 1844. He and his brother started a mercantile business and were quite successful. He married into a wealthy family, and all seemed well.

After Fort Sumter, Lauman answered Abraham Lincoln's call for soldiers. He helped organize the 7th Iowa Infantry and was elected colonel by the soldiers. In their first action at Belmont, Missouri, the 7th Iowa and Lauman performed admirably, drawing praise from Brigadier General Ulysses S. Grant.

At Fort Donelson, Lauman was given command of a brigade consisting of the 2nd, 7th, and 14th Iowa and the 25th Indiana. Once again, Lauman led his men gallantly, and was given a command in Stephen Hurlbut's division. His new command included the 31st and 44th Indiana and the 17th and 25th Kentucky infantries.

At Shiloh, Lauman continued to fortify his stature as a "fighting" general. The right of his brigade faced the repeated charges of Colonel Randall Lee Gibson's Louisianans. Four consecutive times, Gibson's men charged the Union line along the sunken road that would earn the name the Hornet's Nest. Each time his men were beaten by Lauman's and W. H. L. Wallace's men.

On each charge, Lauman had his men hold their fire until he could see the flash of the Confederate bayonets. With Lauman's order to fire, the whole Union line dealt a deadly fire. Not to be deterred, the charging Confederates advanced to within ten yards of the Federal line before they were beaten back.

Repulsing the repeated Confederate charges had left Lauman's men nearly out of ammunition. His brigade was slowly pulled out of the line so they could replenish their ammunition.

Lauman claimed it made him ill when he walked the battlefield after the fight: "The bodies lay in piles, some disemboweled, headless, cut in half by cannon fire. Everywhere wounded men cried and whimpered."

On the second day at Shiloh, Lauman's brigade served as a reserve to Brigadier General Alexander McCook's advance on the Confederate lines. During a Confederate countercharge against McCook's line, Lauman's brigade launched their own offensive at the opportune moment.

Colonel Hugh Reed of the 44th Indiana said: "We found the enemy charging upon and driving our forces to the left and front over cleared ground used as a drill ground by our troops. I immediately brought my regiment into line and opened fire on the enemy. Our charge took them by surprise. They immediately retreated to the rear."

After Shiloh, Lauman fought in the battle of Davis Bridge on the Hatchie River in an attempt to trap the defeated army of Confederate major general Earl Van Dorn. Brigadier General E. O. C. Ord ordered Lauman to cross the bridge and assault the Confederates on the ridge. Lauman did so, but his brigade was caught in a withering cross fire. Lauman never forgave Ord or Hurlbut for the pain his men endured.

The William Manse George cabin is also referred to as the "War Cabin." The cabin formerly stood on Perry Field on the Union right. The only cabin on the battlefield, the battle-scarred logs reveal that it stood in the midst of heavy fighting. The cabin was moved to its present location a few weeks after the battle, to replace the one that was burned during the engagement.

The William Manse George cabin is the only surviving structure that was on the field at the time of the battle of Shiloh.

THE PEACH ORCHARD

Sarah Bell's peach trees were in full bloom. Pink flowers brought the promise of spring and warmer weather. With that warm weather, a bountiful harvest of peaches and other crops was around the corner. However, on April 6, 1862, Bell's peach orchard was the scene of desperate fighting between the North and South at the battle of Shiloh.

Brigadier General Stephen Hurlbut had placed his men just south of Bell's cotton field. At the time of the battle, no cotton was growing in the field. In order to reach the Union line, the Confederates had to march across a hollow south of the Peach Orchard. The Confederate soldiers referred to this field as a "mule lot."

Colonel Isaac C. Pugh, a veteran of the Mexican War, was camped with the 41st Illinois near the Tennessee River. A favorite among his men, the soldiers affectionately called him "Old Pap Pugh."

For the next six hours, Pugh and his fellow Union soldiers were in the fight of their lives, as they desperately tried to keep the tenuous hold on the Federal line. The three Confederate brigades of Brigadier Generals James Chalmers, John K. Jackson, and Adley Gladden, now under the command of Zachariah Deas, formed to attack. Colonel Nelson G. Williams, 1st Brigade commander of Hurlbut's 4th Division, was wounded from one of the initial Confederate battery shots, and command was passed to Pugh.

As the fighting continued, Pugh worried about the security of his left flank. Hurlbut pulled the 32nd Illinois into the Peach Orchard next to the Hamburg-Savannah Road. Eventually, Hurlbut decided to pull the entire division to the same line. This move placed the 28th and 41st Illinois regiments in the Peach Orchard, while the rest of the division extended to the Hornet's Nest.

This new line proved to be a formidable one. When Brigadier General John McArthur's brigade formed on Hurlbut's left, the combined troops were able to hold here for several hours.

The contest in the Peach Orchard provided a surreal moment. The pink blossoms of the peach trees fell slowly to the ground as soldiers from North and South slaughtered each other. Soldiers from both sides likened the falling blossoms to snow falling on the battlefield.

The fighting continued throughout the afternoon, when a massive Confederate assault, led by General Albert Sidney Johnston, pushed some of the Union troops from the field. The desired effect came at a terrible loss, as Johnston was mortally wounded in the fight.

As Johnston lay dying, Brigadier General John C. Breckinridge's Reserve Corps took control of the Peach Orchard, causing Hurlbut's line to fall back. As Hurlbut gave ground, Major General Ulysses S. Grant's last line of defense was hastily formed on the ridge above Pittsburg Landing. The Federals had to hold this final line or be pushed into the Tennessee River, which would mean the annihilation of Grant's army.

With Johnston's death, command of the Army of the Mississippi passed to General P. G. T. Beauregard. The Creole general was convinced that Grant was defeated and could be finished in the morning. In the meantime, Major General Braxton Bragg was forming one final assault on Grant's line. Just as the assault was beginning, orders came from Beauregard stopping the advance.

On the following day, Pugh and the 41st Illinois supported the advance of Major General John McClernand against the Rebel army. The Confederates were forced to retreat to Corinth, Mississippi, wondering what one more charge could have achieved.

Sarah Bell's peach orchard was destroyed. Soldiers said it looked like it had been ravaged by a hurricane.

During the fighting at the Peach Orchard, pink blossoms fell down on the soldiers, resembling a light snow.

THE HORNET'S NEST

A worn dirt road stretches through the woods near the Shiloh Meeting House. The same road that was a popular path for wagons and farmers walking from field to field had sunk through the many years of use. The road, the fence, and the sunken nature of the road proved to be a formidable obstacle for the Confederate Army of the Mississippi during the battle of Shiloh.

After the initial Union defensive line broke, Brigadier General Benjamin Prentiss desperately sought a position that his soldiers could take to repel the Confederate army. With the Federal soldiers lying in a prone position, they could deal a deadly fire while presenting a relatively small target. The first few Confederate advances were repulsed with deadly fire from the Sunken Road. Brigadier General Jacob Lauman saw scores of Confederate soldiers fall as they advanced on his lines.

The Confederate soldiers who tried to take the Sunken Road likened the lead buzzing around their heads to a nest of angry hornets. From then on, the sunken road near Duncan Field was forever known as the Hornet's Nest.

Major General Braxton Bragg was hell-bent on taking the Hornet's Nest, but he saw little opportunity other than repeated headlong charges. Instead of using a combined effort of artillery and infantry, Bragg demanded that Colonel Randall Lee Gibson's brigade of 2,350 men conduct a bayonet charge. Gibson had been awaiting orders, but Bragg viewed the inaction as cowardice. For the next two hours, the men of the 4th, 13th, and 19th Louisiana and the 1st Arkansas infantries repeatedly charged the Union lines at the Hornet's Nest.

The Federal volley included canister and double canister, ripping huge holes in the Confederate lines. Gibson's men staggered back from the fire delivered at point-blank range.

Bragg was incensed to see Gibson's men returning to their lines. He blamed Gibson for errant handling of his troops. In turn, Gibson pleaded with Bragg for artillery support.

Bragg sent Gibson's men on yet another charge. Captain Andrew Hickenlooper's 5th Ohio Battery was firing a round every thirty seconds, until their guns were sizzling. The ground caught fire in front of Hickenlooper's line, and the screams of burning men were heard over the battle.

After two failed charges, Gibson's officers implored Bragg to make a flanking attack, but the stubborn Bragg ordered Gibson's men to make two more charges against the Union lines. Gibson's brigade made four separate charges against the Hornet's Nest. Not an inch of ground was gained on any charge, and the assaults ended with the near destruction of Gibson's brigade.

When it became evident that the Hornet's Nest was going to be surrounded, the 2nd and 7th Iowa moved out of line and withdrew up the Pittsburg-Corinth Road. The Iowans had to fight their way out of the closing Confederate vice at Hell's Hollow. "If we had not left when we did, we would all have been taken prisoners," said William Richardson of the 7th Iowa.

The soldiers in the Hornet's Nest had kept the Confederate soldiers at bay for six hours. The price for such a gallant effort was paid for with the blood of Union soldiers from Iowa, Illinois, and Ohio. Few lived to fight another day, and others were taken prisoners of war. Many men in blue gave their lives at the Hornet's Nest in order to save the Union army at Shiloh.

A morning fog hovers over the Hornet's Nest at Shiloh. Frontal assaults on this Union position proved to be a deadly endeavor.

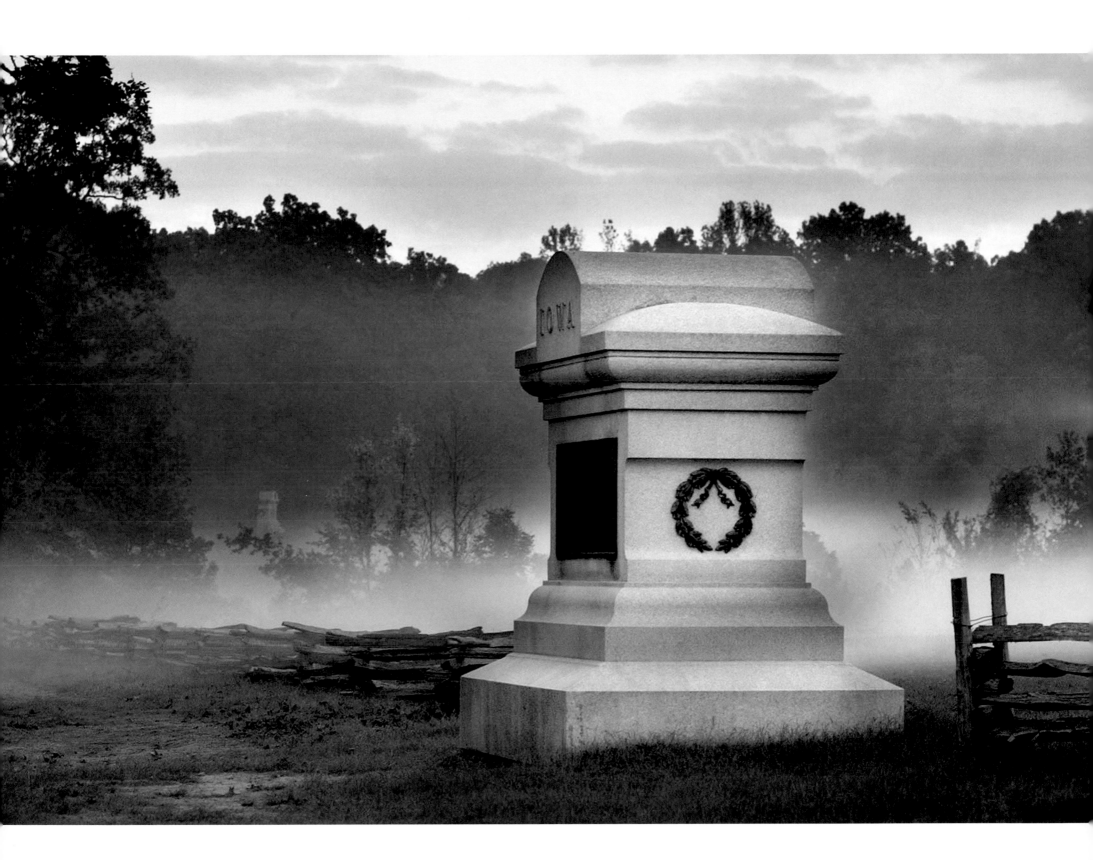

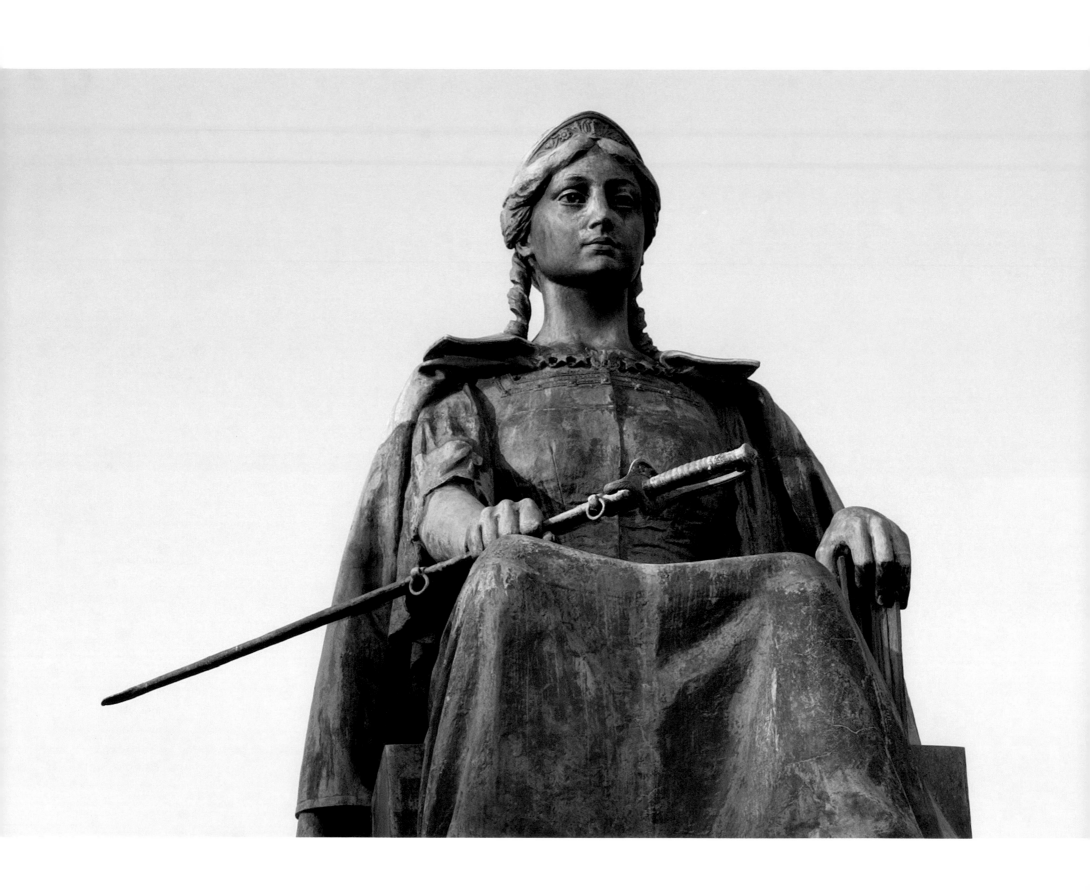

ILLINOIS MONUMENT

Sitting near the crossroads of the Pittsburg-Corinth Road and the Hamburg-Purdy Road, the Illinois state monument dominates the field. A woman representing the state of Illinois looks southward in the direction of her enemy. In one hand is a sheathed sword. She holds the scabbard firmly, ready to once again release the blade at a moment's notice. In the other hand, she holds a book containing a record of her sons' achievements at the battle of Shiloh.

Sons of Illinois enlisted for various reasons. It could have been a patriotic fervor, a desire to save the Union, abolish slavery, or just to teach the "Secesh" a lesson. Whatever the reason, men of Illinois signed up in droves.

As men gathered to join various regiments, the sound of a fife and drum could be heard. A local politician stood near the volunteering soldiers, exhorting the men to rally around the flag. As one volunteer put it, the men of his unit "left home burning with the desire to wipe treason from the earth."

Camps were made in towns like Springfield, Alton, and Cairo to turn farmers, factory workers, city men, and country boys into soldiers. Before these men marched to battle, communities gathered one last time to say good-bye to their fathers, husbands, and sons. Such send-offs were large affairs. Picnics were held; families gathered for what, for many, would be the last time; and politicians used the opportunity for long-winded speeches. The regiments were usually presented with a regimental banner, which each man swore to die for and protect. For most of these men, this banner represented their wives and family. It was a piece of home as they marched to a distant soil.

Forming into various regiments, the Illinois troops took special pride in each individual unit. Although each regiment had its own specific number, the soldiers had their own endearing nickname for their troop. Regiments with names like the Brains Regiment, the Dirty First, the Preacher's Regiment, and the Blind Half Hundred all took pride in calling Illinois home.

The soldiers of the West looked decidedly different from their counterparts in the eastern theater. The dress of the western soldier was simpler. There were no colorful corps patches, feathered caps, brass unit identification numbers, and so forth. In fact, the Union soldiers of the West borrowed from their Southern foe.

In *The Civil War: A Narrative*, Shelby Foote pointed out that the western soldiers "preferred Confederate-style blanket rolls to knapsacks, walked with the long, loose-jointed stride of plowmen, and paid their officers little deference. Except for the color of their uniforms, they looked exactly like the Rebels."

The men from Illinois wore blue wool trousers, the black-felt Hardee hats with wide brims, and tight-fitting blue jackets. The jackets proved to be uncomfortable in the hot and humid weather of the Deep South. Soldiers were glad when they received the looser-fitting standard Federal coat, which was made of lighter-weight wool.

Not every man in the Illinois infantries called that state home. Benjamin Franklin Mills volunteered with the 48th Illinois Infantry after that regiment arrived at Savannah, Tennessee, in March 1862. Two weeks later, Mills was fighting in the battle of Shiloh in his home state of Tennessee.

By the war's end, the sons of Illinois who had fought at Shiloh also spilled their blood and fought valiantly at Fort Donelson and Hatchie River, Tennessee; Corinth, Vicksburg, and Jackson, Mississippi; and Fort Blakely, Alabama.

The Illinois state monument was dedicated in 1904 to all Illinois troops who participated in the battle of Shiloh. During the ceremony, Confederate general Basil Duke said, "When a people renders such honors to the heroic dead it honors itself. The national care bestowed on this historic spot is as much a potent lesson to the future as a sacred duty to the past, for it commemorates the virtues without which nations cannot survive. May those who fell here never be forgotten, and may these monuments erected to their memory remain as enduring admonitions to the youth of succeeding generations, to love and serve their country equally as well."

The Illinois state monument shows a woman holding a scabbard and a book, forever commemorating the deeds of her native sons.

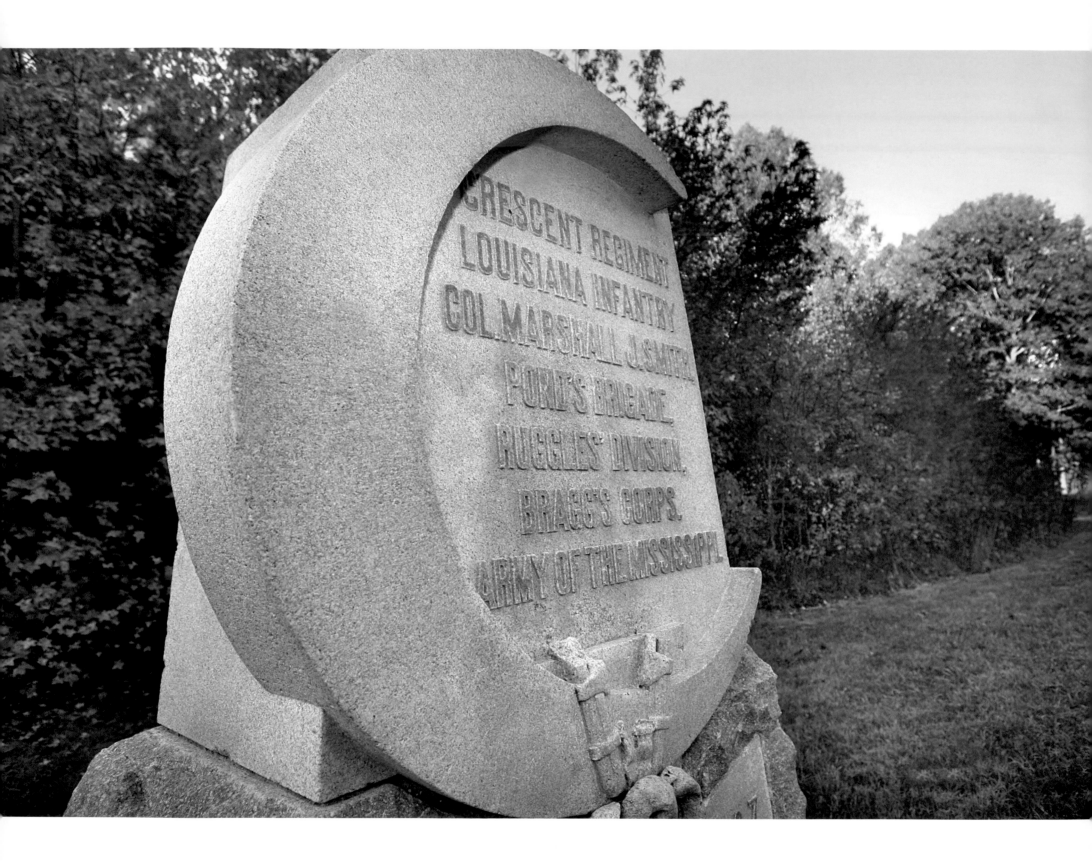

CRESCENT REGIMENT

Colonel Marshall Smith's Crescent Regiment stood ready to charge the Hornet's Nest. The Louisiana regiment had watched numerous charges on this strong position fail, with tremendous loss of life. The Louisiana soldiers prepared to team with Confederate brigadier general Patton Anderson's troops for one last advance on the Hornet's Nest at Shiloh.

The Crescent Regiment was a state militia that had been transferred to Confederate service on March 6, 1862. The regiment was immediately sent to Corinth, Mississippi, to reinforce General P. G. T. Beauregard's growing army. The battle of Shiloh was the Crescent Regiment's first experience in battle.

Eight Confederate charges had been turned back by Brigadier General W. H. L. Wallace's division. Forming to the left of Wallace was Brigadier General Benjamin Prentiss's division. Brigadier General Stephen Hurlbut's division advanced to protect Prentiss's left near the Peach Orchard.

With a spirited charge through the Peach Orchard, General Albert Sidney Johnston compelled Hurlbut to withdraw to a stronger position.

The flanks of Prentiss and Wallace were exposed, and the Confederate army sought to envelop the whole position, rendering any further resistance futile.

Wallace realized his division was almost completely surrounded. He immediately turned his men, and they began fighting their way out of the tightening vice. Wallace's mad dash through Hell's Hollow secured his men an escape route and the ability to fight another day. Prentiss did not react as quickly. His two thousand soldiers—many were Wallace's men—were forced to surrender to the Confederate soldiers, as they completely encircled Prentiss's position.

The surrender was a feather in the cap of the Confederate soldiers. Earlier in the day, the Crescent Regiment had stormed through the camps of their Union foe. The Confederate soldiers were amazed at the bevy of supplies each Federal camp had.

Many of the Confederates had not eaten since the day before the battle. Such a wealth of supplies was hard to turn down, and many of the Rebels dropped from their lines to go plunder the Union camps. For many a Southern soldier, the first night at Shiloh was spent eating the spoils taken from the abandoned Yankee camps.

The following day, the Crescent Regiment served as support for the 5th Company, Washington Artillery, which was positioned near the Davis Wheat Field on the Hamburg-Purdy Road. A Southern advance threatened the battery of Captain John Mendenhall. Realizing the threat to the guns, Colonel William B. Hazen personally led a bayonet charge of the 6th Kentucky Infantry. Hazen's charge broke through the Confederate lines, and his troops emerged in front of the Washington Artillery.

The New Orleans gunners delivered round after round into the oncoming Federals, but the blue wave continued to advance. Soon, the Washington Artillery faced the immediate threat of being overrun and losing their guns.

The Crescent Regiment responded by launching a charge into the ranks of the Union troops. Organized fighting gave way to hand-to-hand combat. During the melee, the Washington Artillery soldiers were able to pull their guns to safety, although the Union soldiers had stuffed the guns' vents with mud in order to temporarily disable them.

The Federals gave way. They were forced to regroup in an effort to stop the Louisiana charge. The Crescent Regiment pushed Hazen's men back through the Davis Wheat Field, delivering a whipping to the Federals. Hazen's brigade lost 406 men out of 1,424 soldiers, accounting for half of the casualties suffered by Brigadier General William "Bull" Nelson's division.

After Shiloh, the Crescent Regiment returned to Corinth, where they were disbanded on June 3, 1862. Most of the men reenlisted with the 18th Louisiana Infantry. The 18th Louisiana served in Louisiana for the remainder of the war. Marshall Smith, the regimental first commander, resigned on July 28, 1862.

Colonel Marshall Smith's Crescent Regiment stopped to plunder Union camps before continuing their advance against the Union soldiers at the Hornet's Nest. The monument marks their second-day position.

STEPHEN HURLBUT'S STAND

Brigadier General Stephen Augustus Hurlbut was a hard-drinking, hard-fighting man. During the battle of Shiloh, the Union Army of the Tennessee relied on his sound judgment and fighting spirit to help hold the Union line.

Hurlbut was an Illinois lawyer and politician who originally called Charleston, South Carolina, home. Hailing from the hotbed of the Confederacy wasn't the best circumstance to expect a high rank. Southern generals serving in the Union army were usually treated with caution and a fair amount of distrust. Hurlbut had one thing on his side. He was an acquaintance of Abraham Lincoln, which didn't hurt when it came to achieving rank. Hurlbut had served as one of Lincoln's emissaries to Charleston during the crisis before the war. For his efforts, Hurlbut was given the rank of brigadier general.

Hurlbut's command was the newly formed 4th Division of the Army of the Tennessee, mainly comprised of men from Illinois. Hurlbut and his men caught up with Major General Ulysses S. Grant's army after the surrender of Fort Donelson. By early March, Hurlbut and his men were ordered from Fort Henry to Savannah, Tennessee. They were part of a massive Union expedition down the Tennessee River.

The sights of the expedition were awe inspiring. Boats with decks full of blue-clad soldiers moved along the river, with huge clouds of smoke coming from the boilers. Upon their arrival in Savannah, boats lined the river sometimes tied up four deep. On the land surrounding the river, thousands of campfires flickered like lightning bugs dancing on a hot summer night. A Union officer wrote his wife describing the scene, calling it "the most magnificent sight" he had ever seen. The officer told his wife, "Say what you will, war has its attractions." Within days, Hurlbut and the 4th Division moved farther south, leaving behind the congestion of Savannah.

On April 6, 1862, the Confederate army surprised the 6th Division of Brigadier General Benjamin Prentiss. As the fighting raged, Prentiss sent word to Hurlbut, who was camped closer to the river, to bring up his men. The Union line eventually formed on a sunken road, which provided good cover and a strong position to resist the Confederate army.

Hurlbut's men formed on the left of the Union line, which was along the Hamburg-Savannah Road. Prior to leaving camp, Hurlbut had sent some of his men to reinforce Brigadier General William T. Sherman's division. Hurlbut procured men from Brigadier General W. H. L. Wallace to come to the aid of Colonel David Stuart's men.

Hurlbut's men beat back repeated charges at the Peach Orchard. Toward the end of the day, Hurlbut was forced to retire after Stuart's brigade ran for safety at Pittsburg Landing. In an effort to protect his exposed flanks, Hurlbut momentarily released his hold on Prentiss to attend to the pressing matters on his left.

This movement saved Hurlbut's men from annihilation or surrender, giving Grant men he could count on for the next day's fight. On April 7, 1862, Grant ordered Hurlbut's men to support Major General John McClernand's advance on the Confederate army.

Hurlbut's leadership during a time of great crisis earned him a promotion. For meritorious conduct at the battle of Shiloh, he was promoted to major general.

In October 1862, Hurlbut engaged the retreating army of Major General Earl Van Dorn at the Davis Bridge along the Hatchie River. Hurlbut hoped to close a noose around the Army of West Tennessee. The Confederates were able to keep Hurlbut at bay, therefore allowing the Southern army to escape farther south.

After the war, Hurlbut served two consecutive terms in the U.S. House of Representatives, serving the state of Illinois. In 1881, he was appointed ambassador to Peru, a position he held until his death in 1882. Hurlbut was buried in his adopted home of Belvidere, Illinois.

Steven Hurlbut's soldiers held the left of the Union line at the Hornet's Nest. His headquarters was located in Cloud Field.

DANIEL RUGGLES

Tired of watching wave after wave of Confederate soldiers butchered at the far fence line of the Sunken Road, Brigadier General Daniel Ruggles called for a show of brute force as he lined fifty-seven cannons along the ridge of Duncan Field. For an hour, Ruggles's cannons rained death among the Union soldiers at the Hornet's Nest.

Ruggles was born in Massachusetts in 1810. His road to Shiloh began when he secured an appointment to the U.S. Military Academy. Ruggles served in various posts prior to the Mexican War, participating in the battles of Palo Alto and Chapultepec. After the war, Ruggles was part of Albert Sidney Johnston's Utah expedition. He was on sick leave when the Civil War started.

Ruggles resigned his commission, was given the rank of brigadier general, and served the first part of the war on a line near the Potomac River and Mount Vernon, Virginia.

Ruggles was ordered to Pensacola, Florida, and two months later was in New Orleans. After organizing a brigade in the Crescent City, Ruggles and his five thousand men were sent to Corinth, Mississippi, in February 1862. Major General Braxton Bragg wanted a soldier with experience and discipline to handle that area.

With Ruggles, Bragg had a soldier whose personality was similar to his own. Both men were irascible, and many soldiers did not enjoy their company. Both men demanded strict adherence to military rule.

While near Corinth, General P. G. T. Beauregard instructed Ruggles to watch the Tennessee River with "the utmost vigilance." Beauregard and General Albert Sidney Johnston feared the Tennessee River would become an avenue of invasion into the Mississippi Valley.

While at Corinth, Ruggles's soldiers began digging entrenchments that would play a significant role during the battle of Corinth in October 1862.

When the Army of the Mississippi began their march to Shiloh, Ruggles, who wore a long white beard, was in command of Bragg's 1st Division. During the first day's fighting at Shiloh, Ruggles watched as the Union soldiers manning the Hornet's Nest repulsed eight full-scale charges. Each charge had ended with a huge loss of life for the Southern soldiers with little to no ground gained.

It was clearly evident to Ruggles that a change of tactics was needed. He began sending out a call for all available cannons to be brought to his position. Within an hour, Ruggles had massed an impressive fifty-seven guns that he lined almost hub to hub, looking toward the position of Brigadier General W. H. L. Wallace.

At 3:30 P.M., Ruggles's cannonade began hurling up to three rounds a second into the Hornet's Nest. The barrage lasted about an hour, and Union soldiers tried to get as close to the earth as possible.

Lieutenant Abner Dunham of the 12th Iowa Infantry described the barrage: "It seemed like a mighty hurricane sweeping everything in front of it." Prentiss was left to face the next Confederate onslaught alone. Repeated charges by Confederate infantry bent the Union line in the shape of a horseshoe. The Union position in the Hornet's Nest was being assailed on the front and on both sides. Panic was spreading throughout the Union lines.

George McBride of the 15th Michigan Infantry recalled, "Someone calls out, 'Everybody for himself!' The line breaks, I go with the others, with the howling, rushing mass of enemy pressing in close pursuit." Prentiss was forced to surrender, but Union forces had held the Hornet's Nest for six hours, buying Grant time to form one last defensive line.

After Shiloh, Ruggles continued to command a division during the siege of Corinth. In August 1862, he was given command of a district comprising the coastal counties of Mississippi and Louisiana east of the Mississippi River.

After the war, Ruggles lived in Fredericksburg, Virginia, where he died in 1897.

After watching numerous unsuccessful charges, Daniel Ruggles massed fifty-seven cannons to blast the Hornet's Nest into submission.

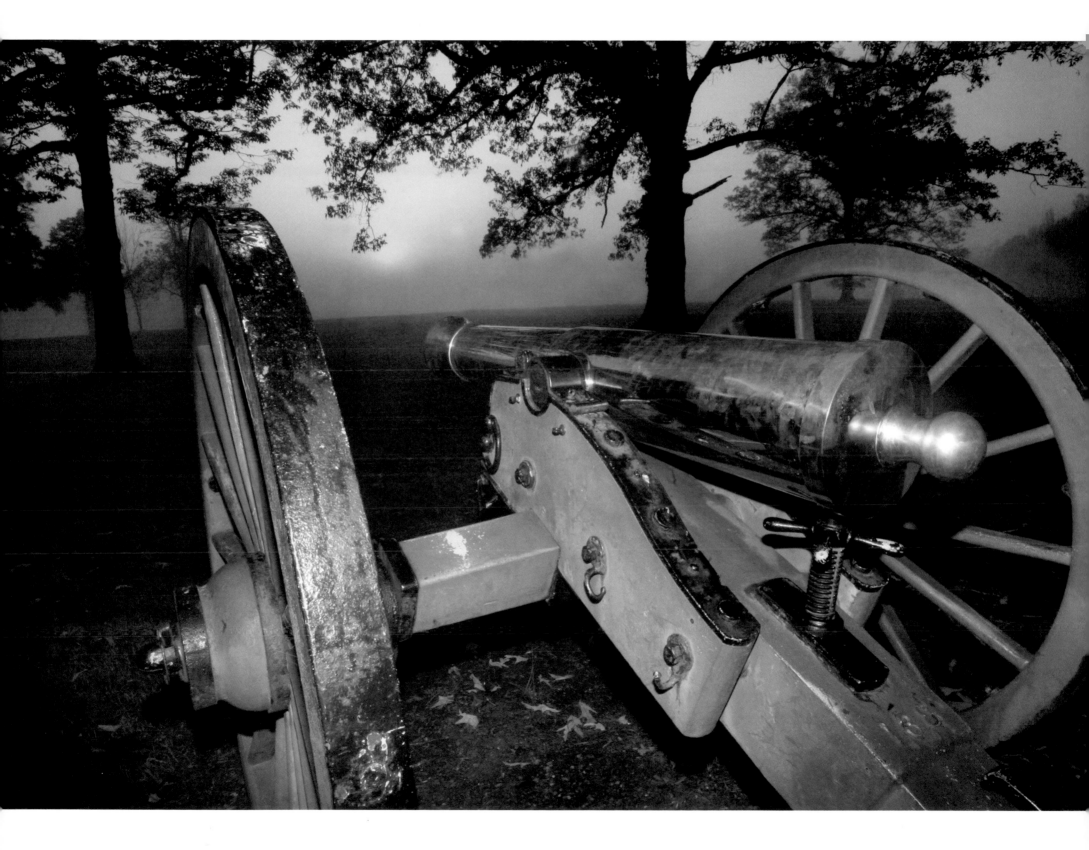

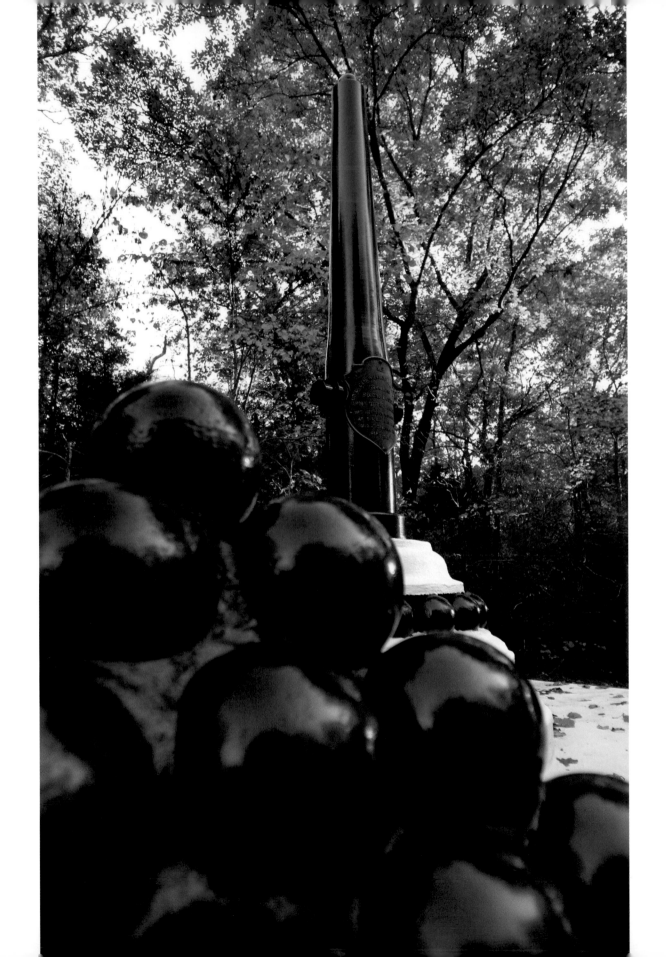

W. H. L. WALLACE

Command had come unexpectedly for W. H. L. Wallace. He had risen in the ranks to brigadier general. Wallace now commanded the 2nd Division of the Union Army of the Tennessee. Wallace's story at Shiloh is a tragic one. He was thrust into the defense of the Hornet's Nest while his wife waited on a transport at Pittsburg Landing.

Born in Ohio, Wallace moved to Illinois in 1834. He studied law in Springfield, Illinois, with Abraham Lincoln and joined the practice of T. Lyle Dickey of Ottawa, Illinois. In 1851, Wallace married Dickey's daughter, Martha Ann.

When the Civil War started, Wallace and Dickey volunteered with the 11th Illinois Infantry. He was elected colonel of the 11th Illinois and received his general's star due to gallant leadership at Fort Donelson.

Wallace was known for his quiet demeanor and Christian faith, putting his life in the hands of God. He wrote in a letter to Ann, "Our Father who art in Heaven will take care of his children and do with them whatever is best." On the morning of April 6, 1862, Wallace had just sat down for breakfast when the unmistakable sound of battle reverberated though the woods near Pittsburg Landing.

After the initial attack, Wallace had his men under arms and sent a message by boat to the headquarters of Major General Ulysses S. Grant, alerting him of the Confederate attack. Brigadier General Benjamin Prentiss formed his second line behind Wallace's line and ultimately placed his men at Wallace's left.

While Wallace was fighting at the Hornet's Nest, Ann had just arrived by steamboat to pay a surprise visit to her husband. Ann had more than a husband at Shiloh. She also had a father, two brothers, and two brothers-in-law serving in the Army of the Tennessee.

A worried Ann waited at Pittsburg Landing. Her concern was evident for her family but also because of what she was seeing. Scared and beaten soldiers ran to Pittsburg Landing and huddled at the river's edge. They cried of a terrible Union slaughter at the hands of the Confederate army.

Wallace's men held despite receiving eight Confederate attacks at their front. An hour-long artillery barrage pummeled the Union lines, followed by another Confederate attack. Major General John McClernand's division was on Wallace's right, but withdrew across Tilghman Branch. Brigadier Stephen Hurlbut also withdrew, exposing Prentiss's left flank. Wallace and Prentiss held the Hornet's Nest while being virtually surrounded by the Confederate army.

Wallace realized the precarious situation his men were in and began to fight his way out of the ever-tightening Confederate vice. At a stretch of land soldiers called Hell's Hollow, Wallace led his men through the gauntlet of fire. An aide called out a warning to Wallace, who rose in his stirrups to see the wall of gray-clad soldiers. At that point, a bullet struck Wallace behind the left ear and exited out of his left eye. The impact of the bullet tossed Wallace from his horse. Cyrus Dickey, Wallace's brother-in-law, and three other men carried Wallace a quarter of a mile. Thinking that he was dead, the men left him beside some ammunition crates.

Ann was told that Wallace was dead and was on ground presently under the control of the Confederate army. That night, Ann tended to the other wounded soldiers as she thought about her lost husband. "I was quite alone that fearful night. God gave me strength and I spent much of the night bathing the fevered brows and limbs of the sufferers around me," she said. "It was slight help to aid men who were suffering in the cause for which Will had given his life."

Wallace was discovered the following day, but he wasn't dead. He had been wrapped in a blanket by a Confederate soldier during the night. Wallace was rushed to Ann at the steamboat. Although weak from his wounds, Wallace recognized the voice of his wife and grasped her hand.

Wallace was taken to Grant's headquarters in Savannah, Tennessee, where Ann kept a constant vigil. On April 10, 1862, Wallace died from the wound he received at Shiloh. Ann remained devoted to her husband and never remarried.

W. H. L. Wallace was mortally wounded while trying to lead his soldiers from Hell's Hollow to avoid being surrounded.

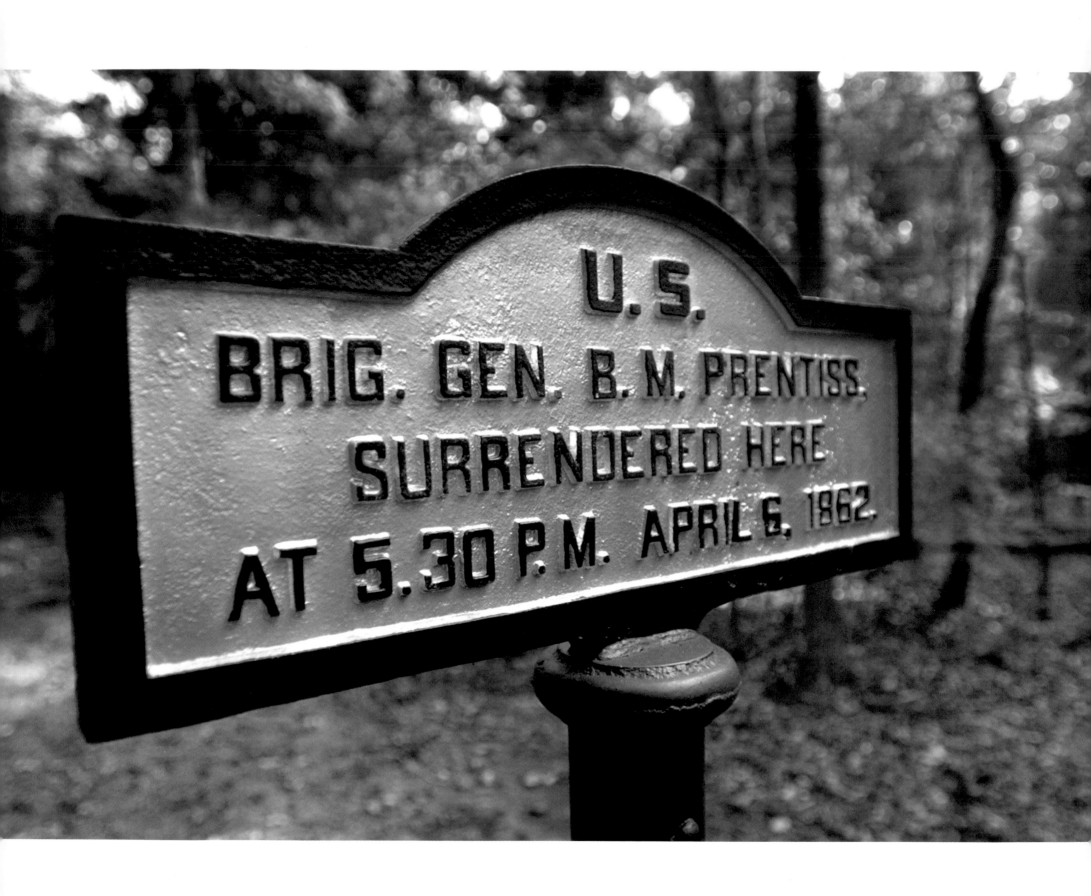

PRENTISS SURRENDER SITE

On April 6, 1862, Brigadier General Benjamin Prentiss's life-or-death struggle began with the Confederate surprise attack at Pittsburg Landing, Tennessee. By the end of the fighting, Prentiss was a prisoner of war and an unlikely hero of the battle of Shiloh.

Born in Virginia, Prentiss was a direct descendant of Valentine Prentiss, who emigrated from England in 1620. After a period of living in Hannibal, Missouri, the Prentiss family eventually made Quincy, Illinois, their home. Prior to the war, Prentiss was a rope maker, auctioneer, and lawyer. His experience in the military came from his service as a first lieutenant in the Quincy Rifles, which was organized to drive the Mormons out of Illinois. Prentiss also served in the Mexican War, earning praise at the battle of Buena Vista.

Prentiss arrived at Pittsburg Landing to take command of the 6th Division of the Union Army of the Tennessee. The division was a mixture of green regiments that had arrived in Tennessee. Since the other four divisions had taken campsites near the Tennessee River, the 6th Division marched farther inland to fill a gap in the Union lines. This unfortunate position placed Prentiss and his men directly in the path of a Confederate surprise attack.

On April 5, 1862, some of Prentiss's men reported sightings of a Confederate force in the woods beyond their camp. Prentiss ordered a patrol, but nothing was found other than some local slaves. The slaves told the Union soldiers there were large numbers of Confederate soldiers nearby.

The Confederate army surprised the entire Union army with a sudden attack. A rattled Prentiss blamed the attack on Colonel Everett Peabody, who had sent out an unauthorized patrol. That group of soldiers had discovered the Confederate army.

Pandemonium seized the Union soldiers as they ran to form a defensive line. After making an initial stand, many of Prentiss's soldiers broke and ran from the battle. The Union lines were forced to fall back to a dirt road running along Duncan Field.

Major General Ulysses S. Grant arrived to inspect the lines. He approved the position, and Prentiss recalled that he was told to "maintain that position at all hazards." For the next eight hours, Prentiss and his Union soldiers repelled charge after charge by the determined Confederate army.

After several failed charges, Confederate brigadier general Daniel Ruggles lined fifty-seven cannons along the ridge opposite from Prentiss. A violent artillery barrage ensued for the next hour. The Union soldiers tried to lie as flat as possible to avoid the shrapnel flying through the air. Lieutenant Abner Dunham of the 12th Iowa recalled the surreal experience, "Men and horses were dying, and a blaze of unearthly fire lit up the scene. At this moment of horror, when our regiment was lying close to the ground to avoid the storm of balls, the little birds were singing in the green trees over our heads!"

Brigadier General Stephen Hurlbut was forced to break his hold on Prentiss's line, calling for the Union line to retreat. Prentiss conferred with Brigadier General W. H. L. Wallace, and the two decided to hold the line and "save the army from destruction."

While the rest of the Union line began to fall back, the Confederate forces started to envelop the Union position. What they couldn't get from head-on charges, the Confederates achieved through flanking maneuvers. Some of Wallace's men were able to fight their way out of Hell's Hollow, but Prentiss was surrounded. One Union soldier summarized the situation, "We were completely surrounded and whipped but did not know it." At 5:30 P.M., Prentiss realized the futility of holding out any longer and raised a white flag. He and twenty-two hundred soldiers were taken as prisoners of war.

The Confederate soldiers cheered and celebrated the surrender of the Federal soldiers. Prentiss told his captors, "Yell, boys, you have a right to shout for you have this day captured the bravest brigade in the United States army." Prentiss was exchanged five months later.

Benjamin Prentiss was forced to surrender 2,200 soldiers after he was surrounded at the Hornet's Nest.

IOWA MONUMENT

Iowa, like most of the Northern states, answered President Abraham Lincoln's call to duty at the outset of the Civil War. Until then, most Iowans concerned themselves with the tasks at hand. They worked on farms, in factories, or on the railroad. The War Department called for one regiment from each state to help put down the Rebel insurgency. Governor Samuel Kirkwood worried whether his state could meet its quota of soldiers. Kirkwood need not have worried since Iowa produced enough volunteers to fill ten regiments.

The state of Iowa did not have an organized militia, but there were volunteer companies throughout the towns. These included some of the first men to volunteer. Unfortunately, they were "play" soldiers who called themselves Blues, Guards, Rifles, Dragoons, or Zouaves. They often dressed in gaudy uniforms and performed exhibition drills on the Fourth of July or other holidays.

Town squares were filled with volunteers. The sound of drums and fifes gave the whole state a patriotic feel. With so many volunteers, the state couldn't afford to arm or equip the newly formed regiments. Men in the state pledged money, banks offered loans, and Governor Samuel Kirkwood used his land as collateral for a loan to pay for supplies.

Women volunteered to make uniforms, bandages, and banners. Some of the first uniforms made for Iowa soldiers were gray, until it was learned that the Confederates were wearing gray.

A number of Iowans sympathized with the South. These people, usually farmers, understood the agrarian need for help to harvest a crop. Those who favored the South were called "Copperheads." Many Iowans feared what these people would do once the men marched to war. Settlers also feared the possibility of raids coming from Missouri.

Home Guards were formed in counties along the borders of the state. These Home Guards protected the citizens of Iowa from Missouri ruffians or Indians to the north.

Many Iowa units accompanied Major General Ulysses S. Grant's various campaigns to gain control of the Mississippi River. Iowans fought at Fort Henry, Fort Donelson, and Shiloh. The 2nd,

3rd, 6th, 7th, 8th, 11th, 12th, 13th, 14th, 15th, and 16th Iowa infantries fought at Shiloh. Five Iowa regiments (the 2nd, 7th, 8th, 12th, and 14th) allowed Grant to form a defensive line by holding the center of the Union line at the Hornet's Nest. Many of these Iowa soldiers were taken prisoner when they were surrounded and forced to surrender to the Confederate army.

Victories at Shiloh and Corinth opened the way for Grant to begin his Vicksburg campaign. This campaign, along with defeat at Gettysburg, dashed any hope for a Confederate victory.

In the spring of 1864, thousands of Iowans took part in General William Tecumseh Sherman's famous March to the Sea through Georgia and South Carolina.

The Iowa state monument at Shiloh stands near Grant's final line, with a solitary column reaching skyward. On the eastern portion of the monument, a woman inscribes: *Brave Of The Brave, The Twice Five Thousand Men Who All That Day Stood In The Battle's Shock, Fame Holds Them Dear, And With Immortal Pen Inscribes Their Names On The Enduring Rock.*

By the end of the war, Iowa had produced the highest percentage of volunteer enlistments of any state, North or South. Iowa provided forty-eight infantry regiments, nine cavalry regiments, and four batteries of artillery. Iowa also furnished one black regiment and a thousand replacement troops. Of Iowa's seventy-six thousand soldiers, twenty-seven received Congressional Medals of Honor. Approximately thirteen thousand Iowa soldiers died. More of these men died from disease than from bullet wounds.

When the soldiers came marching home, Governor Kirkwood said of his state, "When this war began, ours was a new state without a history. Today her name stands on one of the proudest pages of our country's history graven there by the bayonets of our brave soldiers."

The Iowa state monument stands near the position of Ulysses S. Grant's last line of defense at Shiloh.

WINFIELD STATHAM'S BRIGADE

With victory in reach, Colonel Winfield Statham's brigade answered the call of Confederate general Albert Sidney Johnston for one last bayonet charge.

Statham's brigade gathered among the trees south of Sarah Bell's cotton field. The brigade was a mixture of Mississippians and Tennesseans, with Statham commanding the 15th and 22nd Mississippi and the 19th, 20th, 28th, and 45th Tennessee infantries.

As the brigade deployed, all around the men were signs of the vicious fighting that had occurred earlier in the day at Shiloh. For A. H. Mecklin, the battlefield was a revolting sight: "On all sides lay the dead and dying. It was very warm. The sky was clear and but for the horrible monster of death . . . this might have been a pleasant Sabbath morn."

By midmorning, Statham's brigade occupied the camp of the 71st Ohio. Waiting for the Confederates on the other side of Sarah Bell's cotton field was Brigadier General Stephen Hurlbut's Union division. Hurlbut's depleted command was positioned on the Hamburg-Savannah Road. He had already sent Colonel James Veatch's brigade to aid Brigadier General William T. Sherman. As he faced the Reserve Corps of Major General John C. Breckinridge, another cry for assistance came from Brigadier General Benjamin Prentiss at the Hornet's Nest. Knowing he was about to be attacked, Hurlbut lined his men on the northern edge of the cotton field.

Statham's brigade, supported by Captain Arthur Rutledge's Tennessee Battery, formed alongside the brigade of Brigadier General John A. Bowen. With a Rebel yell, the Southerners raced across the open field toward Hurlbut's men. The Federals poured forth a devastating fire, causing the Mississippians to regroup. After several repulses at the hands of the Union army, the 15th Mississippi sought cover in a wooded "mule lot" on the southern edge of the field.

Johnston rode over to the 15th Mississippi to observe the ongoing fight. Edward Munford, an aide who was with Johnston, described the scene: "I saw our line beginning to stagger, not give back, but waiver along its whole length like small grain when struck by a breeze." Johnston noticed the wavering Confederate lines and the strong defense of the Union army. "Those fellows are making a stubborn stand here," Johnston said. "I'll have to put the bayonet to them."

At this moment, a flustered Breckinridge informed Johnston he couldn't get Statham's Tennesseans to attack. Johnston personally appealed to the Tennesseans to do their duty. As he rode among the soldiers, Johnston tapped their bayonets with a tin cup stating, "These must do the work."

As Statham's brigade raced across the cotton field and into the Peach Orchard, the soldiers of the 41st Illinois got up and ran, leaving Battery A of the 1st Illinois Light Artillery to fend for themselves. The battery crew grabbed the tail of the cannons, pulling them to the rear, while all around them "minié balls were falling like hail."

Johnston's spirited bayonet attack forced the brigades of Brigadier Generals David Stuart and John McArthur, along with Hurlbut's division, to fall back, exposing Prentiss's flank at the Hornet's Nest. At this moment, the Union army was falling back in disarray.

The Confederate army wheeled to the west and surrounded the Hornet's Nest and Prentiss. This action gave the remaining soldiers of Major General Ulysses S. Grant's Army of the Tennessee time to regroup and form a last line of defense.

During this charge, Johnston was mortally wounded by a stray minié ball that struck the general behind his right knee. The ball clipped Johnston's artery, causing him to die from the loss of blood.

Statham's brigade participated in the capture and surrender of Prentiss's division. Later that day, they occupied the heights overlooking the Tennessee River.

After Shiloh, Statham's brigade served in defense of Vicksburg, Mississippi, in the army of Major General Earl Van Dorn during the naval bombardment of June–July 1862.

Winfield Statham's brigade participated in Albert Sidney Johnston's last charge at Shiloh.

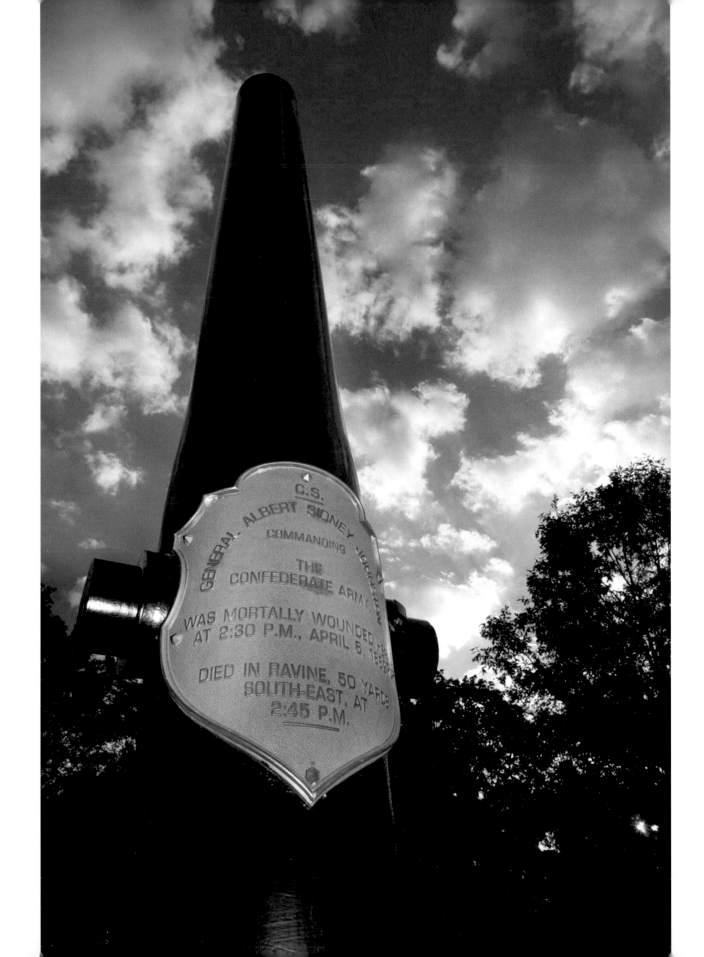

JOHNSTON'S DEATH

After a daylong fight, General Albert Sidney Johnston's Confederate army was within sight of the Tennessee River. Only a few more spirited assaults would win the day for the Southern soldiers.

Throughout the day, Johnston led from the front, while General P. G. T. Beauregard, at the Shiloh Meeting House, tried to keep the fight organized. The original battle plan called for pushing the Union army into the flooded bottoms of Owl Creek. Once the fight started, the sweeping attack became a headlong push. Instead of pushing to Owl Creek, Johnston's Army of the Mississippi had nearly forced Major General Ulysses S. Grant's Union army into the Tennessee River.

After achieving initial success, the Confederate army met a stubborn foe at a piece of sunken road the Confederate soldiers renamed the Hornet's Nest. Johnston was on the Confederate right, along with Brigadier General John Bowen's brigade.

Johnston sought to push the Federals out of the Peach Orchard. In doing so, he had to personally rally exhausted troops. Brigadier General John C. Breckinridge rushed to Johnston, telling him a brigade refused to make the charge. Johnston told Breckinridge he would help him rally the soldiers.

The soldiers were huddled at the foot of a ridge. Johnston rode among the men, tapping their bayonets with a tin cup. "Men! They are stubborn; we must use the bayonet," Johnston said. He spurred his horse, Fireater, forward, shouting, "I will lead you."

The once dispirited soldiers surged forward behind their leader. One Union officer described the scene, "On they came with a quick step in gallant style, without firing a gun, the Stars and Bars flaunting jauntily in the breeze . . . as bold and defiant a battle flag as one could wish to meet in battle's stern array. It seemed almost barbarous to fire on brave men pressing forward so heroically into the mouth of Hell."

The successful Confederate charge pushed the Union soldiers back to the Sunken Road. An elated Johnston reined his horse while talking to Tennessee governor Isham Harris. "Governor,"

he said, "they came very near putting me hors de combat in that charge." Johnston showed Harris his flapping boot.

Johnston began to dispatch his officers with orders for more fighting. Unknown to all around, Johnston was seriously wounded. A minié ball had struck the general behind his right knee.

Harris returned from taking an order to Colonel Winfield Statham and found a pale Johnston reeling in his saddle. Harris grabbed Johnston, asking, "General, are you wounded?" Johnston replied, "Yes, and I fear seriously."

Harris and Captain W. L. Wickham led Johnston to a place of relative safety and helped him from his horse. Harris immediately sent for Johnston's physician, Dr. D. W. Yandell, who had been ordered by Johnston to treat wounded soldiers of the 18th Wisconsin.

The men frantically searched for a wound. Johnston had a leg wound they deemed minor, but his boot was full of blood. A minié ball had nicked the artery in Johnston's leg, causing him to lose too much blood.

It was the same leg Johnston had wounded in 1836 during a duel. That hip wound damaged his sciatic nerve, causing Johnston to not have feeling in his right leg all of the time. At Shiloh, he didn't know he was wounded until it was too late.

With his men hovered over him, Johnston died. At that moment, command of the Army of the Mississippi shifted to Beauregard, who was in the rear, far from the front.

Tragically, Johnston's wound would not have been fatal if a tourniquet had been applied. One was found in the pocket of Johnston's coat.

Johnston's body was initially taken to Beauregard's headquarters. By that evening, Johnston's body was in Corinth, Mississippi.

Johnston was buried in New Orleans, but was later reinterred at Austin, Texas.

Albert Sidney Johnston died after a minié ball clipped an artery in his leg. A tourniquet was discovered in his jacket pocket. He could have lived if the tourniquet had been applied.

GRANT'S LAST LINE

During the late afternoon of April 6, 1862, Adolph Schwartz's battery was rushed to a location on the Union line. The men from Illinois were becoming a part of Major General Ulysses S. Grant's last line of defense at Shiloh. The line ran at a right angle to the Tennessee River and parallel to Dill Branch, along the ridge of Pittsburg Landing and toward the important Hamburg-Savannah Road crossing Snake Creek. The landing had to stay secure to allow for reinforcements from across the river. The bridge was essential in order for Major General Lew Wallace's wayward division to finally arrive. If this last line wavered in any way, Grant's Army of the Tennessee would be pushed into the Tennessee River.

Schwartz's battery, also known as Battery E, 2nd Illinois Light Artillery, was in the battalion of Major Adolph Schwartz. The mainly German battery had fought gallantly trying to hold the line with Major General John A. McClernand's division.

McClernand's line had disintegrated under the intense pressure of the Confederate attack. Colonel Julius Raith sought to rally the soldiers near a lone battery. These guns happened to be Schwartz's battery.

Schwartz's battery was originally a Missouri unit raised in St. Louis. Being a good friend of McClernand, Schwartz was assigned to McClernand's division. Upon the first sound of gunfire on April 6, 1862, Schwartz rushed his guns to support Brigadier General William T. Sherman's line.

When Sherman's men fell back, Schwartz's guns went with them, except for one gun that had been left in the fray. Schwartz's guns were repositioned at the crossroads of the Hamburg-Purdy Road and the Pittsburg-Corinth Road. With his guns loaded with canister, Schwartz readied to deliver his deadly load. Raith rallied his men around Schwartz's battery.

Mississippi infantry under the command of Colonel A. K. Blythe slammed into the Union line. Schwartz delivered a galling fire of canister that staggered the Confederate advance. Blythe was one of the first to fall. An iron ball about an inch in diameter had pierced the heart of the Mississippian.

Only momentarily stunned, the Confederate line continued to advance. The Union line began to fall back, but Schwartz was determined not to lose his guns. Schwartz personally led the 17th Illinois Infantry to slow the Rebel tide. In the midst of the fighting, he was shot in the leg. With Schwartz taken from the field, the battery still had one gun to save.

Lieutenant George Nispel, along with five artillerymen, rushed to save the gun. They were reduced to dragging the gun to the rear since all their horses had been killed or wounded. With the Confederates hot on their heels, Nispel was forced to spike the cannon and fall back to a new Union line.

As Grant rushed to make one last line, Schwartz's battery, now under the command of Nispel, was positioned at the far left of the line. While the line formed, the battle raged around them. A sense of doom swept over many of the Union soldiers. One Iowa soldier wrote: "As far as the eye could reach, through the woods and over the fields for at least a mile, our line of battle was in full retreat. . . . It was a scene of confusion and dismay . . . an army degenerating into a rout."

Through it all, Nispel's and Schwartz's battery had held as reinforcements arrived. A relieved Grant was grateful to see the reinforcements but inwardly was angry at Wallace. It had taken Wallace most of the day to march from his position at Crump's Landing, only six miles away.

As Grant's last line held for the rest of the afternoon, the grizzled general began thinking of victory. He likened the Union situation to the same predicament his army experienced at Fort Donelson. As the sun set on that Sunday evening, Union victory was only hours away.

Grant later wrote, "Victory was assured when Wallace arrived, even if there had been no other support. The enemy received no reinforcements. He had suffered heavy losses in killed, wounded, and straggling, and his commander, General Albert Sidney Johnston, was dead."

Ulysses S. Grant set up a last line of defense on a ridge near Pittsburg Landing in an effort to stop the advancing Confederates.

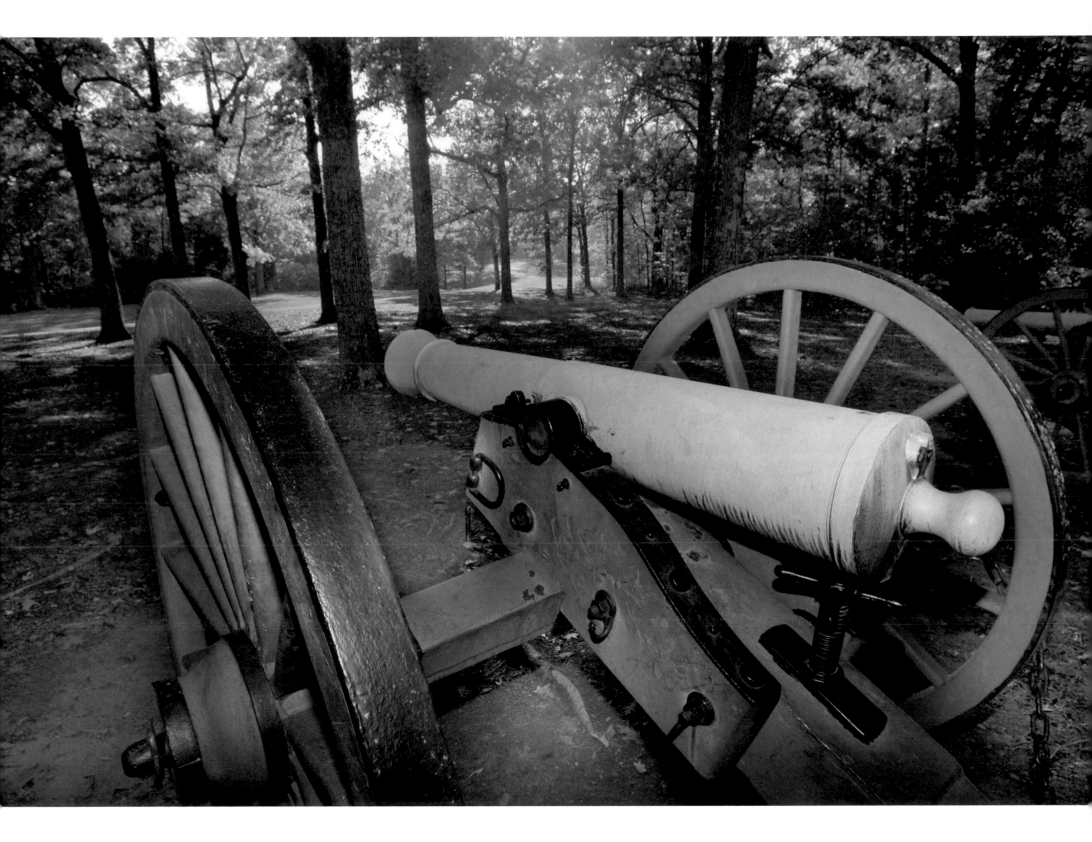

THE LAST ASSAULT

The daylong Confederate attack at Shiloh had almost reached the ultimate goal. Ulysses S. Grant's Federal army was on its last line of defense. One final Confederate assault could push Grant's army in a headlong flight down the steep hills and into the Tennessee River.

Grant's defensive line stretched a mile and a half, from the Tennessee River along a ridge overlooking a deep ravine at Dill Branch to the Hamburg-Savannah Road.

On the morning before the battle, General Albert Sidney Johnston had told his Southern army, "Tonight we will water our horses in the Tennessee River." Johnston had tragically died when a minié ball severed the artery in his leg just above his boot. Command of the Southern army passed to General P. G. T. Beauregard.

Braxton Bragg tried to align as many Confederate soldiers as possible for one final assault. During the day's fighting, Bragg had sent many a gray-clad soldier to his death with repeated frontal assaults at the Hornet's Nest. It wasn't until Daniel Ruggles amassed fifty-seven cannons to pummel the Union lines that the Hornet's Nest was taken. The combination of Ruggles's cannons and the Confederate infantry finally convinced the Federals to retreat or surrender.

While Grant was forming his last line of defense, he worried about the whereabouts of Lew Wallace's division. Grant had expected the wayward Wallace to arrive at any moment for most of the day. Wallace had taken the wrong route at Stoney Lonesome and was marching a long route to Shiloh. Wallace wouldn't arrive until the first day's fighting was complete.

Colonel Joseph D. Webster, Grant's chief of staff, assembled a line of artillery using reserve batteries and siege guns, and placed additional batteries into place as they fell back from forward positions. By 5 P.M., Webster had more than forty guns ready for the Confederate assault. Approximately eighteen thousand Union soldiers, who had fought for most of the day, filled the lines around the guns.

Union gunboats *Tyler* and *Lexington* were on the Tennessee River at the mouth of Dill Branch. The boats hurled their thirty-two-pound and sixty-four-pound shells along the Dill Branch ravine. The Confederates had to weather a storm of cannon balls to make their final charge.

Bragg was certain a final assault would destroy Grant's army. He chose the brigades of James R. Chalmers, Zachariah Deas, Patton Anderson, and John K. Jackson to make the assault. By 5:30 P.M., the Confederate soldiers stepped from their lines and began a steady march toward the Union lines.

For George McBride of the 15th Michigan Infantry, the marching Confederate soldiers presented an awe-inspiring vision. "A grander sight no man ever saw than this coming of the Confederate army," McBride said.

Webster's line and the Union gunboats unleashed a deadly salvo on the approaching Rebel soldiers. If the natural defensive position wasn't enough of an obstacle, many Southern soldiers advanced with bayonets alone. They had long since exhausted their ammunition during the day's fighting.

At best, the Confederate charge was piecemeal, as only Chalmers's and Jackson's men advanced far enough to encounter the Federal infantry. Chalmers's and Jackson's men began to pull back, and Bragg was surprised to see the remaining Confederate army pulling back, too.

Unknown to Bragg, Beauregard had ordered the Army of the Mississippi to halt and withdraw out of range of the Union guns. Beauregard thought Grant's army was whipped and that they could be finished off the following day.

Beauregard told his subordinates that "the victory is sufficiently complete." Upon receiving these orders, Bragg bitterly complained, "Was a victory ever sufficiently complete?"

This ended the first day of fighting at Shiloh. Later in the evening, Wallace finally arrived along with reinforcements from Don Carlos Buell. Later in life, Grant wrote, "Victory was assured when Wallace arrived, even if there had been no other support."

Before P. G. T. Beauregard stopped the final push on the Union lines, Braxton Bragg was forming the Confederate soldiers for one final assault on the Union lines.

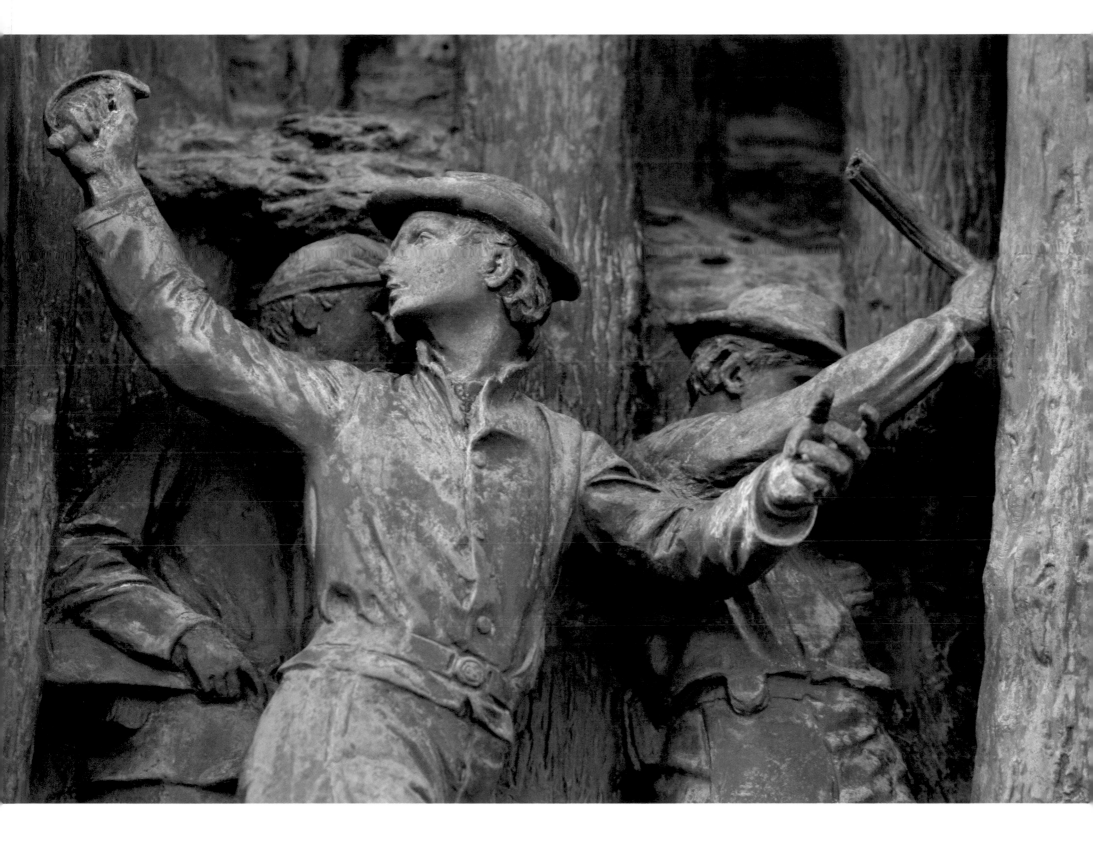

BULL NELSON'S MUD MARCH

Brigadier General William Nelson's journey to the battlefield of Shiloh was a long, muddy affair. Undaunted, the arrival of the burly general's division helped stabilize a dire situation at Pittsburg Landing, Tennessee.

Nelson, known as "Bull" to his soldiers, was an intimidating man in many aspects. Standing six feet four inches tall and weighing more than three hundred pounds, his overbearing size matched his quick temper.

Nelson's forces were the vanguard of Major General Don Carlos Buell's Army of the Ohio. The deliberate Buell was moving from Nashville toward Savannah, Tennessee. Major General Ulysses S. Grant was waiting in Savannah for the two armies to unite and advance on the Confederate army in Corinth, Mississippi.

Buell's journey to Savannah was slow, as his army repaired bridges along the way. While Buell's men were working on the Duck River Bridge, Nelson convinced Buell to let him ford the river and keep advancing to Savannah. To cross the Duck River, Nelson's men had to wade the cold water with their cartridge boxes secured around their necks.

Crossing the Duck River was one final hurdle to clear before Nelson began the last leg of the march to Savannah. The blue-clad soldiers formed a forty-mile-long line as they marched through driving rain to Savannah. Nelson's advance guard arrived in Savannah the morning of April 5, 1862, and the rest of his men arrived the following day.

Grant told Nelson to rest since he had no transports to take Nelson upriver to Pittsburg Landing. Nelson pressed the matter, but Grant was confident there was no attack looming. Unknown to Grant was the fact that Buell arrived in Savannah that same night. The following morning, Grant's breakfast was ruined by the sound of sporadic artillery fire at Pittsburg Landing.

Grant hurriedly boarded the *Tigress* to take him upriver to Pittsburg Landing. Before leaving, he sent orders for Nelson to obtain a guide and to march his division on the east side of the river to a site opposite of Pittsburg Landing. Once there, Grant would provide transport across the Tennessee River.

Guides did not arrive, and Nelson sent his own men out looking for a route to march. The river had flooded the main road, so a route farther from the river was chosen. The route took Nelson's men through marshes and cotton fields. The mud of the marshes was particularly thick. Soldiers marching in columns of four, sometimes two, worried about losing their shoes in the muck.

Knowing that Grant's army was in jeopardy, Nelson kept pushing his men to march as quickly as possible. After three hours of thankless marching, Nelson's men emerged on the bank opposite Pittsburg Landing. What these men saw from the bank was astounding.

The scene around Pittsburg Landing was one of utter bedlam. The soldiers who had fled at the first sight of the Confederate army were huddled on the river's edge. Some men had drowned trying to swim across to escape the Southern army.

As the boats crossed the river, Nelson could see thousands of soldiers who had given up the fight. These skulkers warned of impending doom and tried to board any vessel crossing the river. An irritated Nelson bellowed, "Damn your souls, if you won't fight, get out of the way and let men come here who will!"

Buell and his officers were astonished to see Grant's army in such disarray. Samuel Buford, an aide to Nelson, said later, "If we hadn't come to his [Grant's] relief when we did, his entire army would have been taken prisoners."

The following day, Buell and Grant, acting independently of each other, launched their own counteroffensive that ultimately drove the Confederate army back to Corinth.

William "Bull" Nelson's soldiers marched through cotton fields, mud, and swamps to reach Pittsburg Landing.

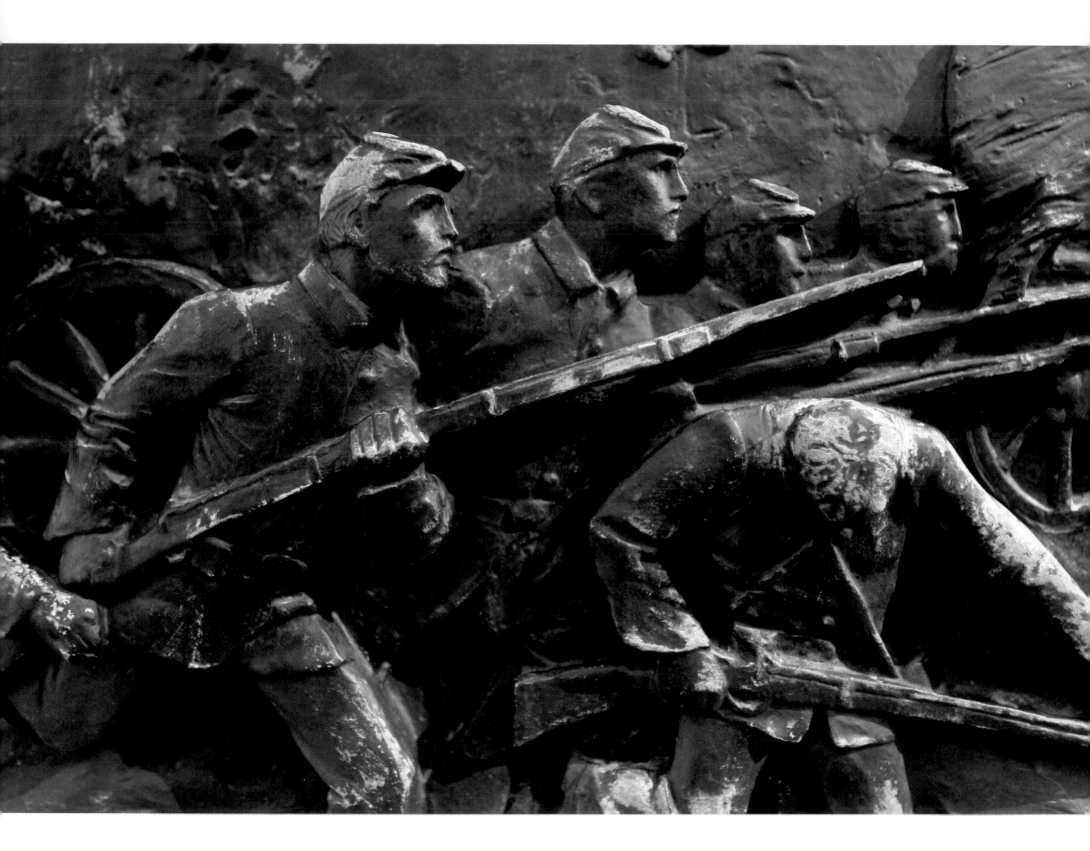

DON CARLOS BUELL ARRIVES

During the evening of April 6, 1862, at Shiloh, Ulysses S. Grant knew he had help on the way. The arrival of Lew Wallace's wayward division and Don Carlos Buell's Army of the Ohio gave Grant an influx of fresh soldiers and an opportunity to go on the offensive at Shiloh.

Grant's army had stopped at Savannah, Tennessee, to wait for Buell, and they made camp at Pittsburg Landing. Major General Henry Halleck wanted to unite Grant's and Buell's armies for the eventual approach to Corinth, Mississippi. While waiting on Buell, Grant's unsuspecting army was attacked by General Albert Sidney Johnston's Army of the Mississippi. The vicious fighting at Shiloh had cost Grant dearly in loss of life.

The wounded and dying lay scattered across the fields of Shiloh. The screams of the wounded could be heard through the torrents of rain and shelling from the gunboats *Lexington* and *Tyler*. As his soldiers were ferried across the Tennessee River, Buell was horrified to see the condition of Grant's army. Scores of defeated soldiers huddled along the riverbank looking for an opportunity to escape from the death at Shiloh.

Ambrose Bierce of the 9th Indiana Infantry crossed the Tennessee with William "Bull" Nelson's division and said of the skulkers, "All the camp-following tribes were there; all the cowards; a few officers. Not one of them knew where his regiment was, nor if he had a regiment. Many had not. These men were defeated, beaten, cowed. They were deaf to duty and dead to shame. A more demented crew never drifted to the rear of broken battalions."

Confederate colonel Nathan Bedford Forrest watched intently as Union soldiers crossed the Tennessee River. Forrest had yet to reach his near immortal status as a Southern general, but the man with an uncanny knack for military strategy and commonsense solutions saw doom for the Confederate army.

On the evening of April 6, 1862, Forrest sent a detachment of scouts to reconnoiter the Federal lines. Forrest's men were dressed in Federal overcoats they had taken from Union camps during the first day's fighting at Shiloh. His men discovered that Buell's army was arriving at Pittsburg Landing.

Forrest realized the importance of this intelligence and rode to the rear, looking for the nearest corps commander. He found Major General William Hardee and Brigadier General John C. Breckinridge and told them the news of Federal reinforcements. Forrest told Hardee, "If this army does not move and attack them between this and daylight, it will be whipped like hell."

Hardee instructed Forrest to take his information directly to General P. G. T. Beauregard, who had taken over the Army of the Mississippi when Johnston was killed leading a charge.

Beauregard had used the Shiloh Church as a headquarters but had relinquished the structure so it could be used as a hospital. Unknown to Forrest, Beauregard had retired for the night in the captured tent of Brigadier General William T. Sherman.

Forrest returned to his cavalry outposts, only to find that the reinforcements had continued to arrive while he was gone. Once again, Forrest brought this information to Hardee. Forrest was told to go back to his regiment and maintain a vigilant watch, reporting all hostile movements.

Forrest returned to his outpost and waited for the sun to rise on another day's battle. True to his prediction, the Army of the Mississippi was overwhelmed by the combined forces of Buell and Grant. The Union army reclaimed ground they had lost the previous day. The Confederate army went from having victory in its grasp to a disheartened retreat back to Corinth.

Buell maintained his timely arrival saved Grant from an inglorious defeat. This assertion added to the growing rift between the two generals. Six months after Shiloh, Buell was removed from command after he failed to pursue a defeated Braxton Bragg at Perryville, Kentucky. He was replaced by William Rosecrans.

Six months after Shiloh, Rosecrans faced Earl Van Dorn's Confederate army at Corinth.

As Don Carlos Buell's army arrived at Shiloh, Nathan Bedford Forrest watched the Union army being reinforced from the Indian mounds overlooking the Tennessee River.

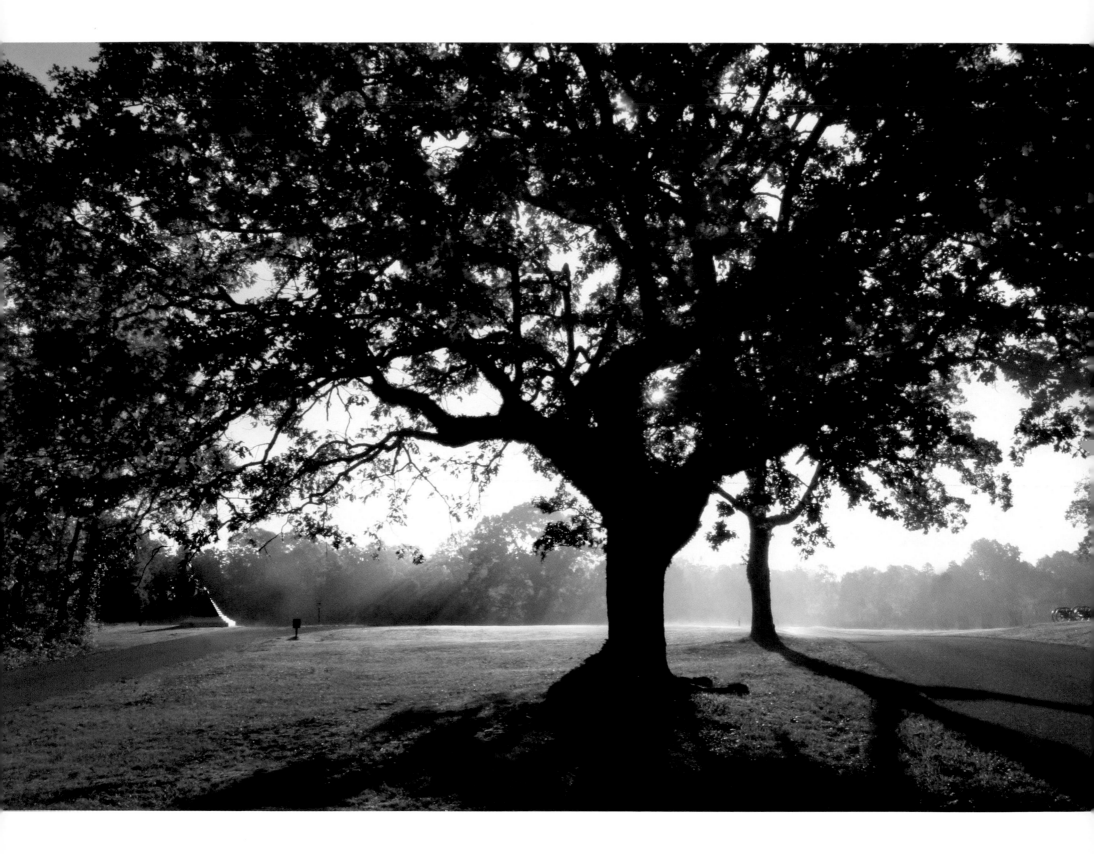

MILITARY HOSPITAL

During the day of April 6, 1862, and throughout the night, the need for medical attention for the wounded and dying soldiers at Shiloh was critical. Field hospitals were established along the battlefield to help care for the fallen soldiers.

Hospitals on the battlefield were usually located in a barn, a home, or a tent to the rear of the fighting. The wounded were usually triaged into three categories: mortally wounded, slightly wounded, or surgical cases. The most common surgery on a Civil War battlefield was amputation.

For Major General Ulysses S. Grant's army, the rear was a hard thing to find. The Army of the Tennessee was almost pushed into the Tennessee River during the first day's fighting. Surgeons worked frantically trying to tend to the wounded as minié balls whizzed past doctor and patient. Behind Brigadier General William T. Sherman's lines, the wounded were hit where they lay waiting for medical help. One wounded man fed up with the incessant fire said, "Captain, give me a gun, this damn fight ain't got any rear."

The medical officers faced the daunting task of caring for the 16,400 wounded. Many were crowded onboard the steamboats docked at Pittsburg Landing. Some of these wounded were transported back to Savannah, Tennessee, and placed in area homes and buildings. Others were shipped to Northern cities.

On the high ground near Noah Cantrell's farmhouse, medical officers of the Army of the Ohio set up a large field hospital using tents, bedding, and supplies that were found in various camps on the battlefield. Housing twenty-five hundred sick and wounded soldiers, this tent hospital was the forerunner of modern military field hospitals. The site where the field hospital was located is at Tour Stop 11 near the 71st Ohio Infantry marker.

While the scenes of the battlefield were bad, the night of April 6, 1862, was horrific. Neither army, North or South, had an organized means to gather the wounded. Tragically, most of the wounded lay on the battlefield throughout the night. For many, their last moments on earth were spent lying on a desolate field crying for water and thinking of home. Wilbur Crummer heard the shrieks while resting in the safety of the Union lines. "Some cried for water, other for someone to come and help them," he said. "God heard them, for the heavens opened and the rains came."

If the elements, the wounds, and the sense of being alone weren't enough, wounded soldiers had to contend with hogs that roamed the battlefield feasting on the dead and wounded. Many of the wounded crawled near each other so they could keep warm in the cold rain.

Colonel Julius Raith was one of the soldiers left on the field of Shiloh. Command was thrust upon Raith due to the fact that Colonel Leonard Ross was absent from the brigade when the battle began. Colonel James Reardon was in charge but too sick to command. Raith was the next in line. He commanded a brigade in Major General John McClernand's division.

Raith's defensive line was near Water Oaks Pond. He desperately tried to hold the line while the rest of the Union line disintegrated. While standing with the 43rd Illinois, a minié ball slammed into the Raith's thigh. The destructive force of the ball broke Raith's femur, exposing the bone.

Raith ordered his men to leave him, and they placed him next to a tree. For the next twenty-four hours, Raith sat in agony. He fell behind Confederate lines. The Southern soldiers picked his pockets but otherwise left him alone.

He was discovered the next evening after the Union army reclaimed the ground lost on the previous day. The soldiers rushed him to a hospital, where his leg was amputated above the knee. Due to the loss of blood and shock of that night, Raith died on April 11, 1862.

Sherman was deeply touched by the suffering of the soldiers. He wrote his wife, "The scenes on this field would have cured anyone of war."

Field hospitals were employed after the fighting at Shiloh in an attempt to save wounded soldiers. One hospital was located near this tree on the Union left.

HEADQUARTERS
GENERAL U. S. GRANT.
NIGHT OF APRIL 6, 1862.

GENERAL GRANT IN HIS MEMOIRS SAYS:
"DURING THE NIGHT RAIN FELL IN TORRENTS AND
OUR TROOPS WERE EXPOSED WITHOUT SHELTER.
I MADE MY HEADQUARTERS UNDER A TREE A FEW
HUNDRED YARDS BACK FROM THE RIVER BANK."
THE LARGE OAK TREE REFERRED TO, STANDING
WHERE THIS MARKER NOW STANDS, WAS DE-
STROYED BY CYCLONE OCTOBER 14, 1909.

LICK 'EM TOMORROW

Major General Ulysses S. Grant was having breakfast at the William. H. Cherry mansion when the first sounds of the battle of Shiloh echoed nine miles away. Grant rose from the table and calmly said to his staff, "Gentlemen, the ball is in motion, let's be off." With that, Grant left for the battle of Shiloh.

Prior to the Civil War, Grant had been a failure in everything he tried. Born Hiram Ulysses Grant, his arrival at the U.S. Military Academy brought about a name change. Congressman Thomas Hamer mistakenly nominated Grant to West Point as Ulysses Simpson Grant. Hamer used the name "Simpson" because it was Grant's mother's maiden name. Unable to change the bureaucratic paperwork, Grant accepted his new name. His classmates at West Point simply referred to him as "Sam."

Grant was an excellent horseman but didn't relish military service. The future general couldn't stomach the sight of blood. During the Mexican War, Grant was a quartermaster, which should have kept him from the front. Once the boom of cannons was heard, the excitement of battle usually lured Grant to the thickest fighting.

After the Mexican War, Grant married Julia Dent. Grant was ordered to California, but his longing to be with his wife and children led to a lonely time in the West. Being miles away from his family sent Grant into a period of depression, which led to drinking. Rumor spread throughout the army that Grant was a drunk.

On July 31, 1854, Grant resigned from the army and returned to his family. For the next seven years, Grant would move from one failed venture to another. At the start of the Civil War, Grant was working as a clerk at his father's store in Galena, Illinois.

At the outset of the Civil War, Grant served as a muster officer. He was given the rank of colonel and command of the 21st Illinois Infantry. His early work with the 21st caught the attention of Governor Richard Yates and Congressman Elihu Washburne, who named him one of four brigadier generals for the state of Illinois.

The success at Fort Henry and Fort Donelson catapulted Grant into the unwanted role of national hero. Now, two months later, Grant's Army of the Tennessee had been caught completely by surprise.

Grant was still hobbling from a fall from his horse. After Grant had visited Pittsburg Landing on April 4, 1862, his horse slipped on some mud and fell on the general. With a severely sprained ankle, Grant had to use crutches whenever he walked. Although the crutches were lashed to his horse, he usually stayed in the saddle to keep from walking.

During the fighting at Shiloh, Grant displayed a calm in battle when all else was chaos. One soldier saw Grant while the Confederate army was making its final push on the first day at Shiloh: "In a word it was pandemonium broken loose. The enemy was advancing in lines of battle that reminded me of waves rolling in on the beach. Yet, in all this chaos . . . General Grant sat on his horse like a statue, watching the enemy's movement as the wreck of his army drifted by." It was at this point that Grant was overheard talking to himself, "Not beaten yet by a damn sight."

The night of April 6, 1862, was miserable for both armies. A driving rain brought cooler temperatures to soldiers who were forced to sleep in the elements. Grant stayed at Pittsburg Landing, quietly thinking. A lone log cabin was made his headquarters, but it was quickly turned into a hospital. Not liking the sight of blood, Grant returned to a large tree on the bluff.

Under the tree, Grant sat in the rain with his hat pulled down low and his coat collar pulled up under this chin. As he sat there, Grant began to smoke one of his cigars.

Sherman was walking through the soldiers resting at Pittsburg Landing. Beaten soldiers huddled near the Tennessee River, not willing to return to the fight. The moans of wounded soldiers echoed from the battlefield and makeshift hospital.

Sherman saw his friend and said, "Well, Grant, we've had the devil's own day, haven't we?" Grant looked up and replied, "Yes, lick 'em tomorrow though."

Ulysses S. Grant sat under a tree after the first day of fighting at Shiloh. The location of the tree Grant sat under is in the Shiloh National Cemetery.

BLOODY POND

The grisly fighting that was the first day at Shiloh changed to a night of horrors once the sun set. The woods, fields, and orchards that surrounded Shiloh were turned into one massive killing field. Shallow ponds situated between the two warring armies became a haven for wounded and dying soldiers from both North and South.

As the day gave way to night, soldiers on the battlefield looked for a respite from the fighting. As if offering tears from above, a driving rain began to fall on the soldiers. The Union gunboats *Lexington* and *Tyler* joined in the deluge with the methodical boom of shelling.

The shelling was intended to keep the Confederate soldiers awake all night and hopefully lessen their resolve to fight. Confederate brigadier general Patrick Cleburne reported that although shells fell near his men, the majority of them fell on wounded Federal soldiers. Cleburne said, "History records few instances of more reckless inhumanity than this."

For the wounded and dying in the no-man's-land between the lines, the night was one of special torment. Groans from the soldiers blinded by pain and an incurable desire for water were intolerable. For the living, it was a night most would not soon forget.

Joseph D. Thompson of the 38th Tennessee remembered the night of April 6, 1862: "Oh what a night of horrors. It will haunt me to the grave."

Union soldiers recalled the ghastly scene near a log cabin at Pittsburg Landing. The structure had been converted into a hospital. From the inside, screams and painful moans filled the air. Outside, a cart filled with amputated arms and legs waited for another deposit.

Many of the Union soldiers thought they had been defeated by General Albert Sidney Johnston's Army of the Mississippi. Even though Johnston had been killed leading a Confederate charge near the Peach Orchard, victory seemed inevitable to the Southern soldiers.

For the wounded and dying, attack and victory were the last things on their minds. Thoughts of home and family were foremost considerations, as was the need for water. Shallow ponds attracted the weary and wounded soldiers of both armies. Union and Confederate soldiers alike drank and bathed their wounds, seeking comfort with a sip of water.

Years after the battle, a local farmer told of walking by a pond a few days after the battle and seeing it stained with blood. After the battle, the water was said to have turned red from the soldiers' blood. The pond is located north of the Peach Orchard. Today, historians question the validity of the farmer's claim of a blood-soaked pond.

Even today, there is no mistaking the fact that Bloody Pond can turn red when the sunlight strikes the water at a certain angle. Is this because of the red clay underneath the waters, or does the red hue come from the blood of soldiers wearing blue and gray?

Whether the pond was a picture of death and destruction is anyone's guess. Now, the pond offers a place of refreshment for area wildlife. Fish can be seen darting about just underneath the surface of the water. Deer sipping the cool water at sunset and sunrise paint a tranquil setting for a battlefield known for unspeakable carnage.

Bloody Pond has been a popular stop on the Shiloh driving tour. Years after the battle, a local farmer claimed the water was turned red by soldiers' blood. Today, the pond is a popular source of water for area wildlife.

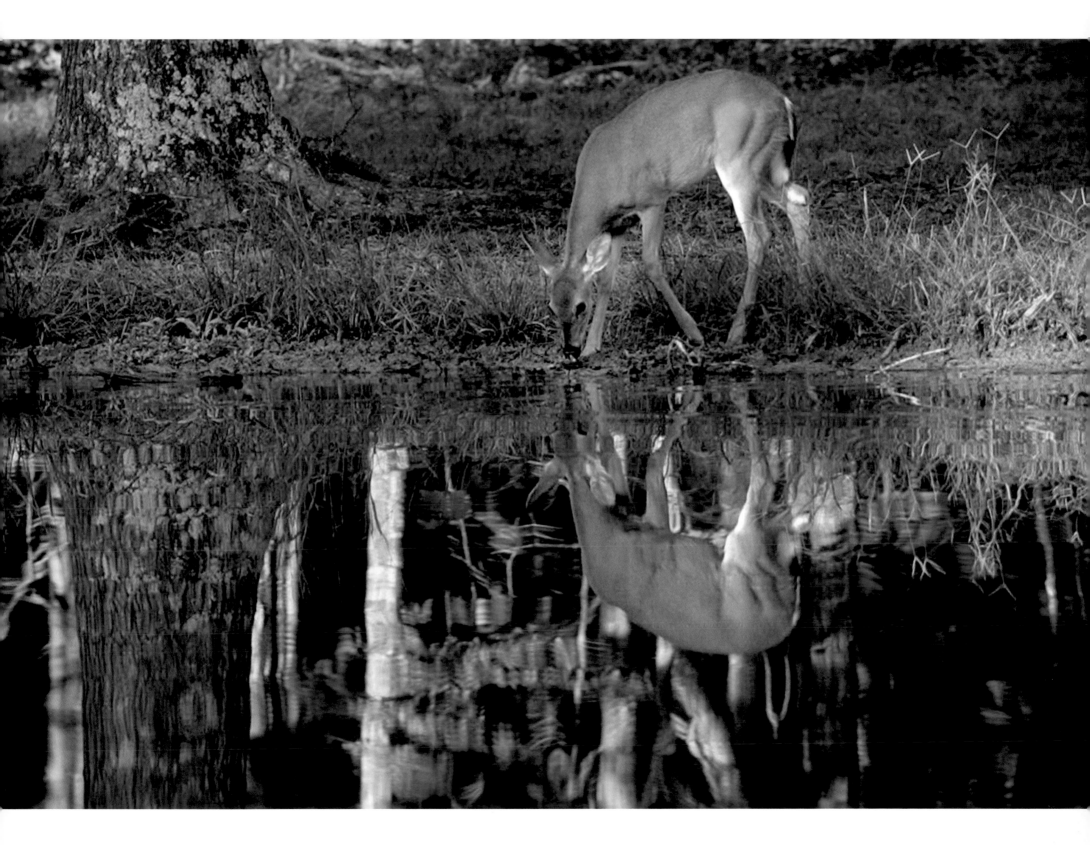

JOHN D. PUTNAM STUMP

The second day at Shiloh promised more than just marching for Private John D. Putnam and the 14th Wisconsin Infantry. While the first day was nothing but marching, the 14th Wisconsin, an unassigned unit of Major Ulysses S. Grant's Army of the Tennessee, was on the front line of the Union advance at Shiloh.

The early spring warmth of Tennessee was different from Putnam's native Wisconsin. Putnam hailed from De Pere, Wisconsin, a settlement started by French Jesuit Pere Claude-Jean Allouez in 1671. De Pere was founded on the last set of rapids just south of Green Bay. The settlement was originally known as Rapides Des Peres, or rapids of the fathers.

With the start of the Civil War, men from De Pere formed the De Pere Rifles. This unit was destined to become Company F of the 14th Wisconsin Infantry. Roughly four months after they were mustered into service, the men of the 14th Wisconsin stood in line of battle waiting to advance on a Confederate army that nearly destroyed Grant's Army of the Tennessee the previous day.

The 14th formed in line two miles south of Pittsburg Landing. Captain William Harper's Mississippi Battery was on a ridge in their front. When the Confederate battery opened with shot and shell, the 14th was ordered to lie down on the slope of the hill. For the next hour and a half, the shells passed over their heads. The 14th stood in time to repulse a Confederate charge. With their spirits buoyed by their early success, the 14th Wisconsin advanced on the Confederate lines in an effort to take the battery.

John D. Putnam was killed during the Union advance. He was buried where he fell by his fellow soldiers in front of an oak tree. Thomas Steele, one of the burying party, suggested that Putnam's name be carved low into the tree. Even if the tree was chopped down, Steele hoped the stump with Putnam's name would remain.

In 1866, the Shiloh National Cemetery was established, and Putnam's body was moved there. Thanks to his comrades of the 14th Wisconsin, Putnam has one of the few graves marked with full name, company, and regiment.

In 1901, the Wisconsin Shiloh Monument Commission visited the field to select a site for the state monument. They found that the tree had been chopped down, but that the stump remained with Putnam's name still legible.

Thomas Steele, who was with the commission, expressed a desire to have the portion of the stump that bore the inscription given to him. The National Park commissioners granted the request, sending the portion bearing the inscription to Steele. Steele forwarded it to G.A.R. Memorial Hall, then located in the state capitol at Madison, Wisconsin, to be preserved as a relic. Unfortunately, the slab was destroyed in the capitol fire of 1904.

Luckily, Steele had the slab photographed before sending it to Madison. The Wisconsin Shiloh Monument Commission decided to reproduce the stump in granite. They placed it on the exact spot where the original had stood. The monument to a fallen private, which now represents an entire regiment, was placed in position on April 7, 1906.

John D. Putnam of the 14th Wisconsin was killed during the second day's fighting at Shiloh. The monument re-creates the stump in which Putnam's friends inscribed his name.

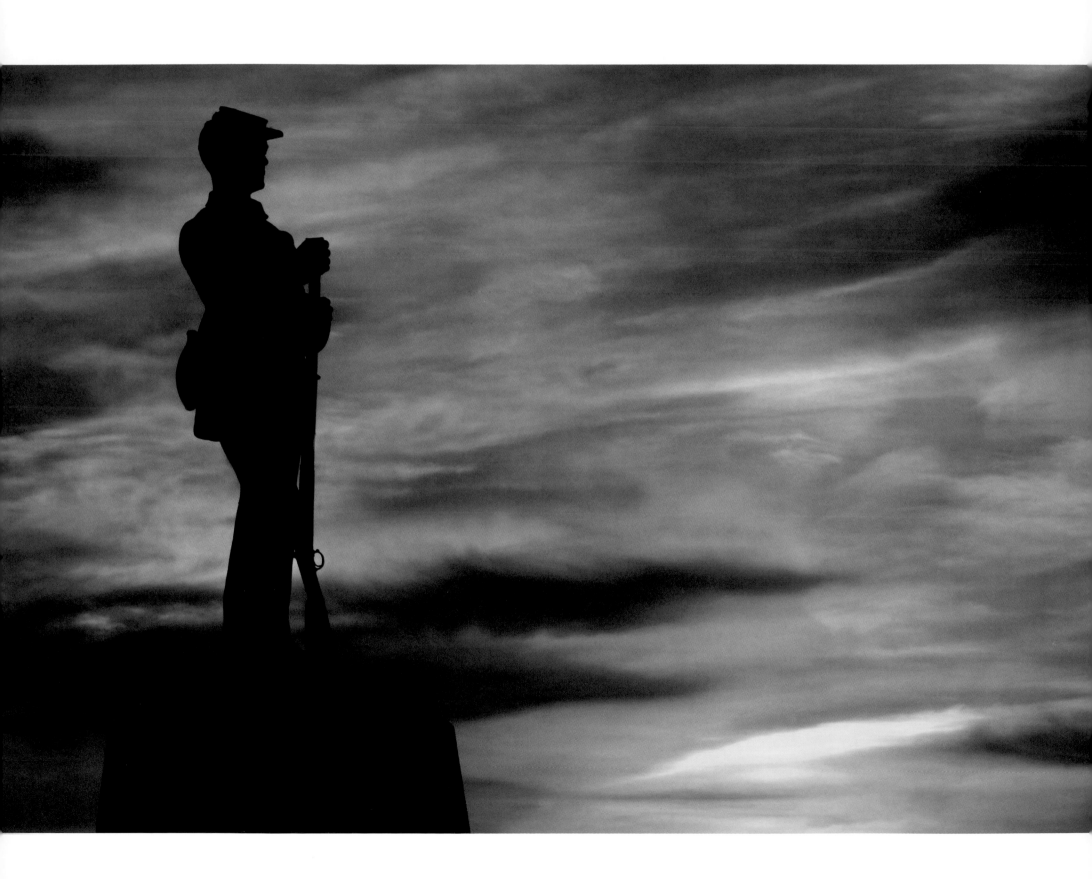

77TH PENNSYLVANIA INFANTRY

In the middle of the night of April 6, 1862, Colonel Frederick S. Stumbaugh's 77th Pennsylvania marched ashore at Pittsburg Landing, Tennessee, to the relief of Major General Ulysses S. Grant's army, which had been treated roughly by the Confederates. The arrival of fresh troops called for a Union advance against the Southern army.

April 6 was a day of marching for the soldiers of the 77th Pennsylvania. While Grant's army was fighting General Albert Sidney Johnston's Army of the Mississippi, the 77th was still twenty-five miles north of Savannah, Tennessee. The sound of the fighting was heard fourteen miles north of Savannah. The severity of the fighting made the 77th quicken their pace toward battle.

The 77th Pennsylvania was one of the few regiments from the Keystone State to serve in the western theater. The men from Pittsburgh had been marching ever since they were mustered into service in October 1861. At the start of 1862, the 77th marched from Bowling Green, Kentucky, to Nashville, Tennessee, and then to Savannah. They were attached to Brigadier General Alexander McCook's 2nd Division of Major General Don Carlos Buell's Army of the Ohio.

To get to Savannah at the best possible speed, the soldiers of the 77th Pennsylvania tossed aside anything but guns and blankets to hasten their journey. They arrived at Savannah at 9 P.M. Sunday night. That day, Grant's troops had fought for their lives at Shiloh.

The 77th was loaded onto transport boats and floated down the Tennessee River to Pittsburg Landing. The effects of the day's battle were evident. The scene at the river was one of bedlam. Skulkers who ran from the fight were huddled near the river. Amputated arms and legs were stacked outside a window of a log cabin, and screams of the wounded could be heard coming from the battlefield.

By the end of the night, Buell had over eighteen thousand fresh troops at Pittsburg Landing. Since both Buell and Grant were independent of each other, each man independently chose to attack the Army of the Mississippi, now under the command of General P. G. T. Beauregard, who had replaced the fallen Johnston.

Union soldiers were forced to sleep in the mud and driving rain since the Confederate army was sleeping in the Union camps that night. To make the night a little less comfortable, the Union gunboats *Tyler* and *Lexington* fired shells on the sleeping Rebels for the rest of the night.

At dawn on April 7, 1862, William Nelson's and Thomas Crittenden's Union divisions began the Federal counterattack, surprising Major General William Hardee. McCook's men were placed on the right of Crittenden. They advanced toward the Review Field, and for the next six hours the exhausted Confederates gave ground as they attempted to quell the assaults of Buell's fresh divisions.

A bayonet charge against the disorganized Rebels pushed the Union line across Duncan Field. After repulsing a fierce Confederate countercharge at Water Oaks Pond, the Union victory was complete, as Beauregard called for a retreat back to Corinth, Mississippi.

After seven days of forced marches, sleeping in the elements, and eight hours of fighting at Shiloh, the 77th Pennsylvania only lost five killed and twelve wounded.

After the battle of Shiloh, the 77th participated in the siege of Corinth and the battles of Stones River, Tennessee; Chickamauga, Georgia; the Atlanta campaign; and the battles of Franklin and Nashville, Tennessee.

After the battle of Stones River, Major General William Rosecrans called the 77th Pennsylvania "the best regiment in the battle."

In 1863, the 77th, under the command of Colonel Thomas Rose, lost most of their command at the battle of Chickamauga. Rose was captured and sent to Libby Prison in Richmond, Virginia.

On February 9, 1864, Rose planned and executed a breakout at Libby Prison. Approximately 109 Federal prisoners escaped through a tunnel that had been dug by the captured soldiers in blue.

The 77th Pennsylvania was part of Alexander McCook's division that fought on the second day at Shiloh.

5TH COMPANY WASHINGTON ARTILLERY

The 5th Company was the lone company of the Washington Artillery that did not go to the Army of Northern Virginia. The Washington Artillery was made up of men who were Louisiana's upper crust. In 1861, these blue bloods, who comprised the 1st, 2nd, 3rd, and 4th companies, joined the Army of Northern Virginia. The 5th Company was formed by twenty members of the reserve force and new recruits from the New Orleans area. W. Irving Hodgson was elected captain, and the men of the Washington Artillery prepared for service in the Confederacy.

The Louisianans sported distinctive uniforms topped with a red kepi cap. Aside from kepis, the 5th Company stood out thanks to their peculiar tents. A local circus had gone bankrupt, and the 5th Company purchased the big top, which was converted into tents for the men of the 5th Company. Their red-striped tents gave the Washington Artillery a distinctive look.

On March 5, 1862, the 5th Company, comprised of 156 men, departed New Orleans for Jackson, Tennessee. They were answering General P. G. T. Beauregard's dispatch four days earlier, stating, "Will accept all good equipped troops. . . . Let the people of Louisiana understand that here is the place to defend Louisiana."

They were outfitted with six guns, including two twelve-pound howitzers that had been captured in the Mexican War. Aside from horses and ammunition, the Washington Artillery was furnished at the men's own expense. The 5th Company had one other accessory. The company sported the new Confederate battle flag, which was copied from one of three made by Richmond women, who had used their silk dresses as fabric.

On April 1, 1862, the 5th Company arrived in Corinth, Mississippi, and was assigned to Brigadier General Patton Anderson's brigade serving in Brigadier General Daniel Ruggles's division of Major General Braxton Bragg's 2nd Corps. In five days, the men of the 5th Company would see their first action at the battle of Shiloh.

During the first day of fighting at Shiloh, the 5th Company helped drive Federals from their camps. They began firing into Captain Allen C. Waterhouse's battery overlooking Rhea Field. The Federal battery was throwing a deadly fire on the Confederate forces. Lieutenant John Crowley of the 11th Louisiana Infantry had his left arm ripped off by the Union shelling. This was especially horrific since Crowley had lost his right arm at the battle of Belmont, Missouri.

By 7 A.M., the Washington Artillery was matched against Captain Samuel E. Barrett's battery at the Shiloh Meeting House. Hodgson opened with canister aimed at a line of Federal sharpshooters. The duel between both sides brought death to soldiers wearing blue and gray. A member of the Washington Artillery recalled, "I shall never forget my feelings when I saw the first man killed, he was within 20 feet . . . and [when] struck in front of the ear, fell backward, expiring without a groan." The 40th Illinois pushed to within two hundred yards of the Louisiana guns but was forced back by a hail of canister. Later in the day, the 5th Company would be part of Ruggles's fifty-seven-cannon barrage on the trapped Union soldiers at the Hornet's Nest.

On the second day of fighting, the 5th Company served on the Confederate right flank near the Davis Wheat Field. The 5th Company needed the help of fellow Louisianans to save their guns. Colonel William Hazen's 6th Kentucky Infantry almost took the Louisiana guns, despite the repeated fire from the 5th Company. Colonel Marshall Smith's Crescent Regiment charged into Hazen's men in an effort to save the battery.

During the melee, the 5th Company troops were able to pull their guns from the field and refit. They were preparing to resume the fight when Beauregard ordered a retreat to Corinth. The 5th Company was ordered to Monterey, Tennessee, to help cover the Confederate retreat.

The horror of Shiloh made a lasting impression on the men of the 5th Company. One member of the battery wrote, "I had no idea of war until then, and would have given anything in the world if I could have been away."

Sunlight breaks through trees lining Davis Wheat Field. The 5th Company Washington Artillery's first fight in the Civil War was at Shiloh. The 5th was the only company of the famed Washington Artillery to fight in the western theater. The 1st, 2nd, 3rd, and 4th companies fought in the Army of Northern Virginia.

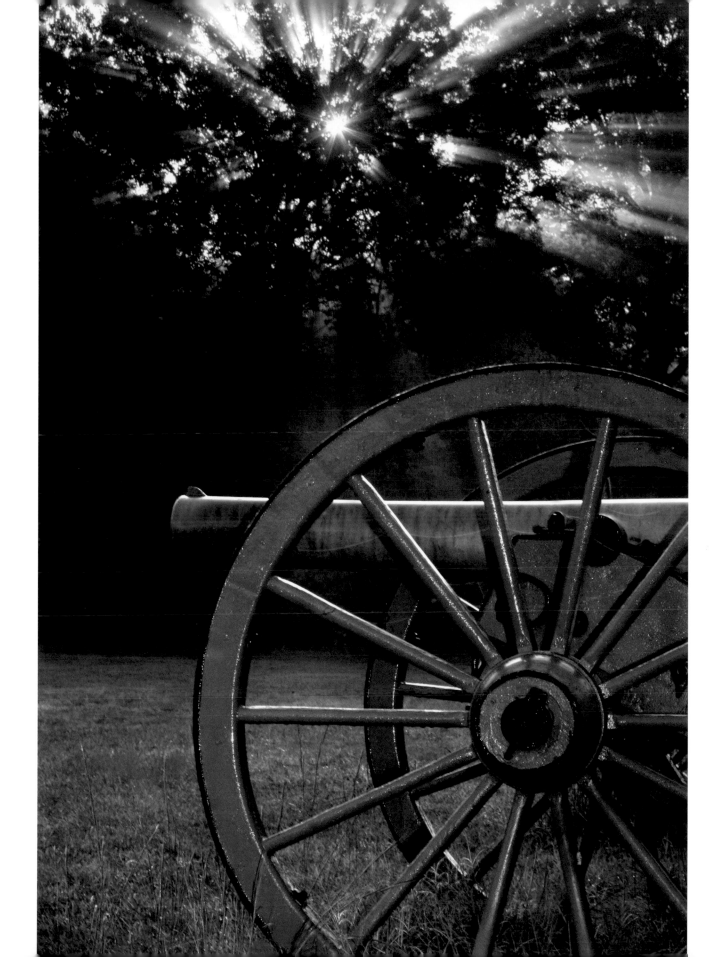

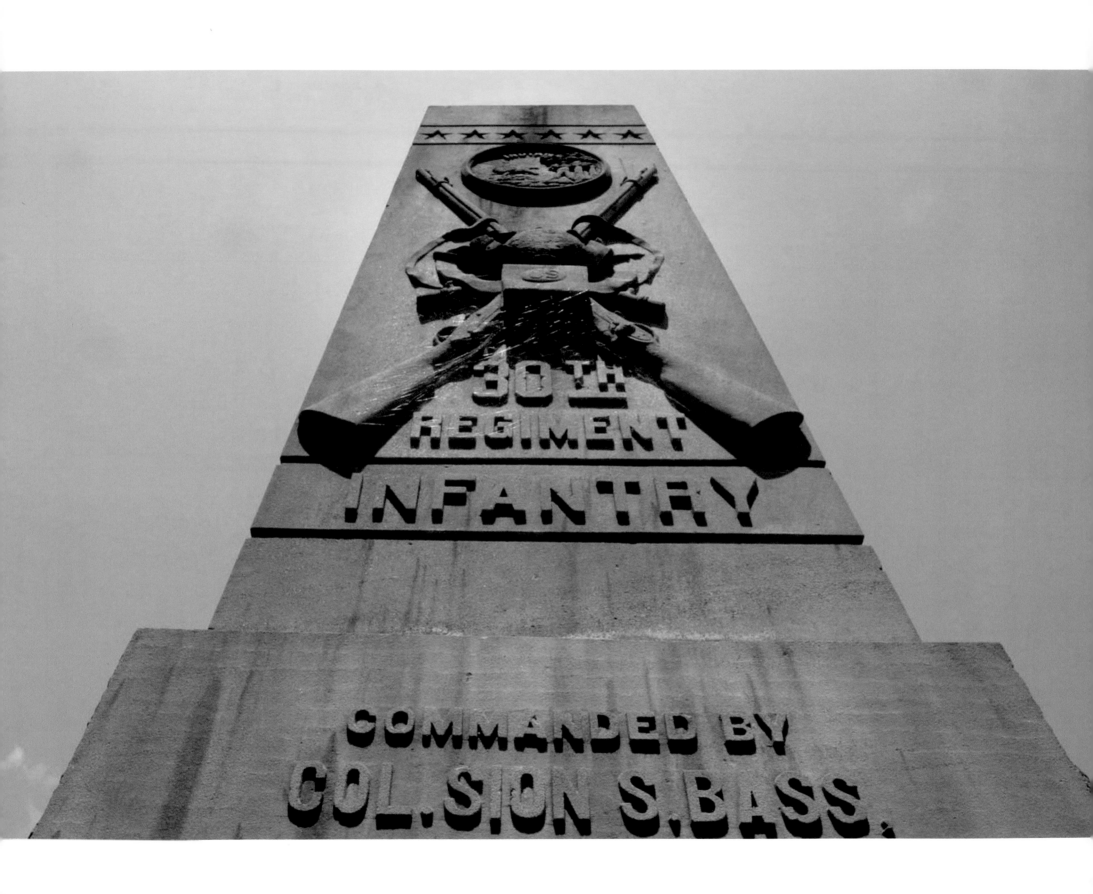

COLONEL SION BASS AND THE 30TH INDIANA INFANTRY

Sion Bass's march through middle Tennessee was a reintroduction to the South. The native Kentuckian had spent his childhood in Charleston, South Carolina, and he was well acquainted with Southern ways. On April 7, 1862, Bass would give his life. The transplanted Southerner died for the idea of an undivided Union at the battle of Shiloh.

The 30th Indiana Infantry was formed in Fort Wayne, Indiana. The men hailed from Allen, DeKalb, Elkhart, Kosciusko, La Grange, and Noble counties. Bass had moved to Fort Wayne at the encouragement of his mother in 1849. Having settled there, he founded a successful iron works business.

With the start of the Civil War, Bass was torn. His mother was originally from Charleston, and he appreciated the Southern way of life and still had many friends in the South. For Bass, there were two reasons to fight. The preservation of the Union was an ideal worth giving one's life for, and he was convinced that slavery was morally wrong.

Unfortunately, Bass had to deal with the stigma of being a Southerner in "Yankee" land. Many Northerners distrusted anyone from the South. Therefore, Bass set about proving himself to a town and area in which he had lived for twelve years.

Bass followed his convictions and enlisted in the Union army. Leaving his wife and two daughters behind, Bass marched to war. By September 1861, he had secured an appointment as colonel of the 30th Indiana Infantry.

The 30th Indiana became part of Major General Don Carlos Buell's Army of the Ohio. Bass's dedication to duty and willingness to learn the art of soldiering garnered praise from his superiors. Like his men, Bass was learning what it meant to be a soldier.

Since the start of the war, the 30th Indiana had been marching across Kentucky and Tennessee. They didn't do any serious fighting at Fort Donelson. Afterward, they marched to Nashville, Tennessee. Major General Henry Halleck called for Buell and Major General Ulysses S. Grant to unite their armies at Pittsburg Landing, Tennessee. Grant's army was already there, and Buell

was en route. On April 6, 1862, the head of Buell's army was at Savannah, Tennessee, only nine miles from Pittsburg Landing.

As fate would have it, that was the same day the Confederate army launched a surprise attack at Shiloh. While Grant's army fought for its survival, Bass and the 30th Indiana marched through mud and muck to get to Pittsburg Landing.

On the following day, the 30th Indiana was assigned to the command of Brigadier General Lovell Rousseau. His brigade had been pounded during fighting earlier that day. Rousseau counterattacked with the 30th Indiana near Shiloh Church.

During that attack, Bass was leading the 30th Indiana with unabashed daring. He was in the thick of the fighting on three charges against the Rebel lines. On the next advance, Bass's horse was shot, and he dismounted to check on the horse's condition.

While checking the horse, a Confederate minié ball slammed into Bass's thigh. Undaunted, Bass remounted the horse and rallied his men. Although wounded, Bass chose to continue fighting instead of seeking medical attention.

Bass's wound was more serious than he realized, and he reeled in the saddle during the attack. He was taken from the field and sent to a steamer on the Tennessee River. Eventually, he was transported to Paducah, Kentucky, where he died one week after he was wounded at Shiloh. His wife was by his side when he died.

The people who had mistrusted a Southern man wanting to fight for the Union gave Bass a hero's funeral. There was a procession down the center of town, with salutes fired and bells ringing.

Bass was interred in the Linwood Cemetery in his adopted hometown of Fort Wayne, Indiana. The men of the 30th Indiana Infantry placed a monument at his grave.

The 30th Indiana state monument commemorates the fighting of the Hoosiers near Water Oaks Pond on the second day at Shiloh.

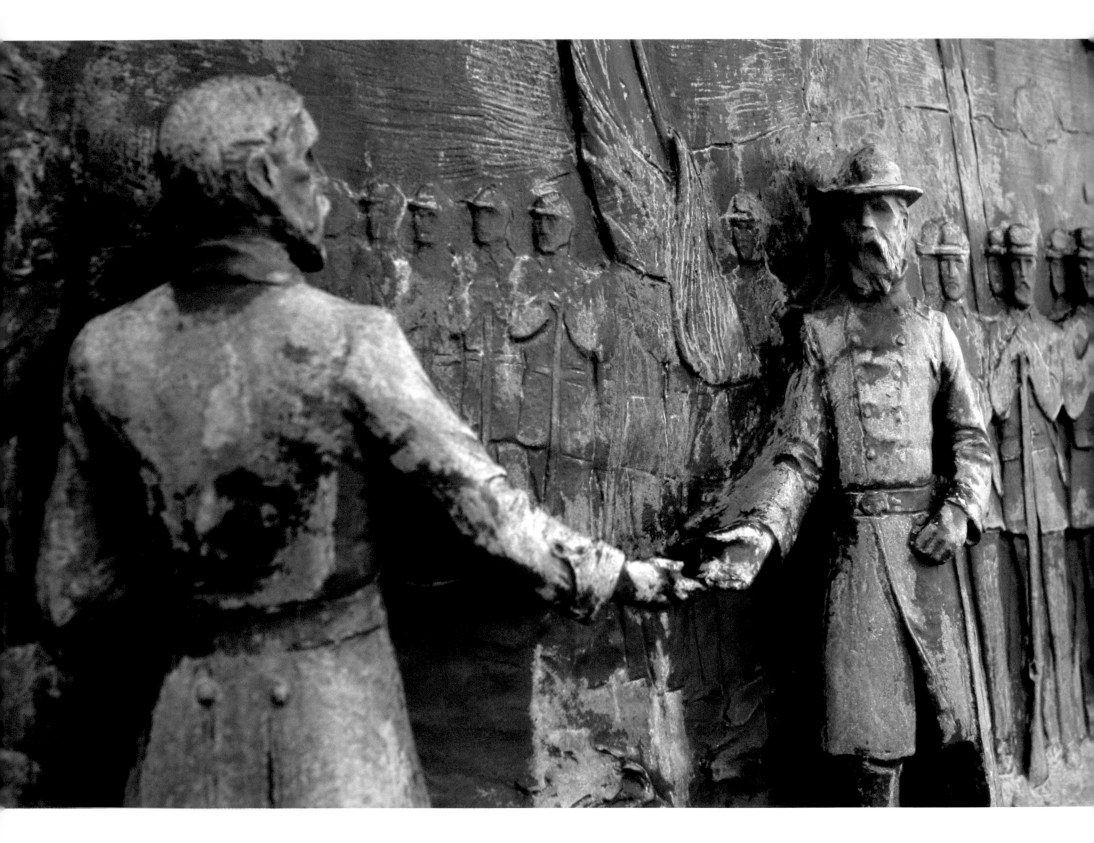

JOEL BATTLE'S SURRENDER

The battle of Shiloh marked a devastating period in the life of Colonel Joel Battle of the 20th Tennessee Infantry. During the second day of fighting, Battle lost two sons and his freedom on the killing fields of Shiloh.

At an early age, Battle inherited a large estate and slaves from his parents. Battle was a Whig who cared little for the political posturing of the radicals of the North and South. Like many Southerners of that time, Battle chose his state over his country. With the secession of Tennessee, Battle organized a company of soldiers at Nolensville, Tennessee. Known as the Zollicoffer Guards, these men served in a brigade under the command of Brigadier General Felix K. Zollicoffer. This group of soldiers would eventually earn the name of the 20th Tennessee Infantry. Battle was elected colonel of the regiment.

Early in the war, Battle and the 20th Tennessee were tasked with guarding the Cumberland Gap in northern Tennessee. During this period, the 20th Tennessee received their baptism of fire. On January 18, 1862, at the battle of Fishing Creek, Battle noticed that some of his men would flinch at the sound of minié balls racing through the air. In an effort to rally his men's bravery, Battle cried out, "Don't dodge men, don't dodge."

An artillery shell passed close to Battle, causing him to dodge. His men laughed as their colonel was also dodging the oncoming shells. Battle amended his command to his soldiers, stating, "Boys, dodge the big ones, but don't dodge the little ones."

Less than three months after Fishing Creek, Battle and the 20th Tennessee were in the middle of the fighting at Shiloh. On the first day, the 20th Tennessee was part of Winfield Statham's push toward Sarah Bell's cotton field. During the second day at Shiloh, the 20th Tennessee clashed with Colonel Frederick Stumbaugh and the 77th Pennsylvania Infantry.

During the two days of fighting, Battle led 350 men into the fight and suffered 158 killed or wounded. Serving with Battle were three of his sons. Battle's oldest son, William Searcy Battle, and youngest son, Joel A. Battle Jr., were killed. The elder Battle was captured after the second day of fighting as he searched the field for his slain sons. Battle surrendered his sword to Stumbaugh and was sent to a prison camp near Sandusky, Ohio.

Battle never recovered his oldest son's body, but Joel Jr. was given a fitting burial. While most Confederate soldiers were buried in mass graves, Joel Jr. was discovered by Union soldiers performing burial detail. These soldiers had been classmates of his at Miami University in Ohio. The classmates in blue made a crude coffin of cracker boxes and buried him in a single grave under a huge oak tree instead of in the mass Confederate graves.

Joel Battle Sr. was exchanged in the fall of 1862, but did not again serve in the Confederate army. Tennessee governor Isham Harris appointed Battle state treasurer. Battle held this position until the end of the war.

In May 1863, Stumbaugh resigned his commission and returned to his home in Chambersburg, Pennsylvania. The town had been raided twice by Confederate armies. On July 30, 1864, Chambersburg was one of the only Northern towns to be burned by marauding Confederate soldiers. The burning was in retaliation for similar burnings in Virginia's Shenandoah Valley.

Confederate soldiers arrested Stumbaugh and brought him out of his house with a pistol to his head. The Southern soldiers hurled insults at the former Union soldier. Stumbaugh informed the men in gray that he had been in the service and that if General Battle were present, they wouldn't dare insult him. When pressed why, Stumbaugh said, "I captured him at Shiloh and treated him like a soldier."

A Confederate major heard Stumbaugh's claim and ordered the Southern soldiers to release Stumbaugh. The soldiers left Stumbaugh's neighborhood untouched from the Confederate torch that night.

Joel Battle of the 20th Tennessee surrendered to Colonel Frederick Stumbaugh of the 77th Pennsylvania Infantry during the second day of fighting at Shiloh. Battle was looking for the bodies of his two dead sons.

WATER OAKS POND

On April 7, 1862, General P. G. T. Beauregard was caught by surprise by the early morning counterattack of the combined forces of Major Generals Don Carlos Buell and Ulysses S. Grant. On the previous day, Beauregard had stopped the soldiers of the Confederate Army of the Mississippi just as they were preparing for a final assault. Beauregard was sure the Confederate army could finish Grant the following day.

Pierre Gustave Toutant Beauregard was no stranger to combat. He graduated second in the 1838 class of the U.S. Military Academy. While at West Point, Beauregard became an admirer of Napoleon, causing his fellow cadets to call him "The Little Napoleon." Beauregard served in the Mexican War, where he was wounded at both Churubusco and Chapultepec.

Beauregard resigned his commission in February 1861 and was put in command of Southern forces at Charleston Harbor. His soldiers fired the first shot to start the war at Fort Sumter. At the start of the war, Beauregard was present in almost all of the meaningful battles. He served as second in command under General Joseph E. Johnston during the battle of First Bull Run.

Beauregard's eastern command was short-lived, as he often clashed with President Jefferson Davis. Beauregard was sent west to be General Albert Sidney Johnston's second in command.

It was Beauregard who drafted the attack orders for the battle of Shiloh. Upon the death of Johnston, Beauregard assumed command of the Army of the Mississippi on the afternoon of April 6, 1862. Beauregard had halted a final Confederate assault, confident that his army could finish Major General Ulysses S. Grant's army the following day. Beauregard even sent a telegram to Richmond lauding the complete Confederate victory at Shiloh.

Since the early morning of April 7, Beauregard's army had fought valiantly but was unsuccessful in stopping the Union counteroffensive. With Grant's army reinforced by Don Carlos Buell's Army of the Ohio, Beauregard had to contend with one assault by Lew Wallace's, William T. Sherman's, and John McClernand's soldiers and another by Alexander McCook's, William Nelson's, and Thomas Crittenden's troops.

The Southern army began to retreat in disorder, and Beauregard frantically worked to rally his army where the Hamburg-Purdy Road crosses the Corinth Road. Water Oaks Pond rests just north of the crossroads.

Sensing the gravity of the situation, Beauregard organized several counterattacks against the advancing Union lines. During one charge, Beauregard "bore the colors in front of the line under the fire of the enemy." When scolded by his aides for unnecessarily endangering himself, the Creole general said, "The order must now be 'follow' not 'go'!"

Despite the leadership and bravery Beauregard displayed, the Southern soldiers were tired and whipped. Some regiments refused to respond to pleas and orders from their superiors. The fight had left them, and it was evident that the Army of the Mississippi was exhausted from two days of hard fighting.

Colonel Thomas Jordan inquired of Beauregard, "Would it not be judicious to get away with what we have?" Beauregard, sensing defeat, replied to Jordan, "I intend to withdraw in a few moments."

At 2 P.M., Beauregard sounded the retreat and gave the responsibility to Brigadier General John C. Breckinridge to protect the rear guard. Beauregard stressed to Breckinridge that "this retreat must not be a rout."

Grant, watching the retreat north of the Shiloh Church, deemed his men "too much fatigued from two days' hard fighting and exposure," and chose not to pursue Beauregard's army.

The Army of the Mississippi limped back to the entrenchments of Corinth, Mississippi. Beauregard expected a Union attack and had his healthy soldiers begin digging entrenchments. He begged Richmond for reinforcements, offering a telling prediction, "If defeated here, we lose the Mississippi Valley and probably our cause."

P. G. T. Beauregard personally tried to rally his Southern army at Water Oaks Pond before calling for a retreat to Corinth.

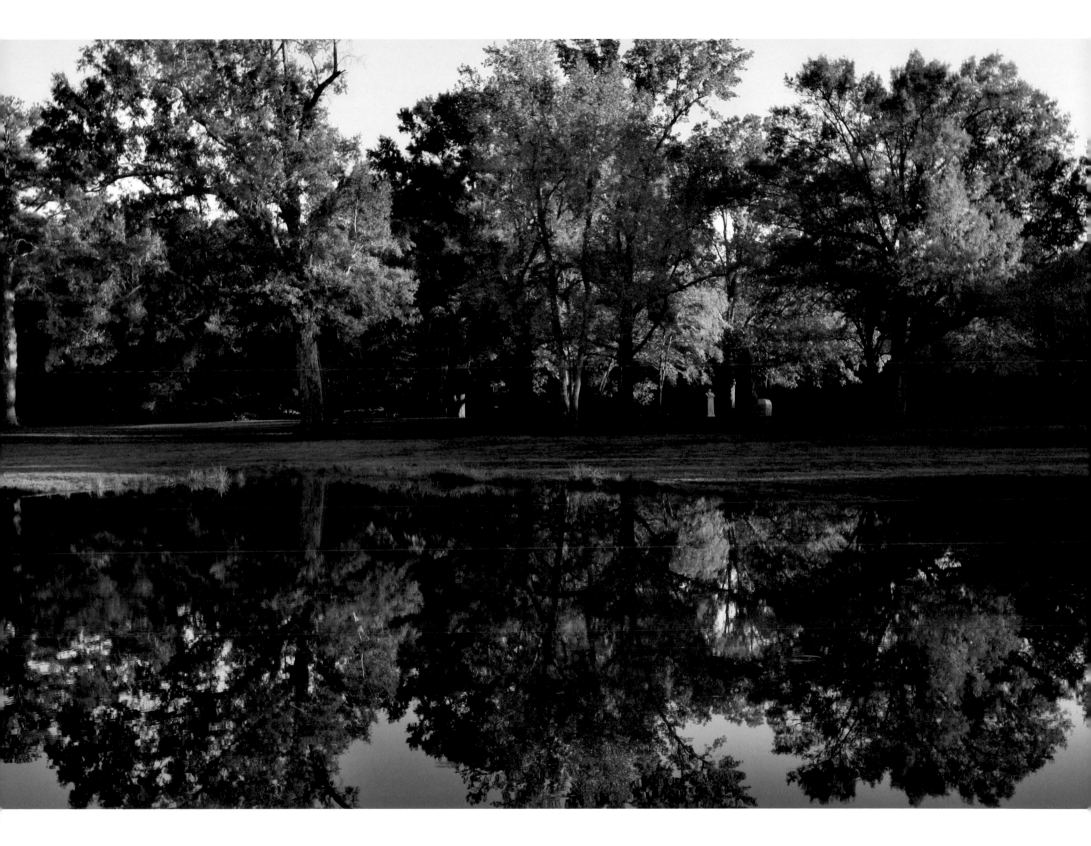

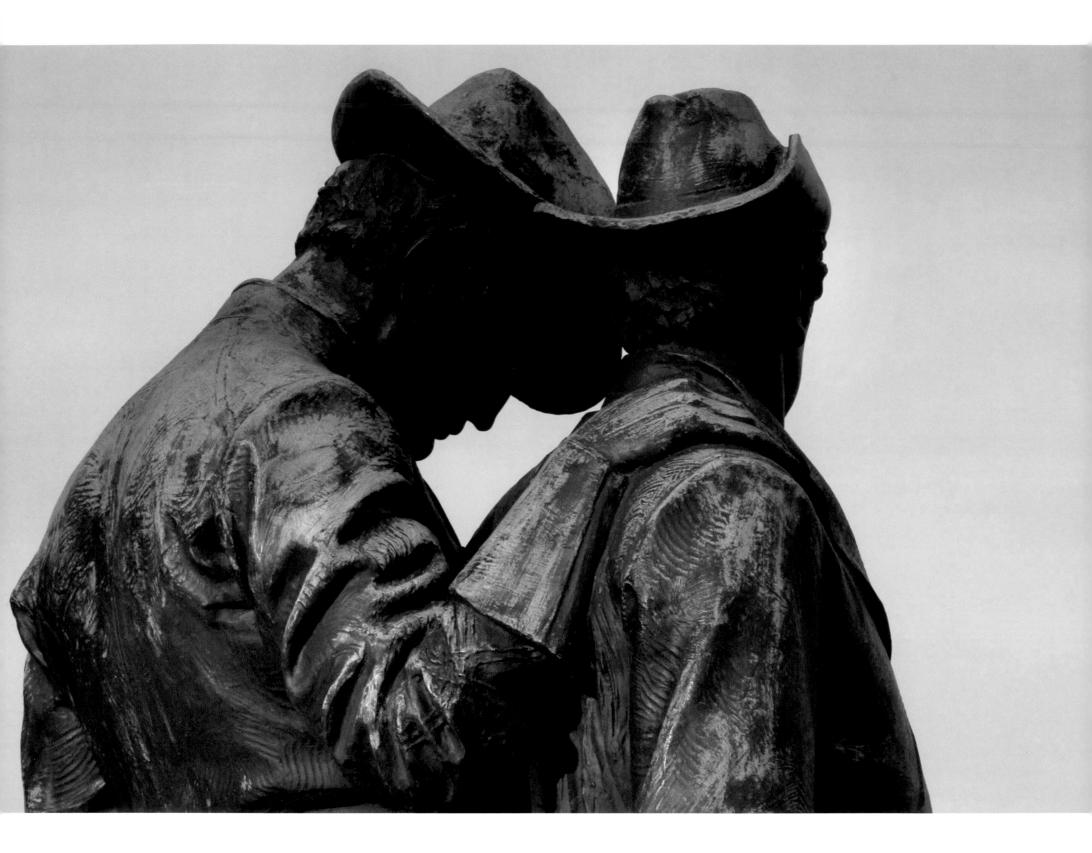

EFFECTS OF BATTLE

As the people of the North and South learned about the carnage at Shiloh, their perception of the war changed with the stark reality of death and destruction. At the time, the battle of Shiloh was the bloodiest two days of fighting in U.S. history. Sadly, it would be surpassed in the fall of 1862 at Antietam, with the bloodiest single day of battle, and in 1863 at the battles of Gettysburg and Chickamauga.

The repeated Union victories in the West began to have a psychological effect on the South. The South's opinion of the Union soldier began to change. No longer could the South boast that the fighting ability of one Confederate was equal to that of ten Federals. Southerners had to grudgingly respect the valor displayed by the Union army at Shiloh. The Federals were all but beaten only to regroup and defeat Beauregard's army the following day.

The North's near defeat at Shiloh removed the illusion of easy victory. The overconfidence displayed after the fall of Fort Henry and Fort Donelson was replaced by a resolute determination to bring the war to an end.

A few days after the fighting at Fort Donelson, one Union soldier wrote: "My opinion is that this war will be closed in less than six months from this time." Shortly after Shiloh, the same soldier wrote: "If my life is spared I will continue in my country's service until this rebellion is put down, should it be ten years."

At Shiloh, the Union found a general who would fight. Ulysses S. Grant faced many trials before, during, and after Shiloh. Prior to Shiloh, Grant was removed from command and didn't have the confidence of his superior officer. During the battle, many of Grant's subordinates counseled retreat over fighting, but Grant was determined to win the battle.

After Shiloh, Grant lost his command to Henry Halleck and was not a factor during the siege of Corinth. Halleck's success moved him from the western theater to Washington, D.C., which allowed Grant to resume command in the West. In the next two years, Grant would continue to win victory after victory.

The Confederate loss at Shiloh was dire since the South didn't have the population base that the North enjoyed. Over the coming years of the Civil War, it would become increasingly difficult to replace Southern soldiers who had fallen in battle.

It is debatable whether Albert Sidney Johnston's death created a void in leadership. Some Southerners had already called for his ouster after Fort Donelson. One can only speculate the reaction to Johnston if he had survived Shiloh but still lost the battle. Looking at his immediate replacements, Beauregard and Bragg, it is safe to say that Johnston's death did have an adverse affect on the Southern war effort in the West.

Due to his death with victory seemingly in his grasp, Johnston transcended into a martyr for the Southern cause. He could have been saved if his tourniquet had been used or if he hadn't sent his doctor to care for wounded Union soldiers. Today, he is remembered fondly as a tragic hero of Shiloh. A solitary upright cannon barrel marks where Johnston was found mortally wounded.

The Confederate monument at Shiloh has many facets and represents all branches of service. The monument features a bust of Johnston carved into the center pedestal. The soldiers on the right of the monument represent the infantrymen who stand in defiance of the Northern army. The artilleryman represents the calm while staring through the fog of battle. Etchings of soldiers marching with heads high represent the spirit of the army during the first day of the battle.

The center figure, "Defeated Victory," represents the Confederacy surrendering the laurel wreath of victory to death and night.

One figure on the left represents an officer with bowed head, who is at a loss due to breakdown in command and control. The Southern cavalryman spreads his hands in disgust due to the wooded terrain rendering the cavalry ineffective. The etched faces of soldiers marching with heads bowed represent the sting of defeats on the second day at Shiloh.

The monument was unveiled in 1917 by the United Daughters of the Confederacy in memory of all Southern troops who fought in the battle.

The Confederate defeat at Shiloh was disastrous for the South. The Union army would take Corinth in May 1862, opening the state of Mississippi for further campaigns.

MASS GRAVES

On April 8, 1862, General P. G. T. Beauregard sent a message by mounted courier to Major General Ulysses S. Grant. Beauregard wanted to send a detail of men through the lines to bury the Southern dead. Grant replied to Beauregard, "Owing to the warmth of the weather I deemed it advisable to have all the dead of both parties buried immediately. Heavy details were made for this purpose and now it is accomplished."

The sights on the Shiloh battlefield were gut wrenching for the burial details and commanding officers, the carnage that the two-day battle left forever stored in their minds. If the sights of the battlefield were not enough, warm weather was returning, causing the smell of rotting corpses to fill the air.

Major General John A. McClernand discovered a Confederate soldier in his tent. The wounded Southerner had rested his head on McClernand's desk and died.

Captain Andrew Hickenlooper entered his tent to find a Confederate corpse and a mortally wounded Union soldier. Hickenlooper tried to aid the dying man, giving him a drink from his canteen. The soldier whispered to Hickenlooper, "Tell mother where you found me, on the front line."

Burial crews spent the days gathering the wounded and burying the dead. The enormity of the task was painfully evident. Each side, North and South, had more than seventeen hundred soldiers killed. More than eight thousand were wounded on each side, calling for an enormous effort to tend to the soldiers.

The burial details were especially grim. The fallen soldiers were in various positions of death. Many had ripped open their clothing to tend their wounds. Others were missing their legs, arms, and even their heads. The stench of death was more than some soldiers could bear.

J. F. True of the 41st Illinois Infantry explained the task of burying the dead: "We dig holes in the ground, lay them side by side without any coffin, fire a salute over the grave and then cover their cold bodies with the Tennessee clay. The Secesh we bury with less ceremony, dig a hole, roll them in and cover them."

For some of the victorious Union soldiers, the task of burying the sons of the South was particularly taxing. One Union soldier said the Rebels were buried "with as little concern as I would bury a dog."

Other soldiers were more respectful of their fallen foes. Private Wilbur Crummer of the 45th Illinois was in one of the burial details. He explained the process of interring the fallen soldiers: "When the grave was ready, they placed the bodies therein, two deep. All the monument reared to those brave men was a board upon which I cut with my pocket knife the words '125 Rebels.'"

The Union soldiers were buried in mass graves but were later reinterred after the creation of the Shiloh National Cemetery. The Southern soldiers remained in their mass graves, some stacked as high as seven deep.

While the death toll was staggering for the North and the South, the effects of Shiloh were especially difficult for the Confederacy. The South did not have the population base that the North possessed. Therefore, replacing the fallen heroes was difficult at best.

For the families of the soldiers wearing blue and gray, their losses at Shiloh were heartbreaking. There would always be a vacant chair at the table as a father, husband, or son didn't return from battle. Children were denied the experience of having a father, wives never again would feel the strength of their husbands' hugs, and communities were forever robbed of the potential of the soldiers permanently entombed at Shiloh.

Confederate soldier George Washington Cable summed up Southern sentiment after this devastating battle: "The South never smiled again after Shiloh."

Today, five marked mass graves hold the remains of the men in gray who died at Shiloh. Cannonballs form a perimeter around the mass graves, like a picket guarding the main body of the army. The wings of a dragonfly are the only things that stir the air in the stifling humidity of a summer's day. Birds sing their comforting songs, bringing peace and solitude for men who died a violent death.

Five marked mass graves, and several others, hold the remains of Confederate soldiers who died at the battle of Shiloh.

FALLEN TIMBERS

The beaten Confederate Army of the Mississippi was a shell of its former self. Just two days earlier, the soldiers had entered Tennessee with the hope of destroying Major General Ulysses S. Grant's forces. After the battle of Shiloh, the Confederate army relied on Colonel Nathan Bedford Forrest to protect the rear guard while the army retreated to Corinth, Mississippi. At a field called Fallen Timbers, Forrest rode into Southern immortality.

While the Confederate army retreated from Shiloh, Brigadier General William T. Sherman followed with the 77th Ohio Infantry and the 4th Illinois Cavalry. Six miles southwest of Pittsburg Landing, Tennessee, Sherman reached a field alongside the road. Fallen trees rested at the far end of the field. Behind the trees, Sherman spied a Confederate field hospital and a detachment of cavalry. The three hundred Confederate cavalrymen were part of John Warton's Texas Rangers and a company of Wirt Adams's Mississippi Regiment under the overall command of Forrest.

Forrest was in a foul mood after the loss at Shiloh. On the night of April 6, 1862, Forrest had seen Federal reinforcements being ferried across the Tennessee River. He had urged his commanders to initiate a night attack to drive the Union army into the river. Forrest had yet to earn the reputation that would garner him praise as one of the best generals, North or South. On that night, he was a little-known colonel who had outfitted his regiment with his own money. Forrest was told to keep a vigilant eye on the ever-growing Union army, and no attack was made.

On the second day at Shiloh, the Union counterattack pushed the Confederate army from its positions and eventually led to its defeat. Now, the army was marching over muddy roads to the safety of Corinth, Mississippi.

Sherman looked to press the Union advantage and ordered the 77th Ohio forward. Forrest, always able to size up a situation quickly, noticed the Federals were having problems clearing the fallen timber. He ordered a charge. The sound of the horses' thundering hoofs and the yelling Rebels struck fear in the Union soldiers, who were still navigating the fallen timber.

Brandishing sabers and firing shotguns and revolvers, Forrest's men turned the charge into a rout. Union Colonel T. Lyle Dickey's men fired too soon and were out of bullets once Forrest's men reached them. The Federal flight to the rear engulfed Sherman, and the Union general was almost captured. Sherman admitted that his staff "fled ingloriously pell-mell through the mud, closely followed by Forrest and his men." The Federals found a safe haven behind Colonel Jesse Hildebrand's brigade.

Forrest galloped in advance of his soldiers, firing as he rode. A volley from Hildebrand's brigade stopped many of the Confederates, but Forrest kept on coming. "I'm sure that had he not emptied his pistols as he passed the skirmish line, my career would have ended right there," Sherman said.

Forrest was within fifty yards of the Union line before he realized that most of his men had already turned back. He immediately wheeled his horse and sought an avenue of escape. The Union soldiers, having regained some of their confidence, yelled, "Kill him, kill him and his horse," and began firing at Forrest.

One Federal soldier shoved his musket into Forrest's side and pulled the trigger. Forrest was hit above his hip, with the bullet penetrating to his spine. The impact of the shot momentarily lifted Forrest from the saddle, but he was able to keep riding.

Although severely wounded, Forrest retired to Corinth. Eventually, he left for his home in Memphis, Tennessee, to recuperate. Only twenty-one days later, still carrying the bullet next to his spine, Forrest returned to Corinth and resumed his duties.

Sherman lost ninety men during the fight at Fallen Timbers. Most of these soldiers were captured by Forrest's men. For Forrest, the legend of the "Wizard in the Saddle" began at Fort Donelson, but another chapter was written on the fields near Shiloh.

Nathan Bedford Forrest gained legendary status for his charge during the rear guard action at Fallen Timbers.

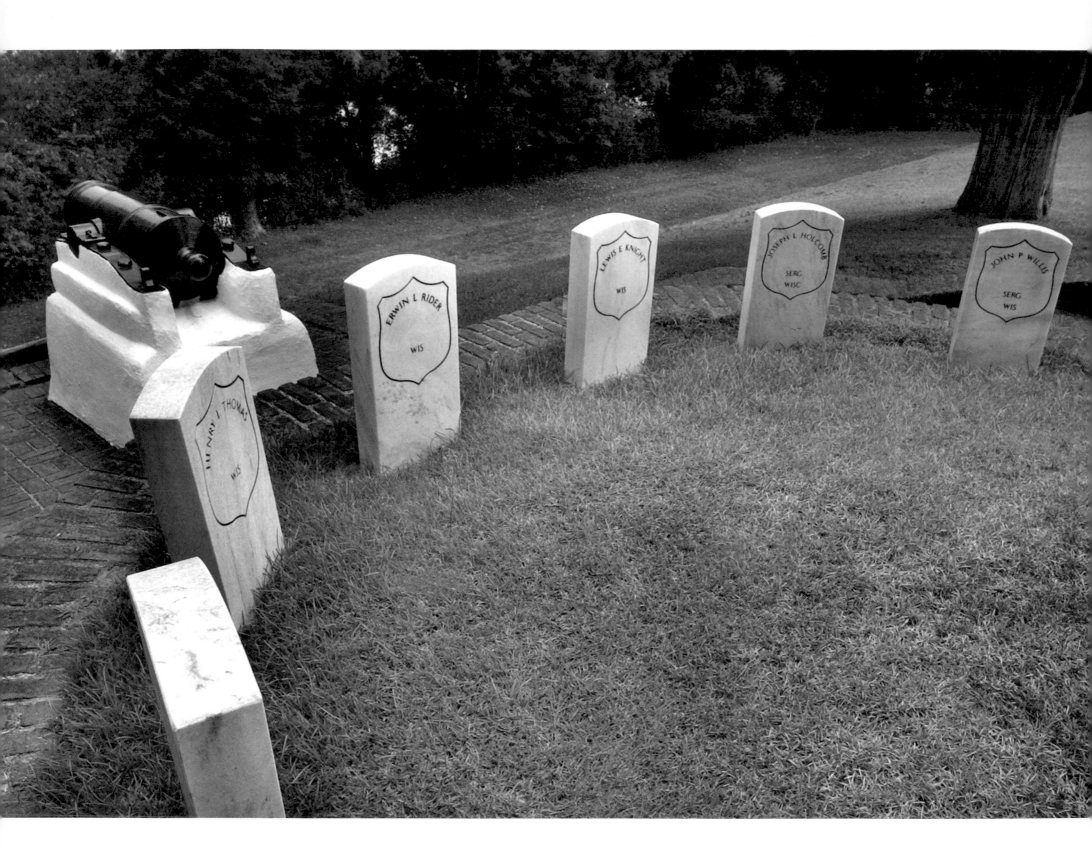

WISCONSIN COLOR GUARD

As the soldiers of the 16th Wisconsin Infantry looked from their boats, they noticed a sea of white tents stretching from Pittsburg Landing, Tennessee, to the woods beyond. Their arrival on March 20, 1862, was met with little fanfare since new regiments were common. For weeks, the Union Army of the Tennessee was continually growing in anticipation of an upcoming offensive into the Mississippi Valley.

The 16th Wisconsin was organized at Camp Randall in Madison, Wisconsin. They were mustered into the Union army on January 31, 1862. In March 1862, the 16th Wisconsin headed south. It would be the last time many of the soldiers of the 16th would see their native state.

Once at Pittsburg Landing, the 16th Wisconsin was attached to Colonel Everett Peabody's brigade of Brigadier General Benjamin Prentiss's 6th Division. Their camp was two and a half miles away from Pittsburg Landing.

For the following weeks, camp life was the usual routine. Drill, drill, and more drill filled the hours of each day. On April 4, 1862, Prentiss conducted a review of his troops. In the woods on the edge of Spain Field, Confederate soldiers were seen watching the review. Word was passed to Brigadier General William T. Sherman, and extra pickets and patrols were sent out the following night.

During the predawn hours of April 6, 1862, Peabody sent the men of the 25th Missouri and 12th Michigan on a patrol, and they encountered the Confederate army at Fraley Field. Company A of the 16th Wisconsin was one of the companies pulling picket duty. At the sound of gunfire, Colonel David Moore ordered Captain Edward Saxe to deploy Company A to the sound of the fighting. The men of the 16th Wisconsin didn't get far when the Confederate skirmishers rose and shot a volley in their direction. Saxe and Sergeant John Williams were killed instantly. Saxe was the first officer killed in the battle of Shiloh.

Prentiss, alerted to the Rebel position, rode up and down his line deploying the soldiers for battle. For most of the men in the battle line, this was their first experience in combat.

The men of the 16th Wisconsin formed a line of battle on the first Union defensive position. The 16th Wisconsin stood their ground against the Confederate advance, but the entire line was forced to fall back due to unprotected flanks. Their second line was just beyond their camps, and the Southern army kept coming.

The 16th's second in command, Lieutenant Colonel Cassius Fairchild, was wounded and taken from the field. Then Colonel Benjamin Allen's horse was shot from under him. Later that morning, Allen was wounded and taken from the field.

When Prentiss yelled for his men to "fall back" and use trees as cover, the 16th Wisconsin was nearly out of ammunition. They began an orderly withdrawal to replace their cartridges. Once reloaded, the 16th was ordered back to the front line so other regiments could resupply.

During the afternoon, the 16th Wisconsin was back on the Union line near a pond, destined to be renamed Bloody Pond. That night the 16th Wisconsin slept in a driving rain. The Confederate army was in possession of their camp and tents.

The following day the exhausted 16th Wisconsin served as a reserve unit for most of the day. The men were used only to plug holes whenever they occurred in battle.

The 16th Wisconsin continued to fight during the battle of Corinth, Mississippi, in 1862, and the Vicksburg campaign in 1863. Later in the war, the 16th Wisconsin participated in the battles for Atlanta and in Sherman's March to the Sea.

Today, six headstones stand in a semicircle overlooking the Tennessee River in the Shiloh National Cemetery. The headstones are for the six color bearers the 16th Wisconsin lost during the battle of Shiloh.

The graves of six members of the 16th Wisconsin color guard look over the Tennessee River at the Shiloh National Cemetery.

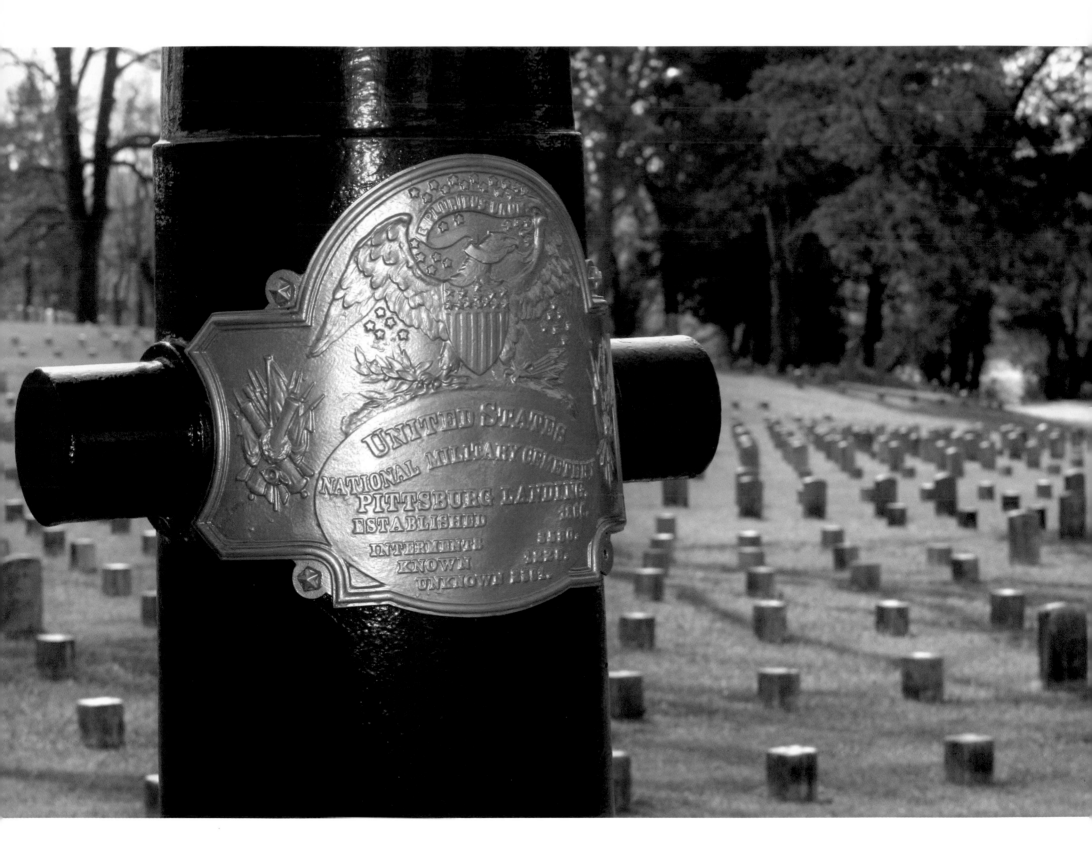

SHILOH NATIONAL CEMETERY

The cemetery at Shiloh was designated a National Cemetery in 1866. The cemetery has about 4,000 interments, of which 2,359 are unidentified.

The ongoing conflict of the Civil War brought about the need for hallowed ground to bury the nation's dead. Early in the war, national cemeteries were created at locations of troop concentration points. For the common soldier, no ground is more hallowed than one that has had blood spilled for the nation's defense.

The losses on each side at Shiloh were staggering. The dead at Shiloh were more than every American war to that point combined. Major General Ulysses S. Grant's Army of the Tennessee suffered 1,754 killed, 8,408 wounded, and 2,885 missing, for a total of 13,047 casualties. The Confederate Army of the Mississippi suffered 1,728 killed, 8,012 wounded, and 959 missing, for a total of 10,699 casualties.

While both sides claimed victory, the families at home across the nation couldn't help but feel a sense of loss as news reached them that a loved one was dead.

Shaken by the near disaster, Major General Henry Halleck assumed command and made Grant second in command. For Grant, this was akin to removal from command. The people of the United States clamored for Grant's removal from the army. Someone had to be held responsible. President Abraham Lincoln answered the calls for Grant's dismissal by saying, "I can't spare this man. He fights!"

The dead of Shiloh covered the field. Burial crews worked for days rounding up the bodies of both blue and gray and interring them, some in individual graves and some in mass graves. It would not be until 1866 that Shiloh would be designated a National Cemetery

The Shiloh National Cemetery at Pittsburg Landing, Tennessee, is located on a bluff overlooking the Tennessee River. It contains ten and a half acres of ground and is surrounded by a stone wall.

The number of Civil War interments in the cemetery is almost 4,000, of which 2,359 are unknown. The soldiers in the cemetery represent 203 regiments of thirteen states.

Once the cemetery was established, the remains of Union soldiers killed in the battle of Shiloh were found and reinterred in the cemetery. The remains of Union soldiers stretching from Fort Henry, Tennessee, to Shiloh and south to Muscle Shoals, Alabama, are also interred there.

The effort to make Shiloh a National Military Park can be tied to the National Cemetery. When the cemetery was established, the land on which the battle occurred was privately owned. Union veterans of the battle wanted Shiloh to become a military park, like Chickamauga and Antietam had become in 1890. There was also talk of turning Gettysburg into a national battlefield, too.

The battlefield movement dates back to 1893, when Union veterans of the battle visited Shiloh. The veterans were disturbed by a report the superintendent of the National Cemetery told them. The remains of Union soldiers were still being discovered thirty-one years after the battle occurred, as farmers plowed their fields or during the process of road construction in Tennessee.

During a meeting on the steamer *W. P. Nesbit*, veterans of Shiloh agreed to form the Shiloh Battlefield Association. Their main goal was to start the drive to preserve Shiloh as a National Military Park. A little more than a year later, the Shiloh National Military Park was created.

Today, visitors from across the nation drive, bike, or walk the Shiloh National Military Park. They learn of great deeds of soldiers wearing blue and gray. The park tells the story of a nation divided by different ideals.

Rangers from the National Park Service give tours of the battlefield and the Shiloh National Cemetery. Three cannon barrels mark the location where Grant sat the night of April 6, 1862, summoning the courage to fight the following day.

The sound of tourists' footsteps has replaced the steady drum of soldiers' boots. Laughter from children running along the paths provides a soothing alternative to the cries of the wounded and dying. Heroes lie in their eternal slumber. Having perished in the horror of war, these men are forever remembered for their service to their country.

The cemetery at Shiloh was designated a National Cemetery in 1866. The cemetery has about 4,000 interments, of which 2,359 are unidentified.

HALLECK'S ARMY

Major General Ulysses S. Grant's reward for victory at the battle of Shiloh was to have Major General Henry Halleck take command of the combined armies of Grant and Don Carlos Buell. For Grant, this was akin to being stripped of command. Halleck blamed Grant for the near defeat at Shiloh. Nothing of that sort would happen during the Corinth campaign.

Halleck was the only Union commander who had provided President Abraham Lincoln with a string of victories. Halleck could claim these victories thanks to the efforts of his subordinate officers. Grant had won at Fort Donelson and Shiloh, Major General John Pope had secured Island No. 10 on the Mississippi River, and Major General Samuel Curtis won at Pea Ridge, Arkansas.

Halleck decided to personally lead the upcoming campaign against Corinth. In doing so, he combined the Army of the Tennessee with the Army of the Ohio and Army of the Mississippi. The combined forces numbered over 120,000 men. Under his command was a who's who of Civil War generals. Halleck had Grant, Don Carlos Buell, William T. Sherman, William S. Rosecrans, George H. Thomas, Phil Sheridan, John A. McClernand, James B. McPherson, John Pope, Lew Wallace, and John Logan at his disposal.

With this corps of Civil War leaders, Halleck's advance on Corinth was remembered as one that was excruciatingly slow. Halleck did not want to suffer the same fate as Grant. Therefore, he painstakingly made sure that fortifications were dug. This translated into Halleck's army averaging less than one mile each day. It took thirty days for Hallack's troops to travel twenty-two miles.

Grant, disheartened by his diminished role in the army's operation, decided to resign. Sherman discovered his friend with his bags packed, ready to leave. Sherman, who experienced a nervous breakdown early in the war, convinced Grant to tough it out a little longer.

As Halleck's army inched closer to Corinth, it was apparent to General P. G. T. Beauregard that he did not have the men to stand up to Halleck's grand army. With conditions at Corinth becoming worse with each passing day, Beauregard decided to evacuate the town instead of giving battle.

Beauregard's masterful charade of having his soldiers cheer at incoming trains completely fooled Halleck. Instead of delivering fresh troops, the Confederate army was evacuating Corinth. The following day, Halleck's army entered Corinth. All along, Halleck hoped to take Corinth without a great loss of life. In a letter to his wife, Halleck wrote, "I have won the victory without the battle."

The importance of Corinth and controlling the railroad junction in the town was never lost on Halleck, who stated, "Richmond and Corinth are now the great strategic points of the war." Halleck's success, coupled with Major General George B. McClellan's failure on the Peninsula campaign, earned Halleck a promotion to general-in-chief. He was then sent to Washington, D.C., where his organizational skills were needed.

Sherman concurred with the significance of securing Corinth, claiming it was "a victory as brilliant and important as any recorded in history."

While Halleck was pleased with securing the "Crossroads of the Confederacy," a correspondent from the *Chicago Tribune* viewed the feat differently: "General Halleck has thus far achieved one of the most barren triumphs of the war. In fact, it was tantamount to a defeat. . . . I look upon the evacuation there as a victory for Beauregard, or at least one of the most masterly pieces of strategy that has been on display during the war."

Grant, who had stayed with the army at Sherman's behest, remarked, "The trophies of war were a few Quaker guns, logs of about the diameter of ordinary cannon mounted on wheels of wagons and pointed in a most threatening manner."

Halleck's departure opened the door for Grant to resume command of his old army.

Henry Halleck combined the armies of Ulysses S. Grant, Don Carlos Buell, and John Pope for his advance on Corinth.

P. G. T. BEAUREGARD'S HEADQUARTERS

After the Confederate retreat from Shiloh, General P. G. T. Beauregard made his headquarters at the Fish Pond House in Corinth, Mississippi. Beauregard was embarrassed by the Southern defeat and looked to put a positive spin on the situation. Corinth was in a crisis. The town was full of wounded and dying soldiers, the Union army was only twenty-two miles away, and Beauregard regarded the town as not worth defending.

Beauregard's premature claim of victory at Shiloh had turned into a defeat. Confederate wounded and survivors made their way down muddy roads back to Corinth. The town was by no means equipped to handle the five thousand wounded soldiers brought into town. Most buildings, homes, stores, porches, and even sidewalks were turned into hospitals. Doctors worked until they dropped with exhaustion, and still men suffered on the streets with untreated wounds. Outside of the Tishomingo Hotel, a pile of amputated limbs continued to grow as each day passed. Soon Corinth's water supply was contaminated, and infections spread throughout the town.

Even then, Beauregard wasn't convinced Corinth was worth saving due to the unhealthy nature of the town. Colonel Leonard Ross agreed with Beauregard's assessment. Ross called the town "a sickly, malarial spot fit only for alligators and snakes."

Beauregard realized the importance of the railroad junction at Corinth. Confederate president Jefferson Davis and the Confederate hierarchy viewed the Memphis and Charleston Railroad as the "vertebrae of the Confederacy" and wanted it under Southern control.

Major General Henry Halleck's creeping advance to Corinth gave Beauregard time to decide to fight or retreat. The cautious Northern general had advanced twenty-two miles in thirty days, the Union army digging fortifications as they advanced.

Once Halleck was on the perimeter of the town, Beauregard initially decided to fight Halleck. With the overwhelming number of Federal soldiers dangerously close to Corinth, Beauregard dis-cussed the predicament with Major General William Hardee. Both men decided it was time to abandon Corinth.

In doing so, Beauregard achieved one of the great acts of deception in the war. He wanted an orderly withdrawal that would confuse the Federal army. In doing this, Beauregard hoped he could buy time for the Army of the Mississippi to escape.

On May 30, 1862, supplies and wounded were the first to leave Corinth. As the empty trains arrived in town to evacuate the Southern army, Beauregard ordered his men to cheer at each arrival. The Union soldiers heard the cheers and were convinced a large number of reinforcements were arriving.

On the morning of May 30, 1862, the Union army entered Corinth. The "Crossroads of the Confederacy" was now under Federal control. Jefferson Davis eventually removed Beauregard from command and replaced him with General Braxton Bragg.

The Fish Pond House was built in 1856 by I. P. Young for his daughter and exemplifies the Greek Revival architecture of the time. The house got its name from a copper-lined cistern located on the roof in front of a cupola. When the home was remodeled in the 1950s, the cistern was removed.

The Fish Pond House served as the headquarters for P. G. T. Beauregard during Halleck's advance on Corinth.

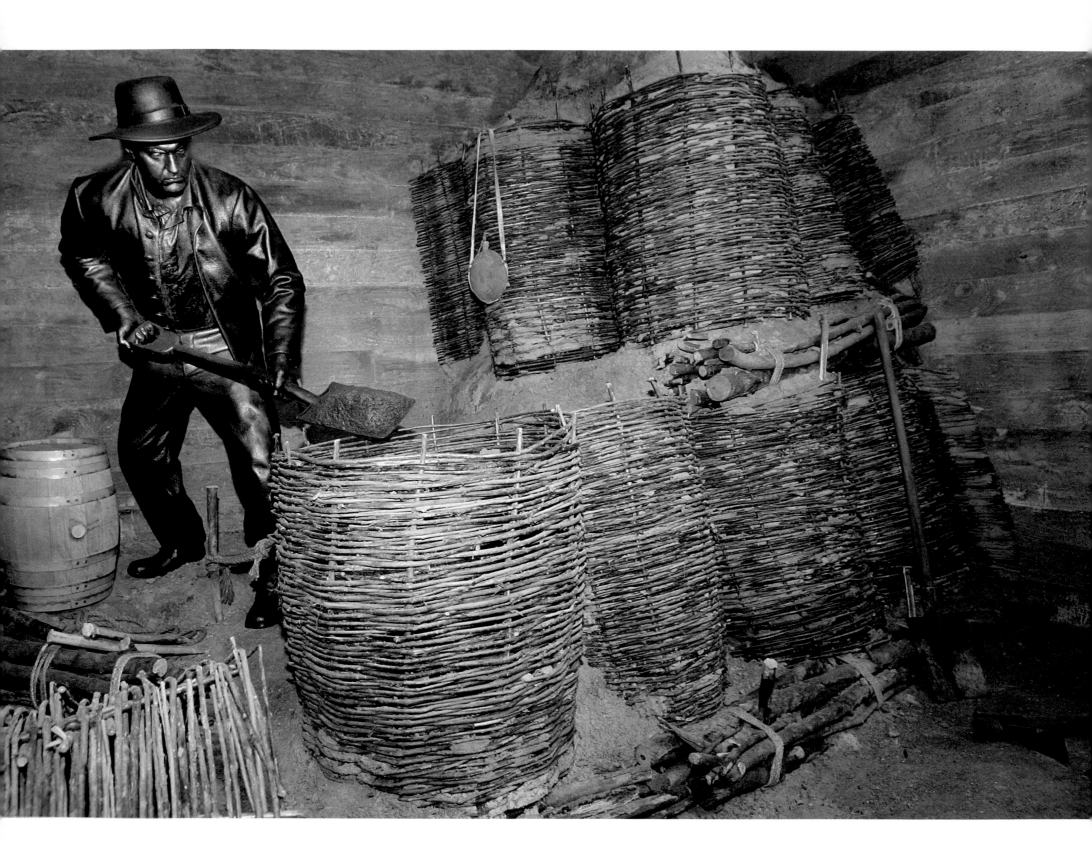

DIGGING IN

General P. G. T. Beauregard's talent as an engineer was put to good use in building earthworks that helped defend the town of Corinth, Mississippi. Many of the fortifications on the "Beauregard Line" are still visible in present-day Corinth.

Beauregard graduated second in the 1838 class at the U.S. Military Academy. His expertise in artillery and as an engineer served him well during his military career. He was an engineer reporting to Major General Winfield Scott during the Mexican War. Afterward, Beauregard served a decade in his native New Orleans, helping clear the Mississippi River and building a customhouse.

After the battle of Shiloh, Beauregard's Army of the Mississippi was in dire straits. Many of the soldiers were wounded from the fighting, and many more got sick due to the squalid conditions in Corinth. The water was contaminated, creating less than sanitary conditions for all in the town. While Beauregard sought to defend Corinth, he also had his soldiers digging wells for better water.

The digging around Corinth wasn't just for water, however. Beauregard desperately wanted to improve the earthworks around the town. Major General Braxton Bragg had begun constructing breastworks east and north of the town before the march on Shiloh. Beauregard looked to improve or add to the existing works.

In a communiqué to President Jefferson Davis, Beauregard said, "These lines are mere rifle pits with slightly constructed batteries, enfilading the roads from the front." Over the next month, the rifle pits became formidable earthworks and a defensive line. Work was renewed on the "Beauregard Line," as five crescent-shaped rifle pits were added.

The use of military earthworks in the Civil War increased with each passing year. The approach was simple. Forts and buildings could be subdued or conquered through prolonged enemy fire. Forts thought to be impregnable prior to the Civil War were often reduced to rubble. While earthworks might show the scars of combat, a spade and a strong back could quickly repair or build another entrenchment.

Soldiers built earthworks to secure a vital area and to allow a smaller force to withstand attacks from a larger army. This was something Beauregard desperately needed.

Major General Henry Halleck had created a super army after Shiloh. He combined the Army of the Tennessee, now under the command of Major General George Thomas, the Army of the Ohio, and Major General John Pope's Army of the Mississippi into one huge fighting force. Halleck had over 120,000 soldiers at his disposal, while Beauregard could only muster 70,000 soldiers, with about 20,000 of these men unfit for combat. If Beauregard was going to defend Corinth, a defensive line with strong earthworks was imperative.

Any earthwork is only as strong as its weakest part, so these fortifications were built in close proximity to one another. The idea of providing mutual support took some of the pressure off of one fortress. A defensive line with several small forts provided a stronger defensive front.

As Halleck's army inched closer and closer to Corinth, Beauregard continued to improve his earthworks, but it became evident to Beauregard and his officers that Corinth must be abandoned. The Confederate army left their earthworks on May 29 and withdrew to Tupelo, Mississippi, fifty-one miles south of Corinth.

When the Union army occupied Corinth during the summer of 1862, Union troops continued to improve the existing earthworks as well as adding more to the western outskirts of town.

In October 1862, soldiers in the Confederate army had to charge earthworks they had helped build eight months earlier.

Corinth still has a number of intact Civil War earthworks. Many of these earthworks can be seen on the town's Civil War driving tours.

After the battle of Shiloh, P. G. T. Beauregard had his soldiers strengthen fortifications around Corinth.

JACINTO COURTHOUSE

Nestled under the comforting shade of oak trees, the Jacinto courthouse harkens back to the romantic days of the Old South.

Located seven miles from Rienzi, Mississippi, the town of Jacinto gets its name from the battle of San Jacinto, Texas, where soldiers cried "Remember the Alamo!" and defeated the Mexican army of Santa Anna, creating the Lone Star Republic.

The Jacinto courthouse was built in 1854, and by the time of the Civil War, Jacinto was the seat of Tishomingo County, one of the largest counties in the state of Mississippi. The county was named for the leading chief of the Chickasaw tribe.

The community was considered to be the political and cultural center of northeast Mississippi. Jacinto had a boys' school that attracted students from three states. A stage line stopped four times a day, and a number of newspapers kept readers informed on the issues of the day.

The town was the seat of a county that was comprised of more than 923,000 acres, including the town of Corinth. After the election of Abraham Lincoln in 1860, many of the Southern states decided to secede from the Union. The courthouse was the scene of a great drama, as the citizens of Jacinto voted twice not to secede.

On January 9, 1861, Mississippi became the second state to secede, following the fire-eaters of South Carolina. After General P. G. T. Beauregard evacuated Corinth and the Union army occupied the town, Jacinto became an outpost for Brigadier General Charles Hamilton's 3rd Division of the Union Army of the Mississippi.

In September 1862, Major General William S. Rosecrans used Jacinto as the staging point for his advance on Major General Sterling Price's Confederate army at Iuka, Mississippi.

A drenching rain slowed Rosecrans's approach to Jacinto and rendezvous with Hamilton's division. Rosecrans bivouacked at Jacinto for the night, resting his tired soldiers. The following day, Rosecrans's men marched northeast on the Jacinto Road toward Iuka. Rosecrans hoped to cut off the escape route of Price, who was facing the armies of Major General E. O. C. Ord.

Despite being late for the initial day's battle at Iuka, Rosecrans was able to slip behind Price's Confederate army. The surprised Price rushed in the brigade of Louis Hebert to confront Rosecrans's army.

Hebert was forced to double-quick his men through Iuka to meet the Union army south of town. He threw the 3rd Texas Dismounted Cavalry, 1st Texas Legion, 3rd Louisiana Cavalry, and 14th and 17th Arkansas and 40th Mississippi infantries forward to stop the Federal advance. The Confederates launched numerous attacks against the Union line, eventually capturing the six guns of the 11th Ohio Battery.

Price evacuated Iuka via the Fulton Road to join Major General Earl Van Dorn's army. The escape was made possible because Rosecrans failed to cover the Fulton Road, leaving open that avenue of escape.

The demise of Jacinto didn't come from the Civil War, but from the vote of the townspeople. Citizens voted not to let the railroads pass through their town, causing the town to suffer from lack of commerce.

In 1870, Tishomingo County was divided into the present-day counties of Alcorn, Prentiss, and Tishomingo. The courthouse was used as a school until 1908 and then as a Methodist Church until 1960.

The Jacinto courthouse is one of the South's most impressive examples of Federal-style architecture. The roof is topped with an octagonal cupola. The foundation is constructed of hand-cut stone. Each brick used in the building is handmade, and each board hand-hewn.

Although the town of Jacinto is long gone, a Fourth of July festival is held at the Jacinto courthouse annually.

Jacinto was the county seat for Tishomingo County. William S. Rosecrans rested his army at Jacinto en route to Iuka, Mississippi.

BATTERY ROBINETT

Standing at Battery Robinett in the center of the Union line, Colonels John Fuller and Joseph Kirby Smith watched in awe as the 2nd Texas, 42nd Alabama, and 35th Mississippi infantries approached. The oncoming Confederates formed a wave of butternut and gray heading directly toward the Union position.

Fuller's immediate concern was the 63rd Ohio Infantry. It had been placed alongside the Memphis Road without protection of breastworks. The men from Ohio were in the open and would be the first unit consumed by the Confederate wave.

Fuller prepared his men for the onslaught and ordered his regiments to lie down and hold their fire until the Confederates were close. Inside the earthen fort of Battery Robinett, Lieutenant Henry Robinett, for whom the fort was named, had his gun crews load their cannons with canister.

The Confederates first felt the wrath of Robinett's guns, along with shells coming from nearby Battery Williams. At a distance of one hundred yards, Fuller's men rose and fired a volley into the approaching soldiers.

Lieutenant Charles Labruzan of the 42nd Alabama survived the initial volley of the 63rd Ohio. He described the scene unfolding before him: "The whole of Corinth with its enormous fortifications burst upon our view. The United States flag was floating over the forts and in the town. We were met by a perfect storm of grape, canister, cannon balls and minié balls. Oh God! I have never seen the like. The men fell like grass, I saw men, running at full speed, stop suddenly and fall upon their faces, with their brains scattered all around; others; with legs and arms cut off, shrieking with agony."

Staggered from the Union volley, the Confederate soldiers regrouped and made their second approach. As the Confederates closed on the Union ranks, the cannons from Battery Williams ceased firing for fear of hitting their own men. Only one gun at Battery Robinett continued to fire.

Now the contest was between two desperate infantries. The second Confederate attack began to punish the Union line. Kirby Smith's 43rd Ohio was hit hard. During the melee, a minié ball smashed into Smith's nose, passed through his head, and exited his left ear. Soldiers ignored the battle and scrambled to retrieve the popular Smith. The Union colonel would die several days later in Corinth. News of Smith's wounding shattered the resolve of the 43rd Ohio. General David Stanley recalled battle-hardened men weeping when hearing that Smith was down.

The first two attacks had virtually wiped out the 63rd Ohio. Nine of thirteen line officers were down, and Fuller knew the regiment couldn't withstand a third attack. Fuller ordered the 11th Missouri to charge the moment the 63rd Ohio faltered.

Inside the fort, the fighting had devolved into hand-to-hand combat. Gun crews used their ramrods as clubs in an attempt to beat back the Rebel tide. Lieutenant Robinett was shot in the head, falling beneath one of his cannons.

As the Rebels took Battery Robinett, the 11th Missouri readied for action. Waiting until the Confederates were within ten paces, Major Andrew Wilson ordered a bayonet charge. The impact of fresh troops joining the fray broke the momentum of the Confederate charge, and they began to give ground.

Charles Labruzan had survived the charge on Battery Robinett and the deadly volley that had killed Colonel William P. Rogers of the 2nd Texas Infantry. Labruzan tried to feign death in an effort to escape the Union onslaught. He was captured by a Union soldier and was forced to hand over his sword. "For the first time in many years, I cried to see our brave men slaughtered so," Labruzan said. "I have never felt so bad in all my life."

During the fight for Battery Robinett, five Union regiments had leveled a converging fire on the charging Confederates. The 11th Missouri, 47th Illinois, and 27th, 43rd, and 63rd Ohio dealt a deadly blow to the men in gray.

Battery Robinett was the scene of vicious fighting during the second day of the battle of Corinth. This is a replica of Battery Robinett.

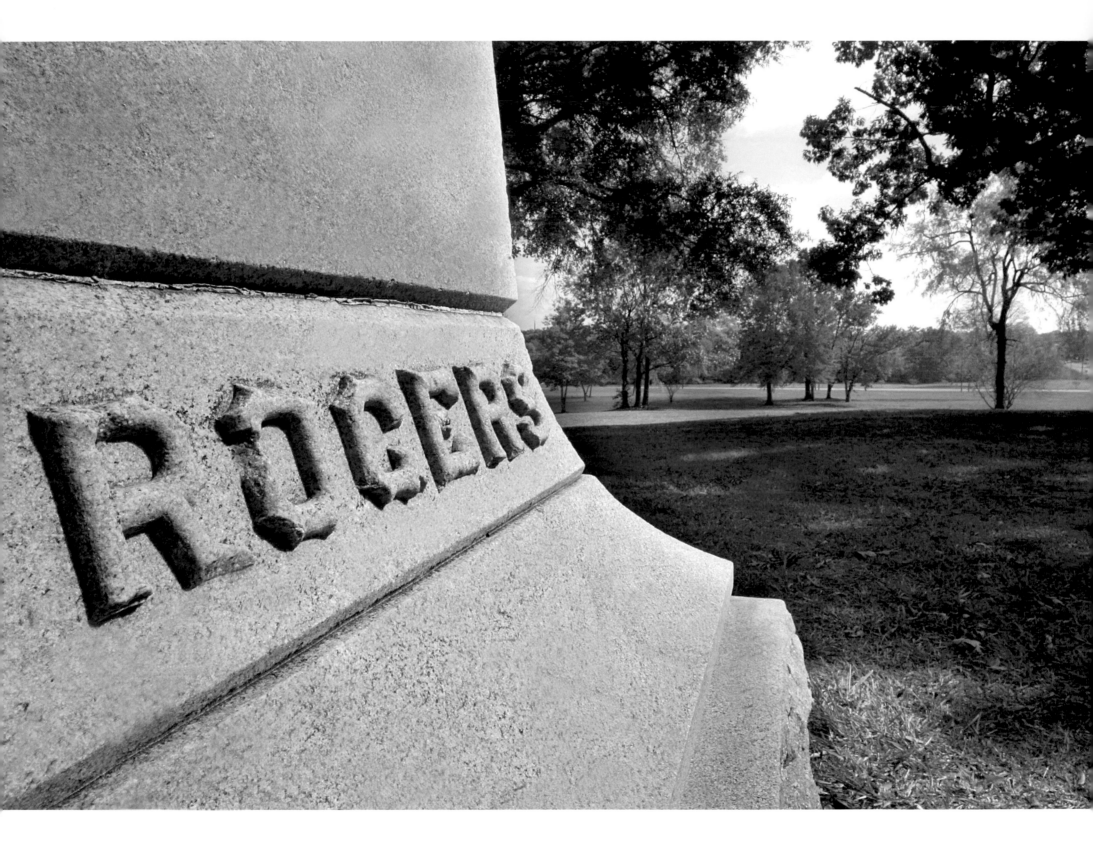

COLONEL WILLIAM ROGERS

Confederate major general Earl Van Dorn's hope of winning the battle of Corinth rested with the battle-tested soldiers of Brigadier General Dabney Maury. Leading the vanguard of the Confederate assault on Battery Robinett was Colonel William P. Rogers. Battery Robinett commanded the center of the Union line.

Rogers spent his early years on a plantation near Aberdeen, Mississippi, in nearby Monroe County, where he studied law and edited a pro-Whig newspaper. In 1846, Rogers joined the Mississippi Rifles under the command of Colonel Jefferson Davis to participate in the Mexican War. Rogers was said to be the second man to scale the walls of Monterey, continually exhibiting courage on the field of battle.

Rogers often clashed with Davis and openly questioned Davis's use of Rogers's company in battle, and he felt slighted in the official reports. Rogers even challenged the future Confederate president to a duel. This deadly proposition was stopped by General Zachary Taylor.

In 1849, President Zachary Taylor appointed Rogers U.S. consul at the port of Veracruz in Mexico. Rogers's wife refused to go to Mexico, opting instead for Texas. Rogers went to Veracruz alone. By 1851, Rogers resigned his post and rejoined his family in Texas.

After Abraham Lincoln won the presidential election of 1860, Rogers was a delegate to the Texas secession convention and signed the ordinance of secession. He also served on the committee to force Governor Sam Houston to comply with the ordinance. Rogers's old friend resigned instead of affirming secession.

With the outbreak of the Civil War, Rogers offered his services to the Confederacy. He accepted a lieutenant colonel's rank in the 2nd Texas Infantry. The 2nd Texas joined General Albert Sidney Johnston's army at the battle of Shiloh, where the regiment lost a third of its men. Afterward, Rogers was promoted to colonel and given command of the 2nd Texas.

Rogers was respected for his leadership qualities, and many of his fellow officers campaigned for him to receive higher rank.

In August 1862, officers of twenty regiments sent a letter to the War Department urging Rogers's promotion to major general and command of a division, but the promotion never came, possibly because of the enmity between Rogers and President Davis.

On October 4, 1862, Rogers and his Texans, joined by the 42nd Alabama and the 35th Mississippi infantries, began the headlong assault on Battery Robinett, located on a ridge above the Memphis and Charleston Railroad. Initially, the attack was repulsed by a horrific barrage of canister and musket fire from the Union line.

Rogers rallied his men for a second and a third attack. During this assault, Rogers, riding on a black mare, carried the regimental colors, reaching the trench in front of Battery Robinett. Rogers led a cluster of soldiers from Texas, Alabama, and Mississippi into the fort, and hand-to-hand combat ensued.

It soon became obvious to these Southern soldiers that support wasn't coming, and they had to choose death or surrender. Rogers realized the futility of the fight, and he tied his handkerchief to a ramrod of a fellow soldier and began waving it to surrender.

Failing to see the act of surrender among the carnage, soldiers from the 11th Missouri and 63rd Ohio infantries fired a volley into Rogers's band of men. Rogers was hit several times at almost point-blank range. Lieutenant Charles Labruzan of the 42nd Alabama, who had fought alongside Rogers, said, "Oh, we were butchered like dogs."

The 2nd Texas Infantry lost more than half its number in casualties, and the failed attack at Battery Robinett sealed Van Dorn's defeat at Corinth.

The night before the battle, Rogers had told a fellow officer, "Tomorrow Jeff Davis must allow my promotion, or tomorrow, I die."

In a tribute to Rogers's bravery, Union major general William S. Rosecrans ordered that Rogers be buried with full military honors. Such a tribute was usually reserved only for general officers.

William Rogers was buried with full military honors because William S. Rosecrans was so impressed with the bravery of the Confederate soldier.

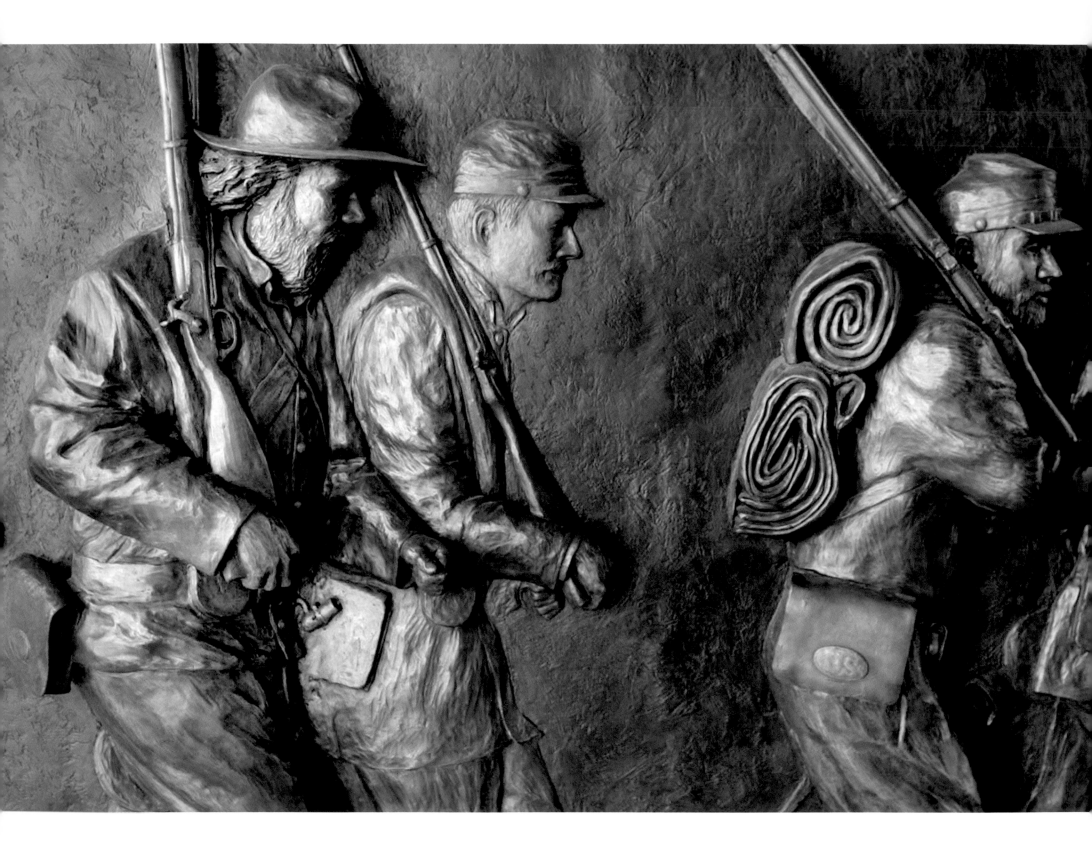

CONTEST AT THE CROSSROADS

While the 2nd Texas and 42nd Alabama infantries were repulsed at Battery Robinett, soldiers from Arkansas and Mississippi entered Corinth in a last-ditch effort to take the town.

The 3rd Arkansas Dismounted Cavalry and Colonel Erasmus Irving (Ras) Stirman's Arkansas Sharpshooters had worked their way around the 29th Ohio during the fight for Battery Robinett. Joining these soldiers were the 15th and 23rd Arkansas and remnants of the 35th Mississippi.

Following the lead of Brigadier General C. W. Phifer, these soldiers advanced along the Elam Creek bottom and fought their way into Corinth. Once in town, the soldiers from Arkansas and Mississippi charged across the Mobile and Ohio Railroad and into the 7th and 15th Illinois infantries. These demoralized Union troops quickly scattered, leaving the town open for the Confederates.

The Confederate assault continued down Polk, Jackson, and Fillmore streets to the railroad intersection. Also on the streets of Corinth were fifteen hundred Confederates of Brigadier General Martin Green's command. They had entered the town earlier after overrunning Battery Powell. Green's soldiers had been fighting house to house ever since they had entered the town.

The Southern soldiers clashed with Union reserves close to the headquarters of Union major general William S. Rosecrans. Many of the demoralized Union soldiers raced past their commanding general. Rosecrans, known for his quick temper, vehemently cursed and hurled threats toward the mob of soldiers. The fleeing soldiers paid little attention to Rosecrans and kept on their way.

The Confederates continued their pursuit past the headquarters and on to the Tishomingo Hotel, located on the Memphis and Charleston Railroad. The hotel had been used as a hospital the night before and was full of wounded soldiers.

Phifer's band was also joined by soldiers from Missouri and Mississippi of Colonel W. H. Moore's brigade. Carrying the distinctive Van Dorn flag, the mixed commands of Confederate soldiers had penetrated the heart of Corinth and were driving the Union soldiers from house to house.

To Rosecrans and many of his soldiers, the day was lost. During the fighting in the town, Rosecrans happened upon the chaplain of the 15th Illinois Infantry, who was in charge of the trains of Colonel John V. DuBois's brigade. Rosecrans declared the army was whipped and told the chaplain to burn the wagons. The chaplain replied, "We are not whipped, sir," and drove the wagons to safety.

The Confederate attack had reached its zenith when DuBois led a counterattack of the 7th, 15th, and 57th Illinois infantries. The Confederates tried to make a stand, but Moore was mortally wounded near the Corinth depot. The guns of Batteries Williams and Robinett began to blindly shell the town. The shells hit soldiers from both sides, adding to the confusion.

The 17th Iowa, which had been held in reserve all day, joined the fray and began picking off the Confederates. Caught in the cross fire of Union reserves, the Confederate soldiers began to retreat. At that moment, the Iowans charged, striking the rear of the Confederate line.

Many of the Missouri and Mississippi soldiers were taken prisoner by the 17th Iowa. The color guard of the 43rd Mississippi surrendered instead of trying to run the gauntlet to their lines. Those who were not captured were driven back in disorder. Some Confederate soldiers grabbed Union horses that had been hitched near the Tishomingo Hotel to hasten their flight.

The soldiers of Arkansas, Mississippi, and Missouri returned to their lines spent and dispirited. Confederate major general Sterling Price met his soldiers as they returned. Price couldn't contain his emotions as he bellowed, "My God! My boys are running. How could they do otherwise? They had no support. They are nearly all killed."

The fight for Corinth spilled into the streets of the northern Mississippi town. The apex of the fighting occurred at the Tishomingo Hotel near the railroad crossroads.

FIGHT AT THE HATCHIE RIVER

While Confederate major general Earl Van Dorn was attacking Corinth, Mississippi, Union major general Ulysses S. Grant dispatched Major General E. O. C. Ord to cut off Van Dorn's escape route. At the Hatchie River, Ord met Van Dorn in a struggle for one army's survival.

Van Dorn's army had marched across the Hatchie River on October 1, 1862, en route to Corinth. The Davis Bridge offered Van Dorn an escape from destruction. After two days of fighting in Corinth, Van Dorn's army wasn't prepared for a full-scale conflict. His weary men needed to retreat to a safe area and regroup.

Ord was advancing from Bolivar, Tennessee, and joined with Brigadier General Stephen Hurlbut's division. With the Confederate army on the run, Grant wanted Major General William S. Rosecrans to pursue the Rebels. Rosecrans chose not to begin his pursuit until October 5, 1862. This gave Van Dorn a day's head start.

Ord's men were at Metamora, Tennessee, when they spotted the vanguard of Major General Sterling Price's army appearing near the Davis Bridge. Ord wanted to keep the Confederate army from crossing the Hatchie River and reaching safety.

Ord launched an attack on the stunned Southerners. Some of Colonel John C. Moore's brigade had reached the west side of the Hatchie and desperately tried to stop the Union advance. These soldiers fell back under the constant bombardment of Ord's men. Those who weren't able to escape across the Davis Bridge threw down their weapons and swam across the muddy river.

Ord continued to press the advantage and personally led Brigadier General James Veatch's men to the Davis Bridge. The Southern army formed on the east ridge and poured canister, shot, and shell on the advancing Federals. Brigadier General Jacob Lauman's brigade was called in to support Ord's advance.

The Union soldiers were trapped on the bridge and in the no-man's-land on the east side of the river. Without exposing their positions, the Confederates poured a deadly fire on Lauman's brigade. Ord was severely wounded in his leg while on the bridge, and Hurlbut assumed command.

Hurlbut, familiar with the terrain, deployed his men in areas that allowed them more room to maneuver. This gave the Federals a foothold on the east side of the river, and by that evening they had secured the hill overlooking the river.

While Price was fighting Ord, Brigadier General John S. Bowen repulsed the lead elements of Rosecrans's army at Young's Bridge located three miles to the east. While these two battles were going on, Van Dorn was able to find another crossing of the Hatchie River at Crum's Mill. Once across the Hatchie, Van Dorn's army was saved from destruction and lived to fight another day.

Lauman resented how his soldiers were butchered at the Hatchie River and held a grudge against Ord. This grudge was ultimately Lauman's undoing. In 1863, at the battle of Jackson, Mississippi, Lauman ordered his one brigade to assault a strongly held position. The men were slaughtered as the rest of Major General William T. Sherman's division watched in horror.

Lauman lost five hundred men as casualties in the foolhardy move. Ord, back in command after recovering from his wounds, accused Lauman of disobeying orders. Lauman vehemently denied the charges and asked for a formal court-martial so that his side of the story could be heard. Sherman and Grant blocked this request. Lauman was relieved of command. He returned to Iowa a broken man, never recovering from the disgrace. He died a couple of months after returning home.

Ord recovered from his wound at the Davis Bridge and replaced Major General John A. McClernand at Vicksburg. McClernand had run afoul of Grant, who had McClernand relieved of command.

Ord never forgot the Hatchie River. He referred to the place as "the miserable bridge." The 15th Illinois Infantry's regimental flag carried the battle designation, "Hell on the Hatchie."

From this position at Metamora, Tennessee, E. O. C. Ord's men saw Earl Van Dorn's army trying to cross the Hatchie River at the Davis Bridge.

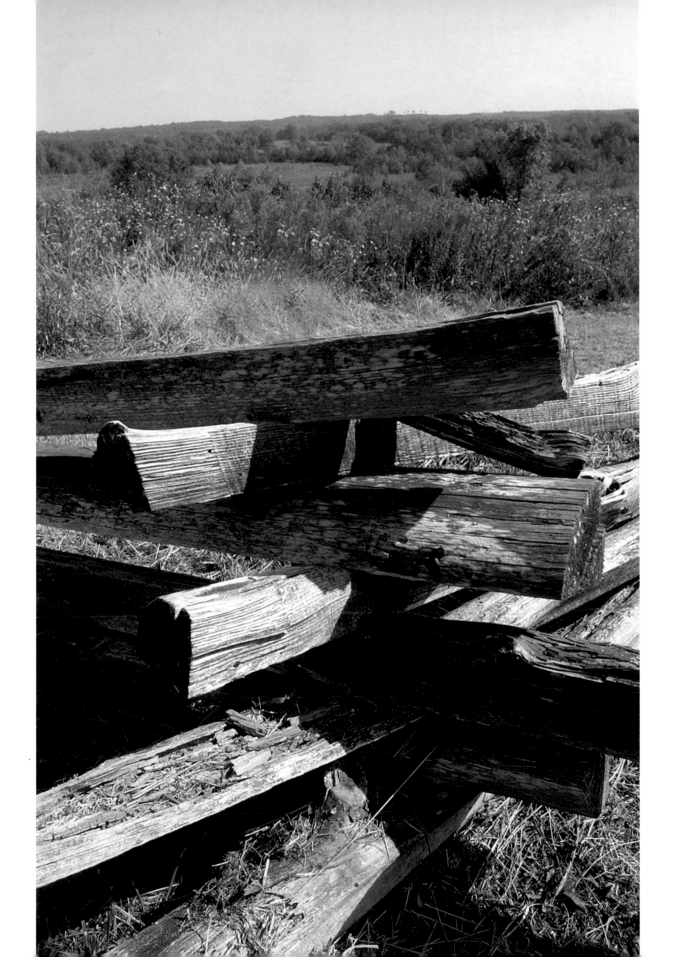

BOWEN'S REAR GUARD ACTION

Brigadier General John S. Bowen faced a daunting task, as he was asked to save Major General Earl Van Dorn's army from annihilation from two converging Union armies. Bowen's rear guard action at the Tuscumbia River helped save Van Dorn's army and brought the hard-nosed Bowen fame.

Van Dorn's retreat from Corinth, Mississippi, began on October 4, 1862. His defeated Army of West Tennessee had broken the Union lines and penetrated into the town of Corinth, but could not marshal the power to sustain the charge. Van Dorn's exhausted army marched away from Corinth, hoping to put some distance between themselves and Major General William Rosecrans's army. Instead of pressing on, Van Dorn halted his army at Chewalla, Tennessee, allowing his men to rest. The embattled Confederate general failed to realize that Major General Ulysses S. Grant had set a trap for Van Dorn.

Unknown to Van Dorn, Grant had sent Brigadier General E. O. C. Ord from Bolivar, Tennessee, to cut off the Confederate retreat. Ord raced to secure the bridge over the Hatchie River near Metamora, Tennessee. Ord won the race and clashed with the lead elements of Van Dorn's retreating army. Ord was able to hold the bridge, trapping Van Dorn on the land between the flooded Hatchie and Tuscumbia rivers.

Bowen's men had seen little combat, as Major General Mansfield Lovell inexplicably had held his division out of the fighting at Corinth. For the past six months, Bowen's exposure to combat was minimal. He was wounded during the first day of fighting at Shiloh and had been on the mend ever since.

While Van Dorn's army tried to hammer a breakthrough at the Hatchie River, Bowen and two thousand men were entrusted to stop Rosecrans's army.

Ever since the Rebel army retreated from Corinth, Bowen was protecting the rear of the retreating force. Bowen used a technique that resembled a game of leapfrog. The 1st Missouri would set up a line and hold it. In the meantime, the 22nd Mississippi and the 9th and 10th Arkansas staggered their lines behind each other.

When the Missouri men were forced to fall back, they passed three defensive lines before they formed a new line. The Union army kept hitting a strong line of rested soldiers on good ground.

Bowen, known for his talent as an engineer and architect, used these skills to set up a strong defensive line. He chose to form on the east side of the Tuscumbia, leaving the flooded river at his back. This was a daring move that could cause him to be trapped by the river. Bowen placed his artillery loaded with double canister in positions that would give his men enfilade fire down the Union lines. He worked to conceal all positions and set up his Mississippi Sharpshooters to assist the artillery in picking off the enemy.

The Union army, led by Brigadier General James B. McPherson, was allowed to advance into Bowen's ambush before he sprang the trap. With a shout from Bowen to "Fire," a sheet of flame erupted from the dark woods surrounding the Tuscumbia. Bowen's position was backlit by a setting sun, making it difficult for the Union soldiers to locate their foe in the shadows.

The 15th Mississippi Infantry received McPherson's attack, and handily repulsed the Federal thrust. Bowen personally led a bayonet charge against the Federal soldiers, proving that a good defense often relies on offensive maneuvers. The move worked, as the Union line was stymied. With Van Dorn's army two miles to his rear, Bowen held the Union army at bay while Van Dorn's force found a secondary location to cross the Hatchie.

The opportunity to destroy Van Dorn's army was foiled by Bowen and his two thousand men. Bowen's men destroyed Young's Bridge and continued to protect Van Dorn's retreating army. This continued even though Bowen's men were receiving little to no rations and getting precious little sleep. Thanks to Bowen and his men, Van Dorn's army escaped to Holly Springs, Mississippi.

Bowen's stock continued to rise as a Southern general. He was destined to play an important role during the ill-fated Vicksburg campaign of 1863.

John S. Bowen's rear guard action at the Tuscumbia River saved Earl Van Dorn's army during the retreat from Corinth.

CORINTH NATIONAL CEMETERY

The Corinth National Cemetery was established in 1866, one year after the end of the Civil War. This hallowed ground is the burial site for twenty-three hundred Union casualties of the battle of Corinth as well as other battles in the area. While it isn't too surprising to see the states of the Midwest represented, one can find a few graves with Tennessee and Alabama listed as the Union soldier's home state.

The 1st Alabama and Tennessee Vidette Cavalry was the result of pro-Union Southerners who joined the Federal army. These soldiers didn't own slaves and were against the secessionist movement in the Deep South. These hill farmers didn't want to fight a war that would only help the gentry class get wealthier.

East Tennessee and northern Alabama were Union bastions in a Confederate land. Any person showing Union loyalty was often subjected to reprisals by those loyal to the Confederacy. After the battle of Shiloh, the Confederate government initiated the Conscription Act of 1862. This required that every able-bodied man between the ages eighteen and thirty-five was subject to military service in the Confederate army.

Many of the Union loyalists of north Alabama fled to caves to hide from conscription patrols, while others moved to safety behind the Union lines. Many members of their families had fled to avoid persecution from Confederate sympathizers. The only way for them to return home was to defeat the Southern army.

The 1st Alabama and Tennessee Vidette Cavalry was formed in October 1862 in Huntsville, Alabama, and Memphis, Tennessee. James H. Smith was from northeast Alabama and joined Company H. The ranks of the 1st Alabama and Tennessee Vidette Cavalry included whites and blacks willing to fight for the Union. These soldiers were ordered to Corinth by the end of 1862.

Colonel Abel Streight of the 51st Indiana Infantry was impressed by the pro-Union Southerners. "I have never witnessed such an outpouring of devoted and determined patriotism among any other people," Streight said.

The soldiers of the Vidette Cavalry were often targets of bushwhackers looking to punish disloyal Southerners.

Smith enlisted as a private and was with the 1st Alabama and Tennessee Vidette Cavalry through the summer of 1864. During that summer, Smith fought in Major General William T. Sherman's Atlanta campaign, at the battles of Resaca and Kennesaw Mountain, Georgia.

Sherman was so impressed with the men from Alabama and Tennessee that he chose the 1st Alabama and Tennessee Vidette Cavalry as his escort during his March to the Sea. The cavalrymen were mustered out of service on October 20, 1865. Most of the men returned to their homes in Alabama and Tennessee. These soldiers found there was huge resentment against them because of their service in the Union army.

Smith died on July 6, 1864, in Decatur, Alabama. He had contracted typhoid fever and died in the post hospital. Smith was buried at the Corinth National Cemetery surrounded by sons of Iowa, Illinois, and Ohio.

By 1870, there were 5,688 interments in the Corinth National Cemetery. Of this number, 1,793 are known and 3,895 are unknown. The dead represent 273 regiments and fifteen states.

Marble headstones stand as if marching in formation to meet their foe. The sounds of battle have been replaced by the gentle chirping of mockingbirds. These soldiers came from battlefields like Farmington, Davis Bridge, and Young's Bridge. They eternally slumber safely behind the stone walls of the Corinth National Cemetery.

The Corinth National Cemetery was established in 1866 and is located in the southern section of town. The cemetery holds over 7,000 graves, with 3,895 of them being marked as "unknown."

CONTRABAND CAMPS

Union victory at Corinth brought about an unexpected change in life in the northeast Mississippi town. With Major General Earl Van Dorn's Confederate army in shambles, the threat of a Rebel offensive seemed remote. Slaves, known as "contraband," arrived at Corinth seeking a safe haven in the Union-held town.

Prior to the battle of Corinth, President Abraham Lincoln issued the Emancipation Proclamation on September 22, 1862. This authorized freedom to slaves in areas still under the control of the Confederate government. Beginning January 1, 1863, true emancipation for the slaves relied upon Union victories gained in the western Confederacy.

Even with Union victories, it was still up to each individual enslaved person to escape the bonds of slavery and seek refuge in areas controlled by the Federal army. Victory at Corinth turned the vital crossroads town into an enclave for escaped slaves and freed blacks from Mississippi, Alabama, and Tennessee.

By December 1862, Major General Ulysses S. Grant reported a population of twenty thousand black refugees within his department. The staggering number threatened to overwhelm the military authorities. On December 17, 1862, Grant named John Eaton "General Superintendent of Contrabands."

The contraband camp began as a tent city but soon flourished under the guidance of Chaplain James M. Alexander of the 66th Illinois Infantry. Within a year, the tent city resembled a small town. Camp residents traded tents for framed and log houses. The community also featured named streets and numbered houses. There was a church, commissary, and even a hospital.

Abolitionists and benevolent societies came to Corinth to provide the freedmen with religious, academic, and vocational instruction. Eager to learn, the freed blacks attended school day and night. Members of the American Missionary Association called the camp "the most thoroughly systematized, cleanest and most healthy camp ever seen."

Through the work of Alexander, black men were given the opportunity to join the Union army. Those who didn't join farmed

four hundred acres, raising a crop of cotton and vegetables. The cotton was sold to purchasing agents, and the produce was sold on the open market to the residents of Corinth. Eaton estimated that the Corinth contraband camp made a monthly profit of $4,000 to $5,000. By March 1863, the contraband camp housed 3,657 former slaves.

As the Union war effort spread farther east, the need for the soldiers pulling garrison duty at Corinth grew. Major General William T. Sherman wanted the troops for future fighting and recalled soldiers in the District of Corinth. The town of Corinth, including the contraband camp, was abandoned on January 24, 1864.

No longer under the protection of the Union army, residents of the contraband camp were moved ninety-three miles west to Memphis, Tennessee. There, the former slaves were crowded into an orchard and cornfield south of town. Left behind were the sturdy homes and gardens of the Corinth contraband camp. The former slaves were once again living in tents and were subjected to one of the coldest winters in Memphis. They built fires inside the tents just to survive the frigid temperatures.

The conditions at the Memphis camp were foul, and overcrowding was a problem. For all the gains made at Corinth, the exact opposite existed at Memphis. Schools, churches, and opportunities to work were virtually nonexistent.

At Corinth, the former slaves worked and learned, creating a new life for themselves and their families. At Memphis, many of the freedmen grew listless and sat around in their tents. The industrious times of Corinth gave way to the idleness of Memphis.

The success of the Corinth contraband camp was never repeated or even attempted in the Mississippi Valley.

Area slaves moved to the safety of the Union lines at Corinth. "Contraband" camps were created to help the slaves start a new and free life. The Corinth "contraband" camp was considered a model camp.

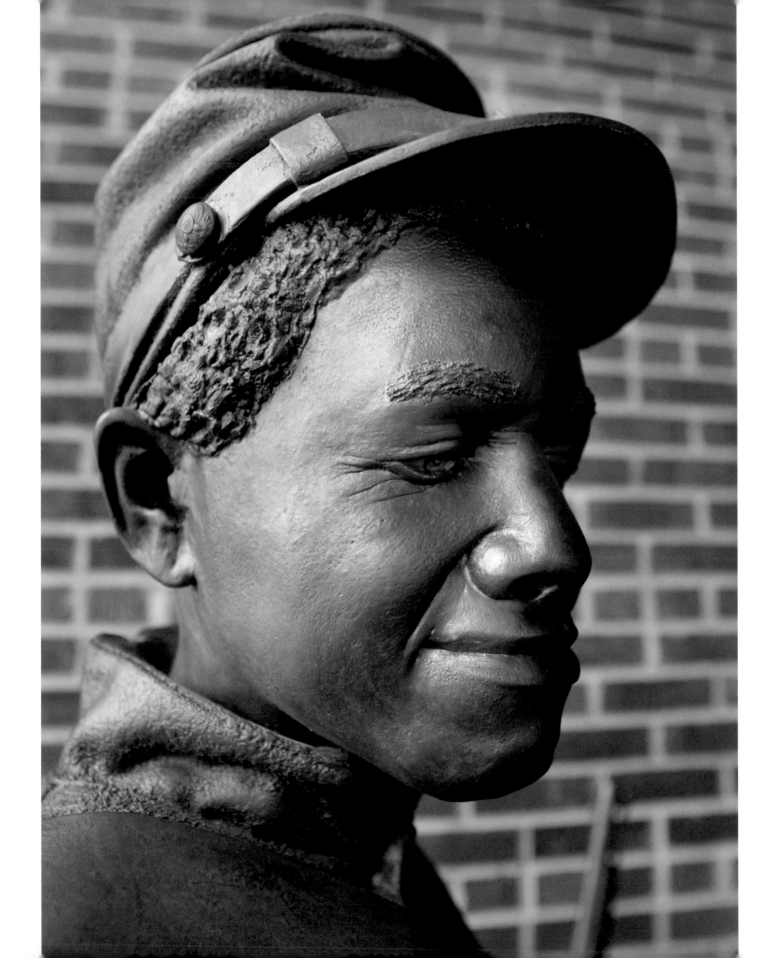

1ST ALABAMA INFANTRY OF AFRICAN DESCENT

The apparent success of the contraband camp at Corinth, Mississippi, brought another opportunity for Ulysses S. Grant's Union army. Acting more quickly than the Federal government, Brigadier General Grenville M. Dodge realized the important role that black soldiers could play in the Union war effort and, just as important, the adverse affect these soldiers would have on the Confederacy.

The influx of former slaves almost overwhelmed the town of Corinth. President Abraham Lincoln's Emancipation Proclamation, which was first delivered in September 1862, freed the slaves beginning January 1863. Slaves from Mississippi, Alabama, and Tennessee came to Corinth after the Union victory over Major General Earl Van Dorn's Confederate army.

"They will not even wait until 1st January," Dodge wrote. "I do not know what I shall do with them." Over time, Dodge realized the qualities of the former slaves. He enlisted them as cooks, teamsters, and laborers. Dodge even recruited male refugees, arming them and placing the former slaves in charge of security at the contraband camp, located in northeast Corinth.

Dodge supported Chaplin James M. Alexander's push to turn these former slaves into soldiers. This action was independent of any authorization from Washington. The Lincoln administration was lagging behind the effort to form black regiments. Once Lincoln committed to the effort, the initial formation of regiments began in the East. Eventually, Lincoln sent Adjutant General Lorenzo Thomas to the western theater to recruit blacks into the Federal army.

When Thomas arrived in Corinth and announced the official decision to form black regiments, he was treated to the thundering sound of applause. Thanks to Alexander and Dodge, former slaves had already been receiving instruction as soldiers. These men, who had only known the life of bondage, drilled each day under the supervision of two white soldiers. It was only a matter of time before these former slaves could call themselves soldiers.

Alexander became colonel and commander of the 1st Alabama

Infantry Regiment of African Descent. Consisting of approximately one thousand men, it was organized at Corinth on May 21, 1863. This new regiment stayed in the Corinth area, guarding the camp and performing outpost duty.

In February 1864, Major General William T. Sherman's Meridian campaign required soldiers who were ready for fighting instead of garrison duty. After a year of relative peaceful life, the Federal army abandoned the town of Corinth. The model contraband camp was destroyed as the former slaves were moved to Memphis, Tennessee.

The 1st Alabama combined with the 2nd Alabama Infantry of African Descent to form the 55th and the 110th United States Colored Troops. On June 10, 1864, the 55th fought at the battle of Brices Crossroads, Mississippi, against Major General Nathan Bedford Forrest's cavalry.

Many of the black soldiers serving in Colonel Edward Bouton's brigade wore handmade badges stating, "Remember Fort Pillow," a reference to Forrest's alleged massacre of black soldiers north of Memphis.

Although initially held in reserve, the black soldiers fought valiantly. Their stand at the Ames house allowed the defeated Union soldiers to retreat. The fighting between the former slaves and Forrest's men was often hand to hand.

Bouton pleaded with Union major general Samuel Sturgis to let his men fight even more. Bouton told Sturgis to "give my blacks the ammunition the whites are throwing in the mud." With that ammunition, Bouton swore his men could check the Confederate advance. Sturgis had had enough of Forrest that day, stating, "For God's sake, if Mr. Forrest will let me alone, I will let him alone. You have done all you could and more than was expected of you, and now all you can do is to save yourselves."

Forrest routed the Union forces, chasing them back to Memphis. Many of the black soldiers removed their "Fort Pillow" badges. Revenge for that massacre would have to wait for another day.

Former male slaves in the Corinth camps were eventually formed into the 1st Alabama Infantry Regiment of African Descent.

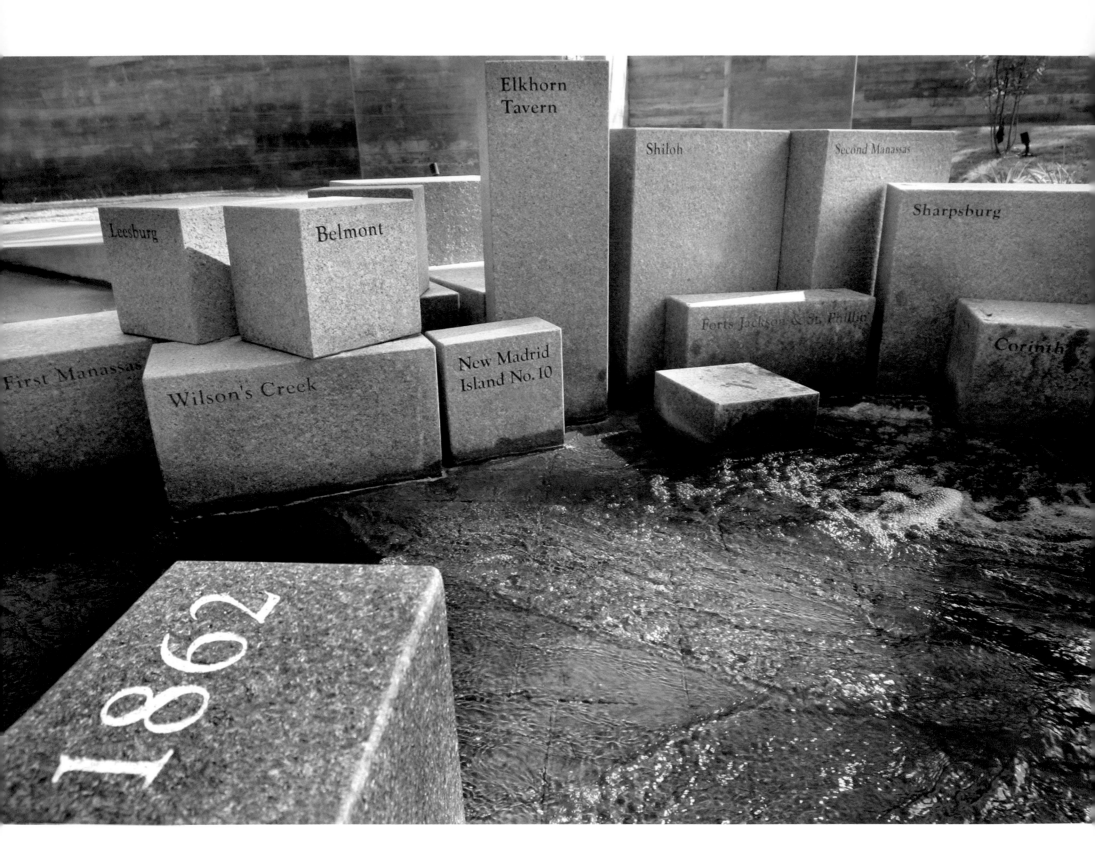

BLOCKS OF WAR

Prior to the battle of Shiloh, the Federal war effort was focused more on preserving the Union than on any other issue. The ghastly carnage that was dealt in two days of fighting proved to both sides that a war of conquest must be waged in order to ensure victory.

The blocks of war were laid even before the formation of the United States. These blocks would continue to gather until the walls of injustice crumbled, bringing a young country to civil war. It can be argued that slavery wasn't the only cause of the Civil War. The power struggle between the North and South included many issues.

Although the North was more populated and industrialized, the South controlled the political landscape and judicial arm of the United States. Looking back through the lens of time, the issue of slavery always pitted the two regions against each other.

As early as 1619, Virginia settlers purchased twenty Africans from a Dutch ship. Although they were sold as indentured servants who could eventually earn their freedom, these Africans, as well as their descendants, entered a lifetime of slavery.

The Massachusetts Bay Colony was the first colony to legalize slavery. The slave trade was a profitable business for New Englanders. In 1660, Virginia was the first Southern colony to legalize slavery. Approximately two hundred years before the election of Abraham Lincoln as president, the first block of the Civil War was laid.

In 1776, the Founding Fathers signed the Declaration of Independence. The document declared that "all men are created equal." Many of the men who signed the Declaration were slaveholders. Four years later, Pennsylvania became the first state to abolish slavery, calling for gradual abolition.

In 1787, the "three-fifths clause" in the Constitution stated that slaves would be counted as three-fifths of a person in order to calculate representation in the U.S. House of Representatives. Northern delegates had wanted only freed people counted in order to decide representation. This would wrest control of the federal government away from the South. The two sides compromised and agreed to count individual slaves as three-fifths of a person.

Eli Whitney's invention of the cotton gin in 1794 turned cotton into a profitable crop and increased the production value of slaves. Six years later, Gabriel Prosser organized a slave rebellion. The idea of a slave rebellion became the worse fear for Southern whites, causing state militias to grow in numbers.

In 1820, the Missouri Compromise allowed Maine to enter the Union as a free state and Missouri as a slave state, maintaining the balance of free and slave states in the Senate.

In 1854, the Kansas-Nebraska Act repealed the Missouri Compromise. The question of slavery would be left to the territorial settlers themselves to decide. Both sides began to send settlers into the area to influence the outcome.

In November 1860, Abraham Lincoln was elected president with 39 percent of the popular vote. He wasn't even on the ballot in Southern states. The following month, South Carolina seceded from the Union. In a matter of months, Mississippi, Georgia, Alabama, Florida, Louisiana, and Texas left the Union. In February 1861, Jefferson Davis was named president of the newly formed Confederate States of America.

On April 12, 1861, after four months of political posturing, the first shot of the Civil War was fired at Fort Sumter in Charleston harbor. The North and South finally had their war. Both sides foolishly thought the conflict would be settled quickly and without any huge loss of life.

By April 6, 1862, the war was almost a year old. The battle of Shiloh shattered any illusions about a decisive victory ending the war. Shiloh introduced the country to the dreadful loss of life that would continue into April 1865.

The water feature in the courtyard of the Civil War Interpretive Center in Corinth, Mississippi, interprets one hundred years of American history. The blocks tumbling through the passing water represent battles of the Civil War. Water rages past the blocks of war until it reaches a pool symbolizing the peace that was attained through the blood of the men in blue and gray.

The water feature at the Corinth Civil War Interpretive Center shows blocks, representing battles, tumbling in the rushing water of war.

THE EMANCIPATION PROCLAMATION

In the summer of 1862, the Federal war effort wasn't looking good. Robert E. Lee had assumed command of the Army of Northern Virginia, and a string of Confederate victories followed. The future of the United States looked bleak. Lincoln devised a plan to make the war a fight for a "moral" issue. Lincoln's Emancipation Proclamation promised to free the slaves.

When Lincoln first ran for president, it was not to free the slaves. Lincoln was content to let slavery stand in the states where the "peculiar institution" already existed. The Civil War was being fought to preserve the Union, not do away with slavery.

As the war continued and defeats began to increase for the Union, Lincoln developed the notion of freeing the slaves. He had tried to emancipate slaves by compensating the slave owners. Representatives in Congress from the border states voted down this measure.

Lincoln knew most people in the North weren't in favor of freeing the slaves. Such an action could possibly galvanize the Southern war effort, causing more Northern soldiers to die.

Lincoln presented the idea of freeing the slaves in a meeting with his cabinet in July 1862. The cabinet reacted in stunned silence at the idea of emancipating the slaves. Secretary of State William Seward advised Lincoln to wait until a favorable military action. According to Seward, issuing the Emancipation Proclamation during a string of defeats would look like "the last measure of an exhausted government, a cry for help."

The president tabled the idea and hoped one of his generals could provide him with a victory that would enable him to bring the war to a higher moral ground. Without that victory, the proclamation was worthless, more style than substance.

The Confederate offensive in the fall of 1862 would provide Lincoln with his much-needed victory. Robert E. Lee advanced into Maryland, Braxton Bragg pushed into Kentucky, and Earl Van Dorn sought to regain control of Corinth, Mississippi.

While the battle of Shiloh's carnage had shocked the country in April 1862, the results after one day of fighting at Antietam, Maryland, were even more staggering. The battle of Antietam was the bloodiest one day of fighting in the war, with 22,720 killed, wounded, or missing.

While the battle was a draw between Lee and George McClellan, the Army of Northern Virginia retreated across the Potomac River back to Virginia.

Lincoln had his "victory," and on September 22, 1862, he issued the Emancipation Proclamation, stating if the Rebels did not end the fighting and rejoin the Union by January 1, 1863, all slaves in the rebellious states would be free.

The proclamation did not free slaves in the Union, an issue to which Seward took issue: "We show our sympathy with slavery by emancipating slaves where we cannot reach them and holding them in bondage where we can set them free."

Following the battle of Antietam were Confederate defeats at Perryville, Kentucky, and Corinth, Mississippi. The Confederate offensive was beaten, and the slaves were freed. The Civil War had moved to a higher plateau. The proclamation allowed black soldiers to fight for the Union—soldiers who were desperately needed. It also tied the issue of slavery directly to the war.

The Emancipation Proclamation became a beacon for black Americans. The Reverend A. L. DeMond, a civil rights orator, describes the Declaration of Independence and the Emancipation Proclamation as "two great patriotic, wise and humane state papers. . . . Both were born in days of doubt and darkness. Both were the outcome of injustice overleaping the bounds of right and reason. The one was essential to the fulfilling of the other. Without the Declaration of Independence the nation could not have been born; without the Emancipation Proclamation it could not have lived."

The words of Thomas Jefferson are etched in stone at the Corinth Civil War Interpretive Center.

TIMELINE OF OPERATIONS IN THE SHILOH AND CORINTH CAMPAIGNS

March 1, 1862
Major General Henry W. Halleck, commanding Union forces in the West, orders Major General Ulysses S. Grant to take the Army of the Tennessee to a position on the Tennessee River near the Tennessee-Mississippi line. Union gunboats on the Tennessee River bombard a small Confederate force at Pittsburg Landing, Tennessee, driving the Confederates away. Albert Sidney Johnston's Confederate army begins marching toward Corinth, Mississippi; other Confederate troops begin moving to join the small Confederate force under Brigadier General Daniel Ruggles in holding the key town, the junction of the Memphis and Charleston and Mobile and Ohio railroads.

March 4, 1862
Henry Halleck sidelines Ulysses S. Grant and places Charles F. Smith in command of the advance up the Tennessee River.

March 8, 1862
Charles F. Smith's forces begin arriving at Savannah, Tennessee, on the east bank of the Tennessee River, about ten miles below Pittsburg Landing.

March 15, 1862
Charles F. Smith, incapacitated by a leg injury, stays in Savannah, Tennessee. Abraham Lincoln forces Henry Halleck to reinstate Ulysses S. Grant to command the Army of the Tennessee.

March 17, 1862
William T. Sherman unloads most of his division at Pittsburg Landing, nine miles south of Savannah, Tennessee.

March 18, 1862
Lead elements of Albert Sidney Johnston's army begin arriving at Corinth.

March 22, 1862
Albert Sidney Johnston arrives in Corinth.

March 29, 1862
Confederate forces in Corinth are consolidated into the Army of the Mississippi, forty-four thousand strong.

April 3, 1862
Albert Sidney Johnston advances toward Pittsburg Landing. Rain and bad roads delay his advance.

April 5, 1862
Union strength at Pittsburg Landing is 39,000 men, with 7,000 more men at Crump's Landing, and with 30,000 to 35,000 soldiers in Major General Don Carlos Buell's Army of the Ohio approaching Savannah, Tennessee.

April 6, 1862
Albert Sidney Johnston's Army of the Mississippi launches an attack on the Federal army at Pittsburg Landing.

April 6, 1862, 4:55–6:30 A.M.
A Federal patrol discovers the Confederate army at Fraley Field.

April 6, 1862, 8:30 A.M.
Confederate soldiers overrun Benjamin Prentiss's camps, routing the Union division.

April 6, 1862, 7:00–10:00 A.M.
William T. Sherman's division repulses Confederates, but pressure on Sherman's left forces him to retreat. Sherman falls back on John McClernand's division.

April 6, 1862, 10:00–11:30 A.M.
Confederates assault Sherman's and McClernand's divisions on the Hamburg-Purdy Road. Once again, Union soldiers are sent reeling.

April 6, 1862, 8:00–9:30 A.M.
W. H. L. Wallace's and Stephen Hurlbut's Union divisions march to battle.

April 6, 1862, 9:00–10:30 A.M.
Albert Sidney Johnston, hearing that his right flank is threatened, orders James Chalmers's and John K. Jackson's brigades to assault the Federal left, with John C. Breckinridge's troops in support.

April 6, 1862, 11:00 A.M.–noon
The Confederates make contact with the Federals on Eastern Corinth Road. The Federals repulse the attacks.

April 6, 1862, 11:00 A.M.–1:00 P.M.
James Chalmers's and John K. Jackson's troops assault David Stuart's forces, but the Confederate attack stalls. The Federal left holds against the attacks.

April 6, 1862, noon–2:30 P.M.
William T. Sherman and John McClernand counterattack, driving the Confederates south.

April 6, 1862, noon–3:30 P.M.
Randall Gibson's Confederates assault the Federal center four times and are repulsed. The Confederates come under murderous fire from the Sunken Road.

April 6, 1862, 1:00–4:00 P.M.
Albert Sidney Johnston orders an attack against the Federal

left-center. Johnston is killed in the attack. He is succeeded by P. G. T. Beauregard. Stephen Hurlbut's division again stalls the Confederates, but then retires toward Pittsburg Landing.

April 6, 1862, 3:00–5:30 P.M.
William T. Sherman and John McClernand do not prevent the Confederates from crossing Tilghman Branch, but retire to defend the Hamburg-Savannah Road, allowing Lew Wallace's division to come up.

April 6, 1862, 4:00–4:50 P.M.
The Federals withdraw across Tilghman Branch.

April 6, 1862, 6:30 P.M.
P. G. T. Beauregard calls off a final assault, claiming that victory at Shiloh was "sufficiently won."

April 6, 1862, 7:00 P.M.
Lew Wallace's division arrives on the Shiloh plateau.

April 6, 1862, evening
Don Carlos Buell's army files in on the Union left, while Thomas Crittenden's troops deploy in the center, with Alexander McCook's forces in support. The Federal gunboats *Lexington* and *Tyler* fire into captured Federal camps. Nathan Bedford Forrest's cavalrymen, wearing stolen Union slickers, stand on the bluff of Pittsburg Landing watching the arrival of Union reinforcements. Forrest tries to warn his superior officers but is told to keep a "vigilant watch."

April 7, 1862
The combined Union army of Ulysses S. Grant and Don Carlos Buell launch a morning counterattack against the Confederate army.

April 7, 1862, 7:00–9:00 A.M.
Lew Wallace's division drives the Confederates from Jones Field.

April 7, 1862, 7:00–9:00 A.M.
Ulysses S. Grant and Don Carlos Buell advance at dawn. The Union army doesn't meet resistance until 7 A.M.

April 7, 1862, 9:00–11:00 A.M.
William "Bull" Nelson advances through Wicker's and Sarah Bell's fields. Thomas Crittenden advances in the center, but stalls at the Hornet's Nest.

April 7, 1862, 9:00–11:00 A.M.
John C. Breckinridge and William Hardee counterattack William Nelson's right flank. They force the Federal left back across the Davis Wheat Field.

April 7, 1862, 9:00–11:00 A.M.
Alexander McCook crosses Tilghman Branch and engages John C. Breckinridge's left.

April 7, 1862, 10:30A.M.–noon
William T. Sherman, John McClernand, and Stephen Hurlbut cross Tilghman Branch and join Lew Wallace in fighting against Leonidas Polk and Braxton Bragg.

April 7, 1862, 10:30A.M.–noon
The Confederate army is flanked by Lew Wallace and is forced to retire to the Hamburg-Purdy Road.

April 7, 1862, noon–2:00 P.M.
Reinforced, William Nelson and Thomas Crittenden advance, forcing P. G. T. Beauregard's right flank to retreat south to the Hamburg-Purdy Road.

April 7, 1862, noon–2:00 P.M.
Alexander McCook slams into Braxton Bragg at Water Oaks Pond. P. G. T. Beauregard counterattacks, halting McCook. With his left under pressure, Beauregard is forced to retire.

April 7, 1862, 2:00–4:00 P.M.
John C. Breckinridge, supported by massed artillery south of the Shiloh Branch ravine, checks the Union advance, and the Confederates retire from field. Federals reclaim possession of the field and bivouac.

April 8, 1862
Nathan Bedford Forrest's cavalry charge halts the pursuit of William T. Sherman's men. Forrest is wounded with a minié ball lodged near his spine. P. G. T. Beauregard sends a message through the lines seeking permission to send a detail of soldiers to Shiloh to bury the Southern dead. Grant denies the request, stating that burial details had already taken care of the fallen from both sides.

April 11, 1862
Henry Halleck arrives at Pittsburg Landing from St. Louis. He orders John Pope's army at Island No. 10 on the Mississippi River to join Don Carlos Buell and Ulysses Grant at Pittsburg Landing.

April 15, 1862
The vanguard of Earl Van Dorn's army arrives at Memphis from Arkansas. Sterling Price's soldiers are the lead element of Van Dorn's army. Van Dorn doesn't arrive in Corinth until April 30, 1862. His forces increase the number of Confederate soldiers to 56,000. P. G. T. Beauregard orders five miles of earthworks strengthened in a semicircle north of the town. The earthworks, which were already there, were strengthened after Shiloh.

April 22, 1862

John Pope's Army of the Mississippi arrives at Pittsburg Landing and forms the Federal left wing at Hamburg; Don Carlos Buell's Army of the Ohio forms the center; and the Army of the Tennessee, now under George Thomas, forms the right wing. Henry Halleck now has 120,000 troops to fight the entrenched Confederates at Corinth. It was thought by many, including Halleck, that this would be the last battle of the war.

April 25, 1862

Charles F. Smith dies at the Cherry mansion in Savannah, Tennessee. His death was due to an infection that developed after he cut his leg while boarding a Union boat.

April 29, 1862

Henry Halleck begins his advance on Corinth. It will take him thirty days to travel twenty-two miles.

May 29, 1862

Realizing his army is no match for Henry Halleck's, P. G. T. Beauregard evacuates Corinth and retreats to Tupelo, Mississippi. Beauregard tricks Halleck into thinking his Confederates at Corinth are getting reinforcements instead of retreating.

May 30, 1862

Henry Halleck's Union army enters Corinth.

June 1, 1862

Ulysses S. Grant establishes headquarters in Corinth. In mid-July, Grant moves to the E. F. Whitfield Sr. plantation one mile south of Corinth.

June 10, 1862

Henry Halleck breaks up his huge army. He sends Don Carlos Buell to Chattanooga, Tennessee.

June 20, 1862

Jefferson Davis replaces P. G. T. Beauregard with Braxton Bragg. Bragg begins transferring troops by rail to Chattanooga. Earl Van Dorn is ordered to Vicksburg. He leaves two divisions at Tupelo under the command of Sterling Price.

June 27, 1862

John Pope is transferred to Virginia; William T. Sherman occupies Memphis, Tennessee.

July 16, 1862

Henry Halleck leaves Mississippi for Washington, D.C. Ulysses S. Grant takes control of the army at Corinth.

September 1, 1862

Braxton Bragg, now at Chattanooga, orders Sterling Price to cross the Tennessee River and prevent the Federals at Corinth from cooperating with Don Carlos Buell at Nashville.

September 13, 1862

Sterling Price's Confederate army enters Iuka, Mississippi, located twenty miles east of Corinth. Upon Price's arrival, the 8th Wisconsin evacuates the town.

September 18, 1862

William Rosecrans concentrates his army at Jacinto, Mississippi. He is to march from Jacinto to Iuka, Mississippi, hitting Sterling Price's army from the south. E. O. C. Ord's army reaches Glendale, Mississippi, ready to board trains that will transport them to Burnsville, Mississippi.

September 19, 1862

Sterling Price's Confederate army clashes with William Rosecrans's two divisions from the south. Price is threatened by E. O. C. Ord's division from the north in the battle of Iuka, Mississippi. The 11th

Ohio Battery, under the command of Lieutenant Cyrus Sears, valiantly fights off repeated charges from Louis Hebert's Confederate brigade. Sears will win the Medal of Honor for his role at Iuka. Brigadier General Henry Little is killed while talking to Sterling Price at the battle of Iuka. Price received a wire from Earl Van Dorn suggesting the two armies unite for an advance on Corinth.

September 20, 1862

Sterling Price's army withdraws from its positions at Iuka, returning to Baldwyn, Mississippi.

September 22, 1862

President Abraham Lincoln issues the Emancipation Proclamation.

September 28, 1862

Sterling Price unites his army with Earl Van Dorn's at Ripley, Mississippi, thirty miles southeast of Corinth. Called the Army of West Tennessee, the three divisions totaled 22,000 men, commanded by Van Dorn.

September 29, 1862

Earl Van Dorn's army marches north on the Pocahontas Road. This starts Van Dorn's Corinth campaign.

October 1, 1862

Earl Van Dorn's forces occupy Pocahontas, Tennessee. His army reaches the State Line Road and rebuilds the Davis Bridge over the Hatchie River. President Jefferson Davis names John C. Pemberton to command the District of Mississippi. The move replaces Van Dorn as commander in the state of Mississippi.

October 2, 1862

Earl Van Dorn's Confederate army begins to march to Chewalla, Tennessee, eight miles northwest of Corinth, then to Corinth. The army bivouacs at Chewalla.

October 3, 1862

Mansfield Lovell's division leads the Confederate advance toward Corinth. Lovell's men are the first to make contact with Union pickets north of Corinth. A large gap opens in the Union line when John McArthur and Thomas Davies deploy on the "Beauregard Line" and Charles Hamilton forms east of the Mobile and Ohio Railroad. Lovell's three brigades initiate vicious fighting at this point. John S. Bowen and Albert Rust lead the attacks. Sterling Price launches frontal assaults, pushing Davies's men back to Battery Robinett. The coordinated attack drives the Federals from the old Confederate works, and by late afternoon the Union soldiers are behind the inner defenses of the town. At 6 P.M., Earl Van Dorn calls a halt to the day's fighting, stating that his men were exhausted. Van Dorn is certain victory can be won the following day. During the first day of fighting, the Confederate army has pushed the Federal forces back two miles.

October 4, 1862

Earl Van Dorn's plan to resume the battle at daybreak is delayed by the alleged illness of Louis Hebert. At 10 A.M., Confederates break through the Federal lines and enter Corinth from the north. Fighting continues in the streets all the way to the Tishomingo Hotel. At the same time, the 42nd Alabama, 35th Mississippi, and 2nd Texas infantries, along with the 6th and 9th Texas Dismounted cavalries, break away from the main body to attack Battery Robinett, commanded by Lieutenant Henry C. Robinett, supported by the 37th, 39th, 43rd, and 63rd Ohio and the 11th Missouri regiments. Colonel William P. Rogers, who led the Confederate attack on Fort Robinett, is killed in the last advance. By 2:30 P.M., three separate charges on Battery Robinett have failed, as has the assault on the town of Corinth. Van Dorn is forced to abandon the field. Van Dorn's Confederate army begins

its retreat toward Chewalla, Tennessee. E. O. C. Ord and Stephen Hurlbut advance from Bolivar, Tennessee, in hopes of blocking Van Dorn's retreat across the Hatchie River.

October 5, 1862
William Rosecrans begins his pursuit of Earl Van Dorn's Confederate army. Sterling Price's Confederate soldiers run into E. O. C. Ord's and Stephen Hurlbut's men at the Davis Bridge on the Hatchie River. The Union army blocks Van Dorn's escape route across the river. John S. Bowen is forced to fight a rear guard action at Young's Bridge on the Tuscumbia River to save Van Dorn's army. Van Dorn's army is trapped between the Hatchie and Tuscumbia rivers. Van Dorn finds an alternative place to cross the Hatchie River at Crum's Mill. Once Van Dorn is safely across the Hatchie, Ulysses S. Grant loses an opportunity to destroy Van Dorn's army.

October 16, 1862
The War Department issues orders that establish the Department of the Tennessee. Ulysses S. Grant keeps his headquarters in Jackson, Tennessee.

October 26, 1862
Ulysses S. Grant assumes command of the newly created Department of the Tennessee. Grant signs an order establishing the military District of Corinth. It is one of four divisions of the Department of the Tennessee.

December 20, 1862
Earl Van Dorn, now commanding cavalry, launches a successful raid on Holly Springs, Mississippi. The raid forces Ulysses S. Grant to withdraw into Tennessee.

A broken wagon wheel stands near the door of the Corinth Civil War Interpretive Center.

The effect of the Battle of Corinth was very great. . . . It was, indeed, a decisive blow to the Confederate cause in our quarter. . . . I could see its effects on the citizens, and they openly admitted that their cause had sustained a death blow.

–MAJOR GENERAL WILLIAM T. SHERMAN,
USA

BIBLIOGRAPHY

SOURCES

Allen, Christopher. "The Battle of Shiloh." *America's Civil War* (January 2000): 30–34.

———. "Shiloh: Devil's Own Day." *America's Civil War* (January 2000): 24–26.

Allen, Stacy D. "Corinth and Iuka." *Blue and Gray Magazine* 19, no. 6 (2002): 6–14, 19–24, 36–38, 41–51.

———. *Shiloh*. Columbus, Ohio: Blue and Gray Enterprises, 2001.

Ambrose, Stephen E. "By Enlisting Negroes, Could the South Still Win the War?" *Civil War Times* 3, no. 9 (January 1965): 16–21.

———. "Old Brains Halleck." *Civil War Times Illustrated* 1, no. 4 (July 1962): 15–16, 33–34.

Ashley, Joe, and Lavon Ashley. *Oh For Dixie! The Civil War Record and Diary of Capt. William V. Davis 30th Mississippi Infantry CSA*. Colorado Springs, Colo.: Standing Pine Press, 2001.

Bagby, Milton. "A Meeting at Shiloh." *Historic Traveler* 1, no. 1 (May 2001): 12–17.

Bailey, Daryl A. "From Shiloh to Spanish Fort." *America's Civil War* 9, no. 2 (March 1999): 62–64.

Barrett, Jason. "Johnston's Wild and Wooly Trek." *America's Civil War* (June 2002): 30–36.

Bearss, Edwin. *The Fall of Fort Henry*. Dover, Tenn.: Eastern National Park and Monument Association, n.d.

———. *Fields of Honor: Pivotal Battles of the Civil War*. New York: National Geographic Books, 2006.

Billings, John D. *Hard Tack and Coffee*. 1887. Reprint, New York: Time-Life Books, 1982.

Burns, Ken. *The Civil War*. New York: Alfred A. Knopf, 1990.

Bynum, Victoria E. *The Free State of Jones, Mississippi's Longest Civil War*. Chapel Hill: University of North Carolina Press, 2001.

Carter, Arthur B. *The Tarnished Cavalier: Major General Earl Van Dorn, C.S.A.* Knoxville: University of Tennessee Press, 1999.

Castel, Albert. *General Sterling Price and the Civil War in the West*. Baton Rouge: Louisiana State University Press, 1968.

Cleburne, Patrick. "Report of Brigadier General P. R. Cleburne, C. S. Army, Commanding Second Brigade.—Battle of Pittsburg Landing, or Shiloh, Tenn." Official Report, Series I, vol. 10, no. 1, April 6–7, 1862, War of the Rebellion Official Records. Washington, D.C.: Government Printing Office, 1880.

Cooling, Benjamin F., III. "The Attack on Dover, Tennessee." *Civil War Times* 2, no. 5 (August 1963): 10–13.

Conger, Arthur Latham. *The Rise of U. S. Grant*. New York: Century, 1931.

Crummer, Wilber F. *With Grant at Fort Donelson, Shiloh and Vicksburg*. Oak Park, Ill.: E. C. Crummer, 1915.

Daniel, Larry J. *Shiloh: The Battle That Changed the Civil War*. New York: Touchstone Books, 1997.

———. *Soldiering in the Army of Tennessee*. Chapel Hill: University of North Carolina Press, 1991.

Davis, William C. *Breckenridge: Statesman, Soldier, Symbol*. Baton Rouge: Louisiana State University Press, 1974.

———. *An Honorable Defeat: The Last Days of the Confederate Government*. New York: Harcourt, 2001.

Dornbusch, Charles E. *Military Bibliography of the Civil War*. 3 vols. New York: New York Public Library, 1961–1972.

Dossman, Steven. *Campaign for Corinth: Blood in Mississippi*. Civil War Campaigns and Commanders Series. Abilene, Tex.: McWhiney Foundation Press, 2006.

Dyer, Frederick H. *A Compendium of the War of the Rebellion*. 3 vols. New York: Thomas Yoseloff, 1959.

Eicher, David J. *The Longest Night: A Military History of the Civil War*. New York: Simon and Schuster, 2001.

Eisenschiml, Otto. "Medicine in the War." *Civil War Times* 1, no. 2 (May 1962): 4–7, 28–32.

———. "Sherman: Hero or War Criminal?" *Civil War Times* 2, no. 9 (January 1964): 7–9, 29–35.

———. "Shiloh: The Blunders and the Blame." *Civil War Times* 2, no. 1 (April 1963): 6–11, 30–34.

Engle, Stephen. *Don Carlos Buell: Most Promising of All*. Chapel Hill: University of North Carolina Press, 1999.

Foote, Shelby. *The Civil War: A Narrative*. Vol. 1, *Fort Sumter to Perryville*. New York: Random House, 1958.

———. *The Civil War: A Narrative*. Vol. 2, *Fredericksburg to Meridian*. New York: Random House, 1963.

———. *The Civil War: A Narrative*. Vol. 3, *Red River to Appomattox*. New York: Random House, 1974.

Fox, William F. *Regimental Losses in the American Civil War*. Albany, N.Y.: Albany, 1889.

Frank, Joseph Allan. *Seeing the Elephant: Raw Recruits at the Battle of Shiloh*. Urbana: University of Illinois Press, 2003.

Fried, Joseph P. "How One Union General Murdered Another." *Civil War Times* 1, no. 3 (June 1962): 14–16.

Grant, U. S. *The Personal Memoirs of Ulysses S. Grant*. Old Saybrook, Conn.: Konecky and Konecky, 1992.

Grimsley, Mark, and Stephen E. Woodworth. *Shiloh: A Battlefield Guide*. Lincoln: University of Nebraska Press, 2006.

Guelzo, Allen. "Ambrose Bierce's Civil War: One Man's Morbid Vision." *Civil War Times* 44, no. 4 (October 2005): 22–29.

Hartje, Robert G. *Van Dorn: The Life and Times of a Confederate General*. Nashville, Tenn.: Vanderbilt University Press, 1967.

Henry, Robert Selph. *Nathan Bedford Forrest, First with the Most*. New York: Mallard Press, 1991.

Howey, Allen W. "Weaponry: The Rifle-Musket and the Minié Ball." *Civil War Times* 2, no. 3 (October 1999): 31–34.

Hughes, Nathaniel C. *The Pride of the Confederate Artillery: The Washington*

Artillery in the Army of Tennessee. Baton Rouge: Louisiana State University Press, 1997.

Hurst, Jack. *Nathan Bedford Forrest: A Biography.* New York: Alfred K. Knopf, 1994.

Isherwood, Justin. "Col. James Alban." *Stevens Point Journal* (University of Wisconsin–Stevens Point), May 19, 1992.

Isbell, Timothy T. *Gettysburg: Sentinels of Stone.* Jackson: University Press of Mississippi, 2006.

———. *Vicksburg: Sentinels of Stone.* Jackson: University Press of Mississippi, 2006.

Jones, Archer. *Confederate Strategy from Shiloh to Vicksburg.* Baton Rouge: Louisiana State University Press, 1961.

Jones, Gordon W. "Wartime Surgery." *Civil War Times* 2, no. 2 (May 1963): 7–9, 28–30.

Johnston, William Preston. *The Life of Albert Sidney Johnston.* New York: Da Capo Press, 1997.

Kennedy, Francis H. *The Civil War Battlefield Guide.* Boston: Houghton Mifflin, 1990.

Kennett, Lee. *Sherman: A Soldier's Life.* New York: Harper Collins, 2001.

Lawrence, Eugene. "Grant on the Battlefield." *Harper's New Monthly Magazine* 39 (1869), 212.

Lee, James. "The Undertaker's Role during the American Civil War." *America's Civil War* (November 1996): 45–47.

Livermore, Thomas L. *Numbers and Losses in the Civil War.* Bloomington: Indiana University Press, 1957.

Luvaas, Jay, Stephen Bowman, and Leonard Fullenkamp. *Guide to the Battle of Shiloh.* Lawrence: University Press of Kansas, 1996.

Marszalek, John. *Commander of All Lincoln's Armies: The Life of General Henry W. Halleck.* Cambridge, Mass.: Belknap Press of Harvard University Pres, 2004.

McDonough, James Lee. *Shiloh—In Hell before Night.* Knoxville: University of Tennessee Press, 1977.

McPherson, James M. *The Atlas of the Civil War.* New York: McMillan USA, 1994.

———. *Battle Cry of Freedom: The Civil War Era.* Oxford: Oxford University Press, 2003.

Morsberger, Robert E., and Katherine Morsberger. *Lew Wallace, Militant Romantic.* New York: McGraw Hill, 1980.

Mosocco, Ronald A. *The Chronological Tracking of the American Civil War.* Williamsburg, Va.: James River Publications, 1993.

National Archives and Records Service. *Military Operations of the Civil War: A Guide-Index to the Official Records of the Union and Confederate Armies, 1861–1865.* Washington, D.C.: Government Printing Office, 1968.

Nevin, David. *The Road to Shiloh.* Alexandria, Va.: Time-Life Books, 1983.

Nevins, Allan. *Frémont: Pathmarker of the West.* Reprint, Lincoln: University of Nebraska Press, 1992.

———. *The War for the Union.* Vol. 2, *War Becomes Revolution 1862–1863.* New York: Charles Scribner's Sons, 1960.

Pohanka, Brian C. *Distant Thunder: A Photographic Essay on the American Civil War.* Charlottesville, Va.: Thomasson-Grant, 1988.

Purdue, Howell, and Elizabeth Purdue. *Pat Cleburne: Confederate General.* Hillsboro, Tex.: Hill Junior College Press, 1973.

Quiner, E. B. *The Military History of Wisconsin: Civil and Military Patriotism of the State, in the War for the Union.* Chicago: Clarke, 1866.

Riggs, Derald. "Commander in Chief: Abraham Lincoln." *America's Civil War* (July 2000): 35–40.

Robertson, James I. *The Confederate Spirit: The Paintings of Mort Kunstler.* Nashville, Tenn.: Rutledge Hill Press, 2000.

Ronan, James B. II. "Catching Regular Hell at Shiloh." *America's Civil War* (May 1996): 42–48.

Sanders, Stuart W. "Kentucky Governor at Shiloh." *America's Civil War* (February 1997): 8, 80, 82.

Shaara, Jeff. *Civil War Battlefields: Discovering America's Hallowed Ground.* New York: Ballantine Books, 2006.

Sharpe, Michael. *Historical Maps of Civil War Battlefields.* London: PRC, 2000.

Sherman, William T. *The Memoirs of General William T. Sherman.* Civil War Centennial Series. Bloomington: Indiana University Press, 1957.

———. "Report of William T. Sherman, Reconnaissance from Shiloh." Official Report, Series I, vol. 10, no. 1, chap. 2, War of the Rebellion Official Records. Washington, D.C.: Government Printing Office, 1880.

Sifakis, Stewart. *Compendium of the Confederate Army: Mississippi.* New York: Facts on File, 1995.

Simpson, Harold B. *Cry Comanche: The Second U. S. Cavalry in Texas.* Hillsboro, Tex.: Hill Junior College Press, 1979.

Smith, Jean Edward. *Grant.* Reprint, New York: Simon and Schuster, 2002.

Smith, Timothy B. *This Great Battlefield of Shiloh: History, Memory, and the Establishment of a Civil War National Military Park.* Knoxville: University of Tennessee Press, 2004.

——— *The Untold Story of Shiloh: The Battle and the Battlefield.* Knoxville: University of Tennessee Press, 2006.

Stanley, Henry Morton. *The Autobiography of Sir Henry Morton Stanley.* Ed. Dorothy Stanley. Boston: Houghton Mifflin, 1909.

Stillwell, Leander. *An Illinois Private Fights at the Hornet's Nest.* Kansas City, Mo.: Franklin Hudson, 1920.

Strain, John Paul. *Witness to the Civil War.* Philadelphia: Courage Books, 2002.

Suhr, Robert Collins. "Battle of Corinth." *American's Civil War* (May 1999): 23–26.

———. "Old Brains' Barren Triumph." *America's Civil War* (May 2001): 42–49.

———. "Saving the Day at Shiloh." *America's Civil War* (January 2000): 34–41.

———. "Small But Savage Battle of Iuka." *America's Civil War* (May 2000): 42–49.

Sword, Wiley. *Shiloh: Bloody April.* Dayton, Ohio: Morningside House, 2001.

Symonds, Craig L. *Stonewall of the West: Patrick Cleburne and the Civil War*. Lawrence: University Press of Kansas, 1997.

Thompson, William C. "From Shiloh to Port Gibson." *Civil War Times* 3, no. 6 (October 1964): 20–25.

Troiani, Don. *Don Troiani's Civil War*. Art by Don Troiani; text by Brian C. Pohanka. Mechanicsburg, Pa.: Stackpole Books, 1995.

Tucker, Glenn. "Nathan Bedford Forrest: Untutored Genius of the War." *Civil War Times* 3, no. 3 (June 1964): 6–9, 19–23.

Tucker, Phillip Thomas. *The Forgotten Stonewall of the West: Major General John S. Bowen*. Macon, Ga.: Mercer University Press, 1997.

U.S. War Department. *The War of the Rebellion. A Compilation of the Official Records of the Union and Confederate Armies*. 128 vols. Washington, D.C.: Government Printing Office, 1882–1900.

van der Linden, Frank. "General Bragg's Impossible Dream: Take Kentucky." *Civil War Times* 1, no. 2 (November/December 2006): 21–25.

Wallace, Isabel. *The Life and Letters of General W. H. L. Wallace*. Carbondale: Southern Illinois University Press, 2000.

Watkins, Sam R. *"Co. Aytch": A Side Show of the Big Show*. Wilmington, N.C.: Broadfoot, 1882.

Welcher, Frank J. *The Union Army, 1861–1865: Organizations and Operations*. 2 vols. Bloomington: Indiana University Press, 1989, 1993.

Wiley, Bell Irvin. *The Life of Billy Yank: The Common Soldier of the Union*. Garden City, N.J.: Doubleday, 1971.

———. *The Life of Johnny Reb: The Common Soldier of the Confederacy*. Garden City, N.J.: Doubleday, 1971.

Williams, T. Harry. *P. G. T. Beauregard: Napoleon in Gray*. Baton Rouge: Louisiana State University Press, 1955.

Woodworth, Steven E. *The American Civil War: A Handbook of Literature and Research*. Westport, Conn.: Greenwood Press, 1996.

———. *Nothing but Victory: The Army of the Tennessee*. New York: Alfred A. Knopf, 2005.

Wyeth, John A. *Life of General Nathan Bedford Forrest*. Edison, N.J.: Blue and Gray Press, 1996.

P. G. T. Beauregard Report
http://www.civilwargazette.faithsite.com/content.asp?CID=56372

Shiloh Historical Handout
http://www.cr.nps.gov/history/online_books/hh/10/hh10f.htm

Shiloh Official Records
http://www.civilwarhome.com/shiloh.htm

William Ketchum
http://www.terrystexasrangers.org/official_records/official_documents/official_reports/1862_04_15.html

WEB SITES

Battle of Davis Bridge
http://www.nps.gov/shil/Tennessee1.htm

Battle of Shiloh
http://www.civilwargazette.com/csacw/tours/shiloh/

Corinth Summary
http://www.cr.nps.gov/hps/abpp/battles/ms002.htm

Edward Allen Journal and 16th Wisconsin
http://www.lib.unc.edu/mss/inv/htm/03737.html

INDEX